Kandinsky

Watercolors and Drawings

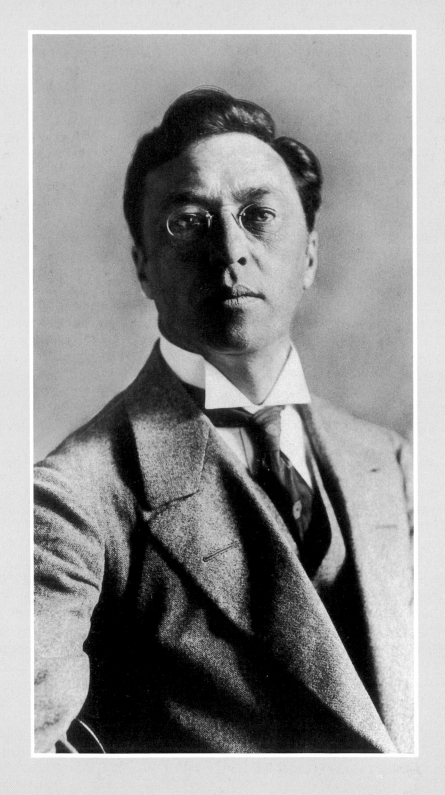

Kandinsky

Watercolors and Drawings

Edited
and with contributions by

Vivian Endicott Barnett and
Armin Zweite

Prestel

First published in German on the occasion of the exhibition
"Kandinsky: Small Pleasures. Watercolors and Drawings"
at the Kunstsammlung Nordrhein-Westfalen, Dusseldorf
March 7 – May 10, 1992
and at the Staatsgalerie Stuttgart
May 23 – August 2, 1992

Armin Zweite's essay translated by David Britt
Edited by Ian Robson

Front cover:
Vasily Kandinsky, *Central Line,* November 1924,
Ingrid Hutton, New York (cat. no. 103)

Back cover:
Vasily Kandinsky, *Birds,* January 1916,
private collection (cat. no. 49)

Frontispiece: Portrait of Kandinsky, 1913,
published in "Reminiscences" (Rückblicke), Berlin 1913,
unknown photographer

Photograph, p. 55:
Kandinsky during the Bauhaus period,
photographed by Elfriede Reichelt, Breslau,
Stadtmuseum München, Photomuseum

Prestel-Verlag, Mandlstrasse 26, D-8000 Munich 40, Germany
Tel: (89) 38 17 09 0; Fax: (89) 38 17 09 35

Distributed in continental Europe by Prestel-Verlag,
Verlegerdienst München GmbH & Co KG,
Gutenbergstrasse 1, D-8031 Gilching, Germany

Distributed in the USA and Canada by te Neues Publishing Company,
15 East 76th Street, New York, NY 10021, USA

Distributed in Japan by YOHAN-Western Publications Distributions Agency,
14-9 Okubo 3-chome, Shinjuku-ku, J-Tokyo 169

Distributed in the United Kingdom, Ireland and all other countries by
Thames & Hudson Limited, 30-34 Bloomsbury Street, London WC1B 3 QP, England

Color separations: Schwitter AG, Basle
Black and white reproductions: Reproduktionsgesellschaft Karl Dörfel GmbH, Munich
Typesetting, printing and binding: Passavia Druckerei GmbH Passau

Printed in Germany
ISBN 3-7913-1184-0 (English edition)
ISBN 3-7913-1195-6 (German edition)

Contents

Preface

When Vasily Kandinsky, in one of his last published utterances, once more invoked the "creative and prophetic power" of art – the power to find "tomorrow" in "today" – he could look back on a rich and multifaceted life's work. His decades of artistic creativity had been accompanied by theoretical reflections recorded in a succession of important essays, in which he presented the analogy between music and painting – a notion widely held among his contemporaries – as the justification for his own move toward a nonobjective art. To this he added the conviction – inaccessible to rational proof – that the laws of concrete nature and of abstract art spring from a common root and are therefore to be seen as parallels. Another idea that was very much of its time served as the principal motive force in his vigorous expansion of the expressive resources of art: this was that art embodied the conquest of materialism and thus heralded a synthesis that would concentrate spiritual forces and open up the cosmic dimension that Kandinsky, as late as 1935, called the "music of the spheres".

Like many other central figures of twentieth-century painting – Malevich, Mondrian, and Kupka among them – Kandinsky thus had recourse to curious and outworn ideas, many of them rooted in the nineteenth century, to justify a paradigm-shift in painting that was as radical as it was momentous. This often unfathomable combination of traditional influences and innovative impulses, this contrast – between a desire to find legitimacy in the past, or in the realm of the imagination, and the most unerringly incisive insights, between remote speculations and compelling logic, between utopian visions and forward-looking, stunningly radical creativity – has clearly lost none of its fascination over the years. Why is this?

It may be because, on his path from the objective to the nonobjective, from the concrete and sensuous to the threshold of the spiritual, Kandinsky played his part in promoting those dematerializing tendencies that are now once more at the focus of cultural criticism and aesthetic thought – as evidenced, for example, by the exhibition "Les Immatériaux" at the Centre Pompidou in Paris in 1985. New technologies simulate new worlds whose immaterial nature demands, and molds, a newly differentiated sensitivity and an altered perception of the world. Action in multiple directions and constantly shifting perspectives and structures of perception define the mindset of our whole culture; and simplicity – as Lyotard remarks – increasingly comes to seem like barbarism.

Kandinsky had no premonition of any such consequences; but especially in his Paris years – and probably with an eye to those artists who were reducing more and more their repertoire of forms – he argued for a relativistic approach to the formal and technical resources from which the "inexhaustible riches of painting" derived. In Kandinsky we find not dogmatism but complexity, not the formalistic hardening of attitudes but flexibility. It is this blend of materialization and dematerialization, of analysis and synthesis, of rigor and playfulness, and the interplay of genre-specific and genre-transcending elements, that makes Kandinsky's work – in general and in particular – so full of tension and so richly stimulating.

There are other reasons for its fascination. Kandinsky's path from conventional beginnings, by way of a phase of high-profile innovation, to the exploration of remote and rarefied possibilities remains both a surprising and a convincing one. Another aspect of Kandinsky deserves attention. He was a cosmopolitan, a European figure, who mediated between Moscow, Munich, and Paris at a time when such a thing was still possible. After the political changes of recent years, perhaps his work will once more stimulate a fruitful debate that will resituate it within the traditions – some surviving, some buried – from which it emerged; although the reception accorded to the big retrospective at the Tretyakov Gallery in Moscow a few years back showed that in Russia this may well take longer than expected. Much remains to be done and much to be explored. Meanwhile, over the past two decades, exhibitions in Munich, New York, Paris, Zurich, Berlin, Frankfurt, and elsewhere have not only expanded and deepened our knowledge but raised many new questions.

Needless to say, the title we have chosen for the exhibition this book accompanies, "Small Pleasures", is not intended to suggest that Kandinsky's work is trivial and anodyne. It is the title that Kandinsky himself gave to an oil painting dated 1913, every last detail of which was the fruit of numerous preparatory studies. A succession of paintings on glass, watercolors, and drawings, and the canvas itself, allow us to follow the progression – so central to this stage of his career – from objective to nonobjective representation; even so, some identifiable, concrete motifs can be traced right through to the last works in the thematic sequence.

In a previously unpublished essay on this painting, Kandinsky describes and analyzes his mode of operation. And even though his repertoire of forms and colors

changed utterly, and Kandinsky ultimately came to rely not on narrative elements but – in the Bauhaus years, at least – almost exclusively on geometrical figures, the principles outlined in 1913 remain clearly present in his later work.

Looking back from exile in Paris in 1935, Kandinsky describes the works painted before the outbreak of World War I as "dramatic"; after 1914, he says, he had set out to eliminate this dramatic element and to put "a red-hot filling into an ice-cold shell". He describes the Bauhaus years as a "cold period"; later, his efforts had been directed toward "polyphony" and toward the "purely painterly fairytale, that can be 'told' by painting alone". His works, he goes on, were intended to radiate agitation in calm, and calm in agitation. *Small Pleasures* thus becomes a metaphorical description of his working strategy, which was "to use inner cohesion to make outer disintegration visible, and to join by dissolving and tearing apart".

The exhibition and the book are exclusively concerned with watercolors and drawings, in recognition of the fact that it has hitherto been possible to show this vital category of Kandinsky's work, if at all, only in parts defined by the extent of the collections concerned. In Munich, for instance, the Städtische Galerie im Lenbachhaus has held several exhibitions of its rich collection; but this extends no further than 1914. Analogous limitations apply to the collection of Nina Kandinsky, selections from which were seen in Bielefeld and in Munich in 1973/74, and to the holdings of the Solomon R. Guggenheim Museum, New York, and of The Hilla von Rebay Foundation, some of which were recently presented in an international touring exhibition.

Our project naturally embraces all these collections, but also attempts to trace the public response to Kandinsky's work by including a large number of works that were in private collections in the artist's own lifetime. For various reasons, however, many drawings and watercolors of great thematic or formal importance have remained inaccessible to us. The generous scale of this showing and publication of drawings and watercolors – works that Kandinsky himself always regarded as entirely autonomous works of art – is to the credit of all those numerous lenders whose contribution to the success of the enterprise has been decisive. We owe them all our heartiest thanks.

The Editors

Armin Zweite

Free the Line for the Inner Sound

Kandinsky's Renewal of Art in the Context of His Time

Stages in a Progress

In October 1912, when Vasily Kandinsky had his first one-man exhibition at Herwarth Walden's gallery Der Sturm in Berlin, the Munich publishing-house Neue Kunst, owned by Hans Goltz, brought out a slim catalogue. In its second and third printings, some supplementary remarks by Kandinsky were added to the preface. In this publication, which had a comparatively wide circulation – two thousand copies in all were printed – the painter formulates his credo: "to create by pictorial means ... pictures that as *purely pictorial objects* have their own independent, intense life." The italics are Kandinsky's own. He goes on to explain what he means by the term "purely pictorial objects": "My personal qualities consist in the ability to make the inner element sound forth more strongly by limiting the external. Conciseness is my favorite device. For this reason, I do not carry even purely pictorial means to the highest level. Conciseness demands the imprecise (i.e., no pictorial form – whether drawing or painting – that produces too strong an effect)."

To recapitulate: the artist speaks of objects that are purely pictorial in nature; he distinguishes outwardness from inwardness, apparently implying a value judgment; he aspires to conciseness; and yet, remarkably, he does not identify this quality – as one might have expected – with clarity and unambiguousness, but, on the contrary, with imprecision. Furthermore, it is noteworthy that, in discussing visual phenomena, he resorts to analogies from music: thus, the "inner element" is not given greater visibility by "limiting the external", but rather by "making it sound forth more strongly".

The unbiased reader feels confused, not least by all this synaesthetic imagery, and is driven to wonder whether the plea for the intrinsic worth of the means employed by the artist, which is implicit in Kandinsky's words, is not undermined – even negated – by the clearly stated antithesis between the inner and the external, conciseness and imprecision. It comes as a surprise, furthermore, to find that the objective of "Painting as Pure Art", to quote the title of another of Kandinsky's essays from the same period,[1] is to be attained in terms of the purest subjectivity, as a result of a "personal characteristic".

The real meaning of formulations like this – and there are a number of similar ones – cannot be extracted with any degree of certitude either from the supplementary remarks or from any of the other writings by Kandinsky that were in circulation at the time. To read them is to encounter a multitude of lively impressions that seem to evanesce as soon as theoretical matters are touched upon. Whole passages lay down a terminological smokescreen, which only lifts somewhat when the painter's writings are collated with his pictorial works. This cannot be done with the necessary comprehensiveness in the space available here; but it seems worth going into some detail about one work, the watercolor that supplies our title – *Small Pleasures* of 1913.

First, however, since the present project excludes the whole of the painter's early work down to 1910 or so, it will be necessary at least to sketch in the artistic and cultural background, in order to elucidate something of the context of Kandinsky's breach with traditional concepts of picture-making.

Important factors in the genesis of Kandinsky's style, as it began to crystallize from 1910 onwards, were his encounters with Art Nouveau, with Symbolism, with Fauvism, and with one specific variant of the general European trend known as Primitivism. To this may be added the growing general tendency to question the reliability of scientific knowledge, Kandinsky's own firm rejection of materialism and positivism, and his increasing concern not only with psychology, but also with theosophy and anthroposophy. We sense in him, as in many of his contemporaries, a deep-seated insecurity that takes the form of apocalyptic moods and visions, sometimes accompanied by the hope that pure spirit will redeem the world. Much of what Kandinsky thought, said, and wrote is by no means unusual; what makes it so momentous and so influential is the drastic and decisive formulation, and the radical expression this found in his artistic oeuvre.

In many works of the last few years before World War I Kandinsky abandoned the reference to concrete reality altogether. Step by step – and certainly not, as the look of some of his works might suggest, spontaneously – he evolved a nonobjective formal vocabulary and a strongly luminous, even flamboyant use of color that dissociates itself from line. He was well aware of the momentous consequences of these forays into abstraction; and it was partly for this reason that he searched for some rationally acceptable and historically tenable justification for a departure that seemed to many contemporaries – including some of his own painter friends – to be a total break with the European art tradition, a surrender to unbridled caprice and sheer, unchecked infantilism.

Scandalous though they may have seemed to many, the works of this phase undoubtedly laid the foundations for Kandinsky's subsequent evolution in Russia (1914-21), at the Bauhaus (1922-33), and in Paris (1934-44). In the few years before 1914, Kandinsky elaborated the basis of his whole creative output. The step-by-step process of formulating the codes of a nonobjective form of painting was attended by much soul-searching and many disappointments; but in retrospect it emerges as an epoch-making achievement. Its lasting fascination lies above all in the way in which the painter, conscious of the explosive force of his art, kept trying to explain it to himself and to his contemporaries, trying to justify something that was past all rational justification. If innovation is taken as the absolute criterion of importance, then the brief and intensive period of work between 1910 and 1914 was the most important and the most fruitful in his entire career.

Multiple Influences in Munich

At the end of 1896 Kandinsky, like a number of other Russian artists, among them Marianne von Werefkin (1860-1938) and Alexej Jawlensky (1864-1941), moved to Munich. There he attended the private art school of Anton Ažbè (1859-1905) and, after one failed attempt, gained admission to the academy class of Franz von Stuck (1863-1925). Older than most of the other students, he was soon pressing forward with his program of self-education; and, still a totally unknown artist, he was impelled by his sense of mission to pass on his experience and knowledge to younger artists through the Phalanx, a society of artists founded in 1901. This deliberate commitment to simultaneous action on a number of levels was a feature of the years that followed. Kandinsky not only painted, he taught, wrote, and began to publish; he organized exhibitions of Claude Monet, Alfred Kubin, the Impressionists, and others; and he made numerous contacts among painters, poets, and musicians, especially in Russia, Germany, and France. A polyglot, with strong philosophical, literary, and musical interests, he observed the major intellectual movements of the turn of the century and witnessed the last, spiritually bankrupt excesses of "art for art's sake". Armed with a determination to bridge the divisions between genres, but with no systematic grounding in technique, Kandinsky embarked on his artistic career. There was a naive and nonchalant streak in this that was not disposed to make concessions to prevailing academic traditions. His outsider status, backed by superior intellect and exceptional sensitivity, was the indispensable precondition for his later radical stance.

More than one commentator has empasized that Kandinsky's knowledge of the Munich brand of Art Nouveau – known as Jugendstil, the periodical *Jugend* having been first published in Munich in 1896 – and of its major exponents, such as Hermann Obrist (1863-1927), exerted an influence on his own development. It is quite true that the ornamental designs and finished works of Obrist, Hans Schmithals, August Endell, and others can be regarded as precursors of nonobjective imagery. The same also goes for a number of works done around 1905 by Adolf Hölzel (1853-1934); and Stuck was another who contributed various motifs to Kandinsky's work. In her study of these affinities, Peg Weiss has collected a wealth of detailed material, and she concludes that Jugendstil and the Arts and Crafts movement, especially in printmaking and graphic design, formed a bridge between the applied arts and Kandinsky's ultimate breakthrough to abstraction.[2]

Whether or not printmaking played so decisive a role in Kandinsky's radical abandonment of tradition, the nature of his engagement with Jugendstil is unmistakably evident in a number of modest works in the field of applied art that he produced soon after the turn of the century. The truth is, however, that these ornamental designs for garments, jewelry, embroideries, and the like (consciously excluded from this exhibition), are not much more than tentative attempts at self-orientation. Kandinsky certainly borrowed Jugendstil features – two-dimensionality, gentle curves, plant forms, an ornamental treatment of objects, and a partial dissociation of line and color – but his true affinities are mainly to be found in his choice of motifs, to which we shall return later. Kandinsky's earliest works give no hint, let alone promise, of his true achievement and significance.

Kandinsky met many artists in this early Munich period, although we do not hear of any very close friendships. From 1904 onward there followed a phase full of unrest, expressed in physical terms by constant travel. He repeatedly went back to Russia for a few weeks at a time. With Gabriele Münter (1877-1962), whom he had met when she was his student at the Phalanx painting school, he spent the summer of 1904 in Holland. Many journeys followed, including protracted stays in Tunis, Rapallo, and Sèvres,[3] before the couple returned to Munich in September 1908.

This whole phase was marked by a gradual growth in public appreciation of his work, which still largely remained within the bounds of what was then accepted as progressive art. In the often rather folksy-looking paintings of the period, Kandinsky tends to evoke fairytale moods and a lost, medieval world; however, he is clearly not translating specific literary sources into the pictorial medium. The figures and their settings conjure up a sense of mystery, a dreamlike atmosphere that – as has rightly been pointed out – shows numerous parallels with Symbolism (figs. 1, 2). Escapist longings materialize in long, sweeping, Jugendstil-derived curves and in the use of glowing colors against dark backgrounds, so that the subjects seem to dematerialize into multicolored dabs of paint. The same range of themes, with some Rococo and Biedermeier motifs thrown in, prevails in Kandinsky's work until 1907 or thereabouts. Artistically, these works undoubtedly amount to no more than a transitional phase; but their ethereal metaphorical imagery makes a decisive contribution to Kandinsky's gradual detachment of pictorial form from objective reality.

Subjective or Objective Reality?

Symbolism, with its systematic devaluation of concrete reality in favor of the transcendent, supersensible perception of a cosmic spiritual order, was undeniably an important factor in the development of Kandinsky's abstract art. Maurice Maeterlinck, for example, whose plays and other writings appealed to a wide public around the turn of the century, had revived the much-debated Romantic dichotomy of intellect and insight. He agreed with Johann Gottlieb Fichte in regarding intellect as essentially unproductive, receptive, and passive in relation to mind or spirit, and in seeing insight as a positive metaphysical quality, beyond both emotion and intellect – something close to the faculty to which Henri Bergson gave the name of intuition,[4] and to which Kandinsky in turn was repeatedly to refer as the final court of appeal in the creative process. In such a context it is understandable that, for Maeterlinck, images – in the widest sense of the word – cause within the human being a resonance, inaccessible to thought, that gives direct access to supposedly eternal verities: "An image can divert my thoughts; and if this image is precise and full of organic life, it is in far stricter conformity to the laws of the universe than my thoughts are. I am convinced, therefore, that the truth will almost always lie in an image rather than in my abstract thinking. When I hear the image, the universe and the eternal order of things are thinking in my stead."[5]

The work of art as the organon of philosophy: such ideas echo the thinking of Friedrich Schelling and Arthur Schopenhauer.

Increasingly, Kandinsky became preoccupied with finding a trigger for "vibrations in the psyche" that would correspond to the universe and the eternal order of things. And so, in the first instance, his aesthetic reflections were fueled by Symbolist poetry, and by the theory that accompanied Symbolist tendencies in painting. The issue that confronted the Symbolist painters, and Kandinsky after them, was roughly as follows: can visual perception ever give a true rendering of reality and the transcendental; or can the underlying truth be evoked in other ways? Following Charles Baudelaire, the painter Maurice Denis considered the imagination to be one such other way, and took the view that art should cease to be a copy and become a "subjective deformation" or "objective deformation" of nature.[6] Artists should not reproduce nature but represent it.[7]

Outside Symbolist circles, opinion in the 1880s had polarized around two possible answers, in a way that was to have momentous consequences for the evolution of painting right down to our own day. On the one hand, Vincent van Gogh set out to depict a reality so infused with soul that things would appear even more true than their literal likenesses. On the other, Paul Cézanne explored the laws of the perception of reality in line with his own conviction that the artist was a merely receptive organ, an instrument for the recording of sense impressions: "The landscape reflects itself, humanizes itself, thinks itself, in me. I objectivize it, transpose it, hold it fast upon my canvas."

There consequently emerged two diametrically opposed ways in which an artist might make reality his own: the pursuit of subjective truth through immediacy of expression, and the pursuit of objective truth through the reflection of the process by which it is perceived, and of the conditions of its adequate rendering. Van Gogh became the mentor of the Expressionists, Cézanne that of the Cubists.

The same problem confronted Kandinsky; and his answer to it was twofold. His theoretical sympathies were with Symbolism; but his paintings increasingly told a dif-

1 *Sunday – Old Russian,* 1904/05. Woodcut.
Städtische Galerie im Lenbachhaus, Munich

2 *Dialogue,* 1904. Tempera on gray card.
Städtische Galerie im Lenbachhaus, Munich

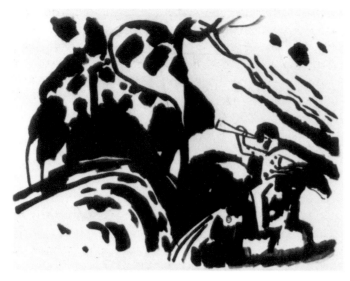

3 *Landscape with Rider Blowing Trumpet,* 1908/09. Brush and ink on paper. Städtische Galerie im Lenbachhaus, Munich

ferent story. However, unlike the much younger painters of The Bridge [Die Brücke] – and unlike Jawlensky – he never deferred to the example of Van Gogh. Both in his brushwork and in the increasing brilliance of his color, it was the Fauves who decisively influenced his style.

The memory of the scandalous début of these French artists was still fresh when Kandinsky and Münter were staying at Sèvres, close to Paris, in 1906/07. Kandinsky was certainly well aware of what the Fauves had done, both in liberating colors to become free expressive values and in reshaping objects for expressive effect; but it was not until the end of 1908, and in 1909 above all, that he applied all of this in his own painting. He was quick to recognize the supreme significance of Henri Matisse, whom – along with Pablo Picasso – he regarded as the most important painter of his time. "It is impossible for me to copy nature slavishly," wrote Matisse; "I am compelled to interpret it, and to subordinate it to the spirit of the painting."[8] It was a motto that Kandinsky at once made his own.

He did so in the summer of 1908, during a study visit to Murnau, in the Bavarian Alps, with Münter, Werefkin, and Jawlensky. It seems to have been Jawlensky who gave Kandinsky the encouragement to persevere on the path on which he had set out. The works he produced at Murnau and immediately afterward, with their interpenetrating motifs, their conversion of spatial relationships into planar correspondences, and their dissociation of line from color, are major steps along the way to the deformation of represented reality and the dissolution of the forms in which it presents itself (fig. 3).

In theoretical terms, all this had been discussed in France long before. One idea runs like a leitmotiv through the writings of Denis, a firm partisan of those artists – such as Paul Gauguin and Émile Bernard – who took a stand against Impressionism: "Even before a picture reproduces nature or dream, it is first and foremost a flat surface covered by colors in a definite, contained order."[9]

It is clear that Jawlensky, who at this time was the more advanced painter of the two, not only drew Kandinsky's attention to such theories but also stimulated him to transpose them into pictorial terms. What is more, before the turn of the century Denis had already discussed the problem – which fascinated many French painters – of possible correspondences between forms and emotions; and this, too, was a question to which Kandinsky sought an answer. Equally importantly, Denis pointed to so-called primitive art as a fruitful source of inspiration for the contemporary avantgarde. As models he cited Japanese woodcuts, Breton calvaries, Épinal prints, tapestries, medieval stained-glass windows, and so on: sources that were valued for their expressive content by Gauguin and his Cloisonniste associates long before the Fauves appeared on the scene.[10]

Toward the Dissolution of the Object

The phenomenon that, for simplicity's sake, bears the label of "Primitivism" is a highly significant element in modernist discourse, especially as manifested in Kandinsky's works. At Murnau it seems to have been Gabriele Münter who drew her companions' attention to Bavarian folk art. Above all, the mainly religious tradition of painting on glass, as practiced in the Staffelsee area, struck them as entirely authentic; this was before it was ruthlessly commercialized for the benefit of the tourist trade.

Kandinsky was better prepared than any of the others to respond to this rustic art form (fig. 4), and also to the naive decorative patterns of country furniture. His first encounter with folk art had been long before, on an expedition to the government of Vologda, in northern Russia, in 1889; and it had left an indelible impression. "I sketched a great deal – those tables and various ornaments. They were never petty, and so strongly painted that the object dissolved in them."[11]

4 *Mountain,* 1909. Oil on canvas.
Städtische Galerie im Lenbachhaus, Munich

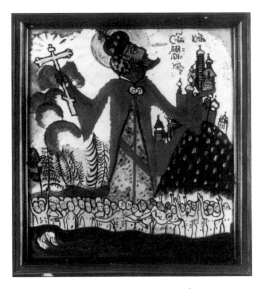

5 *St. Vladimir,* 1911. Painting on glass.
Städtische Galerie im Lenbachhaus, Munich

This was precisely the phenomenon – the dissolution of the object and the superimposition of different levels of reality and experience – that now preoccupied Kandinsky in his own work (fig. 5); and this in turn explains the strong affinity for the indigenous culture of Upper Bavaria that led him to don local costume, on occasion, and to paint the furniture of the house at Murnau with floral ornaments and figure motifs.

It was probably during the stay at Murnau that the four artists had the idea of showing their work publicly and making an effort to propagate their ideas. This seemed all the more necessary because Munich reminded Kandinsky of the Sleeping Beauty's castle before the kiss – or so he told the readers of the Russian art magazine *Apollon* on October 3, 1909.[12] At the beginning of 1909 the friends founded the New Artists' Association Munich [Neue Künstlervereinigung München, NKVM], which held its first exhibition at the end of the same year at the Galerie Thannhauser in Munich. The little catalogue for this event contains a number of assertions of principle that were no doubt formulated by Kandinsky: "It is our basic belief that, aside from the impressions that the artist receives from the outward world of nature, he is constantly garnering experiences in an inward world. The quest for art-forms that will convey the interpenetration of all these experiences – forms that need to be freed from all inessentials, so that they may powerfully express the necessary alone – in a word, the striving for an artistic synthesis, this seems to us to be a watchword by which more and more artists are spiritually united ..."[13]

Kandinsky had found his slogan. "Synthesis" was the formula that he was to repeat over and over in the years that followed.

In the present context, the history of the NKVM can largely be taken as read, and we shall restrict ourselves to just one of its aspects. In Kandinsky's works of 1909 and 1910, the representational element became more and more tenuous; or this, at any rate, was the direction in which he made the most rapid progress. This led to con-

flicts with other members of the association, who either could not or would not follow suit. The explosion came early in December 1911, when *Composition V* was rejected for an exhibition. Kandinsky, Münter, and Franz Marc thereupon resigned from the NKVM and organized a show of their own under the name of "The Blue Rider" [Der Blaue Reiter]. By the time this opened, a few weeks later, a number of other painters had joined them, or contributed works; but the group that emerged was by no means homogeneous. In the "Blue Rider" catalogue, Marc and Kandinsky attempted to mask this lack of cohesion by proclaiming (their emphasis): "In this small exhibition, we do not seek to propagate any *one* precise and special form; rather, we aim to show by means of the *variety* of forms represented how the *inner wishes* of the artist are embodied in manifold ways."

This is not the place for an account of the exhibition itself, or of the print show that followed, or indeed of *The Blue Rider Almanac* (fig. 6), which was published in mid-1912, after the two epoch-making exhibitions. It is, however, worth devoting some attention to the book that Kandinsky published at the end of 1911, *On the Spiritual in Art* (fig. 7). This was based on a concept of "spirit" that was

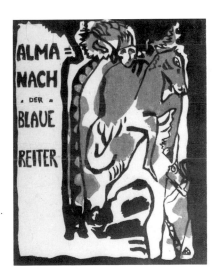

6 Cover design for
The Blue Rider Almanac, 1911.
Brush and ink, and
watercolor on paper.
Städtische Galerie
im Lenbachhaus, Munich

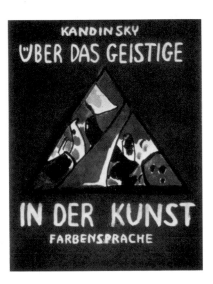

7 Cover design for
On the Spiritual in Art, c. 1911.
Brush and ink, and gouache
on tinted paper.
Städtische Galerie
im Lenbachhaus, Munich

decisively colored – as we know from the research of Six-
ten Ringbom, Rose-Carol Washton Long, and others – by
theosophy and anthroposophy.

Such influences were not uncommon in those days, for
theosophy seemed to offer its devotees the kind of eternal
certainties that science, with the growth of specialization
in all fields, was ever more firmly dismissing as outworn.
The books of Helena P. Blavatsky, *Isis Unveiled* (1877) and
The Secret Doctrine (1888), enjoyed a wide circulation and
were much read by visual artists in particular. Theosophy
professed to be the rediscovery of ancient forms of wis-
dom that had been forgotten in the age of materialism
and science; it harked back to Pythagoras and Plato,
whose ideas it combined with those of the religions of
India, Egypt, and Greece. All this captivated those who
longed for a sense of meaningful historical continuity in
an age of constant change. This was as true in France
(with František Kupka)[14] as it was in Holland (with Piet
Mondrian)[15] or in Russia (with Kandinsky, Kazimir Male-
vich, and others).[16] The responsiveness was reinforced by
the fact that the Russian Symbolists, among others, had
been promoting similar ideas for decades past; indeed,
the differences between Rudolf Steiner and Andrei Bely,
or between Blavatsky and Mikhail Ivanov, seem no more
than marginal.[17]

On all sides there was a resurgence of a pattern of ideas
that contrasted the darkness of matter with the radiance
of spirit, seeking to impose an abiding order on the va-
garies of sensory experience. Scientific discovery, and
indeed all positivist inquiry, was seen as a further ob-
scuring of eternal principles that could only gradually be
brought back to light.

In *On the Spiritual in Art,* Kandinsky quotes from Stei-
ner, Blavatsky, and others; but his book is far more than a
patchwork of such sources. Above all, it is a treatise on
specific artistic and pictorial problems. It is worth noting,
however, that Kandinsky does not echo the central semio-
logical shift of modernism, which equates the signifier
and the signified and asserts the self-referential character
of the means of representation. He does, however, come
close to this position in his essay "On the Question of
Form", which appeared in the 1912 *Almanac.* Here he
reflects on the justification of "free" lines: "A line is a
thing that has a practical or purposeful significance just
as much as a chair, a fountain, a knife, a book, etc. And, in
this last example, this thing is employed as a purely picto-
rial means without those other aspects which it may
otherwise possess – i.e., for the sake of its pure, inner
sound. If, therefore, within the picture, a line is freed from
the purpose of indicating an object, and itself functions as
a thing, its inner sound is not weakened by being forced
to play an incidental role, and assumes its full, inner
power."[18]

Not Formal Reduction but Spiritual Enhancement

The above may be true of an individual line; but can it
become the constitutive principle of a whole painting? In
1912, Kandinsky still hesitated to give a definitive answer
to this question; instead, he sought to argue that, in prin-
ciple, "it is of absolutely no significance whether the artist
uses a real or an abstract form. For both forms are in-
ternally the same".[19] In the works of this period, as before,
readily identifiable motifs subsist alongside the barely
decipherable and the wholly free-form; almost invariably,
color and line are dissociated, as can be seen in many
examples in the present volume (3-31). Between the ren-
dering of a concrete object – however stylized – and total
abstraction "lie the infinite number of forms in which
both elements are present, and where either the material
or the abstract [element] predominates.

"These forms are at present that store from which the
artist borrows all the individual elements of his creations.

"Today, the artist cannot manage exclusively with pure-
ly abstract forms. These forms are too imprecise for him.
To limit oneself exclusively to the imprecise is to deprive
oneself of possibilities, to exclude the purely human and
thus impoverish one's means of expression."[20]

In such statements Kandinsky precisely stakes out the
territory within which he chose to operate in the prewar
period – and, indeed, for some years after 1914; there is a
continuum from purely abstract configurations at one
end to works with a narrative core at the other. It is thus
evident – and this would seem to be particularly impor-
tant – that pure abstraction, the production of paintings
devoid of any reference to objective motifs, is not simply
the outcome of a formal process of reduction. It marks the
conclusion of the painter's quest for a "sound", for a reso-
nance purged of any material substrate, for a purely spiri-
tual – and of course nameless – thing that would generate
in the viewer the same psychic vibration that had filled
the painter himself, in his capacity as the medium of the
creative process.

There is more in *On the Spiritual in Art* that helps to
account for this half-abrupt, half-hesitant rejection of the
imitation of reality. One notable contributory factor is
Kandinsky's (widely shared) skeptical view of science,
and of the concomitant tendency toward specialization in
every area of life in society. He repeatedly cites this in
invoking his own ultimate goal of the "great spiritual",
which he associates with his hopes for the disappearance
of all the discontents and social ills, as he sees them, of
civilized life.

Kandinsky's doubts about positivism are not confined
to this manifesto, but also surface in his memoir "Remi-
niscences" [Rückblicke] of 1913. This literary self-portrait
is all the more illuminating because in it he explains his
decision, in 1896, to abandon the prospect of a university
career and to take an incalculable risk with the rest of his
life. Kandinsky accounted for this move at the age of
thirty, in which he turned his back on bourgeois life and

staked everything on becoming a painter, by referring to two artistic experiences – though it may well be that these emerged as moments of decision only in hindsight, from the vantage-point of his conversion to abstraction. One experience was that of seeing a painting by Monet, which for him finally discredited the object as an indispensable element in a painting. Kandinsky could not tell that the object was a haystack until he looked in the catalogue. The other encounter was with the music-theater of Richard Wagner, which showed him the power of art and inspired him to hope that painting might evolve powers analogous to those of music.

Both the dilemma of the object and the position of music as the most abstract of the arts were to loom large in Kandinsky's thinking during his time in Munich. Scientifically trained, he saw both these factors in the context of the new discoveries in physics and chemistry, which he summarizes – somewhat vaguely, it is true – as "the further division of the atom". So seriously did this shake his confidence in reality that art alone seemed to offer him a renewed sense of certainty: "Within my soul, the disintegration of the atom was like the disintegration of the whole world.... Science, it seemed to me, had been destroyed; its central foundation was no more than an illusion, an error on the part of the scholars who... groped in the darkness for truths and blindly mistook one object for another."[21]

The Light at the End of the Tunnel

In the above passage Kandinsky is articulating or reformulating an experience that had been so described in a popular magazine in 1906: "Our common sense ... is a match for only a small number of phenomena, truths, and laws of nature; it leaves us woefully isolated in this world. But within us we have other capabilities that maintain a wondrous reciprocal relationship with the Unknown in the universe; these seem to be given to us specifically in order that we may acknowledge, if not understand, this Unknown and bow before it dimly suspecting. These capabilities are imagination and the mystic heights of our reason.... Above the thinking part of our intellect lies another, which prepares us for the great surprises of the future, and which abides whatever the Unknown may have in store for us...."[22]

In the German-speaking countries, especially – with whose culture Kandinsky had so long and so close a connection – such views were often found in combination with an oppressive, apocalyptic sense of the impending end of time, a loathing of technological civilization, and a disgust with the shallowness of materialism. Behind this fin-de-siècle vision of decline and fall – as expressed in powerful and suggestive imagery by such writers as Stefan George, Friedrich Gundolf, Georg Trakl, and Georg Heym – there was, however, almost always the expectation of a new start, the hope for a radical transformation of the world.[23] And so, at the end of the nineteenth century,

a variety of apocalyptic interpretations of history began to emerge, and to supplant the prevailing belief in progress.[24] With skepticism and insecurity on every side, it is no wonder that artists reacted seismographically and began to search for new foundations to build on. In *On the Spiritual in Art* Kandinsky reflects on all this and articulates it to greater effect than any other painter of his time.

It was Kandinsky's historic achievement, roughly between 1910 and 1914, to set an end to the tradition of European pictorial imagery. His revolutionary new conception did not come to him all at once. He groped his way toward it, step by step, constantly trying to furnish a rational explanation and justification for all that was new in his work; and he associated it in his mind with the hope of establishing a new, spiritual cosmos. He believed that the coming of spirit would first be apparent in the arts. Literature and music – to which he constantly refers in his writings – and painting, too, "immediately reflect the murky present; they provide intimation of that greatness which first becomes noticeable only to a few, as just a tiny point, and which for the masses does not exist at all."[25]

As we have seen, Kandinsky's theoretical conception combines the hope of a parousia of pure spirit with a pronounced antimaterialism and a profound mistrust of positivism. His paintings reflect the "somber" present in that they show up the flaws, the inconsistencies that nevertheless constitute a totality. He couches this in characteristically vivid metaphorical language: "Clashing discords, loss of equilibrium, 'principles' overthrown, unexpected drumbeats, great questionings, apparently purposeless strivings, stress and longing (apparently torn apart), chains and fetters broken (which had united many), opposites and contradictions – this is our harmony. Composition on the basis of this harmony is the juxtaposition of coloristic and linear forms that have an independent existence as such, derived from internal necessity, which create within the common life arising from this source a whole that is called a picture. Only these individual constituents are essential. All the rest (i.e., including the objective element) are incidental."[26]

"Opposites and contradictions: this is our harmony." This rhetorical figure – virtually a summation of Kandinsky's thinking in the period before World War I – encapsulates what he sought to express both theoretically and artistically: the feeling of standing at a turning-point in time, and of having to find an appropriate pictorial expression for the new world that – supposedly or in fact – was on the way.

This same alternation between insecurity and confidence, skepticism and hope, loathing of the present and longing for a better future whose first scattered signs could already be discerned characterizes the thinking of many of the painter's contemporaries. In Munich, Berlin, Moscow, St. Petersburg, Paris, Milan, New York, traditions rooted in the nineteenth century were being undermined, assailed, and demolished by the avantgardes. Reality, once called into question, emerged as ever more enig-

matic and ambiguous; in the endeavor to grasp life in all its complexity, traditional modes of comprehension were of no use. Epistemological uncertainties were matched in early twentieth-century literature by a crisis of language, which was perhaps most forcefully articulated by Hugo von Hofmannsthal in his "Chandos Letter", and which was subjected to theoretical analysis by Fritz Mauthner and others.[27]

"We have no truth any more; the old calls and compulsions of instinct have faded." With these words Carl Einstein began his essay on "The Snob" in 1909;[28] and Franz Marc noted, in his prologue to the projected second volume of *The Blue Rider Almanac*: "The world is giving birth to a new age; and there is only one question: has the time yet come to break loose from the old world? Are we ripe for the *vita nuova*? That is the anxious question of our times."[29]

Such statements may help us to feel something of what was in the air, the contrast between the entrenched forces that still set the tone in society at large and the innovatory impulses that were heatedly debated in select circles but as yet evoked very little public response. Many of these new initiatives soon foundered, but there was much in them that lasted far into the twentieth century as the basis of a modernist tradition that inspired generations of artists. It was a time when two systems of values were growing apart with increasing speed and explosive effect; in the process, art in all its genres took on a new radicalism.

Kandinsky's Complexity in Context

The year 1913 (in the summer of which Kandinsky painted *Small Pleasures* [fig. 8]) was one of revolutionary upheaval in many spheres; it was also the year in which successive crises in the Balkans heralded the outbreak of World War I. It is worth enumerating some of the artistic innovations of this period. Frank Lloyd Wright's Prairie houses in the USA, Adolf Loos's Michaelerplatz house in Vienna, and the Fagus factory in Alfeld an der Leine by Walter Gropius and Adolf Mayer were seminal works of twentieth-century architecture. Similarly in music: Arnold Schönberg completed *Die Glückliche Hand* and Anton Webern his Five Pieces for Chamber Orchestra; in Paris, Stravinsky's *Rite of Spring* had its premiere. James Joyce and Marcel Proust embarked on the masterpieces that were to revolutionize the narrative form of the novel and Franz Kafka published his volume of short stories *The Judgment*, while in Russia Alexei Kruchenykh and Vladimir Khlebnikov were formulating the theory of the so-called Zaum language, full of neologisms "without specific meaning". In the theater, Adolphe Appia, Edward Gordon Craig, and Vsevolod Meyerhold broke with tradition and evolved antinaturalistic approaches to stage design and performance style. Sergei Diaghilev's Ballets Russes caused a furor all over Europe; Isadora Duncan and Alexander Zakharov were furthering the cause of expressive dance. Umberto Boccioni made his Futurist

sculpture *Unique Forms of Continuity in Space*, and Constantin Brancusi made the bronze version of his stylized, idol-like portrait bust *Mademoiselle Pogány*, Marcel Duchamp painted *Nude Descending a Staircase*, Robert Delaunay *Circular Forms*; Picasso brought Synthetic Cubism to its maturity; Giorgio de Chirico's Pittura Metafisica culminated in a series of masterpieces. In Berlin, the Bridge group disbanded; Ernst Ludwig Kirchner, Erich Heckel, and Karl Schmidt-Rottluff went their separate ways.

All these highly diverse manifestations of artistic renewal serve to convey some idea of the international background against which the towering figure of Vasily Kandinsky must be seen.[30] In his striving for synthesis – the central, albeit widely shared, motto of his Munich years – and in his hope of achieving a new "total work of art", a *Gesamtkunstwerk* still very much in the Wagner tradition, Kandinsky was influenced by a variety of current initiatives not only in painting but also in music, literature, theater, and dance. This is evident in his book of poems and woodcuts *Sounds* [Klänge]; in stage works such as *The Yellow Sound* [Der gelbe Klang]; and also in his intensive exchange of ideas with Schönberg.[31] Indeed, all of his many publications contain an abundance of references to parallels – alleged, suspected, or real – between the arts, or between science and the arts.

Frequently, if erroneously, hailed as the sole inventor of abstract painting, Kandinsky produced in Munich between 1910 and 1914 an array of works that are very much more complex than they look. And this in turn serves to cast light on the artist's own conviction that his paintings were "purely pictorial objects" that "have their own independent, intense life".

Autobiography as Self-Defense

The arts pages of the daily press were extremely hostile to Kandinsky. He read all the criticisms; always the complete professional, he had engaged a clipping service to collect everything that appeared in print about him and about his work. The art magazines, too, were highly skeptical. In 1913, for example, Karl Scheffler, one of the best-known art writers of the day and no friend of the avant-garde, wrote that in Kandinsky's new work the "new impulse is being swallowed up in dogmatism."[32] Again, in one of the publications of the Dürer League, which advocated a "healthy art, rooted in native soil", a certain Albert Lamm opined that *On the Spiritual in Art* was ill-digested, wrong-headed stuff that would have cost any fourteen-year-old his promotion to tenth grade.[33] At first Kandinsky seems to have taken all this fairly calmly, but as the attacks became more and more scurrilous his attitude changed.

The turning-point came in February 1913, when Walden brought to the Galerie Louis Bock & Sohn in Hamburg the Kandinsky exhibition that he had shown at Der Sturm in Berlin in the previous fall. The show opened on February 4; on February 15 the *Hamburger Fremdenblatt*

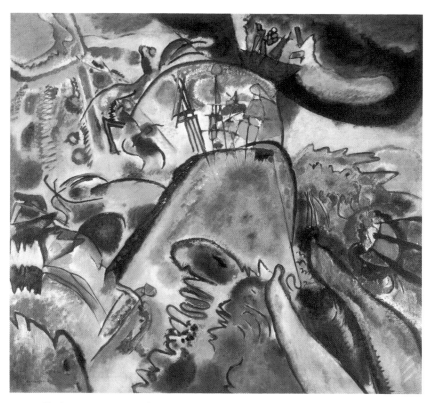

8 *Small Pleasures,* 1913. Oil on canvas.
Solomon R. Guggenheim Museum, New York

published a notice by Kurt Küchler that went far beyond what had become the customary critical tone. Küchler described Kandinsky as an "unfortunate monomaniac" and dismissed his painting as a "botched job". So incensed was he by Kandinsky's "atrocious spattering of color and sputtering of line" that he was at a loss what to marvel at most, "Kandinsky's larger-than-life arrogance", the "offensive impudence" of those who lent their patronage to the exhibition, or the "disgraceful sensationalism of the art-dealer who permits the use of his premises for this formal and coloristic insanity". Without mentioning, let alone describing, a single one of the paintings, Küchler worked up to the following polemical climax: "Ultimately, one is left with a feeling of compassion for this deranged artistic soul, now long past being called to account for its actions; before the shadows of insanity closed in, it was capable – as a few earlier paintings show – of conceiving noble and beautiful painted forms. At the same time, one is gratified to see that this type of art has finally reached the point of revealing just what kind of an 'ism' it is: cretinism."

Kandinsky and Walden reacted at once, and planned a protest campaign. On February 20 Walden reported to Kandinsky in Munich that the campaign had been successfully launched. In Hamburg, a few days later, he gave a lecture on Kandinsky's objectives and paintings with, in his opinion, "some success". In March, under the headline "For Kandinsky – Protest", passages from Küchler's review were published in Walden's magazine *Der Sturm,* together with an array of messages of support. Among

those who took sides for Kandinsky were many painters, including Hans Arp, Robert Delaunay, Paul Klee, Fernand Léger, Oskar Kokoschka, and Ludwig Meidner; writers, including Guillaume Apollinaire, Blaise Cendrars, Richard Dehmel, Alfred Döblin, and F. T. Marinetti; critics, such as Wilhelm Hausenstein and Hans Moeller van den Bruck; and collectors, dealers, art historians, and the directors of major museums in Germany and elsewhere. This manifestation of support, expressed in many cases through lengthy statements, continued in the magazine through April 1913.

As the next step it was decided to publish an autobiography. Kandinsky wrote "Reminiscences", completing the manuscript in May 1913. Walden's chronic shortage of funds prevented the book from being published (as intended) in time for the opening of the First German Fall Salon on September 20, and it finally came out early in December. The first copies reached Munich in time for Kandinsky's forty-seventh birthday.

The structure of the book – a poem by Albert Verwey, ten reproductions of works painted by Kandinsky in 1913 (including *Composition VI, Small Pleasures,* and *Painting with White Border*) and of works dating from 1901-12, the text itself, and "Notes" – was devised, as the surviving correspondence indicates, by Walden. A strategy is detectable here: the new is more important than the old; pictures take precedence over verbal explanation. The "Notes" comprise Kandinsky's own analyses of *Composition IV, Composition VI,* and *Painting with White Border;* here, too, it is possible to detect a calculation. For *Compo-*

Das Bild „Kleine Freuden" (1913)

[manuscript text, fig. 9 — German handwritten commentary]

9 Two pages of manuscript commentary on *Small Pleasures,* 1913. Gabriele Münter- und Johannes Eichner-Stiftung, Munich

sition IV, Kandinsky names the identifiable motifs; for *Composition VI* he does no more than refer to the painting's origin in his own glass painting, *Deluge;* his elucidation of *Painting with White Border,* apart from the identification of the troika motif, restricts itself to a purely abstract description of forms, with much talk of clarity and simplicity, obliteration, dissolution, "squashing" technique, and "inner simmering in diffuse form".

The Artist Explains

It can be assumed that Kandinsky intended to include in the "Notes" section of the book a further text on *Small Pleasures;* the great importance he attached to the work is sufficiently demonstrated by its prominent position among the reproductions in the front section. The work itself survives (fig. 8), as do a number of studies; and so does the text of the planned essay, previously published only in extracts.[34] We print it here in full (fig. 9).

> The Painting *Small Pleasures* (1913)
> Painted after my *Glass Painting with Sun.* The softness of the colors, reinforced in the glass painting with gold, silver, and transparent glazes, aroused in me the desire to develop the same qualities further on canvas. I first made a drawing (there I emphasized the softness by means of fine and very fine lines) in order to eliminate the asymmetry in the large composition and to make this composition cool and well balanced in its constituents for the painting.
> The overall distribution of the forms is almost schematic.
> The center, comprising two parts:
> 1 Interpenetration of lines and forms;
> 2 Large plane.
> The four corners, each differently weighted and bounded:
> 1. Above left – dissolved forms;
> 2. Below left – collocation of large planes and lines;
> 3. Above right – large masses, modeled;
> 4. Below right – large masses, flat.
> Here I had no desire to speak a secret language, and so I presented the compositional structure with total clarity and in a naive form. This painting is thus composed in contrast to all my paintings, and a blind person will recognize the constructive principle.
> This spiritual background was really an unconscious choice. I said to myself: Let's do it this way! I know now that this was the best foundation to provide the right playground for, the Small Pleasures. My aim was, after all – to let myself go and to deluge the canvas with lots of small pleasures. Without thinking of the end product, I made a half-blue dab, surrounded it with dull yellow, drew zigzag or curved lines, threw in a quantity of white explosions, and tried to color each explosion differently. There were only a few moments when I felt the burden of the undertaking, the effort and inner tension necessary to accomplish it. By and large it was easy, fun, and I put in new details all the time. Here, each white explosion resolves itself into a different color. One goes on and on, and finally drains away like water into sand. Another meets an obstacle and resembles a funny little wave rebounding from a round, funny rock.

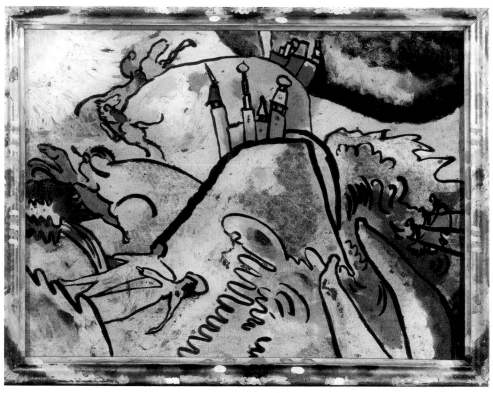

10 *With Sun,* 1911. Painting on glass. Städtische Galerie im Lenbachhaus, Munich

Apart from these resolvings and checkings, I have brought in here, too, the subtle inner simmering and the overflowings, radiatings, etc. But everywhere it all remained within the realm of small pleasures and never acquired any painful overtones. The whole painting reminds me of drops falling into water, all making bright and different sounds. And when suddenly one drop plops down with a melancholy bass tone (the somber upper right corner!), one feels no apprehension. It's like a yellow pug puppy sitting, looking pensive and earnest. There is, to be sure, a distant resemblance to a menacing bulldog – but who would be afraid of the tiny pug!

I have used the gold and silver in such a way that they have the effect of colors and not of glitter. This worked out so well that one day I want to try the same technique in a somber painting. Any technique can be made to serve a purpose, if treated properly. Likewise, gold and silver, in their decorative character, do need to be liberated.

The use of the meticulous execution with the thin brush was extremely helpful to me in "Small Pleasures". There are truly powerful antidotes to the large-plane style, which should only be used with the greatest caution. I have never been able to do much with it. At first I always broke up the large planes. The thin brush is a great help here, which needs to be used sparingly (initially, at least).

[June 1913][35]

The painting *Small Pleasures* (fig. 8) has been discussed many times, by Washton Long, Ringbom, Weiss, Angelica Zander Rudenstine, Vivian Endicott Barnett, and others,[36] and we shall draw on their comments and observations here. Kandinsky himself, in the first sentence of his exegesis, provides the key to the understanding of the work.

Glass Painting with Sun (fig. 10) shows us the motifs involved more clearly than do the relevant drawings and watercolors, or the completed painting itself. In the center is a precipitous mountain, crowned with towers and walls, a motif that is repeated at the top, where it is backed by a massive dark cloud. The central rocky peak is surrounded by the following objects: choppy sea with rowboat (right), waves breaking on the shore (below), couple walking in front of a tree (below left), and three riders on galloping blue and yellow horses. On the sketch for the glass painting (fig. 11) we can clearly see that rain was intended to fall from the dark cloud (right), in order to emphasize still further the contrast with the sun of the title (above left).

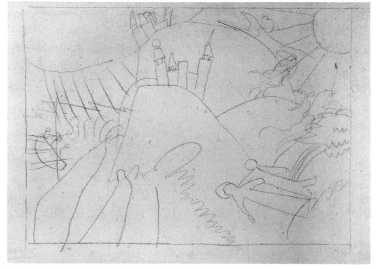

11 Study for the glass painting *With Sun,* 1911. Colored pencil on paper. Städtische Galerie im Lenbachhaus, Munich

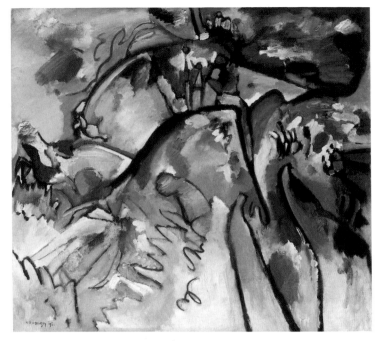

12 *Improvisation 21a,* 1911. Oil on canvas.
Städtische Galerie im Lenbachhaus, Munich

Kandinsky set out to transfer the transparency and brilliance of the painting on glass onto canvas. The technical implementation was however not entirely successful, and the painting as a whole appears rather matte. The drawing mentioned in the essay (cat. no. 26) was done in preparation for the transfer and enlargement onto canvas; it marks a move away from the narrative content of the glass painting. Approximately square in format, it is so overlaid with pencil and ink-brush lines that the details no longer stand out so clearly from each other. Without prior knowledge of the connection with the glass painting, it is unlikely that we would be able to identify the motifs.

The drawing shows clear traces of Kandinsky's efforts to "eliminate the asymmetry" of the glass painting and to "make this composition cool and well balanced in its constituents": the narrative features are counterpoised by structural aspects. This process of transformation from glass painting to drawing is the decisive stage in the genesis of the final painting. Kandinsky expresses this in his own terminology: "The combination of the revealed and the hidden will constitute a further possibility of creating new motifs for formal composition."[37]

The watercolor in the present exhibition (cat. no. 27) occupies something of an intermediate position. Mountaintop citadels and a rowboat with three oars extended are easily discerned, as are the light-source and the cloud that confronts it; but only the merest traces are left of the couple and of the riders. Pictorial coherence now depends less on the ornamental arrangement of the motifs than on the interaction of graphic elements and color. Light, transparent colors are applied in patches – the little "explosions" to which the painter refers – and wavy (sometimes zigzag) lines applied with a dry or a wet brush. Both lines and tonal areas seem to float in a weightless state, giving the watercolor a look of lightness and looseness.

Much of this has also found its way into the painting (fig. 8), which nevertheless also betrays the effort to strike a balance in the larger format (110 x 120 cm) between spontaneity and calculation, motif and structure, object and abstraction. And this is the key to understanding the terminology of Kandinsky's self-exegesis: he wants the compositional aspect to be conveyed "with total clarity", so that even "a blind person will recognize the constructive principle." And so the painter sets out, as we can observe, to emphasize in the four corners the antitheses between clear and unclear, line and plane, modeled and unmodeled masses, without however jeopardizing the unity of the painting. Kandinsky releases himself from the objective world and yet finds himself compelled, both pictorially and verbally, to find a metaphorical paraphrase for his aim: "to provide the right playground for the Small Pleasures."

His verbal paraphrase is particularly quaint in the passage where he tries to convey the mood of the painting in his richly analogical language. He explains that "resolvings and checkings", "overflowings, radiatings", and "subtle inner simmering" are meant to convey small pleasures free from all painful overtones, even though dark and even somber elements mingle with all this brightness: "It's like a yellow pug puppy sitting, looking pensive and earnest. There is, to be sure, a distant resemblance to a menacing bulldog – but who would be afraid of the tiny pug!"

Conflicting Interpretations of a Key Work

There has been much controversy among art historians as to the interpretation of *Small Pleasures*. On the one hand, the painting has been seen as an expression of the painter's apocalyptic vision, as conveyed in many of his contemporary works and writings. This is the view held, notably, by Washton Long and Ringbom, who see the forms on the left as Horsemen of the Apocalypse (but why only three and not four?) and on the right a stormy sea, in which the rowboat is additionally threatened by a whale (this being Washton Long's reading of the large double form below). According to Ringbom, the city on the mountaintop is about to collapse in ruins – as described and depicted elsewhere by Kandinsky – in token of the expected and imminent end of the world.[38]

Such an interpretation seems plausible on the strength of other iconographic details and analogies with *Improvisation 21a* (fig. 12) of 1911. But Rudenstine, for her part, has firmly denied all this, detecting in the painting as a whole a sense of palpitating joy.[39] In her view, Kandinsky's own commentary – which she was the first to cite – and the visual evidence of the work itself suggest that he intended to evoke the small pleasures of life: boating, walking, riding.

The question reduces itself to this: can the formal alienation of subject-matter from reality justify an interpretation that is primarily based on the more or less convincing identification of isolated motifs and does not take adequate account of the ways in which they are combined, the wider context of specific but not precisely definable elements, and the intrinsic value of the colors and forms of the composition? Kandinsky's pictorial strategy is directed toward the "great abstraction", whereby he deliberately reduces objective forms to a minimum; for, in his words, only the "demonstration of the abstract elements" can be the surest revelation of "the inner sound of the picture. … It must become possible to hear the whole world, just as it is, without objective interpretation."[40]

To interpret such a work convincingly, it is necessary to reconcile its visual character with the detail of the aesthetic impression, its vestigial motifs with the autonomy of the painterly means employed, and the artist's own interpretation with the context of related works. As the present example shows, this is no easy matter.

Pictures, according to Kandinsky, are to be heard and not seen; once again, he alludes to the synaesthetic syndrome. What is ultimately at stake, however, is the transition from one semiotic system to another: from a narrative and objective system, as represented here by the original glass painting *With Sun* (fig. 10), to an abstract

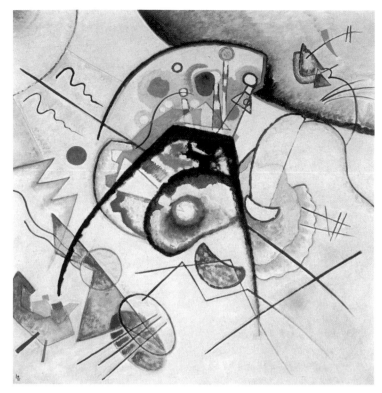

14 *Backward Glance,* 1924. Oil on canvas. Kunstmuseum, Berne

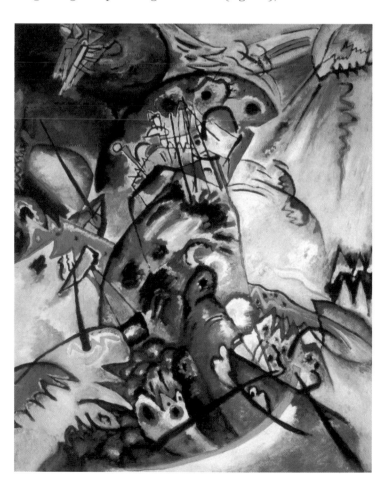

13 *The Blue Arch (Crest),* 1917. Oil on canvas.
Russian Museum, St. Petersburg

physiognomic system,[41] as it emerges in the subsequent elaboration of *Small Pleasures.*

Kandinsky was well aware that he stood on a borderline, as can be seen from the manuscript of a lecture written for delivery at an exhibition in Cologne early in 1914: "I dissolved objects to a greater or lesser extent within the same picture, so that they might not all be recognized at once and so that these emotional overtones might thus be experienced gradually by the spectator, one after another."[42]

An unusually perceptive insight into Kandinsky's philosophy is given by Johannes Langner in one of his superb analyses of individual paintings. Of the motifs in Kandinsky's works before 1914 he writes: "The object is assigned a subliminal existence that does not, ultimately, detract from its presence. It does not become insubstantial but takes on a new and different kind of consistency. What it loses in depictive immediacy it gains in richness of suggestion, through the allure of indirectness, the multiplicity of meaning, the expansion into the realm of fundamentals. We no longer see face to face, but through a glass darkly; new arenas of perception open up."[43]

Ultimately, Langner continues, Kandinsky is seeking "not the abolition, but a new definition, of the principle of representation".

How much the complex of issues outlined here was to concern him in his later work is shown, above all, by those paintings that bear a more or less direct relationship to *Small Pleasures.* One of these is *Moscow I,* of 1916 – a small, representational work, described by Kan-

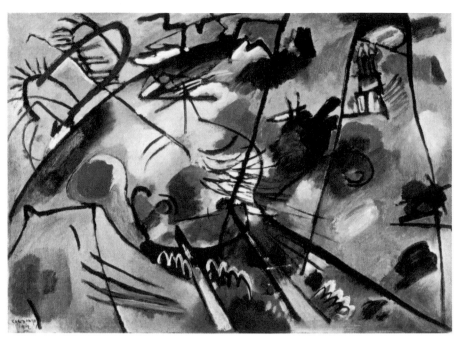

15 Study for *Improvisation 24 (Troika II)*, 1912. Oil on canvas.
Formerly Norton Simon Museum, Pasadena

dinsky in several letters to Münter in which he empha-
sizes the difficulty of reconciling its deeply serious tone,
complicated and simple at the same time, with the archi-
tectural content of a view of the Kremlin.[44] Another, the
watercolor *Birds*, of 1916 (cat. no. 49), reflects the central
features of *Small Pleasures*, except that the birds replace
the riders. *The Blue Arch (Crest)* (fig. 13), dated 1917, is
even more directly related, in layout and in the use of
identifiable motifs (city or fortress on a mountain, clouds,
light, sea, rowboat, etc.), to the painting of 1913.[45]

In 1924, at the Bauhaus, Kandinsky once more reverted
to the same thematic material. *Backward Glance* (fig. 14),
and the drawing for it that has erroneously been dated
1913, translate the central motifs of *Small Pleasures* into a
more abstract formal language, most notably in a free
geometric transposition of the central mountain, with its
towers, walls, and roofs; however, the sun and the cloud
can still be discerned at the upper corners of the painting.

Revivals of other prewar compositions also date from
Kandinsky's Bauhaus period, both in Weimar and in Des-
sau. What were once freehand shapes he transforms into
mathematically precise elements, turning irregular
curves into segmental arches, patches into circles,
hatched lines into checkerboard patterns. The painting
Small Dream in Red, for instance, of 1925, is based on
Study for Improvisation 24 (Troika II), of 1912 (figs. 15,
16).[46] However, this kind of direct appropriation remains
exceptional in Kandinsky's work; it can be understood
only in the light of his efforts to escape from the her-
meticism of pure geometric form by adding playful ele-
ments or witty apercus. And so the predominantly
abstract forms of the painting *Black Grid* (fig. 17), of
1922,[47] are relieved by stylized ocean liners with fish
cavorting in their wakes.

Discrepancies of Concept – Consistency of Method

But let us return to the prewar period. For Kandinsky, the
year 1913 was perhaps one of the most decisive in his en-
tire career. Among the many watercolors, drawings, and
paintings he produced that year (not to mention his publi-
cations, exhibitions, and press polemics) are an impres-
sive array of major works: *Improvisation 30 (Cannons),
Painting with White Border, Composition VI, Small Plea-
sures, Composition VII, Dreamy Improvisation, Black Strokes,
Improvisation with Cold Forms, Painting with Red Spot*.[48]
All these are key works in Kandinsky's momentous transi-
tion from an object-bound to an abstract language of
form. The fact that vestigial motifs are still encountered
in these works – be they unprocessed residues or fruitful
sources of inspiration – has much to do, as we have seen,
with his conviction that the time was not yet ripe for an
art free of reminders of the world he aspired to transcend.
The objective was clear, nevertheless. Kandinsky saw art
as utopia: a state in which things are divested of their
material and concrete quality and transform themselves
into inner sounds, vibrations in the psyche, and pure
spirit: "The work of art is spirit, which speaks, manifests
itself, and propagates itself by means of form."[49]

What was ultimately to be revealed was still concep-
tually undefined; and, conversely, the path to that revela-
tion could be conceived only in terms of eschatological
catastrophe. This is particularly evident in *Painting with
White Border, Composition VI*, and *Composition VII*. In this
sense, *Small Pleasures* represents a step backward, as in it
Kandinsky was principally concerned to "deluge the can-
vas with lots of small pleasures", as he puts it in his essay.

We have alluded, if no more than that, to the largely out-
worn ideological implications of the painter's theories,

and also indicated his major conceptual sources. In his endeavor to evoke the "great spiritual", Kandinsky remained tied to traditions in which there was much of questionable merit; and yet the formal means that he single-mindedly evolved to that end are among the most influential innovations in twentieth-century painting. The paradox of his creative process, as revealed in his paintings and drawings, lies partly in this inextricable interlocking of outworn ideas with utopian aspirations. Only in the creation of visual form could he recapture the wholeness that lay beyond rational explanation.

On a conceptual level, the disparity between tradition and innovation interlocks with the contrast between an idealism that verges on fantasy and the resolve to clarify and control imagery derived from transcendental impulse. *Small Pleasures* and the other works of the crucial phase of change that preceded World War I clearly lie at the intersection of tendencies such as these.

When we review the Munich years, Kandinsky the theoretician often seems to be one or two steps ahead of Kandinsky the painter. Objective reality aside, his formal repertoire and his bright and varied color seem to belong to the world of Expressionism; and yet, as early as 1911, Kandinsky considered that precise analysis of the relationship between drawn and painted form was the "future theory of harmony for painting (*Harmonielehre der Malerei*). These 'somehow' related forms have a fundamental and precise relationship to one another. Ultimately, this relationship may be expressed in mathematical form, except that here one will perhaps operate more with irregular than with regular numbers. In every art, number remains the ultimate form of abstract expression."[50]

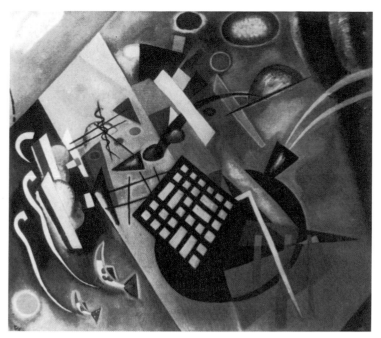

17 *Black Grid,* 1922. Oil on canvas.
Musée National d'Art Moderne, Centre Georges Pompidou, Paris

Stylistic Changes during the Years in Russia

As a definition of Kandinsky's aims, this is comparatively vague; but a few years later, after leaving Munich, he was to formulate those aims in a succession of elaborate programs.

A Russian citizen, he was compelled to leave Germany on the outbreak of World War I. By way of Switzerland – where he pursued his theoretical work and put some of it on paper – he returned to Moscow. There he underwent a creative crisis. The day-to-day hardships of wartime were compounded by others, both financial – he was an artist cut off from his collectors – and personal, as the growing estrangement from Gabriele Münter began to move toward a final break.

Under these circumstances, Kandinsky's work was decidedly uneven until 1921. He temporarily gave up oil painting; and the watercolors, drawings, prints, and paintings on glass that he did produce vary widely in quality. Only a few of these works bear comparison with his prewar output. Alongside totally nonobjective works, he produced representational views of Moscow and, when staying on the country estate of his relatives the Abrikosovs in 1917, conventional landscapes. A number of watercolors and drawings represent a continuation of the Munich work (cat. nos. 41-44, 51-54); but the "bagatelles" (cat. nos. 47-49, 60, 61) hark back to the folksy, fairytale style of his early period. These surprisingly anodyne works, painted in Moscow in 1915, were exhibited in the following year at the Stockholm gallery owned by Carl Gummeson, who also bought them.[51] Will Grohmann has plausibly suggested that Kandinsky painted these studiedly naive, rather Biedermeier-looking motif arrangements, as well as subsequent paintings on glass in much the same vein, simply because they were more salable.[52]

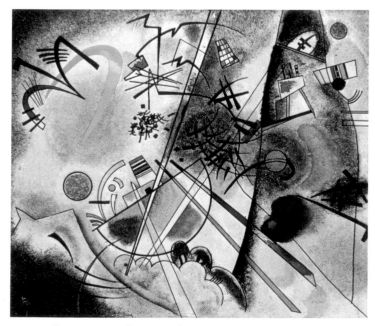

16 *Small Dream in Red,* 1925. Oil on canvas.
Musée National d'Art Moderne, Centre Georges Pompidou, Paris

18 *Small Worlds I,* 1922. Colored lithograph.
Städtische Galerie im Lenbachhaus, Munich

program of work: its goal was to be the founding of a new discipline that would investigate, both analytically and synthetically, "the basic defining characteristics both of the individual arts and of art as a whole".[54] Kandinsky wanted to discover the roots of a general law of painting and to relate this to the laws of other genres, such as music, literature, architecture, and dance.[55] His idea was to investigate the intuitive element in creativity, and here he was picking up where he had left off in Munich. To this end he drew up a lengthy questionnaire, which he circulated among his colleagues at Inkhuk. The questions on the psychological effect of colors and forms are particularly revealing, being based on ideas he had been pursuing since his time in Munich. They include the following: "…Imagine a triangle, for instance. Does it seem to move? Where to? Does it move more cheerfully than a square? Is the sensation of a triangle like that of a lemon? What is most like the song of a canary, a triangle or a circle? What geometric forms correspond to philistinism, to talent, etc.?…What color is most like the song of a canary? Which of these is most like the mooing of a cow: the whispering of the wind, a whip, a man, talent, a storm, rejection, etc.? Can you express your feelings about science, life, etc., through colors?"[56]

Kandinsky's approach very soon fell foul of his colleagues, many of them very much younger than he was, and there were some stormy debates.[57] In 1919, for example, Nikolai Punin wrote: "I most vehemently protest

The backward-looking quality of the "bagatelles" and some other works is one more demonstration of the dichotomy between the abstract and the allusively representational in Kandinsky's work. It is a contrast that is more evident in the – mostly weaker – work of the war years than in his prewar phase, when he mostly contrived to both veil and unveil form and content within one and the same work.

In January 1918, after the Russian Revolution, Kandinsky accepted an invitation from Vladimir Tatlin to become a member of the Department of Visual Arts (IZO) of the People's Commissariat of Enlightenment (Narkompros or NKP), headed by Anatoly Lunacharsky. IZO was working on programs for art education and for research into the means of artistic expression; it was also engaged on the planning of a number of publications and on the setting up of didactic museums. Kandinsky was actively involved in all these fields. At the end of 1918 he took charge of a painting class at the Free State Art Schools (Svomas), and he also briefly headed the theater and film section of IZO, where he made contact with a number of German art groups and with Walter Gropius. On the committee of the new Museums of Painting Culture he was active both in acquisitions and in museum installation.[53]

In March 1920 he was appointed director of the Institute of Artistic Culture (Inkhuk), for which he drew up a

19 *Small Worlds IV,* 1922. Colored lithograph.
Städtische Galerie im Lenbachhaus, Munich

against Kandinsky's art.... All his feelings, all his colors are lonely, rootless, and remind us of freaks. No, no! Down with Kandinsky! Down with him!"[58] In a 1923 report we find: "Kandinsky's psychological ideas were markedly at odds with those views that took the object itself as the basis of creation."

These ideological differences soon led to Kandinsky's eclipse. Rodchenko, Stepanova, Babichev, and others came to the fore, with a utilitarian message incompatible with Kandinsky's idealist position. "Art is the creation of new objects", announced the periodical *Veshch/Gegenstand/Objet*, edited by another member of Inkhuk, El Lissitzky, in 1922: "But that is not to say that by objects we mean exclusively utilitarian objects. We do of course include utilitarian objects made in factories – airplanes, say, or automobiles – within our definition of true art. But we do not regard artistic creativity as limited to such objects of practical use. Every organized work – whether it be a house, a work of literature, a painting – is a functioning 'object', not with a tendency to turn people against life but with a mission of contributing to the organization of life."[59]

Clearly, Kandinsky represented the survival of ideas that – in the context of a total reorientation of society, such as the Revolution proclaimed – inevitably looked like a hangover from the bourgeois era. His paintings and his ideas were repeatedly condemned as romantic, illogical, and literary. He increasingly found himself at loggerheads with a large part of the Russian avantgarde. Those who subordinated formal and psychological explorations to practical usefulness were beginning to prevail over those whose view of art was primarily aesthetic and spiritual. The conflict crystallized around two rival concepts: "Construction" and "Composition".

It is at this time that Kandinsky's works undergo a remarkable change. Now and again, individual zones of a picture are set off against each other by parallel stripes; the lines begin to appear premeditated rather than spontaneous; the patches begin to coalesce; the colors no longer flow freely, but fall into alignment with linear forms that become boundaries. Objective associations are for the most part still excluded (cat. nos. 66-69). This more systematic mode of pictorial organization on Kandinsky's part may well have been influenced to some extent by younger artists, whose formal idiom was more rational and whose motifs were both fewer and more geometric. What we know of the works of such artists goes a long way to support such a hypothesis; it must be remembered, however, that the notion of the relevance of mathematics already had a long history in Kandinsky's work and – above all – in his thought.

In 1920 and 1921 Kandinsky participated in a number of exhibitions, and his paintings were hung in a number of museums;[60] but disagreement within IZO was acute, and it is no great wonder that at the end of 1921 he left the Soviet Union. Nominally he was on official business, but he had every intention of staying in Germany, the country

20 *In the Black Square,* 1923. Oil on canvas.
Solomon R. Guggenheim Museum, New York

where he had found collectors, friends, and success in the prewar period. In March 1922 he was appointed to teach at the Bauhaus in Weimar. Those who sent for him did so partly on the strength of his previous contacts with Gropius, but also – and above all – for the sake of his international reputation, his experience of organizational and educational policy, and his intimate knowledge of equivalent institutions in Moscow.

The Geometric Component in the Watercolors after 1921

In the work of the final phase before Kandinsky left Moscow there is a pronounced tendency to abandon expressiveness in favor of an idiom based more on geometric elements; and the same is true, in increasing measure, of the watercolors of 1922 and 1923. This applies in particular to the studies for *Small Worlds* (cat. nos. 69-71; figs. 18, 19), but also to those works in which he contrasts compact, softly rounded forms with splayed, stick-like projections and long-drawn-out curves with precise arrow-like forms, and in which the superimposition and interlacing of details becomes a theme in itself (cat. no. 72).

The array of possibilities that now presented itself to Kandinsky is exemplified by a comparison between *Watercolor for Gropius* (cat. no. 74) and *Two Black Spots* (cat. no. 77). The light, playful touch in the former contrasts with rigid formal control in the latter, rhythmic surface articulation with the calculated opposition of the diagonals and the dark spot, the unity of the multiple and the scattered with the multiplicity of the monumental and the austere. A vocabulary of squares and triangles, trape-

21 *Square*, 1927. Oil on canvas. Private collection

In the works of this period we again and again encounter strongly emphasized rings and circles. At times they balance a collection of smaller elements that seem to undulate through the pictorial space and are supported by especially massive verticals (cat. no. 88). Or they interlock with large, densely packed isosceles triangles, in which the one or the other internal or marginal form evokes associations with object-forms, in this case architectural ones. It comes as no surprise to find that the titles of some of the watercolors are allusions to music (*Strings*, cat. no. 93), and that other titles hark back to the terminology of the Munich years, as with *Vibration* (cat. no. 99) or *Inner Simmering* (cat. no. 105). Rarely, and only in small studies, does Kandinsky revert to the open structures of earlier years (cat. no. 92). He is increasingly and more intensively occupied with the segmentation of the picture-plane (cat. nos. 94, 95, 102); hauntingly, *Brown Double Sound* (cat. no. 102) features pictures within a picture and a leitmotiv-like repetition of the combination of square and triangle.

As this exhibition abundantly shows, the works of Kandinsky's first few years in Weimar exemplify the intensity of feeling – but also the care and deliberation – with which he incorporates circles, squares, trapezoids, triangles, etc., into his multifarious, spontaneous, urgently expressive work. On rare occasions reminiscences of concrete objects emerge within an otherwise entirely abstract ensemble, and we seem to recognize abbreviated, schematic echoes of such things as boats, mountains, and towers.

zoids and circles, wavy lines and straight lines provides convincing solutions to pictorial problems: the precision of the forms is balanced by the lucid color, the geometric figuration by the contrasting background. *Arrowform to the Left* (cat. no. 81) is an excellent example. A dominant diagonal, shooting up from a stepped base and narrowing as it nears the upper left corner, literally slides underneath a number of barriers consisting of jagged-edged planes and circles, and is finally saved from crashing to the ground by three horizontal bars on the left and a stylized, decorative ensemble of small elements that combine to remind us of a sailing-ship.

Kandinsky does not simply arrange a variety of abstract forms into a pattern: the forms, in conjunction with the colors, tell their own story. Each defined by its own setting, they take on a specific and – in varying degrees – trenchant character. This is particularly clear in the watercolor study for *In the Black Square* (cat. no. 86), in which bars, rays, angles, arrows, triangles, segmental arches, circles, and the rest look as if projected onto the distorted trapezoid of the discrete central area; it is rather as if all this were only a detail from a greater assemblage of forms. The more emphatic elements in the center "hold" the frame, while the frame itself sets the eye wandering, because the edge accentuates the contrast between the oblique and the orthogonal. This irritant moment is even more noticeable in the corresponding painting (fig. 20).

Union of Art and Science under the Primacy of Painting

Kandinsky was not the first "pure" artist to be appointed to teach at the Bauhaus. Lyonel Feininger, Johannes Itten, Gerhard Marcks, Georg Muche, Oskar Schlemmer, Paul Klee, and Lothar Schreyer were already there when he arrived. This may seem surprising at first, when we reflect how Gropius, in the Bauhaus manifesto and program, had proclaimed that "the ultimate goal of all creative activity is the building." But it must be remembered that the Bauhaus itself, constantly under political fire from the right wing, had to wrestle with a mass of economic difficulties that made it impossible ever to envisage the architectural *gesamtkunstwerk* that Gropius had hailed in the visionary words of his manifesto: "Together let us will, devise, create the new building of the future, which will be everything in a single form: architecture *and* sculpture *and* painting, and which will one day rise toward the skies from millions of hands of the craftsmen as a crystalline symbol of a new, common faith."[61]

This messianic impulse is pure Expressionism, as is the dominant image of the medieval cathedral as a historical model for the integration of all artistic activities. It may be mentioned in passing that Gropius was borrowing his vocabulary – if nothing else – from members of the Berlin Art Soviet (*Arbeitsrat für Kunst*), and particularly from

Bruno Taut, who had himself referred to Kandinsky's ideas of the *gesamtkunstwerk*.

At the Bauhaus, Kandinsky was appointed director (*formmeister*) of the mural painting workshop. Like Klee, he also taught the theory of form as part of the foundation course, which all students were obliged to take before they could enter any of the specialized workshops. Gropius believed that artists brought with them to the Bauhaus the vision necessary for the creation of a new kind of social design; and he also became convinced that instruction in theory was necessary in order to make the students understand the principles and elements of form. Kandinsky, for his part, took the view that pure art must be the foundation of the applied arts; and he continued to argue this after the school had taken a turn toward functional design.[62]

This is not the place to describe the tenets and objectives of the Bauhaus, or the internal feuds and external difficulties that continued to afflict it until its final closure by the Nazis. Nor is it possible to trace the whole of Kandinsky's own evolution through the works that are on show here, or to unravel the complexities of his teaching. There can be no substitute for the visual experience of the works on exhibition. But it is worth singling out two or three aspects of the theoretical explanations that Kandinsky supplied for his own work.

During and after the Munich years, Kandinsky linked his definition of art with the idea of a "vibration" in the psyche; he defined form as the material expression of an abstract content.[63] He saw a painting as a kind of spiritual organism, made up – like every material organism – of many parts. The picture must be a combination of painted and drawn forms in accordance with laws and inward necessity – admittedly, a fairly vague definition. In Russia, in his encounter with Constructivism, Kandinsky found that his talk of the "great spiritual" was met with head-shaking and ultimately flat rejection; nor did his utopian vision of the dawn of a spiritual age at all coincide with the reality of revolution and social change in Russia. He found himself under a compulsion to justify himself and his work; and this intensified with the growth of his own determination to convey to others the fundamental principles of his painting.

In his book *Point and Line to Plane*, which was published as the ninth in the series of Bauhaus Books in 1926, Kandinsky undertakes to describe the psychological effects of a whole series of basic abstract elements (including horizontal, vertical, and oblique lines, curves, circles, zigzags, and curlicues), both separately and in simple combinations of two or three, and goes on to define more complex configurations. Such an approach (which has its parallels in contemporary writing on the psychology of perception) makes sense only on one basic assumption: that there exists a form of conditioning that is independent of history and civilization, i.e., that a particular curve evokes the same emotional response in all human beings and at all times. Kandinsky proceeds to apply the same method to colors, although here it is noteworthy that he limits himself largely to the spatial effect of various tones and at the same time plays down the aspects of content that had loomed so large in his book *On the Spiritual in Art*. It looks rather as if he were troubled by doubts as to the soundness of his own theoretical exposition – though he never, to my knowledge, makes these doubts explicit.

Now that it was no longer quite enough to cite the "great spiritual" and the utopia embodied therein, Kandinsky looked for another authoritative sanction that would permit him to rise above sordid materiality and to install art in a realm beyond function. In the light of his basic (antimaterialist and antipositivist) convictions, one of his trains of thought might surprise us, even though it was sanctioned by tradition: ultimately, the references to science and engineering that run through *Point and Line to Plane* serve only to underline the idea of the morphological identity of art and nature. This leitmotiv of Kandinsky's writings in the 1920s is most clearly expressed in a footnote: "Abstract art, despite its emancipation, is subject here also to 'natural laws,' and is obliged to proceed in the same way that nature did previously, when it started in a modest way with protoplasm and cells, progressing very gradually to increasingly complex organisms. Today, abstract art creates also primary or more or less primary art-organisms, whose further development the artist today can predict only in uncertain outline, and which entice, excite him, but also calm him when he stares into the prospect of the future that faces him. Let me observe here that those who doubt the future of abstract art are, to choose an example, as if reckoning with the stage of development reached by amphibians, which are far removed from fully developed vertebrates and represent not the final result of creation, but rather the 'beginning.'"[64]

Elsewhere, Kandinsky says that the "recognition of natural law is indispensable for the artist", or he refers to the "inner kinship between Nature and art".[65] In 1928 he writes: "Like art, Nature works with its own means – the primary element in Nature is like the point in art – and today it can be confidently assumed that the laws of composition have the same roots in art as in Nature. The relation between the two consists in the fact…that both domains produce their works in similar or identical ways."[66]

Such a relationship is however only possible in the abstract.[67] The exact sciences being engaged in the exploration of nature, and the theory of painting having embarked upon a scientific path in order to achieve theoretical precision, Kandinsky's analogical reasoning brings him to the conclusion that there are no fundamental differences between art and science; and, furthermore, that the barriers between art and technology have been cast down.[68] This, clearly, is the idealist's obeisance to the Bauhaus ideology, and to its program of putting art to practical use.

Kandinsky's goal was not specialization (which he regarded as evidence of shallow materialism),[69] but the synthesis of all areas of life, the union of spirit and matter – not under the primacy of architecture, as called for in the Bauhaus manifesto, but under the leadership of painting. Only painting could be entrusted with the momentous task of "fertilizing all of the arts and steering their evolution onto the right course".[70] When Kandinsky speaks of developing a vocabulary and a grammar of painting – and all his teaching tends in that direction – he does so in the conviction that his explorations, exercises, and arguments are no more than preparatory or propaedeutic. Art, to him, is not something that can be taught; and in this he is entirely in agreement with Gropius, who had said just that in his manifesto. In Paris, in 1938, Kandinsky once more speaks as he had done in Munich – less emphatically, perhaps, but no less plainly: "Art is subordinate to cosmic laws revealed by the intuition of the artist."[71]

Purism and Poetry

This position is entirely ahistorical, and I believe that Kandinsky never abandoned it. He did, however, make two determined attempts to reconcile his supposedly eternal and immutable ideals with the ephemeral concerns of practice. Both in Russia and at the Bauhaus he set out – with what magnificent success, this exhibition shows – to furnish his own conception of art with what he regarded as a scientific basis, one that was transferable as a model to other arts. There were bound to be conflicts; and one of the reasons for Kandinsky's failure in Moscow was that the younger artists, such as Rodchenko and Stepanova, did not share his approach. The Bauhaus was very different: expressionist, theosophical, socioromantic, and oriental ideas played a major part in the prehistory and immediate origins of the institution. But above all, Kandinsky was not alone in Weimar and Dessau. There was an evident affinity with Klee, who – as his address to the Art Union in Jena in 1924 shows – also regarded art as an analogy of creation itself, and opined that only those artists had a true vocation "who have now ventured close to that mysterious bedrock where developments are nourished by primeval law".[72] At the end of this remarkable confession of artistic faith, Klee describes the motivation of his work at the Bauhaus. The aim is to achieve a synthesis of ideological purity and immaculate artistry: "We have found parts of it, but not yet the whole. We do not yet have this last resource of strength, for we have no popular base. But we are looking for one; and we have already made a start, over there at the state Bauhaus. We have made a start with a community, to which we dedicate all that we have. More we cannot do."[73]

It is possible, indeed probable, that Kandinsky would have subscribed to these words of Klee's, although the two artists were by no means entirely of one mind, as is also reflected in their work. *Checkered* (cat. no. 106), for example, contains something that would be unthinkable in Klee: the superimposition and merging of three comparable but quite different forms of organization. First there is the planar tile pattern of slightly irregular brown and white squares. Into this is inserted a plane made up of colored rectangles, which seems to be perspectively distorted – as is the central element, built up from light and dark squares and balanced by the dark, outward-pointing isosceles triangle, which is however absent in the corresponding painting (fig. 21). One cannot interpret such a work as an anticipation of Op Art; Kandinsky indulges in too many painterly nuances for that. It is the combination of purism and poetry, of planar quality and spatial suggestion, of layering and interpenetration, of shifts of scale and equivalence of basic form; it is the alternation of black and white with color, of transparent with opaque tones: all this creates an aesthetic structure on a simple but not rationally consistent basis. It fascinates not least because the simplicity and immediacy of the structure manifests an astonishing degree of complexity.

Sometimes Kandinsky simply contrasts the pointed with the rounded and imprecise, the angular with the nebulous, as in *Zigzag* (cat. no. 109); or else he strings together a series of pictorial inventions paratactically, like entries in a catalogue (cat. no. 110), extracting an astonishing measure of poetry even from this schematic device.

At the end of the 1920s Kandinsky began using a spray technique for many of his watercolors, with the result that here the elements begin to hover and glide, become transparent, and seem even more immaterial than other works of the Bauhaus period (cat. nos. 114-116).

Sometimes, though very rarely, the watercolors assume a physiognomic, associative quality (cat. no. 130); sometimes Kandinsky gives free rein to the background color (cat. no. 128); but he most often opts for filigree structures in unstable equilibrium (cat. nos. 124, 125, 135, 136). The last picture he ever painted in Germany, in the late summer of 1933, *Development in Brown* (fig. 22), is based on a small watercolor (cat. no. 145); in spite of the title, there seem to have been no political overtones. Blocks of semitransparent vertically oriented trapezoids enclose a lighter zone in which triangles and crescents are stacked one above the other. This floating ensemble of rising and falling, advancing and receding forms, of meticulous lines and of veils of color, is held erect by a circle-form at top right that is echoed by several arcs at center and left.

If, toward the end of his Bauhaus period, Kandinsky predicts that the theory of painting will transform itself into "a precise body of doctrine", create a "methodical vocabulary", and evolve a "grammar containing the rules of its structure",[74] only rudimentary traces thereof are found in his own work. He makes no attempt to rationalize his technical resources, though from time to time he does seem, at least superficially, to fulfill one demand made by László Moholy-Nagy, who had declared that, in

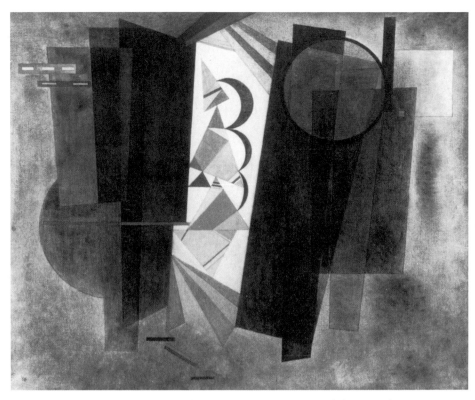

22 *Development in Brown,* 1933. Oil on canvas. Musée National d'Art Moderne, Paris

an age of machine production, painting could evolve only with the aid of mechanical and technological precision instruments and processes – spraying devices, stencils, and the like.[75] Kandinsky has used such aids in some of the works shown here (cat. nos. 122, 126, 127), but not in order to simplify his working process: these are watercolors intended to evoke a mood, and his purpose was to explore new expressive possibilities.

It is thus no wonder that, even while constantly emphasizing the necessity of theory, Kandinsky is perfectly well aware that "these 'doctrines' could never oust the intuitive element, because knowledge is barren in itself".[76] In his view of the aesthetic process, reason – which he sometimes equates with mathematics – remains a secondary element; the primary factor is intuition.[77] Even though his motifs in the Bauhaus period display virtually no analogies with reality, Kandinsky maintains that in his abstract art the link with nature, though not objectively verifiable, has grown in intensity: "Nowadays, in painting a point sometimes expresses more than a human face.... The contact between the acute angle of a triangle and a circle has no less effect than that of God's finger touching Adam's in Michelangelo."[78]

Intuition and Affinity with Nature
versus Constructivism and Calculation

Kandinsky's position at this stage in his career was thus markedly distinct from that of other "abstract" artists. For Moholy-Nagy, who in a sense represented the opposition to Kandinsky and Klee within the Bauhaus, painting had only a limited role in comparison with the favored media

of photography and the film: "The essence of the individual picture is the production of tensions in chromatic and/or formal relationships, the production of new color harmonies in a state of equilibrium."[79] Malevich, for his part, not only dismissed the object in all its forms as meaningless but denied the value of conscious mental images; "nonobjective feeling" was the organon of his new Suprematist art, which aspired "to institute a new, genuine world order, a new world-view".[80] This global aspiration was shared by the artists of De Stijl, who from the outset rejected all individuality as outworn:[81] Theo van Doesburg saw it as his task to "detect the hidden harmony, that universal equilibrium in things, and to give it form, thus manifesting the laws to which it conforms. The (truly exact) work of art is a parable of the universe by artistic means."[82] Lastly, Mondrian set out to purge his "new design" of all generation of form – a central concern of Kandinsky's. In the "living reality of the abstract", according to Mondrian, all emotions – delight, pain, terror, or whatever – had been transcended, and the tragic had been abolished.[83] Painting had become "the composition of colored rectangles, which express the profoundest reality. ... The colored planes, through their position and size and through the strength of their colors, creatively express only relationships and not forms."[84]

In the 1930s Kandinsky, it is true, borrowed the term "concrete" art from Doesburg;[85] but he gave it a definition of his own. In general, he took a firm stand against the Constructivists: he accused them of basing themselves on a materialistic position, of excluding intuition from their work, and of painting bad pictures.[86]

Doesburg, Mondrian, Malevich, and Kandinsky were all

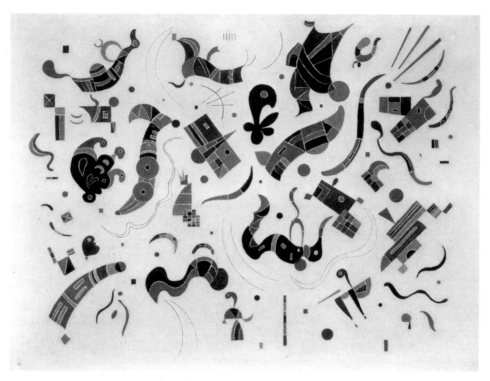

23 *Relations,* 1934. Oil on canvas. Private collection

concerned with transcending the objective world; all were convinced that their works were manifestations of cosmic laws – whatever that may mean. For Malevich, it was the artist's goal to represent a sphere that transcended both will and imagination. Doesburg's aim was "to offer truth in the manner of beauty".[87] Mondrian set out to create, in paintings where the universal as the fountainhead of art never errs,[88] a completely new reality that would satisfy the aesthetic needs of the human being of the future.[89] What these three expected to achieve through an active process was, for Kandinsky, the result of forces that acted on the artist and lay partly beyond his rational control: "Art is subordinate to cosmic laws revealed by the intuition of the artist."[90] Abstract art is independent of "nature", it is true, but "subordinate to the laws in nature. To listen to its voices and to obey it, is the height of happiness for the artist."[91]

Kandinsky was thus arguing for multiplicity, imagination, flexibility, change, and spontaneity, while the others placed all their stress on consistency, purism, concentration, and calculation. "The black square on a white ground was the first formal expression of nonobjective sensibility," wrote Malevich.[92] Doesburg asserted that the painter expressed his aesthetic experience through relationships between colored and uncolored planes.[93] For Mondrian, the power and equilibrium of the painting resided in the exclusive use of rectangles and the avoidance of curves:[94] only thus could it attain the dynamic equilibrium that was the true content of reality.[95]

Kandinsky consistently challenged such attitudes. Naming no names, he drew a firm distinction between abstract artists and Constructivist artists, "who use abstract forms, but only dead ones". The Constructivist, in

his eyes, was no more than an "abstract *pompier*".[96] Elsewhere he calls them "mechanics (spiritually limited children of 'our mechanistic age'); yet they produce machines deprived of movement, engines that do not move, planes that do not fly."[97] With such formulations Kandinsky was doubtless attacking Malevich, who saw "aviatics" as the determinant of the new culture and defined Suprematism accordingly as "aeronautic" art.

In the 1930s, "the crucial issue in today's and tomorrow's painting"[98] was for Kandinsky still the emancipation from the object; and yet, in spite of his continuing quest for the spiritual, the underlying ground of his inspiration remained living, visible, organic nature, the expression of cosmic laws.[99] Thus, he was not concerned with the issues raised by the technological civilization, however passionately Moholy-Nagy might beat this drum at the Bauhaus; nor did he aspire to a version of transcendence as rarefied, rigorous, and purist as that advocated by Malevich, Mondrian, and Doesburg. Even in old age, his mental horizon was still dominated by the idea of synthesis. This also explains why he was quite unperturbed to find that one of his abstract works "had been infiltrated by a shape reminiscent of a natural form: I let it be, and won't delete it."[100] In Kandinsky's work one is always finding things that in Doesburg's or Mondrian's would be totally inconceivable (cat. no. 159).

During Kandinsky's years in Paris, his involvement with natural phenomena intensified. There are now no more horses, birds, or fishes, but there are obvious analogies to protozoa and to celestial bodies. In France, where he lived largely in isolation from the Parisian art world, he was preoccupied with the infinitely close and the infinitely remote, the minute and the vast.[101] In 1935 he wrote

in an essay: "This experience of the 'hidden soul' in all the things, seen either by the unaided eye or through microscopes or binoculars, is what I call the 'internal eye.' This eye penetrates the hard shell, the external 'form,' goes deep into the object and lets us feel with all our senses its internal 'pulse.' And this experience enriches the individual, and specifically the artist, because within this experience lies the inspiration for his works. *Unconsciously.*"[102]

In a well-documented in-depth study of Kandinsky's late works, Vivian Endicott Barnett investigates their links with published biological illustrations and concludes that these metamorphoses of amoebas, embryos, and marine invertebrates stand for regeneration and the beginning of life anew (fig. 23).[103] In view of his spiritual convictions and his ideas concerning abstract art, Kandinsky might well have agreed that the new figuration of his Paris works is symptomatic of rebirth and renewal.

This is one more manifestation of the logic and consistency of Kandinsky's career. However many times he may have changed direction and revised his formal repertoire, Kandinsky never abandoned certain firm positions that he had first adopted during his years in Munich. He subjected these positions to a constant process of re-

vision, modification, and verification, without ever being appreciably influenced by anyone. Even among abstract painters, Kandinsky stands out as an individual who carried onward some of the most vital initiatives within turn-of-the-century art, and who evolved a visual language that was to inspire many generations of artists.

What makes his work in its historical context so revealing and so significant is not only the artistic quality of the watercolors, drawings, and easel paintings and the impact of the theoretical writings, but the exceptional clarity with which his work manifests a contradiction that remains characteristic of the century as whole. Jürgen Habermas describes this as the contradiction "between the democratic movement, which called for universal participation in culture, and the fact that in industrial capitalism more and more areas of life were becoming alienated from formative cultural forces". Such issues may not directly concern Kandinsky's works, which "have their own independent, intense life as purely pictorial objects"; and yet, when his achievement is assessed within the wider context of European culture, this disparity between universal artistic aspiration and real public response may not be without relevance.

1 Kenneth C. Lindsay and Peter Vergo (eds.), *Kandinsky: Complete Writings on Art,* Boston 1982, pp. 345-346.
2 Peg Weiss, *Kandinsky in Munich: the Formative Jugendstil Years,* Princeton 1979, p. 135.
3 Jonathan David Fineberg, *Kandinsky in Paris 1906-1907,* Studies in the Fine Arts 44: The Avant-Garde, Ann Arbor 1984.
4 Paul Gorceix, *Les Affinités allemandes dans l'œuvre de Maurice Maeterlinck: Contribution à l'étude des relations du symbolisme français et du romantisme allemand,* Publications de l'Université de Poitiers, Lettres et Sciences Humaines 15, Paris 1975, p. 178.
5 Quoted in Jules Huret, *Enquête sur l'évolution littéraire,* Paris 1981, pp. 124-125.
6 Maurice Denis, *Théories,* 4th ed., Paris 1920, p. 268.
7 See note 6, p. 223.
8 Henri Matisse, "Notizen eines Malers", *Kunst und Künstler* 7 (1908/09), p. 341.
9 See note 6, p. 22.
10 See note 6, p. 263.
11 Hans K. Roethel and Jelena Hahl-Koch (eds.), *Wassily Kandinsky: Gesammelte Schriften 1,* Berne 1980, p. 38.
12 *Der Zwiebelturm: Monatsschrift für das bayerische Volk und seine Freunde* 5 (November 1950), p. 241.
13 *Neue Künstlervereinigung München e.V.: Turnus 1909-1910,* exh. cat., Moderne Galerie, Munich, December 1-15, 1909, unpaginated. Reproduced in Rosel Gollek (ed.), *Der Blaue Reiter im Lenbachhaus München,* Munich 1988, p. 388.
14 Robert P. Welsh, "Sacred Geometry: French Symbolism and Early Abstraction", in *The Spiritual in Art: Abstract Painting 1890-1985,* exh. cat., Los Angeles County Museum of Art, Los Angeles 1986/87, pp. 78-82.

15 Carel Blotkamp, "Annunciation of the New Mysticism: Dutch Symbolism and Early Abstraction", in *The Spiritual in Art* (see note 14), pp. 96-97.
16 John E. Bowlt, "Esoteric Culture and Russian Society", in *The Spiritual in Art* (see note 14), pp. 165-183.
17 See note 16, p. 173.
18 See note 1, p. 247.
19 See note 1, p. 248.
20 See note 1, p. 166.
21 See note 11, p. 33.
22 Maurice Maeterlinck, "Die moralische Krise", *Die neue Rundschau* 17 (1906), p. 83.
23 Klaus Vondung, *Die Apokalypse in Deutschland,* Munich 1988, p. 369.
24 See note 23, p. 105.
25 See note 1, pp. 145-146.
26 See note 1, p. 193.
27 Walter Eschenbacher, *Fritz Mauthner und die deutsche Literatur um 1900: Eine Untersuchung zur Sprachkrise der Jahrhundertwende,* Frankfurt and Berne 1977, p. 45.
28 Carl Einstein, *Werke,* vol. 1, *1908-1918,* ed. by Rolf-Peter Baacke and Jens Kwasny, Berlin 1980, p. 23.
29 Vasily Kandinsky and Franz Marc (eds.), *Der Blaue Reiter,* documentary ed. by Klaus Lankheit, Munich 1965, p. 325.
30 Comprehensively documented in L. Brion-Guerry (ed.), *L'Année 1913: Les formes esthétiques de l'œuvre d'art à la veille de la première guerre mondiale,* 3 vols., Paris 1971.
31 Jelena Hahl-Koch (ed.), *Arnold Schönberg – Wassily Kandinsky: Briefe, Bilder und Dokumente einer aussergewöhnlichen Begegnung,* Vienna 1980.
32 Karl Scheffler, "Die Jüngsten", *Kunst und Künstler* 11 (1913), p. 407.

33 Albert Lamm, "Ultra-Malerei", in *Dürer-Bund: 99. Flugschrift zur Ausdruckskultur,* Munich 1912, p. 12.
34 Angelica Zander Rudenstine, *The Guggenheim Museum Collection: Paintings 1880-1945,* vol. 1, New York 1976, pp. 268-271.
35 Original in Gabriele Münter- und Johannes Eichner-Stiftung, Munich.
36 Rose-Carol Washton Long, *Kandinsky: The Development of an Abstract Style,* Oxford 1980, p. 130-131; Sixten Ringbom, *The Sounding Cosmos: A Study in the Spiritualism of Kandinsky and the Genesis of Abstract Painting,* Acta Academiae Aboensis, Series A, vol. 38,2, Åbo 1970, pp. 167-168; see note 2, p. 131-132; see note 34, p. 264-265; Vivian Endicott Barnett, *Kandinsky at the Guggenheim,* New York 1983, pp. 108-111.
37 See note 1, p. 170.
38 See note 36 (Long, Ringbom).
39 See note 34, p. 269.
40 See note 1, pp. 154-155.
41 Felix Thürlemann, *Kandinsky über Kandinsky: Der Künstler als Interpret eigener Werke,* Berne 1986, p. 84.
42 See note 1, p. 396.
43 Johannes Langner, "Gegensätze und Widersprüche – das ist unsere Harmonie", in Armin Zweite (ed.), *Kandinsky und München: Begegnungen und Wandlungen 1896-1914,* Munich 1982, p. 131.
44 Hans K. Roethel and Jean K. Benjamin, *Kandinsky. Catalogue Raisonné of the Oil Paintings,* 2 vols., London 1982-84 (*Moscow I* is cat. no. 605).
45 See note 44, cat. no. 614.
46 Kenneth C. Lindsay, "The Genesis and Meaning of the Cover Design of the First Blaue Reiter Exhibition Catalogue", *Art Bulletin* 35/3 (1953), p. 51; see note 44, cat. nos. 426, 754.

47 See note 44, cat. no. 687.
48 See note 44, cat. nos. 452, 464, 465, 466, 476, 478, 485, 486.
49 See note 1, p. 290.
50 See note 1, p. 209.
51 Vivian Endicott Barnett, *Kandinsky and Sweden,* exh. cat., Konsthall, Moderna Museet, Malmö 1989/90, pp. 29, 52.
52 Will Grohmann, *Wassily Kandinsky: Leben und Werk,* Cologne 1958, pp. 165-166.
53 See note 52, p. 169.
54 Hubertus Gassner and Eckhardt Gillen, *Zwischen Revolutionskunst und Sozialistischem Realismus. Dokumente und Kommentare: Kunstdebatten in der Sowjetunion von 1917 bis 1934,* Cologne 1979, p. 106.
55 Christina Lodder, *Russian Constructivism,* New Haven and London 1983, p. 80.
56 Clark V. Poling, *Kandinsky – Unterricht am Bauhaus: Farbenseminar und analytisches Zeichnen, dargestellt am Beispiel der Sammlung des Bauhaus-Archivs,* Berlin 1982, p. 26.
57 See note 54, pp. 97-99; John E. Bowlt, "Vasilii Kandinsky: the Russian Connection", in John E. Bowlt and Rose-Carol Washton Long, *The Life of Vasilii Kandinsky in Russian Art: A Study of "On the Spiritual in Art",* Russian Biography Series 4, Newtonville 1980, p. 31-33; Vasilij Rakitin, "Zwischen Himmel und Erde oder wie befreit man das Rationale vom trockenen Rationalismus", in *Wassily Kandinsky: Die erste sowjetische Retrospektive,* exh. cat., Schirn Kunsthalle, Frankfurt 1989, pp. 79-88.
58 See note 57, p. 32.
59 See note 54, p. 128.
60 See note 57, p. 33.
61 Marcel Franciscono, *Walter Gropius and the Creation of the Bauhaus in Weimar: The Ideals and Artistic Theories of its Founding Years,* Urbana 1971, p. 98.
62 See note 56, p. 38.
63 Max Bill (ed.), *Kandinsky: Essays über Kunst und Künstler,* Berne 1973, p. 64.
64 See note 1, p. 628.
65 See note 63, pp. 94-95.
66 See note 63, pp. 116-117.
67 See note 63, p. 152.
68 See note 63, pp. 104-105.
69 See note 63, p. 107.
70 See note 63, p. 108.
71 See note 1, p. 825.
72 Paul Klee, *Das bildnerische Denken: Schriften zur Form- und Gestaltungslehre,* ed. by Jürg Spiller, Basle 1964, p. 93.
73 See note 72, p. 95.
74 See note 63, p. 111.
75 László Moholy-Nagy, *Malerei, Photographie, Film,* Bauhaus-Bücher 8, Munich 1925, p. 19.
76 See note 1, p. 725.
77 See note 63, p. 148.
78 See note 1, p. 759.
79 See note 75, p. 18.
80 Kasimir Malewitsch, *Die gegenstandslose Welt,* Bauhaus-Bücher 11, Munich 1927, p. 98.
81 H. C. L. Jaffé, *De Stijl 1917-1931. Der niederländische Beitrag zur modernen Kunst,* Berlin, Frankfurt, and Vienna 1965, p. 26.
82 Theo van Doesburg, *Grundbegriffe der neuen gestaltenden Kunst,* Bauhaus-Bücher 6, Munich 1925, p. 32-33.
83 Piet Mondrian, *Neue Gestaltung, Neoplastizismus, Nieuwe Beelding,* Bauhaus-Bücher 5, Munich 1925, p. 8.
84 See note 83, p. 11.
85 See note 63, p. 221.
86 See note 63, p. 148.
87 See note 82, p. 33-34.
88 See note 81, p. 121.
89 See note 83, p. 36.
90 See note 1, p. 825.
91 See note 1, p. 779.
92 See note 80, p. 74.
93 See note 82, p. 15.
94 See note 83, p. 49.
95 Piet Mondrian, "Plastic Art and Pure Plastic Art (Figurative Art and Non-Figurative Art)", in J. L. Martin, Ben Nicholson, Naum Gabo (eds.), *Circle: International Survey of Constructive Art,* London 1937, p. 45.
96 See note 63, p. 172.
97 See note 63, p. 770.
98 See note 63, p. 164.
99 See note 63, p. 213.
100 See note 63, p. 208.
101 Christian Derouet, "Kandinsky, triumvir de l'exposition du Jeu de Paume en 1937", in *Paris-Paris: Créations en France 1937-1957,* exh. cat., Musée National d'Art Moderne, Centre Georges Pompidou, Paris 1981, pp. 64-66; Christian Derouet, "Kandinsky in Paris: 1934-1944", in *Kandinsky in Paris 1934-1944,* exh. cat., The Solomon R. Guggenheim Museum, New York 1985, pp. 12-14; Christian Derouet, "Paris, Neuilly-sur-Seine 1934-1944", in Christian Derouet and Jessica Boissel (eds.), *Kandinsky: Œuvres de Vassily Kandinsky (1866-1944),* exh. cat., Musée National d'Art Moderne, Centre Georges Pompidou, Paris 1984/85, pp. 353-368.
102 See note 1, p. 779.
103 Vivian Endicott Barnett, "Kandinsky and Science: The Introduction of Biological Images in the Paris Period", in *Kandinsky in Paris 1934-1944,* see note 101, pp. 61-87.

Vivian Endicott Barnett

Kandinsky's Works on Paper

The Blue Rider Period, 1911-13

Although Kandinsky drew and painted watercolors throughout his life, his artistic involvement with works on paper was most intense between 1910 and 1944. Prior to 1910 Kandinsky used sketchbooks to make small studies for his own work, to copy works by other artists, and to record places he saw on his travels. In his essay "Reminiscences" [Rückblicke], published by Der Sturm and dated June 1913, the artist relates how he learned to draw and paint as a child in Russia: "Early on, my father noticed my love of drawing and allowed me, even as a schoolboy, to take drawing lessons." He also recalls how his aunt Elisabeth Ticheeva had helped him to paint a watercolor sketch of a piebald horse as a very small child.[1]

A small group of Kandinsky's earliest surviving watercolors dates from 1902-04, when he was involved with the Phalanx school and exhibitions in Munich. The works, which are extremely small in scale, depict medieval subjects, fairy-tales, and reminiscences of Russia, such as *Russian Village on a River with Boats* of 1902/03 (fig. 1).[2] At that time, Kandinsky's work consisted primarily of woodcuts, small oil studies on canvasboard, temperas or colored drawings [farbige Zeichnungen] on cardboard, and paintings on cardboard or canvas. The artist recorded many but by no means all of his works in several Handlists [Hauskataloge]: thus, the Handlists of small oil studies, paintings [Bilder], and colored drawings give an inventory according to his own categories of the majority of his paintings before 1909. The Handlist of woodcuts catalogue his prints from 1903-07. Although Kandinsky made drawings and painted with watercolor and gouache on individual sheets, the number and importance of the works on paper are limited through the first decade of the century. Significantly, the Handlist of watercolors was begun only about 1922, although it includes some earlier works.

By 1910/11, Kandinsky's artistic direction had become defined and his original and distinctive style emerged. The artist, who was already in his mid-forties, had exhibited his paintings often in Germany, France, and Russia, had traveled extensively in Europe as well as in his native Russia, and had written exhibition reviews, stage compositions, prose poems for the book of woodcuts *Sounds* [Klänge], and the lengthy manuscript for his treatise *On the Spiritual in Art* [Über das Geistige in der Kunst]. Around 1910 Kandinsky painted several watercolors related to his color woodcuts and designs for a projected Russian edition of *Sounds*, which was never published. He selected off-white, shiny, very thin cardboard (measuring approximately 33 x 33 cm) for this group of works, which includes several studies for color woodcuts as well as *Sound of Trumpets (Large Resurrection)* (cat. no. 3) and *Nude* (cat. no. 4). The latter two watercolors are thinly painted with shades of pink and blue against a light background. The abstracted form of the female nude lacks descriptive details and evokes the figure with simple lines and touches of color. A freedom and directness in the artist's handling of the medium are particularly striking in the watercolors *Study for "Composition II"*, *Nude*, and *With Three Riders* (cat. nos. 2, 4, 5).

Kandinsky's predilection for abstraction is already apparent in both his watercolors and his oil paintings. Similar motifs often appear in the paintings on canvas or glass and in the works on paper, as well as in the woodcuts. It becomes increasingly necessary to refer to several

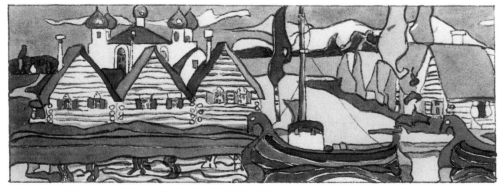

1 *Russian Village on a River with Boats,* 1902/03. Watercolor on paper.
Städtische Galerie im Lenbachhaus, Munich

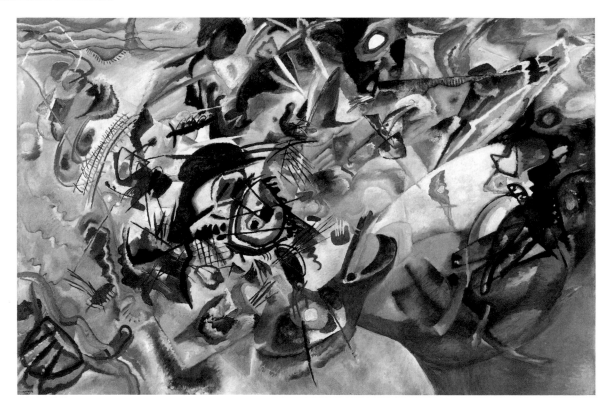

2 *Composition VII,* 1913. Oil on canvas. State Tretyakov Gallery, Moscow

works by the artist in various media in order to decipher the objects and to interpret the imagery. *Sound of Trumpets* is related to a 1911 glass painting [Hinterglasbild] of the Resurrection, in which the images are presented in reverse,[3] and to a slightly later woodcut of the same subject.[4] *With Three Riders* resembles the oil painting *Lyrical*, which dates from January 1911,[5] as well as a color woodcut done after the painting.[6] At first glance the black lines cannot be read as three horses with riders, and the red, blue, and yellow oval shapes in the middle seem unrelated to images and thus devoid of specific meanings. The images have been abstracted from nature to such an extent that they cannot easily be identified or "read".

The horse and rider is one of the most prevalent motifs from 1901-13, and probably the single image with which Kandinsky associated most closely. It brings to mind the medieval knight on horseback, St. George and the dragon, St. Martin converting the heathen, the Christian knight crusading against materialism, and the artist fighting for a new art.[7] Kandinsky's canvas entitled *The Blue Rider* of 1903[8] foreshadows the title and cover designs for the almanac *The Blue Rider* of 1911 (cat. no. 6). The horse-and-rider motif also appears in *Watercolor for Kojève, Sound of Trumpets, Annunciation*, and *Announcement of the Blue Rider* (cat. nos. 1, 7, 8). In the last work, the horseman reaches out and grasps one of the towers within a small citadel.[9] In the watercolor inscribed *Sound of Trumpets (Large Resurrection),* the juxtaposition of the leaping horse and rider with the walled city and the images of a storm, a whale, angels with trumpets, and the resurrected figure refer to the Last Judgement.

The stylized image of a boat with oars and rowers often recurs around 1910-13 and reappears in different form in the 1920s.[10] Sometimes small and rounded (cat. nos. 3, 9, 10, 12, 27) and sometimes elongated with several figures (cat. no. 16), the boat conveys a religious or apocalyptic meaning. In the titles of several paintings and in his writings, Kandinsky makes references to the Deluge. Although the boat-shape and the dark lines of the oars are prominent in *Boat* and *Study for "Improvisation 26 (Rowing)"* (cat. nos. 9, 10), they are difficult to discern in *Study for "Sketch for Deluge II"* and in *Small Pleasures* (cat. no. 27). Without knowing other works by Kandinsky, it would be almost impossible to interpret the very abstract images in his pictures.

In many cases – especially in 1911-13 – the watercolors are detailed studies for the oil paintings.[11] There is a greater clarity and profusion of detail in *Watercolor No. 3 (Garden of Love)* (cat. no. 13) than in the canvas *Improvisation 27 (Garden of Love II)* of 1912, which is based on it.[12] Likewise, the images are more clearly visible in the watercolor *Study for "Improvisation 28"* (fig. 1, p. 44) than in the final picture.[13] The artist painted five watercolors (including cat. no. 20) and a drawing that are closely related to the *Improvisations 33-34 (Orient)* of 1913.[14] In fact, preparatory drawings or watercolors exist for the twelve paintings entitled *Improvisations 23-34*. The prevalence of explicit studies for the Improvisations might be seen as a contradiction in terms. Kandinsky defined the Improvisations as "chiefly unconscious, for the most part suddenly arising expressions of events of an inner character, hence impressions of 'internal nature.'"[15] But can one consider

these oil paintings to be improvised and spontaneous when they were carefully planned in advance? One wonders whether Kandinsky painted the watercolors quickly, and whether they were the sudden expressions. Surely the canvases (for which the artist sometimes specifies a precise date) were painted more slowly and deliberately? Certainly, the artist worked out the overall composition as well as the details before he executed his important pictures between 1910 and 1914.

Before he painted the monumental canvas *Composition VII* on November 25-28, 1913 (fig. 2), Kandinsky made numerous drawings, watercolors and oil studies.[16] He inscribed several works on paper "For Composition 7"[17] and numbered seven of them. The first three (cat. nos. 31, 32) are india ink drawings that resemble more fully developed watercolors (cat. nos. 33, 34), whereas others are schematic diagrams with notes written in Russian (fig. 3). In several cases Kandinsky made two remarkably similar watercolors of the same motif. However, none of them is identical to the final canvas, which was painted in three days following a long period of deliberation. In *On the Spiritual in Art* Kandinsky categorizes the Compositions as "the expressions of feelings that have been forming within me in a similar way [as the Improvisations] (but over a very long period of time), which, after the first preliminary sketches, I have slowly and almost pedantically examined and worked out... Here, reason, the conscious, the deliberate, and the purposeful play a preponderant role."[18] Since there are more than thirty studies for *Composition VII*, they cannot be placed in a sequential

progression but should be viewed as groups of explorations leading to a solution. Images of the Last Judgement, All Saints' Day, the Deluge, and the Garden of Love emerge in highly abstracted form in *Composition VII*, which can be considered the culmination of Kandinsky's early work. In this painting, moreover, the artist pushes the limits of abstraction to the farthest point without breaking the tie to the object.

In 1913 Kandinsky created watercolors as well as drawings in ink or pencil for virtually all of his pictures. If we study the india ink drawing and watercolor for *Painting with White Form* (cat. nos. 21, 22), the numerous studies for *Painting with White Border* (cat. nos. 23-25), the watercolor and drawing for *Small Pleasures* (cat. nos. 26, 27), and the three watercolors for *Painting with White Lines* (cat. no. 28), the artist's method of developing motifs and arriving at pictorial solutions becomes apparent.[19] The repetitions and experiments expand the range of possibilities and also focus upon the resolution. There seems to be a correlation between the large number of works on paper and the period of intense creativity and experimentation.

Realism and Abstraction, 1914-21

After the increased production of drawings and watercolors in 1911-13 there are only four known watercolors definitely dated 1914 (cat. no. 40).[20] The outbreak of the First World War in August 1914 forced Kandinsky to leave Germany. He went to Switzerland with his companion,

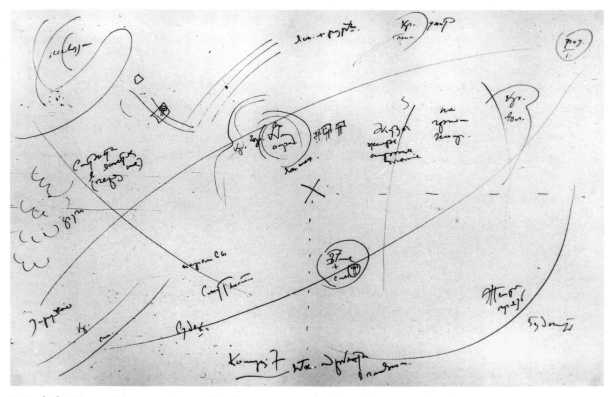

3 *Study for "Composition VII",* 1913. India ink on paper. Städtische Galerie im Lenbachhaus, Munich

4 *Untitled,* 1915. Watercolor and india ink on paper. Private collection

the German artist Gabriele Münter, and then he returned alone to Russia. It is impossible to know with certainty how many watercolors he made before 1923 and how many preparatory drawings once existed. The majority of Kandinsky's drawings from 1900-14 were kept by Münter, and large numbers of later drawings belonged to the artist's widow, Nina Kandinsky. It remains unknown how many works on paper he gave to friends in either Germany or Russia and how many watercolors and drawings may have been lost or destroyed during the First World War and the Russian Revolution.

In 1915 Kandinsky made no oil paintings but only works on paper. There are twenty-nine extant watercolors bearing the date 1915, and probably a dozen more date from this year.[21] In his letters to Münter, Kandinsky gives reasons why he is unable to paint any oils and describes his work. He writes on May 31: "I am drawing a lot, doing watercolors, and want to experiment a lot with colors." Again, on November 16 he states: "I am working a lot in watercolor. It is very precise work and I am, so to speak, learning the art of the jeweler. It helps me prepare for the large paintings, which are slowly taking shape in my heart." He goes on to explain that, as a result of the numerous watercolors he has done recently, he has a better and more practical sense of the distance and depth he wishes to express in painting.[22] Most of the works on paper are abstract and often appear to have been executed quickly. The india ink lines are scratchy and stippled in a manner that recalls Kandinsky's etchings from 1913/14 (cat. nos. 41, 42, 45). Many watercolors are painted on sheets from sketchpads, which have similar dimensions and frequently have perforated edges on

three sides. Some of the watercolors are reminiscent of *Painting with White Border* (cat. nos. 43, 44) and of *Composition VII*, which date from 1913; others are figurative in style and anticipate future developments.

Kandinsky went to Stockholm to meet Gabriele Münter for Christmas 1915 and stayed there until mid-March 1916.[23] During this time he made a separate Handlist of fourteen "bagatelles," which includes both boldly abstract works and fanciful, figurative watercolors (cat. nos. 47, 49). The first bagatelles seem to be fairy-tales, but the specific subjects defy interpretation (fig. 4, cat. no. 47). Other works, from 1916 (listed in either the Handlist of bagatelles or that of watercolors) are total abstractions (cat. nos. 50, 52, 53). After the artist's return to Russia this dichotomy persisted for several years. Kandinsky made surprisingly realistic drawings and landscapes in 1917; he continued to depict fairy-tales and Biedermeier subjects in watercolors and glass paintings until 1919; but, at the same time, he drew and painted in a completely abstract manner. Many works on paper appear dark and foreboding (cat. no. 58). There is an unsettling ambivalence and hesitation in his work from the Russian period.

Although the precise reasons for these changes may be difficult to establish, personal and political events were no doubt contributing factors. Kandinsky's long relationship with Gabriele Münter ended, and he married Nina Andreevskaya in February 1917. As a result of the Revolution, Kandinsky's family lost all its assets: he found himself in a desperate financial situation without the possibility of selling works of art. The artist took an active role in post-Revolutionary activities. He was a member of the Department of Visual Arts (Izo) in the People's Commis-

5 *Study for "On White I",* 1920. Watercolor on paper. Private collection

sariat of Enlightenment (Narkompros), he was appointed director of the Museums of Painting Culture, he taught at the Free Workshops (Svomas), and he participated in the painting section of the Institute of Artistic Culture (Inkhuk). In view of these administrative duties it is not surprising that Kandinsky created fewer works than he had during the Munich or would during the Bauhaus period. In 1915, and again from October 1917 until January 1919, he did not paint any canvases. From 1919 to 1921, however, Kandinsky made several watercolors on which he based major paintings: for example, *White Oval, Blue Segment, Green Border, On White I* (fig. 5), *Red Spot II*, and *Circles on Black* (cat. nos. 62, 64, 65, 67).[24]

At the end of December 1921, Nina and Vasily Kandinsky left Russia and went back to Germany, first staying in Berlin and then moving to Weimar, where Vasily was invited to teach at the Bauhaus. With his return to Germany, Kandinsky found new opportunities for exhibiting his art. One-man exhibitions were held at the Galerie Goldschmidt-Wallerstein in Berlin in the spring, at the Moderne Galerie Thannhauser in Munich in the summer, and at Gummesons Konsthandel in Stockholm in the fall; his work was also included in the First Exhibition of Russian Art in Berlin in 1922. Beginning with the Goldschmidt-Wallerstein exhibition, Nina made lists in a notebook of the watercolors and paintings shown at exhibitions (including information on prices and sales). The numbers of the watercolors in Nina's lists correspond to those in the artist's Handlist.[25] It is no coincidence that in 1922 Kandinsky also began to catalogue his watercolors in a separate Handlist. He recorded seventeen out of approximately thirty-five known works from that year. Although many of the watercolors from 1922 are untitled, the artist assigned them consecutive numbers beginning with number 31, made a small sketch of the work, recorded the price, and often gave the name of the owner. For example, numbers 44 (cat. no. 73) and 46 were given to Cargher on January 2, 1923, for the stay in Oberhof. He gave the first watercolor of 1923, number 47 entitled *Good Mood*, to Nina on the same day. Kandinsky usually indicates with Roman numerals the month or months in which a work was executed, although he records specific dates for a few watercolors in December 1922. Thus, we know that *Black Circle* (HL 20) is one of two watercolors that he painted on December 20, and that he made two a day on the 21st and 22nd and one the following day. The Handlist information becomes more consistent in 1923; by February of that year most watercolors have dates with months as well as specific titles. By 1924 the Handlist seems to be quite comprehensive, since it includes seventy-seven works and omits only three known works from that year.

The first few pages of the Handlist remain puzzling since they catalogue twenty-three watercolors in rather unsystematic fashion on four pages before the page with the heading "1922". The first page is written entirely in French, although the works are assigned dates from the Munich period (fig. 6), and a few French titles also appear on the third page. All the other works on pages 2 and 3 were either exhibited in Erfurt in January 1925 or remained with the artist until at least the mid-1920s. Those on page 4 date from 1918-22 and did not leave the artist's possession before the 1930s. Moreover, all the watercolors with French titles belonged to the artist in the thirties and early forties when he lived in Paris. Precise dimen-

sions are listed for the works with French titles, although their dates are often lacking or questionable. It therefore appears likely that in Paris Kandinsky added works to the first four pages of the Handlist of watercolors. The fact that none of the watercolors that belong to the Städtische Galerie im Lenbachhaus (and thus remained with Gabriele Münter) and none of the early watercolors that Kandinsky sold or gave away before the mid-1920s are recorded in the Handlist of watercolors is significant. The artist's Handlist of watercolors coincides with his return to Germany and his increased production of watercolors at the Bauhaus.

New Role of the Watercolors, 1921-34

Although the shift in Kandinsky's style had commenced during his last two years in Russia, the changes in his surroundings hastened the evolution of his art. At the Bauhaus his canvases and his works on paper became increasingly geometric and theoretical. The circle emerged as the most prevalent and meaningful form. Circular shapes had occurred in much earlier watercolors, such as the untitled work from 1912 (cat. no. 17) or *Watercolor with Red Spot* from 1913 (cat. no. 36), and were emphasized in *Simple* from 1916 (cat. no. 52) and an untitled work from September 1917 (cat. no. 59). During the Bauhaus period, however, circular forms were drawn with the compasses rather than freehand. The circular composition of *Black Circle* (HK 20) and the repetition of circular forms in the untitled work from December 1922 (cat. no. 73) signal the change. By 1922 the tiny hole from the compasspoint can be detected in the works on paper. Like-

wise, because of the use of the ruler, lines become straighter and sharper. A new precision and rigidity are visible in the checkerboard patterns (cat. nos. 70, 75, 76), familiar from the Russian period. Kandinsky's titles for the watercolors from 1922/23 accentuate the new imagery: *Black Circle, Light Circle, Study for "Circles within a Circle", Gray Oval, Gray Circle, Gray Square, Three Free Circles, Around the Circle, Red Circle, Black Triangle.*

By 1923 not only the images but also the compositions of the watercolors have changed. Often much of the white sheet remains bare, and the geometric shapes are scattered across the page. The studies for *Composition VIII* and *In the Black Square* (cat. nos. 84, 86), which both date from July 1923, rely upon precise, schematic lines and flat, well-defined geometric forms that stand out against the white background. Moreover, contemporary canvases such as *On White II, White Picture*, and *Through-going Line* (fig. 7), which are based on watercolors, emphasize the white ground, which functions like a white sheet of paper. In *Through-going Line* curving lines are contrasted with the straight ones at the lower right. Likewise, the untitled 1923 watercolor (cat. no. 88) and the watercolor titled *Strings* of April 1924 (cat. no. 93) resemble the ink drawings Kandinsky made during the same years (cat. no. 75, fig. 8).

In 1924 Kandinsky painted a much larger number of watercolors – at least eighty – than in previous years, and they assumed a greater and far more independent role in his art. The fact that from 1924 until mid-1934 he does not refer to the watercolors in the Handlist as studies for paintings, but assigns them individual titles, is indicative of their uniqueness and autonomy. Since he records the watercolors consecutively by month, it is possible to trace the development of certain motifs and to determine the diverse directions in which he worked simultaneously. *All Around* (cat. no. 89), which was painted on New Year's Day 1924, is followed by *Heavy Falling* (cat. no. 90) and four other watercolors in January. Not surprisingly, over the next three months many of the watercolors resemble *All Around* in color, composition, and imagery. However, among the ten works executed in April, the linear grids in *Strings* (cat. no. 93) differ noticeably from the more painterly and colorful washes in *Study* (cat. no. 92). Likewise, the subdued, textured surfaces in *Heavy between Light* (cat. no. 97) and *Brown* (cat. no. 96) contrast with the bright, translucent colors in *Joyful Structure* (cat. no. 95), which immediately follows *Brown* in the Handlist.

Toward the end of 1924 Kandinsky completed fourteen watercolors in October (cat. nos. 98-100), eleven in November (cat. nos. 101, 103), and ten in December, in addition to painting ten oils during the same three month period. In seeking to explain or analyze the reasons for his remarkable production, the artist's Handlists provide at least partial answers. Most of the watercolors and paintings done from March onward were also exhibited in 1924 or at the beginning of 1925 – or else he soon gave the watercolors to friends. Between 1924 and 1926 the artist

6 First page of Handlist of watercolors.
Musée National d'Art Moderne, Paris

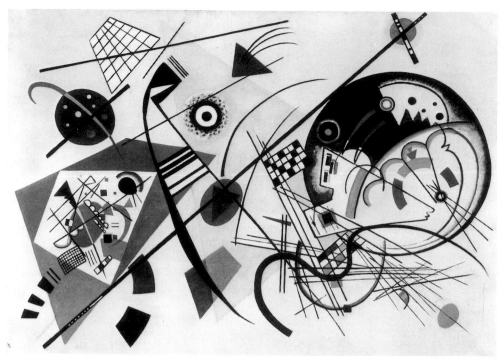

7 *Through-going Line,* 1923. Oil on canvas. Kunstsammlung Nordrhein-Westfalen, Dusseldorf

participated in more than thirty different exhibitions.[76] He showed recent watercolors in Vienna, Zurich, London, Stockholm, Zwickau, Dresden, and Berlin in 1924, and then in Erfurt in January 1925, Wiesbaden in January/February, Barmen in March, and Jena in March/April 1925. In 1926 a jubilee exhibition was held at the Gesellschaft der Freunde junger Kunst in Braunschweig and a large exhibition to celebrate the artist's sixtieth birthday took place at the Galerie Arnold in Dresden, traveling to the Galerie Neumann und Nierendorf in Berlin and to numerous other institutions. Within this context, it is readily understandable why Kandinsky painted more than one hundred watercolors in 1924/25, but only three in 1926. The Bauhaus closed in Weimar in April and moved to Dessau in June 1925. From May until November Kandinsky did not paint any watercolors, but during the same period he completed the manuscript for *Point and Line to Plane* [Punkt und Linie zu Fläche], which was published in 1926.

Between 1924 and 1926 Kandinsky's artistic vocabulary consisted of circles, semicircles, triangles, squares, checkerboards, arrows, horn-forms, zigzags, and straight and curved lines. *Inner Simmering, Checkered,* and *Upward* (cat. nos. 105-107) all date from the end of 1925 and were followed by *Upper Center* (HL 208), which was done on January 3, 1926. Stylistically, the works with consecutive Handlist numbers emphasize the diversity found in coeval works. Technically, they reveal the artist's extraordinary control of the watercolor medium: his experienced use of wash in *Inner Simmering,* his mastery of complex checkerboards seen in perspective in *Checkered,* and his creation of illusionistic space in *Upward.* In September 1927 Kandinsky began to use the technique of spraying

watercolor that his close friend Paul Klee (who was also his neighbor in Dessau) had employed since the mid-1920s. *Capriccio* (fig. 9) appears to be the earliest example where Kandinsky sprayed a fine mist of watercolor to create an atmospheric effect. He explored the possibilities of the spray technique further in *Modest Transverse* (HL 218) and *Hard, but Soft* (HL 220).

8 *Drawing No. 1,* 1924. India ink on paper. Private collection

9 *Capriccio,* 1927. Watercolor and india ink on paper.
Solomon R. Guggenheim Museum, New York

In 1928 Kandinsky created many watercolors entirely
with sprayed pigment and cut-out shapes. *Into the Dark*
(cat. no. 118) was done by spraying diluted watercolor
onto paper with an atomizer or blowpipe. The artist used
both positive and negative stencils for the background
forms and the three sets of ascending triangles. As he
changed and removed the stencil shapes, he repeated
spray applications in different colors. Details such as the
cross at the upper right or the dark square at the lower
right were made by either covering or exposing the paper
while spraying. Likewise, *Square in Circle, Black-White,
Start,* and *Red Square* (cat. nos. 114-117), which were done
exclusively with a spray technique, are among the twenty-
one watercolors executed in May 1928. During the sum-
mer Kandinsky made several intensely colored, sprayed
abstractions on colored paper: for example, the deep red
in *Subdued Glow* (cat. no. 120) and the dark blue in *Blue
Haze* (HL 287). He returned to the motif of rising tri-
angles in *Moderate Attachment* (HL 268), *Three* (HL 283),
and *Heavy Points* (HL 292) the same year, and in *Almost
Submerged* (cat. no. 127) in 1930.

Concurrently, Kandinsky executed watercolors that are
essentially drawings: for example, *Drawing in Pink* (HL
226) and *Small Pictures* (cat. no. 110) of 1927, *Double
Ascending* (HL 277) and *Pink* (HL 280) of 1928, and *Two
Spirals* of 1932 (cat. no. 139). Although the artist has
added wash or spray, the images are drawn rather than
painted in several works between 1927 and 1932. During

these years he made numerous ink drawings, of which
many were published in *Sélection* in 1933. He numbered
some but not all of his finished drawings from 1923-33,
but did not keep an inventory or Handlist. By 1928/29
Kandinsky was beginning to make sketches in pencil or in
ink for his watercolors as well as his oil paintings. These
sketchbooks and individual sheets of preliminary draw-
ings have become known since the artist's widow be-
queathed them to the Musée National d'Art Moderne in
Paris.[27]

In 1928 Kandinsky's works on paper were remarkably
prolific. He painted the ninety-one works in the Handlist
of watercolors and two versions of studies for the stage
sets of Mussorgsky's *Pictures at an Exhibition* in addition
to making twenty-five oil paintings. During the month of
May he recorded twenty-one watercolors and then thirty
for the following two months, before he went on vacation
in August.

In January 1929 fifty of the watercolors from 1928 were
among the recent works in that medium presented at the
Galerie Zak in Paris (cat. nos. 105, 107, 111, 114-116, 119,
120, 122). The success of this first one-man show in Paris
was decisive. The following year Christian Zervos ar-
ranged for Kandinsky to execute the first etching for the
periodical *Cahiers d'Art,* and he published Will Groh-
mann's monograph on the artist in French. Kandinsky
contributed essays to *Cahiers d'Art* and other French
publications. Moreover, his work was included in exhibi-
tions of both the Surrealist and Cercle et Carré groups.
Kandinsky's works of art from 1929-33 demonstrate his
awareness of Surrealism as well as of Art Concret. Al-
though he did not move to Paris until the very end of
1933, the transition from the Bauhaus to Paris took place
gradually over these years.

Among the pre-Paris works on paper there are several
with dark backgrounds that foreshadow the gouaches on
black paper dating from 1935-41. The extremely dark
blues in *Blue Haze* (HL 287) and *From-To* (HL 376) and
the somber brownish black of *Almost Submerged* (cat. no.
127) recur in the painted black grounds of *Restrained*
(cat. no. 131) and *Hot* (cat. no. 134). The latter two were
done during the summer of 1931 at the same time as
Kandinsky was painting such light, delicate, spare water-
colors as *Light Weights* (cat. no. 132) and *Glimmering* (cat.
no. 136). The ambiguities and shifts in his style became
more pronounced the following year with the experimen-
tal medium of *Development* (cat. no. 140), the fuzzy, spot-
ted forms in *Blurring* (cat. no. 141), and the dark, textured
surface of *Over Here* (cat. no. 142), as opposed to the frag-
ile, linear construction of *Red-Green* (HL 497). *Over Here*
and *Red-Green* are recorded consecutively in the Handlist
under November 1932, soon after the Bauhaus closed in
Dessau and relocated briefly in Berlin. The Bauhaus was
closed permanently in July 1933, and in August Kandin-
sky painted the subdued watercolor he titled *Similibus*
(cat. no. 144) and the somber study for his last canvas in
Germany, *Development in Brown* (cat. no. 145).

Poetic Titles – Biological Forms, 1934-44

Several months after Kandinsky resettled in Neuilly-sur-Seine, near Paris, he began again to paint watercolors. He gave them simple titles in French in contrast to the poetic, theoretical titles he had favored in Dessau. The first seven works, which date from April-July 1934, are named for their colors: for example, *Green-Black* (cat. no. 147). Only at the end of the year did the artist add to the Handlist three watercolors from March, including *Four* (cat. no. 148) and an untitled study for *Each for Himself* (fig. 10). In 1934 he began to record the medium in the Handlist of watercolors, although examination of the work sometimes fails to prove that the artist included oil with watercolor or omitted India ink when it is obviously present.[28] In the thirties Kandinsky frequently used mixed media in works catalogued in the Handlists of both paintings and watercolors. In accordance with his annotations in the Handlist for *Development* and *Turning* (cat. nos. 140, 154), there are indications that oil paint has been added to these works on paper.

Not only new titles but also new images distinguish the Paris works from those of the Bauhaus period. Biological forms are evident in *Start* (the first work to be entered in the Handlist of paintings after the move to Paris), in *Four,* and in the following Handlist entry (fig. 10), where an amoeba is depicted.[29] *Creeping* (cat. no. 150) contains images of marine life and *Spots: Green and Pink* (cat. no. 155) has clear underwater associations. The artist's emphasis on line and the diversity of his motifs are apparent in three watercolors painted in December 1934: *Ends, Capricious,* and *Turning* (cat. nos. 151, 152, 154). In May 1935 Kandinsky began to use black paper supports for works in watercolor and gouache. For the first work, *Ascent in White* (cat. no. 156), he noted in the Handlist: "on black Aq. + Temp". Subsequent works are also painted on black grounds: *Grids* of 1935 (fig. 9, p. 51), *White Line* of 1936 (cat. no. 157), and *White on Black* of 1937 (cat. no. 160). Throughout 1938 and 1939 Kandinsky listed the medium in parentheses after the titles of works in the Handlist of watercolors, and he referred to the opaque medium as either "tempera" or "gouache".

In contrast, he ceased to give dates with months in 1940, he assigned specific titles extremely rarely to the works on paper in 1940 and 1941, and he recorded instead the colors of the supports in the Handlist. Thus, numbers 662 and 667 are listed as "g. on black", although number 669 is "g. on gray" (cat. nos. 177, 180, 182). The artist's descriptions of the materials become more precise: for example, number 682 is "g. on dark cream", number 699 is "aq. on lt. blue", number 703 is "aq. + g. on gray", and number 705 is "g. on d. gray" (cat. nos. 184, 185, 187). In looking at Kandinsky's works on paper from 1935 through 1941 one tends to see them in groups based on colors and motifs. The emphasis on dark supports painted with opaque pigments can be related to the artist's early temperas and gouaches from 1900-08, many but not

all of which were catalogued in the Handlist of colored drawings. However, the figurative style, illusionistic space, and narrative subject-matter of the early colored drawings do not recur in the late work. Kandinsky worked with white on black in 1922 (cat. no. 71), continued to paint dark grounds through the Bauhaus period, and created *Composition X,* the last work in his monumental series, with a black background in 1938/39. In fact, the artist first conceived of flat, light-colored, decorative shapes against a black sheet of paper in the woodcuts he executed from 1903 to 1911.

In 1941 Kandinsky made thirty-five gouaches and watercolors as well as a large number of drawings (cat. no. 189), but during the following two years he did not paint any watercolors or gouaches. In July 1942 he completed his last large canvas, and from then until July 1944 he did only small oils and temperas on wood or cardboard. Thus, Kandinsky's general categories of works changed during the last three years of his life. By 1942 the works in the Handlist of paintings resemble those from the immediately preceding years in the Handlist of watercolors (which he no longer made) and recall the colored drawings from 1900-08. Because of the war and later because of his health, Kandinsky drew copiously and painted small works on board. In his last years he filled several sketchbooks with meticulously detailed drawings.[30] The number of india ink drawings increased dramatically in 1941, and the artist relied on them in formulating his watercolors and paintings. In fact, the last watercolor in the Handlist is an untitled work dated 1944, but based on a drawing from a 1941 sketchbook.

10 *Study for "Each for Himself",* 1934. Watercolor on paper. Musée National d'Art Moderne, Paris

42 Vivian Endicott Barnett

1 "Reminiscences" in *Kandinsky: Complete Writings on Art,* Kenneth C. Lindsay and Peter Vergo, eds., Boston 1982, vol. 1, p. 365.

2 Erika Hanfstaengl, *Wassily Kandinsky, Zeichnungen und Aquarelle: Katalog der Städtischen Galerie im Lenbachhaus München,* Munich 1974, nos. 7, 9, 12-13, 16-18.

3 Hans Konrad Roethel and Jean K. Benjamin, *Kandinsky: Catalogue Raisonné of the Oil Paintings,* vol. I, *1900-1915,* London 1982, no. 420.

4 Hans Konrad Roethel, *Kandinsky: Das graphische Werk,* Cologne 1970, no. 138. See also no. 82, which appears on the cover of *On the Spiritual in Art.*

5 See note 3, no. 377.

6 See note 4, no. 98.

7 Peg Weiss, *Kandinsky in Munich: The Formative Jugendstil Years,* Princeton 1979, pp. 128-132; Rose-Carol Washton Long, *Kandinsky: The Development of an Abstract Style,* Oxford 1980, pp. 80-84.

8 See note 3, no. 82.

9 Sixten Ringbom, *The Sounding Cosmos: A Study in the Spiritualism of Kandinsky and the Genesis of Abstract Painting,* Abo 1970, p. 168. Ringbom postulates that the Blue Rider is about to shake the foundations of the Establishment.

10 Armin Zweite, "Kandinsky zwischen Tradition und Innovation", in *Kandinsky und München: Begegnungen und Wandlungen 1896-1914,* Munich 1982, pp. 151-169.

11 Vivian Endicott Barnett, "The Relationship of Kandinsky's Watercolours to His Oil Paintings", in *Kandinsky Watercolours. Catalogue Raisonné,* vol. I, *1900-1921,* London 1992, pp. 29-37.

12 See note 3, no. 430.

13 See note 3, no. 443.

14 See note 11, nos. 333-337.

15 *On the Spiritual in Art* in *Kandinsky: Complete Writings on Art,* Kenneth C. Lindsay and Peter Vergo, eds., Boston 1982, vol. 1, p. 218.

16 See note 3, nos. 471-476, and note 11, nos. 354-365.

17 See note 2, nos. 241-257.

18 See note 15, p. 218.

19 For the final paintings see note 3, nos. 457, 465, 466, and 470.

20 See note 11, nos. 380-383.

21 See note 11, nos. 388-428.

22 The letters are preserved in the Gabriele Münter- und Johannes Eichner-Stiftung in Munich.

23 Vivian Endicott Barnett, *Kandinsky and Sweden,* Malmö and Stockholm 1989. All the works executed in Sweden are illustrated and discussed here.

24 For the paintings see note 3, nos. 661, 676, 671, 665, 675, and 682.

25 The artist's handlists and Nina Kandinsky's notebooks are in the Fonds Kandinsky at the Musée National d'Art Moderne, Centre Georges Pompidou, Paris.

26 For a complete list of exhibitions see note 11, pp. 493-538.

27 Christian Derouet and Jessica Boissel, *Kandinsky: Œuvres de Vassily Kandinsky (1866-1944),* Paris 1984, no. 433 and pp. 306-447.

28 Much earlier, Kandinsky had annotated the Handlist (Paintings I) to indicate the medium (oil, lacquer, tempera) for paintings done before 1908. Although many of the early pictures and colored drawings have information about the medium written on the reverse, this does not always correspond to what is found.

29 Vivian Endicott Barnett, "Kandinsky and Science: The Introduction of Biological Images in the Paris Period", in *Kandinsky in Paris, 1934-1944,* New York 1985, pp. 61-87.

30 See note 27, no. 724, and *Kandinsky: Carnet de dessins 1941,* Paris 1972, with an introduction by Gaëtan Picon.

Vivian Endicott Barnett

Kandinsky's Works
in Private Collections

When we think of Kandinsky's work, we focus on the vast public collections of the Städtische Galerie im Lenbachhaus in Munich, the Musée National d'Art Moderne in Paris, the Solomon R. Guggenheim Museum in New York, and the Russian museums in Moscow and St. Petersburg.[1] Gabriele Münter kept Kandinsky's early paintings and works on paper dating from before 1916 in her house in Murnau, and in 1957 she made a large donation to the Städtische Galerie im Lenbachhaus. Nina Kandinsky bequeathed the works that had remained with her in Neuilly-sur-Seine to the Musées Nationaux of France in 1980. However, the largest number of Kandinsky's works of art were purchased earlier by private collectors, art galleries, and numerous museums. Although we think first of the important holdings in a few museums, we must remember that Kandinsky's art is dispersed around the world in hundreds of public and private collections. It is the intention of this exhibition to focus upon works that are rarely seen, many of them belonging to private collectors. This essay will discuss the people who were instrumental in acquiring and promoting Kandinsky's art during his lifetime.

Many works left the artist's possession at a remarkably early date. From the beginning, private individuals acquired Kandinsky's paintings in gouache/tempera on cardboard, which he called "colored drawings" [farbige Zeichnungen]. From the artist's Handlist [Hauskatalog] of colored drawings we know the names of the owners of the first three works he recorded, which date from 1901. He noted in the same Handlist that number 10, _Lady in Blue,_ was sold to Prince Vladimir in St. Petersburg in 1904, and that number 19, _The Conqueror,_ was purchased after it was exhibited at the Berlin Secession in December 1903. In the Handlist of paintings, number 8, _Evening,_ of 1902 went to an unidentified owner in Stettin and number 9, _Sunspot,_ was sold after an exhibition in Odessa in 1902. The canvas titled _Stormy Weather_ of 1904 was acquired by a private collector in Dresden after the Berlin Secession in 1904, two colored drawings were sold after the Salon d'Automne in Paris in 1904, _Quiet Water_ of 1905 went to an unknown person in Odessa in 1906, and _Arrival of the Merchants_ of 1905 was purchased by Captain von Zastrow in Berlin after it was shown there at the Secession in 1906. _Costume Ball_ of 1906 was acquired after the Salon des Indépendants in Paris in 1907 by a collector named Clostre. Although our information remains fragmentary[2] and many of these works are known only from the artist's

Handlists, it can be concluded that Kandinsky sold his pictures during the early years of his career to collectors in Germany, France, the Netherlands, and Russia.

The Early Private Collectors and the Important Galleries

The artist records that several works were sold through auctions and lotteries to benefit causes. He donated the painting _Autumn Sun_ of 1901 to an international art lottery in The Hague to support the Boer widows, orphans, and other destitutes in South Africa in 1903, and he gave a colored drawing, _Foreign City,_ of 1904 to a lottery in Paris in 1906/07. A few years later he contributed seven paintings (all of which were sold) to a private auction that took place on March 15, 1911, in the studio of the Munich artist Adolf Erbslöh in order to raise funds for the New Artists' Association Munich [Neue Künstlervereinigung München (NKVM)].[3] Kandinsky had been a founder of the NKVM in 1909, and he participated in its exhibitions in December 1909 and September 1910 at the Moderne Galerie Thannhauser in Munich.

Through the second exhibition in 1910, Franz Marc met Kandinsky, Münter, Erbslöh, Alexej Jawlensky, Marianne von Werefkin, and other artists affiliated with the NKVM. During the following year Kandinsky and Marc worked together closely on several projects: most important, they decided to publish an almanac, and as co-editors they prepared articles and illustrations for the book during the summer of 1911. Kandinsky painted more than ten watercolor studies for the cover of the Blue Rider almanac (cat. no. 6). In early December Kandinsky, Münter, and Marc left the NKVM after the jury for the third exhibition rejected Kandinsky's painting _Composition V._ On December 18, 1911, the first exhibition of the Blue Rider [Die erste Ausstellung der Redaktion Der Blaue Reiter] opened at the Moderne Galerie Thannhauser simultaneously with the third NKVM show.[4]

Kandinsky's circle of friends and colleagues included the artists Marc, Jawlensky, Paul Klee, Alfred Kubin, August Macke, Heinrich Campendonk, and Arnold Schönberg, the composer Thomas von Hartmann, the collector Bernhard Koehler, the publisher Reinhard Piper, and dealers such as Heinrich Thannhauser and Hans Goltz. At the Moderne Galerie (Arco-Palais, Theatinerstrasse 7, Munich), Heinrich Thannhauser (1859-1935) hosted the NKVM exhibitions and also gave Marc and Klee early one-man shows in May and June, respectively,

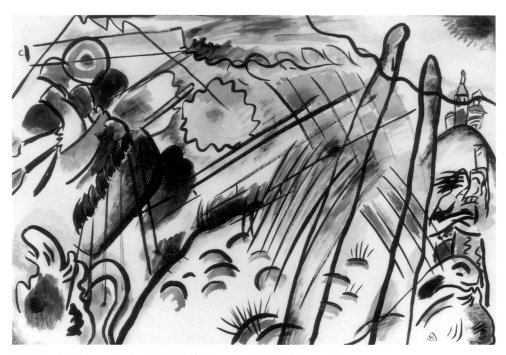

1 *Study for "Improvisation 28"* (Second Version), 1912. Watercolor on paper.
The Hilla von Rebay Foundation

of 1911. It was undoubtedly through Marc that Kandinsky became acquainted with the businessman Bernhard Koehler (1849-1927) from Berlin.[5] Koehler, whose niece was married to Macke, had an agreement with Marc whereby he paid the artist a monthly salary in exchange for works of art. Koehler purchased several works from the Blue Rider exhibition (including Kandinsky's painting *Impression II Moscow*) and also financed the publication of the Almanac.

It was in July 1911 at the fourth London Salon, which was organized by the Allied Artists' Association and held at the Royal Albert Hall, that the son of Michael Sadler bought a half-dozen small woodcuts by Kandinsky and obtained his address. The following summer the Sadlers contacted the artist and were invited to come to Murnau for an afternoon in mid-August.[6] They had tea, went for a walk to the church, and visited a local glass painter. They conversed on many subjects, although the younger Sadler recalls: "Kandinsky was inclined (although not at all obtrusively) to talk about religious things, and is much interested in mystical books and the lives of the saints." Kandinsky and Münter (whom they referred to as "Mrs. Kandinsky") urged the Sadlers to stay longer, but were unaware that the late train from Murnau to Munich did not run that day. Thus, the Sadlers had to spend the night at a hotel in the village. On August 17 Mr. Sadler wrote to Kandinsky from Munich to thank him for the visit, and mentioned that he had seen his works on paper at Goltz's gallery. Michael Ernest Sadler (1861-1943) was vice-chancellor of Leeds University in England from 1911 to 1923. His son, Michael T. H. Sadler, translated *Über das Geistige* into English and wrote an introduction to the book, which was published in London in 1914. The father (who became Sir Michael) owned several watercolors and a can-

vas by Kandinsky. The artist apparently gave him *Study for "Improvisation 28" (Second Version)* of 1912 (fig. 1) at Christmas 1912. Sadler hoped that the first Blue Rider exhibition would travel also to London, but the project had to be abandoned for lack of money.

The second Blue Rider exhibition, which took place from February 12 to April 2, 1912, at Hans Goltz's gallery in Munich, presented only works on paper. Kandinsky and Münter compiled a list of the twelve watercolors he exhibited there and recorded the names of the purchasers. Goltz bought five works and one went to the Galerie Flechtheim in Berlin. *Watercolor No. 10* was ac-

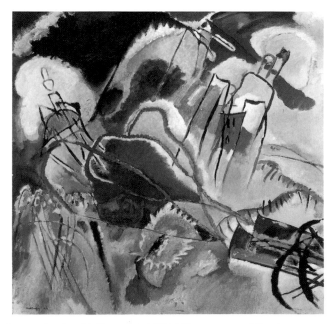

2 *Improvisation 30 (Canons),* 1913. Oil on canvas. The Art Institute of Chicago, The Arthur Jerome Eddy Memorial Collection

quired by Sadler (presumably in August 1912) and another was purchased by the well-known collector Karl Ernst Osthaus from Hagen. *Watercolor No. 3 (Garden of Love)* and *Watercolor No. 8 "Last Judgement"* (cat. nos. 13, 14) remained with Gabriele Münter. *Watercolor No. 6* belonged to a Dutch collector at an early date.

The first Blue Rider exhibition traveled from Munich to several cities in Germany and was shown at Herwarth Walden's gallery Der Sturm in Berlin from March 12 to May 10, 1912. Herwarth Walden (1878-1941) included Kandinsky's work in group exhibitions during that summer and presented a major one-man show in October 1912.[7] From then until 1922, Walden was the primary dealer handling Kandinsky's work. In a new pricelist dated December 12, 1913, which Kandinsky sent to Walden, the artist asked that two pictures be omitted from the second edition of the catalogue of his exhibition: *Improvisation 10*, which had been sold to Franz Kluxen, and *Impression 2*, which belonged to Koehler.[8] Because of his contacts in the Netherlands and in Scandinavia, Walden organized traveling exhibitions, through which Kandinsky's art became better known. Several early watercolors (cat. nos. 8, 20) were acquired from the gallery Der Sturm, and many important collectors, including the German businessman Franz Kluxen (1888-1968), purchased works by Kandinsky from Walden.

In the Sturm Album *Kandinsky, 1901-1913,* which was published by Walden in October 1913, numerous paintings were illustrated with information about the collectors: *Marketplace* of 1902 was owned by Dr. Alfred Hagelstange of Cologne, *Improvisation 3* of 1909 was in the collection of Franz Kluxen in Münster, and *Improvisation 9* of 1910 belonged to the art historian Dr. Franz Stadler in Zurich. In addition, the album published five pictures from the collection of Arthur Jerome Eddy, as well as *Improvisation 27 (Garden of Love),* which the American photographer Alfred Stieglitz had acquired early in 1913 at the famous Armory Show in New York.

Private Collectors in the States and in the Netherlands

The Chicago lawyer Arthur Jerome Eddy (1859-1920) first saw Kandinsky's work at the International Exhibition of Modern Art, or "Armory Show", which opened at the 69th Regiment Armory in New York in February 1913 and subsequently traveled to Chicago. During the summer of the same year he saw Kandinsky's paintings at the Allied Artists' Association exhibition at the Royal Albert Hall in London in July; he bought all three canvases on show, *Improvisation 29, Improvisation 30* (fig. 2), and *Landscape with Two Poplars,* and then traveled on to Germany.[9] When he arrived in Murnau neither Kandinsky nor Münter was there, but the housekeeper showed him the contents of the studio, from which he selected about twelve paintings. In a letter to Kandinsky dated October 13, 1913, Eddy explained that he wanted to buy the work of new artists who were still unknown.[10]

In his book *Cubists and Post-Impressionism* from 1914, Eddy quotes from Kandinsky's letters, which emphasize that "the observer must learn to look at the picture as a graphic representation of a *mood* and not as a representation of objects."[11] In a letter to Kandinsky dated March 5, 1914, Eddy writes: "I hope to receive some little photographs of some of your latest work. I wish to keep track of what you are doing, and I would particularly like to know if at any time you paint a picture that is unusually brilliant in color. You will see that color interests me very much. I like to see it and to have it about me. It helps to relieve the monotony of business and professional surroundings."[12] Again on May 19, 1914, Eddy states in a letter: "If I do not go to Europe, and feel that I can afford to purchase any more of your pictures, I may write you to send over six or eight of your latest and most brilliant pictures, and I would keep two or three of those that I like, but I should want you to make me a much better price than 600 marks, because you must realize that I cannot afford to buy so many pictures of one artist unless the price is very low."

Through Eddy his friend Edwin R. Campbell commissioned Kandinsky to paint four canvases for the entrance-hall of his New York apartment (fig. 3). It was Eddy who sent the specifications and exact description of the reception-hall of Campbell's apartment at 635 Park Avenue to

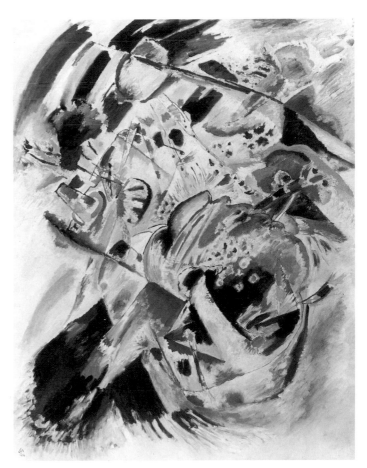

3 *Panel for Edwin R. Campbell, No. 4,* 1914. Oil on canvas.
The Museum of Modern Art, New York

4 *Picnic,* 1916. Watercolor on paper.
Solomon R. Guggenheim Museum, New York

Münter in a letter dated June 15, 1914. Eddy also tells her: "I was glad to get this commission for Herr Kandinsky because it gives him an entrance in New York, and while the price is not large, yet it is quite a venture for my friend to hang four such extremely modern pictures in a place where everybody must see them. I think my friend has a good deal of courage, but I am very sure he will be very much pleased with the result." Because of the First World War, the four Campbell panels as well as three paintings for Eddy were not shipped to the States but were stored by Willem Beffie in Amsterdam. In 1915/16 Eddy corresponded with Münter in Sweden and Kandinsky in Moscow regarding shipment of Campbell's paintings to New York, and only in December 1916 did the artist receive payment in Moscow.[13]

The Amsterdam collector Willem Beffie acquired important works directly from the artist. On July 22, 1913, Beffie and his wife went to Sindelsdorf, where they purchased several works by Marc, and then to Munich, where they bought *Group in Crinolines* of 1909, *Sketch for "Composition II"* of 1909/10, and *Small Pleasures* from Kandinsky.[14] Also in 1913 another Dutch collector, Dr. H. van Assendelft (1875-1928), a minister from Gouda, acquired *Improvisation 33 (Orient I)* and the watercolor *Study for "Painting with White Border"* (cat. no. 23). Both van Assendelft and the collector Marie Tak van Portvliet of The Hague, who owned the painting *Lyrical* of 1912, had direct contact with the artist.[15]

Before the First World War, works of art by Kandinsky belonged to collectors in Germany, France, Switzerland, the Netherlands, England, the United States, and Russia. *Study for "Painting with White Lines"* (cat. no. 28) was one

of the first works to enter a public collection. In December 1913 Kandinsky offered a selection of watercolors to the Germanisches Museum in Nuremberg, and at the beginning of 1914 he gave the museum two watercolors and a drawing.[16] From the artist's correspondence with Herwarth Walden, we know that the Reiff-Museum in Aachen was interested in buying two early colored drawings in 1913, and was in fact the first German museum to purchase a Kandinsky painting, *Improvisation XXIV*, in 1914.

The First World War and Return to Germany

Because of the war, Kandinsky (who was an alien) could not stay in Germany, and he found it increasingly difficult to sell his works there. Through Walden and Münter, the gallery-owner Carl Gummeson in Stockholm organized a Kandinsky exhibition for February 1916, which included not only the Campbell panels that were stored in Amsterdam but also *Composition VI* and other canvases still in Sweden after the 1914 Baltic Exhibition in Malmö.[17] In addition, many of the fanciful watercolors or "bagatelles" that the artist painted in December 1915 (cat. no. 47) and January 1916 (cat. no. 49) in Sweden were shown. Before the exhibition Kandinsky had sold one of the bagatelles to Michael Sadler, and he also gave another entitled *Picnic* (fig. 4) to Beffie in return for storing the Campbell panels. Gummeson sold watercolors to the critic Johnny Roosval (cat. no. 47), to the architect Stenhammer (cat. no. 49), to other Swedish private collectors, and to the Nationalmuseum. Kandinsky stayed with Münter in Stockholm for almost three months, and his visit attracted considerable interest there. He made a watercolor (cat. no. 48) for the psychiatrist Dr. Poul Bjerre (1876-1964), with whom he established a friendly relationship.[18] Although the artist returned to Russia in mid-March 1916, Gummeson continued to sell his work through 1918 and again in the thirties.

While Kandinsky and Münter were together in Stockholm, the latter drafted a letter in English (dated March 8, 1916) from Kandinsky to Arthur Jerome Eddy in Chicago.[19] The artist explains that "the war has had a frightful influence on my general income" and "I am deep in debts." He continues: "My exposition here had an enormous moral success. Unfortunately the business result has not been accordingly but anyway it has helped me out of the difficulty for the year." He goes on to propose: "These three years 1916, 17, 18 I oblige myself to send to you two of my *best* new paintings of the size of about 1 meter for the price of 600 dollars both. That is you oblige yourself to pay 600 dollars for two pictures each of these three years. (Transfer and insurance on your account.)" Eddy's reply dated March 28 was sent to Kandinsky in Moscow with a copy to Münter in Stockholm: "I cannot very well agree to take a certain number of pictures each year. I do not like to do that because I buy more pictures than I should. I always like to see the pictures I buy before

taking them. When I wrote in my letter to Moscow that I thought it would be good for you to have some of your pictures in this country, it was because I thought the pictures were doing you no good in Europe. If you are exhibiting the pictures in Europe they will do you as much good there as if they were over here." Eddy then concludes: "Of course, your pictures ought to bring higher prices in Europe than in this country, because they are better known there."

After Eddy's rejection of Kandinsky's proposal, the artist's financial situation deteriorated further. In the October Revolution of 1917 he lost all his assets and his land was expropriated. In Russia there were no opportunities to sell his work, and his contacts with Walden and Gummeson became increasingly difficult because of the war and the revolution. Because of his marriage to Nina Andreevskaya in February 1917 he could no longer ask Münter to act on his behalf. On May 6, 1918, he turned to Poul Bjerre in Sweden: "Dear Dr. Bjerre, after lengthy consideration, I have decided after all to write you a hasty letter. As a result of the changes that have occurred here, I find myself in a desperate financial situation: within a few weeks I shall be totally destitute. Under normal conditions I would have been able to sell some of my pictures abroad – but not now. My relatives here are also in such a plight that it is out of the question to borrow from them. I do not know whether this letter will reach you as I do not have your present address. I am therefore writing to Gummeson as well, asking him to speak to you about my situation. Could you perhaps arrange something for me with Hjalmar Wijk? I would be happy to sell any of my paintings half-price at the first opportunity. An advance or a loan of something like to 2-3 thousand crowns would keep me going for some months – after that I hope to be better off again."[20] It is not known whether the Göteborg businessman Hjalmar Wijk, Bjerre, or Gummeson sent money to Kandinsky through the Swedish Embassy or the banks specified in his letter.

Around 1917-19 Walden was able to sell Kandinsky watercolors and colored drawings to his Dutch colleague Paul Citroën and to the artist Georg Muche in Berlin (cat. no. 8). Kandinsky, however, received none of the money owing to him. Walden's gallery had continued to exhibit Kandinsky's art and had sold pictures he had left there on consignment (cat. no. 35). Kandinsky tried to recover his work with the assistance of intermediaries around 1920. After his return to Berlin at the end of December 1921, the artist renewed his efforts and then initiated legal action against Walden. On February 16, 1922, Kandinsky wrote again to Bjerre and asked him to tell Gummeson the following. "Der Sturm is no longer my representative and manager in art matters. Unfortunately, I am even engaged in legal action against him, but have not yet lost hope that Walden and myself might settle our affairs without further recourse to court." In the end, the suit was dismissed and a settlement reached out of court.[21] *All Around* (cat. no. 89) is one of two watercolors that Kan-

dinsky gave to his lawyer Joseph Wolfsohn in June 1924 in payment for his services.

Soon after Kandinsky arrived in Berlin, he had a one-man exhibition at the Galerie Goldschmidt-Wallerstein, where several watercolors were sold. He also renewed his contacts with Gummeson in Stockholm and Thannhauser in Munich, and showed canvases and works on paper from the Russian period at both galleries in 1922. Even before he moved to Germany, Kandinsky had been in contact with Walter Gropius (1883-1969), who had founded the Bauhaus in 1919. In June 1922 the artist moved to Weimar, where Gropius provided him with a room, and in September Gropius invited Kandinsky and Lyonel Feininger to stay at Timmendorfer Strand on Kiel Bay, where his mother had a house. Kandinsky expressed his gratitude in Gropius's guestbook (fig. 5) and with the *Watercolor for Gropius* (cat. no. 74), which he inscribed on the reverse: "To my dear Gropius, in memory of summer 1922."

At the Bauhaus Kandinsky was reunited with his old friend Paul Klee. He worked closely with Feininger, whom he had met upon his return to Berlin, and became acquainted with Georg Muche, Oskar Schlemmer, and other Bauhaus masters. In 1922 Kandinsky renewed his friendships with Jawlensky, who lived in Wiesbaden (cat. no. 103), and with the pianist Gottfried Galston in Berlin (cat. no. 76). In October 1922 the American collector and educator Katherine S. Dreier (1877-1952) visited Kandinsky in Weimar and purchased the painting *Blue Circle* of 1922 and four watercolors (cat. nos. 22, 29, 30).[22] Later

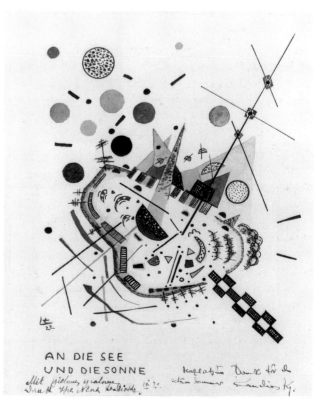

5 Guestbook of the Gropius family, 1922. Watercolor on paper. Private collection

that fall he was appointed first honorary vice-president of the Société Anonyme, which presented his first one-man show in New York in the spring of 1923.

In his Handlist of watercolors Kandinsky often recorded when he gave watercolors to friends, artists, and art critics. Thus, we know that Kandinsky and Klee exchanged works in November 1923 and that *Cool Yellow* (cat. no. 98) was a birthday present for Klee in December 1924. In February 1924 Kandinsky presented *Two Black Spots* (cat. no. 77) to Sophie Küppers, apparently for her assistance with the exhibition of Russian art at the Neue Galerie in Vienna. At the same time the Albertina bought three Kandinsky watercolors (cat. no. 43). *Bent Point* of 1924 (cat. no. 101) was the first of several works the artist gave to the art historian Will Grohmann in Dresden, who first wrote about Kandinsky's work in 1924. During the 1920s Kandinsky gave several watercolors (cat. no. 79) to the photographer Hugo Erfurth in Dresden, some of them in exchange for photographs. When Muche, Herbert Bayer, Laszlo Moholy-Nagy, Schlemmer, and Walter Peterhans left the Bauhaus, Kandinsky noted in the Handlist that he contributed watercolors to the portfolios presented to them (cat. no. 124).

The Kandinsky Society, 1925-33

The Weimar Bauhaus attracted a circle of friends and believers in the new art. Through the Bauhaus, Will Grohmann, Galka Scheyer, and Otto Ralfs came into contact with Kandinsky and Klee. Emmy Scheyer (known as Galka) came from Braunschweig (1889-1945), had studied painting, and was a great admirer of Jawlensky's art. By late December 1923 she had decided to found the group The Blue Four [Die Blaue Vier] to promote the art of Kandinsky, Klee, Feininger, and Jawlensky.[23] On March 31, 1924, in Weimar, they signed an agreement creating the group and designating Scheyer their representative in America. Soon afterwards she left for New York, taking with her paintings and watercolors by the four artists. Scheyer contacted galleries and museums regarding exhibition possibilities and, finding more interest in California, moved there the following year. Scheyer arranged lectures and numerous exhibitions on the West Coast; she also owned or had on consignment many works by Kandinsky (cat. nos. 97, 99, 116, 147).

During the summer of 1923 the Braunschweig businessman Otto Ralfs (1892-1955) visited the Bauhaus, where he met Klee, Kandinsky, and Feininger. Kandinsky's first drawing in Ralfs's guestbook is dated "Braunschweig 16 xii 23" (fig. 6).[24] In 1924 Ralfs founded the Society of Friends of Young Art [Gesellschaft der Freunde junger Kunst]: he was elected president in September, and Erich Scheyer (brother of Galka) was treasurer. When Kandinsky was in Braunschweig in mid-December 1924, he designed the society's emblem: a circle intersected by a triangle at the upper left and a whiplash line at the bottom and, adjacent to it, the initials GFJK. The artist also gave a

lecture on "The Spiritual in Art" [Das Geistige in der Kunst] in December, when his work was included in an exhibition of Expressionist art at the Landesmuseum in Braunschweig.

Ralfs's great enthusiasm for the work of Klee, Kandinsky, and Feininger and his wish to give the artists a certain degree of financial independence led to the founding of three separate societies. Years later Ralfs remembered: "At this moment of dire need, in early 1925, I founded the Klee Society, in order to help him. One should not forget that it was at the time extremely uncommon for pictures to be purchased, especially from such a rank outsider."[25] Ralfs must have been referring to the closing of the Bauhaus in Weimar in April 1925 and the feeling of insecurity that accompanied its relocation in Dessau. When the Klee Society [Klee-Gesellschaft] was formally established on July 1, 1925, the members were Otto Ralfs, Heinrich Stinnes of Cologne, Werner Vowinckel of Cologne, Rudolf Ibach of Barmen, and Hanny Bürgi-Bigler of Belp.[26]

According to the recollections of Otto and Käte Ralfs,[27] the Kandinsky Society was founded soon thereafter. As early as June 24, 1925, Kandinsky wrote to Grohmann: "In the matter of the Klee and Kandinsky Society Mr. Ralfs

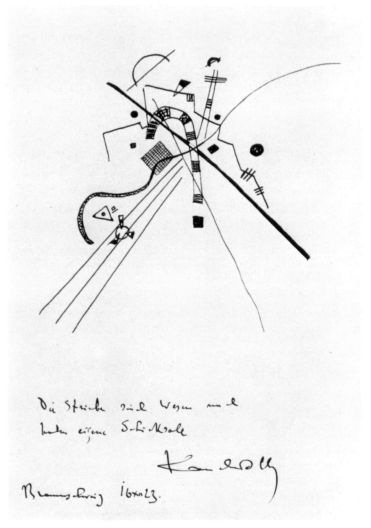

6 Guestbook of the Ralfs family, 1923. Watercolor on paper. Städtisches Museum, Braunschweig

also approached Mr. Gutbier, who totally misunderstood things and got very angry about the ungratefulness of artists who want to fight the art trade and forget the extraordinary efforts of the art dealers – Klee, Goltz, or Probst. Both of us – Klee and I – were in a very precarious situation during the winter, due to the dissolution of the Bauhaus in Weimar. The favorable turn that things took after the dissolution is for me personally not entirely satisfactory: the salary in Dessau is not enough to feed 5 people – (my Russ[ian] relatives, who would literally starve without my aid) – so I have to see that I get some sort of income besides the salary. The art trade was unwilling or unable to help me in this and some collectors wanted to do so. It is a matter quite restricted to a small circle and should have no repercussions outside thereof."[28]

Although the Kandinsky Society was an informal circle of friends, the group of collectors can be reconstructed from lists of accounts in the Fonds Kandinsky at the Centre Georges Pompidou. In addition to Ralfs himself, the most active members from 1925 to 1928 were Heinrich Stinnes of Cologne, Rudolf Ibach of Barmen, Dr. Hermann Bode of Hanover, Werner Vowinckel of Cologne, and Heinrich Kirchhoff of Wiesbaden. By 1929/30 Dr. Hermann Schridde of Dortmund, Ida Bienert of Dresden, Harald Voigt of Dresden, Adolf Rothenberg of Breslau, Dr. Georg Hartmann of Breslau, Richard Doetsch-Benziger of Basle, and Dr. Otto Baier of Cologne were also associated.[29] Of these thirteen collectors affiliated with the Kandinsky-Gesellschaft, nine were, at one time or another, members of the Klee-Gesellschaft. Moreover, Ralfs, Stinnes, Bienert, and Doetsch-Benziger belonged to the Feininger-Gesellschaft, which was founded in 1929.

The members of the Kandinsky-Gesellschaft contributed 600 reichsmarks annually in monthly installments of 50 RM, in return for which they could choose to purchase works of art at the atelier price (two-thirds of the dealer price). At the end of each year, a selection was shipped to the members so that they could personally select watercolors to the value of 900 RM. In addition, they received a special print at Christmas (fig. 7). As Otto Ralfs explains about the Klee-Gesellschaft: "Each member usually selected works on paper or pictures and then paid them off in regular installments to me, the purchases having to be paid off in 12 months. A few wealthy members paid the whole price in one sum. I collected all the payments and every month, regularly on the 1st of each month and always punctually on the 1st, I paid out a considerable sum to the artist, which he could count on. The money from the wealthy members, who had paid outright, I also apportioned for the monthly payments, for it was more important to receive as much as possible regularly every month than a lot at once and less later."[30]

In December 1925 Bode acquired *Strings* (cat. no. 93) and *Small Blue* (HL 150) through the Kandinsky-Gesellschaft and Ibach and Stinnes each selected two watercolors. The following year Stinnes acquired *Dream Motion* of 1923 (cat. no. 78), Ralfs chose *Zigzag* of 1926 (cat. no.

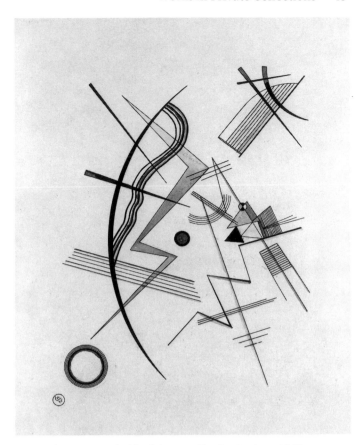

7 Members' annual gift of the Kandinsky Society, 1925. Colored lithograph. The Hilla von Rebay Foundation

109), and Vowinckel selected *Loose Attachment* (HL 202). Heinrich Bode (1900-77), a friend of Ralfs,[31] was also active in the Kestner-Gesellschaft in Hanover. Rudolf Ibach (1873-1940) was president of the Art Association [Kunstverein] in Barmen from 1921 to 1937 and a member of the Association of Friends of Art [Verein der Kunstfreunde] in Barmen. His family's firm manufactured pianos and, like his father, he was active in the Ruhmeshalle Art Association.[32] Dr. Heinrich Stinnes (1867-1932), who was a senior civil servant in Cologne, owned one of the largest collections of graphics and rare books in Germany in the twenties, which was however dispersed by 1938. Werner Vowinckel (1896-1943) was a partner in the firm of G. Vowinckel in Cologne until 1937, and collected many works by Klee as well as Kandinsky (cat. no. 130). In 1927/28 Ralfs acquired *Semicircle* (cat. no. 112) through the Kandinsky-Gesellschaft and Ibach selected *Small Pictures* (cat. no. 110) as well as *Zigzag Upward* (cat. no. 119).

Kandinsky's one-man show at the Galerie Zak in Paris in January 1929 included loans from four members of the Gesellschaft. Kirchhoff lent *Square in Circle* (cat. no. 114), Ibach gave *Zigzag Upward*, and Stinnes and Schridde each lent two recent watercolors. Later that year, in a letter to Kandinsky dated December 23, 1929, Ralfs writes: "The watercolor shipment has been forwarded by Mr. Ibach without his having looked at them." Because of difficulties with his business, Ibach could not choose any works, but

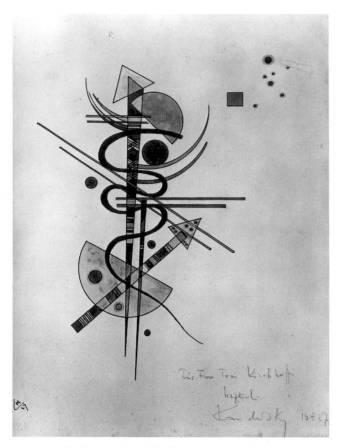

8 *Watercolor for Toni Kirchhoff,* 1927. Watercolor on paper.
Private collection

hoped to be able to remain a member.[33] "…The shipment is with Dr. Stinnes in Cologne just now, after Mr. Stinnes it must go to Mr. Voigt in Dresden, to Mr. Schridde in Dortmund, to Mr. Kirchhoff in Wiesbaden, and to Mr. Doetsch-Benziger in Basle…. I have not yet heard from the two gentlemen in Breslau whether and what they have selected." As of January 1, 1930, Stinnes had 1370 RM in his account and Vowinckel 605 RM.[34] Both Kirchhoff and Doetsch-Benziger had balances over 2000 RM, but Ibach and Voigt had to resign from the Gesellschaft for lack of funds. The two collectors from Breslau, Rothenberg and Hartmann, did not participate very actively and made only small contributions.

Although little is known about either Rothenberg or Hartmann, Kirchhoff and Doetsch-Benziger possessed renowned collections. Heinrich Kirchhoff (1875-1934) lent works by several modern artists, including Kandinsky and Jawlensky, to the Museum Wiesbaden, where he was active in establishing a Kandinsky room.[35] Ralfs got to know Kirchhoff after his father went to Wiesbaden for a cure and saw Kirchhoff's collection, which contained works by many of the same artists that his son collected.[36] Kandinsky was also in contact with Kirchhoff and his wife (fig. 8). Originally from Essen-Rüttenscheid, Kirchhoff managed the family building firm and apparently knew Schridde. Dr. Hermann Schridde (1875-1946) was director of the Institute of Pathology in Dortmund, where he had in 1920 founded the Research Institute for Histopatholo-

gy and Traumatology.[37] Richard Doetsch-Benziger (1877-1958), who was born in the Rheinland but after 1905 lived in Basle, traveled frequently on business to Munich and Berlin, where he became familiar with modern art.[38] In 1931 he selected *Restrained* (cat. no. 131) and *Rows of Signs* (HL 442). The same year, Baier acquired *Shallow Depth* (HL 412) and Kirchhoff selected *Angular* (HL 425). In addition to Kandinsky's art, Doetsch-Benziger collected the work of Klee, Feininger, and other German artists; moreover, he sought to become personally acquainted with the artists. Nina and Vasily Kandinsky visited Doetsch-Benziger in Basle in December 1933, just before they moved to Paris.[39]

As the economic situation in Germany deteriorated in the 1930s, many members had to drop out of the Gesellschaft. On March 15, 1932, Ralfs wrote to Kandinsky: "Prof. Schridde has resigned because his salary has been cut three times." Doetsch-Benziger acquired two watercolors in January 1933 and Bienert selected one in November 1933. She wrote to Kandinsky at the time: "I have now had here your big shipment from the K. Society for this year, or rather I still have it; it should be sent on tomorrow. Marvelous works from a rich oeuvre."[40] Ida Bienert (1870-1965) and her husband Erwin, who was a wealthy industrialist in Dresden, formed a large collection of avantgarde art with works by Kandinsky (cat. no. 141), Klee, El Lissitzky, Malevich, Moholy-Nagy, and Mondrian. Their son Fritz also collected (cat. no. 132); he was married to the dancer Gret Palucca, who knew Kandinsky. The Ralfses were also good friends of the Bienerts.[41]

After December 1933 the Gesellschaft could no longer function as before and, of course, Kandinsky no longer lived in Germany. By March 1934 Doetsch-Benziger was sending his monthly payments direct to the artist in Paris rather than to Ralfs in Germany. In November 1934 Vowinckel had to reduce his payments to 25 RM per month, and both he and Baier informed Ralfs that they did not need to have works sent that year. Kandinsky gave a drawing with a dedication to Doetsch-Benziger on January 1, 1935 (cat. no. 153). Ralfs himself had suffered financial losses in 1931 when his iron merchants firm in Braunschweig went out of business, and he had begun to work as branch manager for the Bleichröder insurance agency in Hamburg the following year.

Since virtually all of the German collectors could no longer contribute, Ralfs wrote at the beginning of 1935 to several collectors in Switzerland – including Hermann Rupf in Berne – and to Solomon R. Guggenheim in New York. In a letter dated January 28, 1935, Ralfs explains to Guggenheim: "As you know, Kandinsky had to leave Germany a year ago as he no longer had the possibility of exhibiting in Germany, and most of all as certain sectors abroad were not accepting for exhibition pictures that came from Germany. Kandinsky therefore moved temporarily to Paris, where he is at present working extremely successfully and well, as his latest exhibitions in Paris and Milan have shown. Due to the economic and political

situation, the K[andinsky] Soc[iety] has shrunk so much that successful functioning no longer appears possible …. I would approach you with the humble request whether you are willing to become a member of the K. Soc. in order to assist this great artist and to provide him with the opportunities to continue working successfully."[42] In spite of Ralfs's plea that "for you, too, it will be a proud and fine feeling to belong to the K. Soc. now of all times, to further the work of one of our greatest artists of our day," both Rupf and Guggenheim responded negatively to the invitation. At the beginning of 1935 Kandinsky gave *Sonorous* of 1928 (cat. no. 125) to Rupf; he gave *Development* of 1932 (cat. no. 140) to Hilla Rebay on July 27.

Hilla Rebay first met Kandinsky probably in late July 1929, when she brought Solomon and Irene Guggenheim to visit the artist in Dessau.[43] At that time Guggenheim purchased a major oil painting, *Composition VIII* of 1923, from the artist's studio. Although she had not met Kandinsky before, Rebay had expressed the wish to do so in her letters since 1918. She had known Kandinsky's work even earlier, and her close friend Hans Arp undoubtedly encouraged her interest. A German-born artist, Rebay (1890-1967) exhibited her own work at Walden's gallery Der Sturm in Berlin and probably acquired a 1913 Kandinsky watercolor (cat. no. 20) from him in 1916. Guggenheim and Rebay corresponded with Kandinsky from 1929 to 1938. In 1935/36 they purchased seven important paintings and numerous watercolors and gouaches from the artist during their trips to Paris. In August 1935 Guggenheim acquired *Balancing Act* and *Accompanied Contrast*, which had been shown at Cahiers d'Art in Paris, and the following summer he purchased three canvases from the artist. In May 1936 Rebay acquired five watercolors, including *Grids* (fig. 9). Like Arthur Jerome Eddy, Guggenheim and Rebay preferred to buy from the artist himself rather than from a dealer.

Recognition and Disappointment in France

Several years earlier, in 1929, Mme. Zak had given Kandinsky his first one-man show in Paris at her gallery.[44] It was then that André Breton acquired *Small White* (HL 267) and *Subdued Glow* (cat. no. 120). The collector Alphonse Kann also bought two watercolors, and André Level and E. Tériade were among the French dealers and critics who selected works. Christian Zervos bought *A Little Violet* (HL 315) and received as a gift *Violet Center* (HL 329). When Kandinsky moved to Paris at the end of 1933, he renewed his contacts with Zervos, who published the periodical *Cahiers d'Art* and whose wife Yvonne organized small exhibitions on the premises. Kandinsky first showed his work at Cahiers d'Art in May 1934, and again the following year. The artist gave Yvonne Zervos a 1934 painting, *Black Forms on White*, and a 1935 gouache, *Ascent in White* (cat. no. 156), in September 1935. Giuseppe Ghiringhelli organized an exhibition of Kandinsky's watercolors and drawings at the Galleria del Milione in

Milan in the spring of 1934; this generated considerable interest and led to purchases by private collectors in Italy (fig. 10). Kandinsky was discouraged by his reception in France and by the widespread difficulties in selling works of art. In a letter dated April 20, 1934, he writes to Galka Scheyer in California: "They are anything but optimistic in Paris today. But, despite the pessimism, I was strongly advised to move here, as 'collectors in other countries would certainly come to the aid of an artist who *had* to leave his country.' I now realize that this was 'idealistic optimism' and that the collectors couldn't care less about the artists' situation. In this case I even regret that nothing surprises me any more − it would certainly be more natural to be surprised."[45] On July 3, however, Kandinsky wrote to Scheyer: "The Milan exhibition went off with great success …. As I have heard from various people, the success of my Paris exhibition was extraordinary."

9 *Grids*, 1935. Gouache on black paper.
Solomon R. Guggenheim Museum, New York

10 *Pointed Silence,* 1933. Watercolor
on paper. Private collection

The conflict between recognition and growing disappointment can be discerned in the artist's letters from 1934-36. In December 1936 the Galerie Jeanne Bucher presented the first of three Kandinsky exhibitions. Through Mme. Bucher Kandinsky met André Dézarrois, director of the Musée Jeu de Paume, who prominently displayed his work in the exhibition "Origines et développement de l'art international indépendant" in Paris in the summer of 1937 and arranged for the acquisition of a gouache, *The White Line* (cat. no. 157), and an important painting, *Composition IX,* by the French Musées Nationaux. Also in July 1937, the "Degenerate Art" (Entartete Kunst) exhibition opened in Munich, which definitively ended the possibilities of showing or selling in Germany during the artist's lifetime. Throughout the thirties Kandinsky stayed in touch with Rupf, Doetsch-Benziger, and other collectors in Switzerland who acquired his art (cat. nos. 19, 125, 131, 152, 164), and in 1937 the Kunstmuseum Berne presented a one-man show. Kandinsky participated in a large exhibition of modern art in Copenhagen in September 1937, in conjunction with which the sponsors published a special issue of the magazine *Linien;* the artist sold *Checkered* of 1925 (cat. no. 106) to Robert Olsen and gave *Acentric* (HL 182) to Bjerke Petersen the following year. In a letter dated October 14, 1936, to Hermann Rupf in Berne Kandinsky states: "I have the persistent impression that all countries are slowly but surely closing off the channels of action more and more. So now France is starting, too. In Germany things have come to a complete standstill, however small the amounts one has to pay someone."

Increasingly, Kandinsky looked outside of France for support. J. B. Neumann (1887-1961), who had moved from Berlin to New York in 1923, became his representative on the East Coast of the United States and Karl Nierendorf (1889-1947) was also active in organizing exhibitions at his New York gallery and in attempting to sell his works. Although Rebay's relations with Kandinsky were strained after 1937,[46] she continued to buy his work from Nierendorf or Neumann (cat. nos. 94, 102, 105, 118, 123, 126, 134, 136). Kandinsky turned to these two and to Galka Scheyer in the hope that they could sell pictures to wealthy collectors. On December 1, 1937, he wrote to Scheyer: "I am unfortunately obliged to think about new 'markets'. In Europe they have become too stagnant, in the USA the circle of collectors is fairly limited – nobody knows if and when it will expand. So one is forced to look at still untouched territories. One of these, as far as I can see, is for instance Mexico. What do you say to that? After all, Diego di Rivera lives there, and he used to value my painting [fig. 11] …. I already have a collector there. I should like to take this opportunity of asking you to let me know the name of this collector – I didn't make a note of it when you told me his name once before, and I need it for my Handlist." In letters Kandinsky had expressed his expectation that American collectors would buy his pictures and his incomprehension that the economic crisis in the States had affected the art market to such a degree.

The Second World War

During the Second World War, of course, Kandinsky's contacts abroad were limited.[47] He corresponded with Rupf, Nierendorf, Neumann, and Scheyer in French around 1940, although he continued to write letters in German to Grohmann in Dresden up to the end of 1943. Kandinsky also wrote to the judge Pierre Bruguière in Tours, who collected the work of several artists he knew (cat. nos. 173, 175). Because of the Occupation, Kandinsky's 1942 exhibition was held clandestinely at the Galerie Jeanne Bucher during the summer. In his letter to

11 *Heavy Plane,* 1928. Watercolor on paper. Private collection

12 *Concentrated,* 1937. Gouache on black paper. Private collection

Bruguière of October 16, 1942, he writes of the exhibition: "No, it was not bad at all and I can't complain about the success – not great, but not bad."[48] In Paris he had few visitors and his circle of friends included primarily non-French artists: Hans Arp, Sophie Täuber-Arp, and Alberto Magnelli (cat. no. 133). During the war, however, two Germans, Helmut Beck of Stuttgart and Dr. Hans Lühdorf of Dusseldorf, bought works from the artist in Paris (cat. nos. 67, 154).

Kandinsky's Handlists record the names of the people who acquired his paintings and watercolors during the war years: Mme. Bucher, Fernand Graindorge (cat. no. 160), Dr. Hermann, Mme. Korzenowska (fig. 12), Mme. San Lazzaro (cat. no. 187), Mme. Lecoutoure (cat. nos. 178, 180). Noëlle Lecoutoure and Marcel Panier managed the Galerie L'Esquisse, which presented the last exhibition during the artist's lifetime. On January 31, 1941, when his work was included in a group show at the Galerie Jeanne Bucher, Kandinsky wrote to Pierre Bruguière: "Madame Bucher is very pleased with the moral success, but regrets the lack of sales." To Galka Scheyer he often wrote about money and asked to be paid in dollars. In his last letter to Scheyer, which is dated June 3, 1940, Kandinsky is particularly annoyed that the American collector Mrs. Walter Maitland has not purchased a watercolor: "To take 3 watercolors on approval and not to be able to make up one's mind to buy a single one – I find that incredible, a hundred dollars or so is really 'small change' for the Americans, particularly if they are fairly (or very!) rich. In Paris I have sold several aq. and a small canvas *during* the war. It's not much to live on, but the very facts of the purchases are significant for our poor Europe in flames. What do you say to 'excuse' your fellow-countrymen? It's

no wonder that neither my wife nor I feel like going to America, that land of 'big talkers', of outer warmth and inner coldness."[49]

As his opportunities became fewer, Kandinsky again hoped that a private collector or someone in another country would come to his rescue. He had, of course, placed such hope (but to no avail) in two other Americans, Arthur Jerome Eddy in 1914 and Solomon R. Guggenheim in the mid-1930s. The artist's longing for an understanding group of supporters had been fulfilled only by the Kandinsky-Gesellschaft. Kandinsky's letters to friends in the late thirties and early forties express great sadness for Europe. There is a sense of isolation and of disbelief. As he wrote to Hermann Rupf on October 28, 1939: "And the times are very unfavorable for the art market – this damned insecurity. Still, sales in Lucerne were not bad – I mean the 'degenerates'. Such an opportunity however occurs seldom (fortunately), and it had to be seized. There was none of my work in Lucerne, since, as an art dealer told me, all my pictures from the German museums had already been disposed of. He got this information when he was trying to acquire something by me from the museums. To my special pleasure, my large picture *Several Circles* from the Dresden Staatsgalerie is already in an Amer[ican] collection. I really treasure this picture and was rather afraid that it might be destroyed or damaged. The unpleasant side of this business is that it has brought us too much competition. The competition as regards the German collectors would be quite enough. These poor people, who built up their collections with much love and often with sacrifices, are forced to sell, you know, unless they are unusually courageous. Where is this madness going to end? And when?"[50]

1 N. B. Avtonomova, "Kandinsky in sowjetischen Sammlungen", and V. E. Barnett, "Kandinsky in den grossen Sammlungen des Westens", in *Wassily Kandinsky: Die erste sowjetische Retrospektive,* exh. cat. Schirn Kunsthalle, Frankfurt am Main 1989, pp. 32-34, 55-58.

2 For information on the works mentioned, see Vivian Endicott Barnett, *Kandinsky Watercolours: Catalogue Raisonné,* vol. 1, *1900-1921,* London 1992, nos. 18, 36-38, 66, 79, 191, 194, 203.

3 Hans K. Roethel and Jean K. Benjamin, *Kandinsky: Catalogue Raisonné of the Oil Paintings,* vol. 1, *1900-1915,* London 1982, p. 21.

4 *Der Blaue Reiter,* exh. cat. Kunstmuseum, Berne 1986, and Rosel Gollek, *Der Blaue Reiter im Lenbachhaus München,* Munich 1982, pp. 388-413.

5 Hans Konrad Roethel, *Bernhard Koehler Stiftung,* exh. cat. Städtische Galerie im Lenbachhaus, Munich 1965.

6 Michael Sadleir, *Michael Ernest Sadler: A Memoir by His Son,* London 1949, pp. 237-239.

7 Kandinsky's first one-man show had taken place at the Galerie Krause in Barerstrasse, Munich, in February/March 1905 and traveled to Paul Cassirer in Berlin and Hamburg and to Eduard Schulte in Dusseldorf and Cologne.

8 Walden's papers are preserved in the Sturm-Archiv, Staatsbibliothek Preussischer Kulturbesitz (Handschriften-Abteilung), Berlin.

9 Arthur Jerome Eddy, *Cubists and Post-Impressionism,* Chicago 1914, p. 116.

10 Letter preserved in the Fonds Kandinsky, Musée National d'Art Moderne, Centre Georges Pompidou, Paris.

11 See note 9, p. 126.

12 Unless indicated otherwise, the letters from Eddy to Kandinsky are in the Gabriele Münter- und Johannes Eichner-Stiftung, Munich. I am grateful to Ilse Holzinger for her help.

13 Letter from Kandinsky to Münter dated December 30, 1916 (Münter/Eichner-Stiftung).

14 Klaus Lankheit (ed.), *Wassily Kandinsky – Franz Marc Briefwechsel,* Munich 1983, pp. 233, 236-237.

15 I am grateful to Sonja Bay for her research on the Dutch collectors who owned works by Kandinsky.

16 Korrespondenzarchiv of the Germanisches Nationalmuseum, Nuremberg (Journal nos. 4939,2 and 5072).

17 Vivian Endicott Barnett, *Kandinsky and Sweden,* Malmö and Stockholm 1989, pp. 7-37.

18 See note 17, pp. 40-43.

19 Münter's draft of the letter is in the Münter/Eichner-Stiftung; the letter sent to Eddy probably no longer exists.

20 The letters to Dr. Bjerre are preserved in the Handskriftssektion of the Kungliga Biblioteket, Stockholm.

21 Nell Walden, *Herwarth Walden: Ein Lebensbild,* Berlin and Mainz 1965, pp. 24-25.

22 The papers of Katherine S. Dreier, which are kept in the Beinecke Library at Yale University, New Haven, include a document dated October 18, 1922, regarding the sale of the works.

23 Peg Weiss, "Foreword", in *The Blue Four,* exh. cat. Leonard Hutton Galleries, New York 1984, pp. 8-10. Dr. Weiss has kindly confirmed this information.

24 Peter Lufft, *Das Gästebuch Otto Ralfs,* Braunschweig 1985, p. 83, ill. See also pp. 21-22, 25.

25 The papers of Otto Ralfs are in the Stadtarchiv, Braunschweig (H VIII A Nr. 40r4a). His reminiscences of the Klee and Kandinsky Societies date from 1952.

26 Stefan Frey has generously provided new information about the Klee Society. See also Stefan Frey and Wolfgang Kersten, "Paul Klees geschäftliche Verbindung zur Galerie Alfred Flechtheim", in *Alfred Flechtheim: Sammler, Kunsthändler, Verleger,* exh. cat. Kunstmuseum, Dusseldorf 1986, pp. 75-76.

27 I am most grateful to Käte Ralfs for her assistance with my research (personal communications 1988, 1991).

28 The Grohmann-Archiv is in the Staatsgalerie, Stuttgart.

29 Hans Konrad Roethel, *Kandinsky: Das graphische Werk,* Cologne 1970, p. 455, lists nine members: Bienert, Doetsch-Benziger, Ibach, Kirchhoff, Ralfs, Rothenberg, Schridde, Stinnes, and Vowinckel. See also Magdalena Droste, "'... du liebe kunstpolitik!': Kandinskys Ausstellungen und seine Verkäufe während der zwanziger Jahre in Deutschland", in *Kandinsky: Russische Zeit und Bauhausjahre 1915-1933,* exh. cat. Berlin 1984, pp. 66-71.

30 See note 25.

31 See note 27.

32 I am grateful to Dirk Luckow of Dusseldorf for assisting me with research and finding biographical information on the German collectors who were members of the Kandinsky Society.

33 The correspondence with Ralfs and other members of the Society belongs to the Fonds Kandinsky, Musée National d'Art Moderne, Paris, where Jessica Boissel kindly assisted my research.

34 This and the following information comes from Ralfs's letter to Kandinsky dated January 30, 1930, and his letter to Nina Kandinsky dated February 6, 1930 (Fonds Kandinsky).

35 Ulrich Schmidt, "Heinrich Kirchhoff – ein Schrittmacher moderner Kunst", *Kunst in Hessen und am Mittelrhein* 22 (1982), pp. 95-100.

36 See note 27.

37 See note 32.

38 See *Katalog der Sammlung Richard Doetsch-Benziger,* Basle, 1956.

39 See letter from Kandinsky to Doetsch-Benziger dated December 5, 1933, and letter from Doetsch-Benziger to Kandinsky dated December 29, 1933. The correspondence between artist and collector is in the Fonds Kandinsky, Musée National d'Art Moderne, Paris.

40 Letter from Ida Bienert to the artist dated November 20, 1933 (Fonds Kandinsky).

41 Seen note 27. For information on the Bienert collection, see Will Grohmann, *Die Sammlung Ida Bienert Dresden,* Potsdam 1933, and Fritz Löffler, "Ida Bienert und ihre Sammlung", in *Literatur und Kunst in der Gegenwart,* Jahresring 71/72, Stuttgart 1971, pp. 187-197.

42 The correspondence from Ralfs to Guggenheim is in the Hilla von Rebay Foundation Archive, which is deposited at the Solomon R. Guggenheim Museum, New York. Stefan Frey kindly brought to my attention Ralfs's letter to Rupf dated January 25, 1930, and Rupf's reply dated January 30. The Rupf correspondence is preserved in the Kunstmuseum, Berne. In the Fonds Kandinsky there is a copy of the same letter to a Dr. Friedrich in Zurich.

43 Joan M. Lukach, *Hilla Rebay: In Search of the Spirit in Art,* New York 1983, pp. 55-56.

44 Among the watercolors exhibited at the Galerie Zak were nos. 114, 115, 116, 119, 120, 121, and 122 in the present catalogue.

45 The correspondence between Galka Scheyer and Kandinsky and the other artists of the Blue Four is in the Norton Simon Museum, Pasadena, California. The letters cited are also available on microfilm through the Archives of American Art. Peg Weiss is preparing a book on Scheyer's correspondence with the Blue Four.

46 See note 43, pp. 114-117. Kandinsky also had serious disagreements with Zervos in 1937: see Christian Derouet and Jessica Boissel, *Kandinsky: Œuvres de Vassily Kandinsky (1866-1944),* Paris 1984, p. 358.

47 Christian Derouet, "Kandinsky in Paris: 1934-1944", in *Kandinsky in Paris: 1934-1944,* exh. cat. Solomon R. Guggenheim Museum, New York 1985, pp. 12-60.

48 Christian Derouet, "Vassily Kandinsky: notes et documents sur les dernières années du peintre", *Cahiers du Musée National d'Art Moderne,* no. 9, Paris 1982, p. 96.

49 In earlier letters to Scheyer, Kandinsky had expressed interest in taking a trip to the United States to see New York and Hollywood. In May 1941 Varian Fry at the Centre Américain de Secours in Marseille obtained visas for Nina and Vasily Kandinsky to go to the United States, but they declined the offer and remained in France.

50 Sandor Kuthy (ed.), "Kandinsky: Briefe an Hermann Rupf 1931-1943", *Berner Kunstmitteilungen,* no. 152/153, Berne 1974, p. 16. The painting *Several Circles,* which belongs to the Solomon R. Guggenheim Museum, New York, was purchased from Gutekunst & Klipstein in Berne in February 1939.

Plates

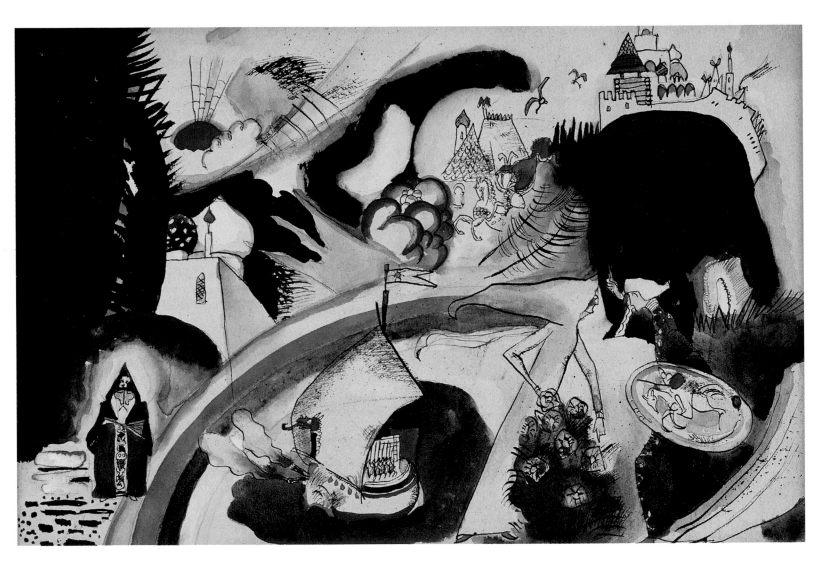

1 Watercolor for Kojève, c. 1910-12

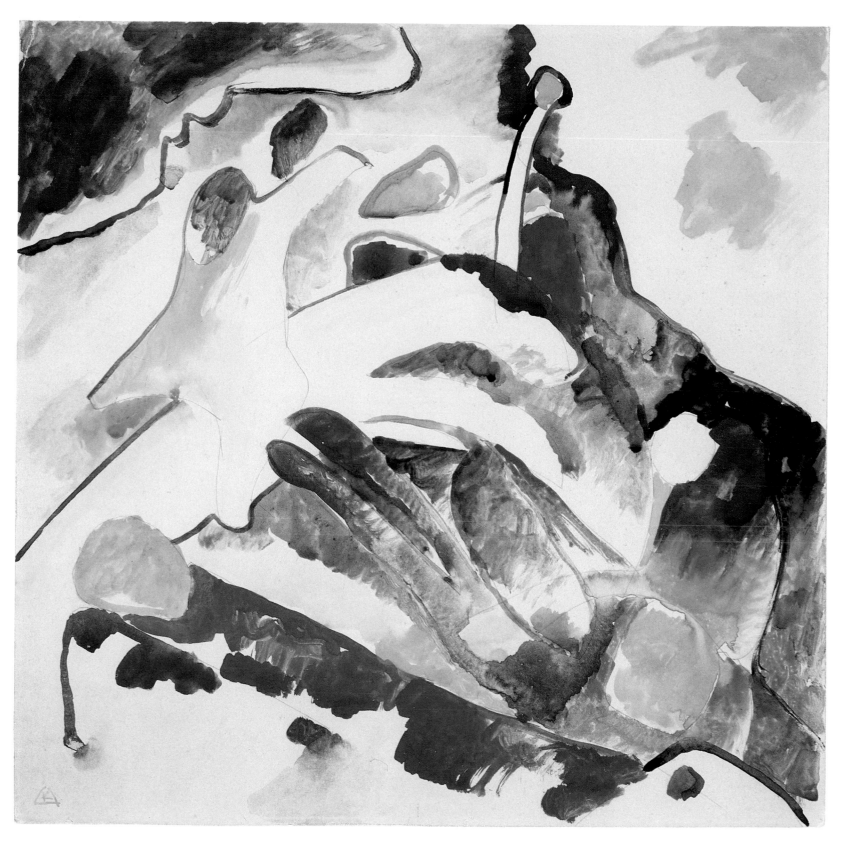

2 Study for "Composition II", c. 1910

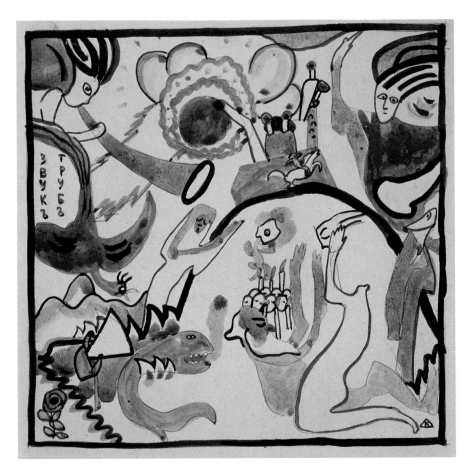

3 Sound of Trumpets (Large Resurrection), 1910/11

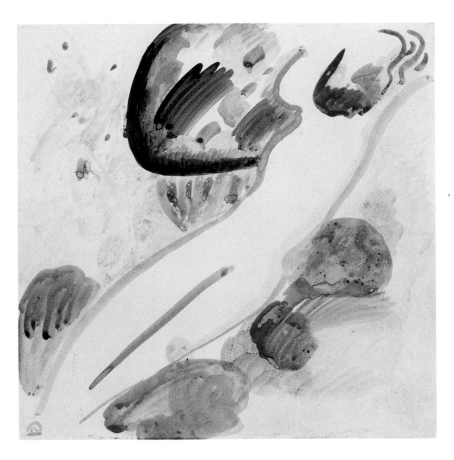

4 Nude, 1910/11

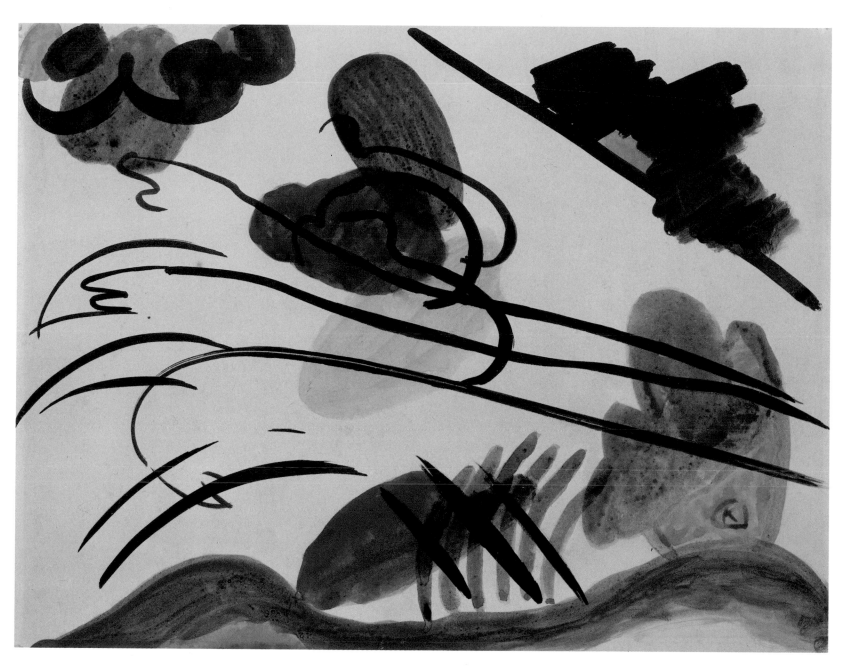

5 With Three Riders, 1910/11

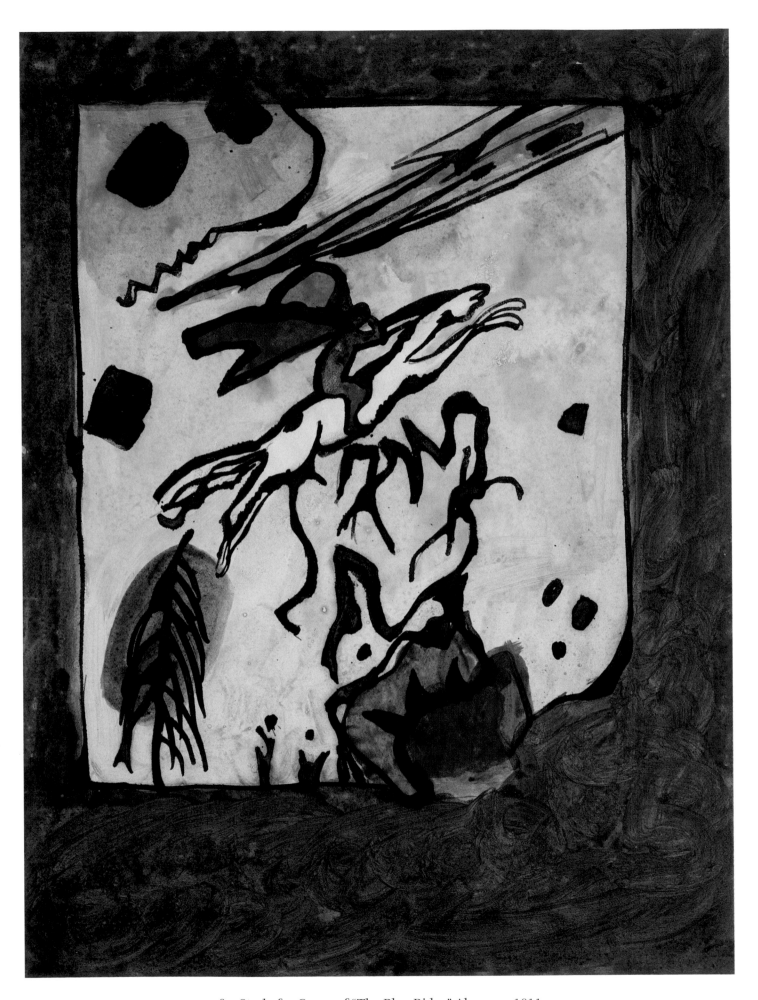

6 **Study for Cover of "The Blue Rider" Almanac,** 1911

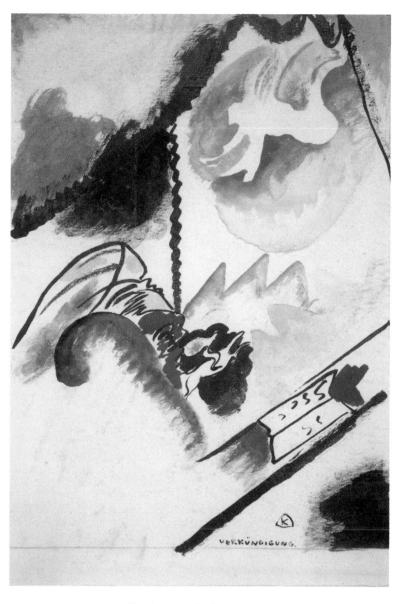

7 Annunciation, c. 1911

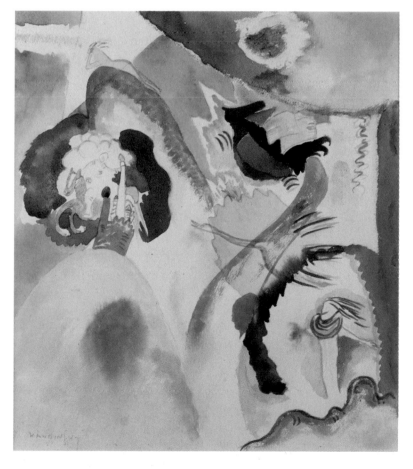

8 Announcement of the Blue Rider, 1911/12

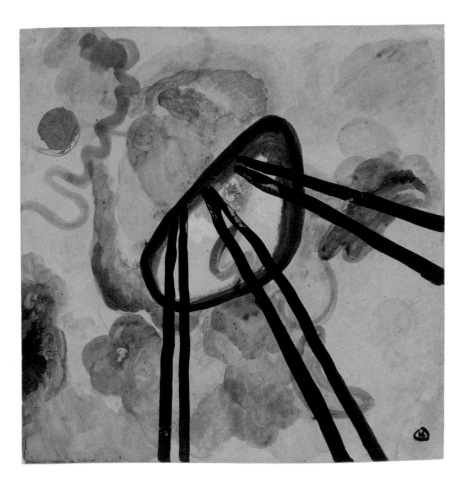

9 Boat, 1911/12

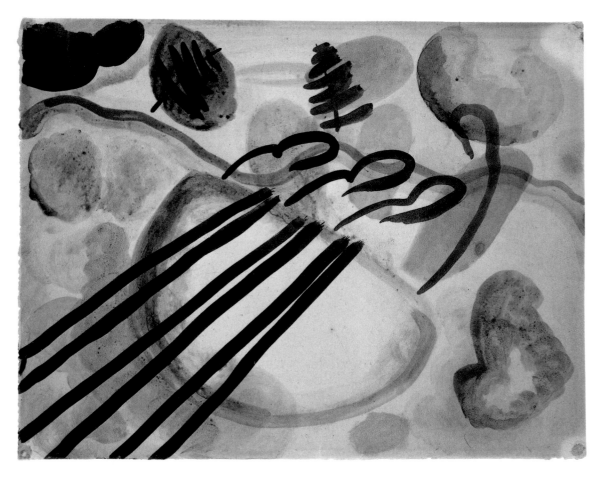

10 Study for "Improvisation 26 (Rowing)", 1911/12

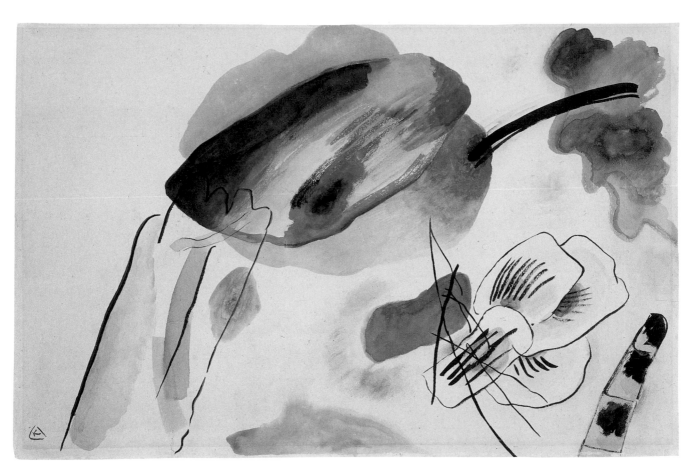

11 Untitled, 1911/12

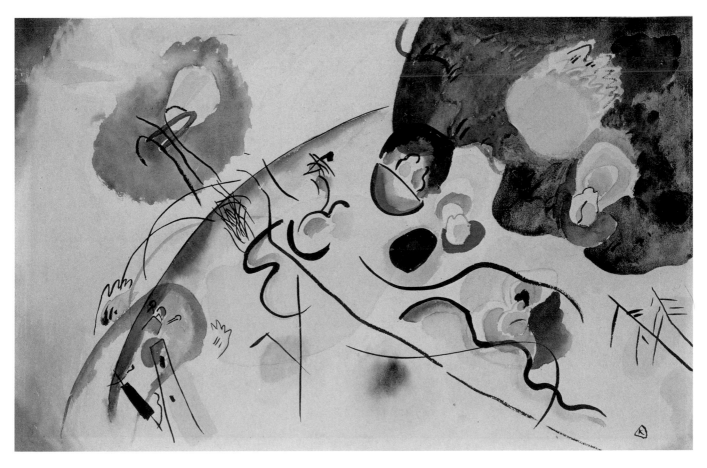

12 Untitled, 1911/12

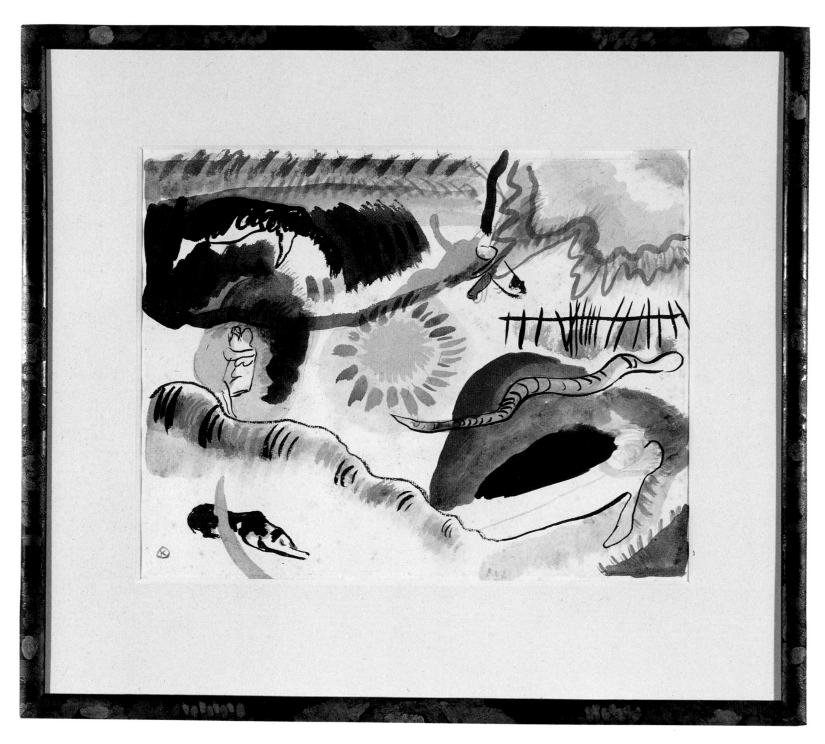

13 Watercolor No. 3 (Garden of Love), 1911/12

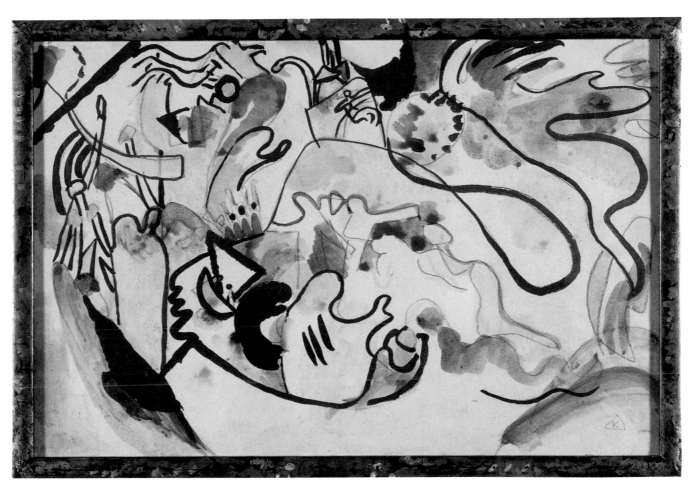

14 Watercolor No. 8 (Last Judgement), 1911/12

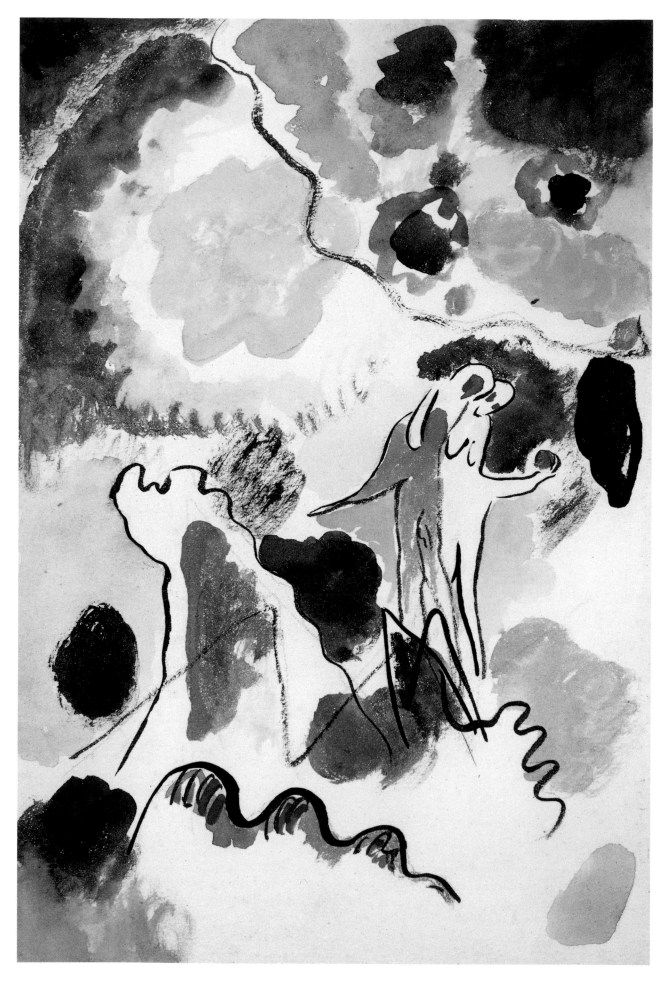

15 Paradise, 1911/12

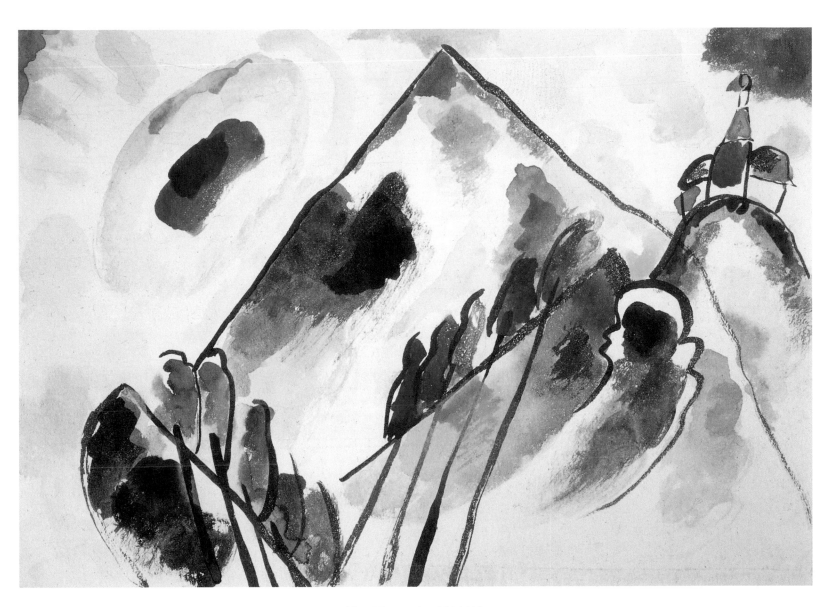

16 **Mountain**, 1911/12

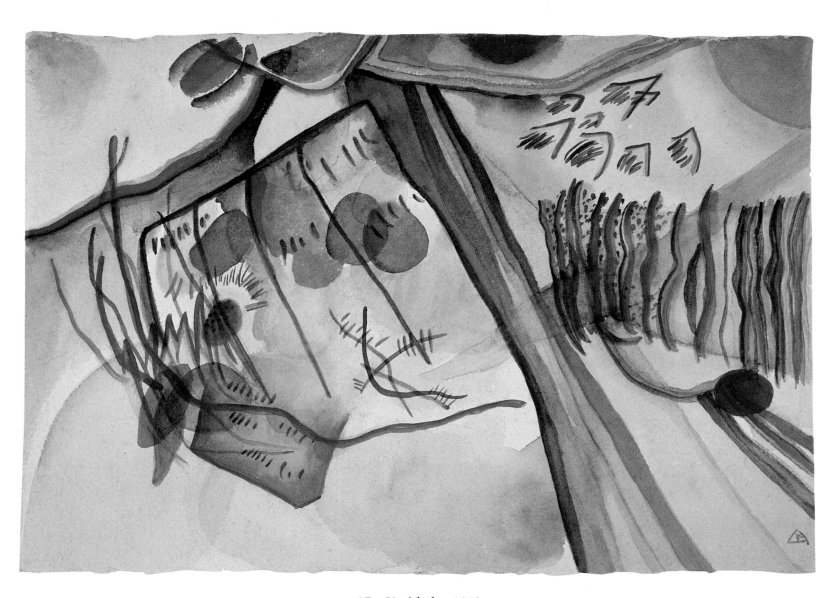

17 Untitled, c. 1912

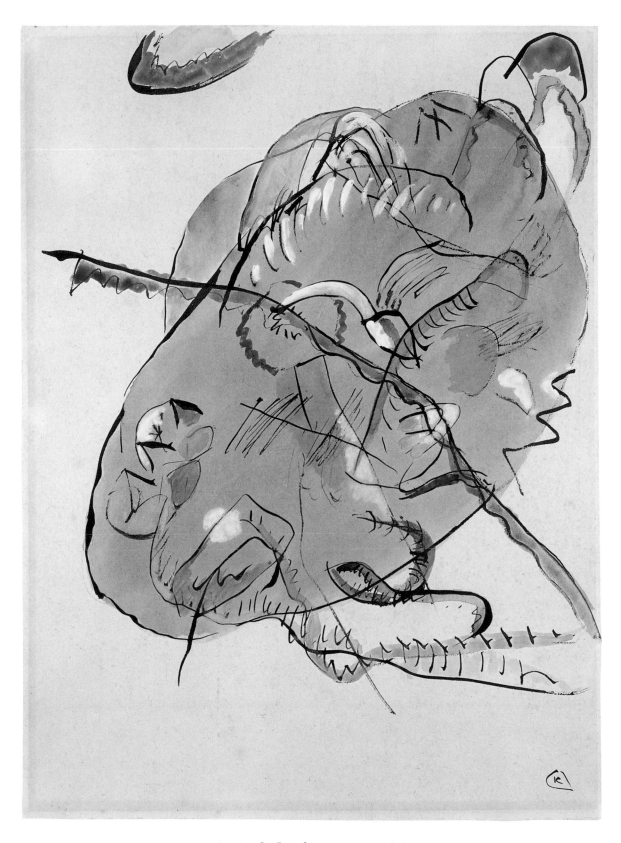

18 **Study for Blue Spot**, 1912/13

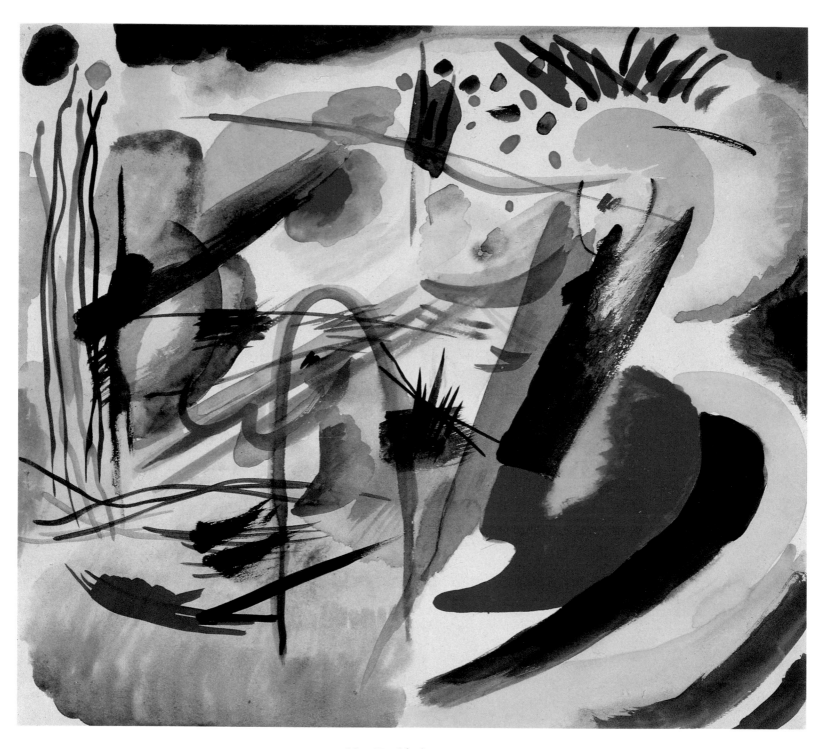

19 Untitled, 1912/13

20 Study for "Improvisation 34 (Orient II)", 1913

21 Drawing for "Painting with White Form", 1913

22 Study for "Painting with White Form", 1913

23 Study for "Painting with White Border", 1913

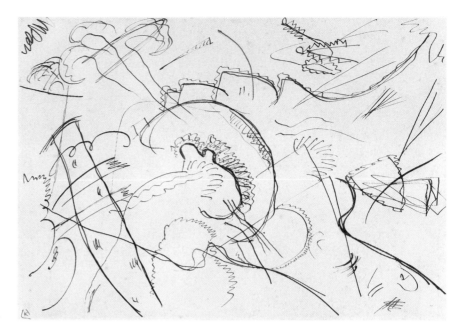

24 Study for "Painting with White Border", 1913

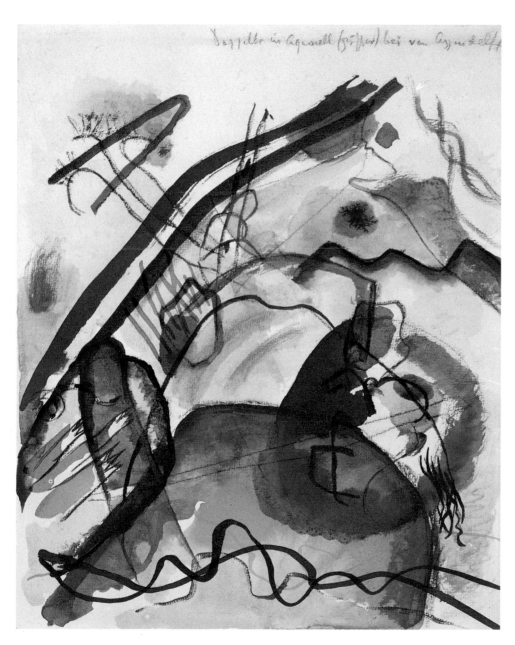

25 Study for "Painting with White Border", 1913

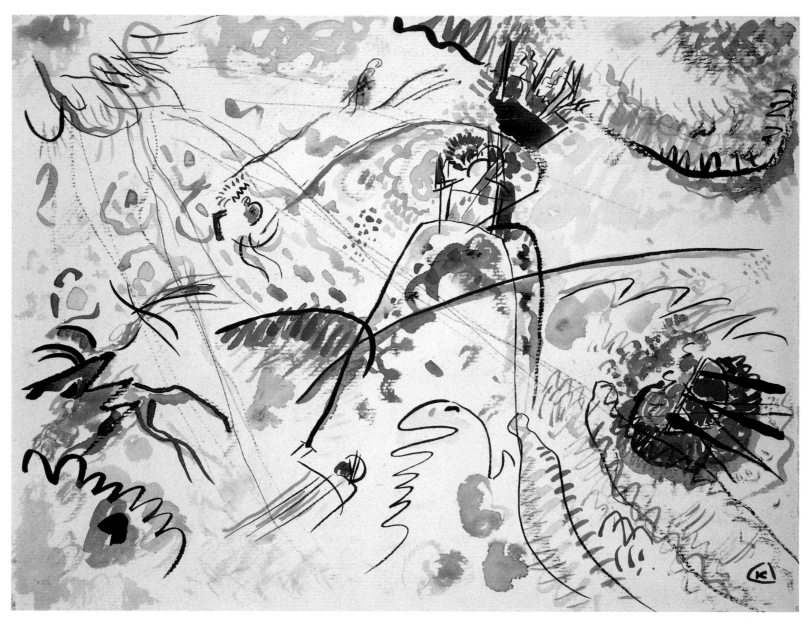

26 Study for "Small Pleasures", 1913

27 Study for "Small Pleasures", 1913

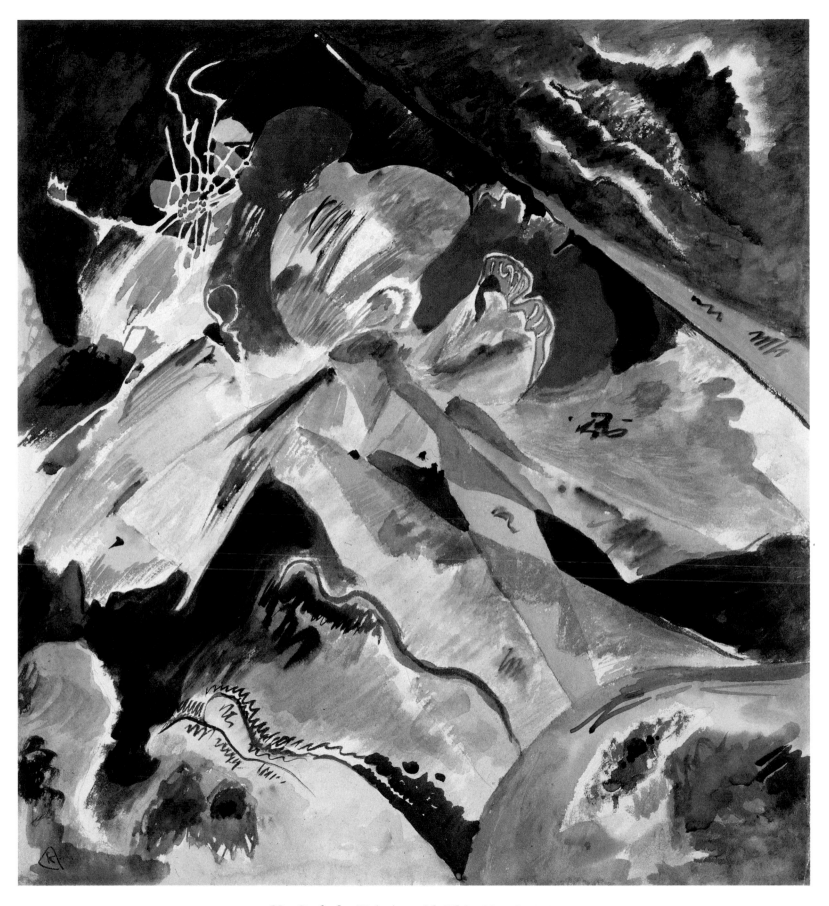

28 Study for "Painting with White Lines", 1913

29 Watercolor No. 13, 1913

30 Watercolor No. 14, 1913

31 Study for "Composition VII", 1913

32 Study for "Composition VII", 1913

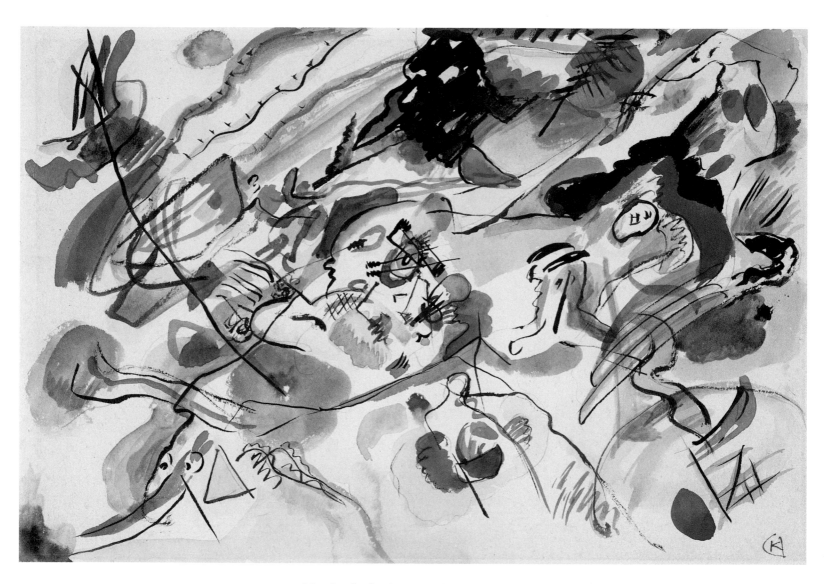

33 Study for "Composition VII", 1913

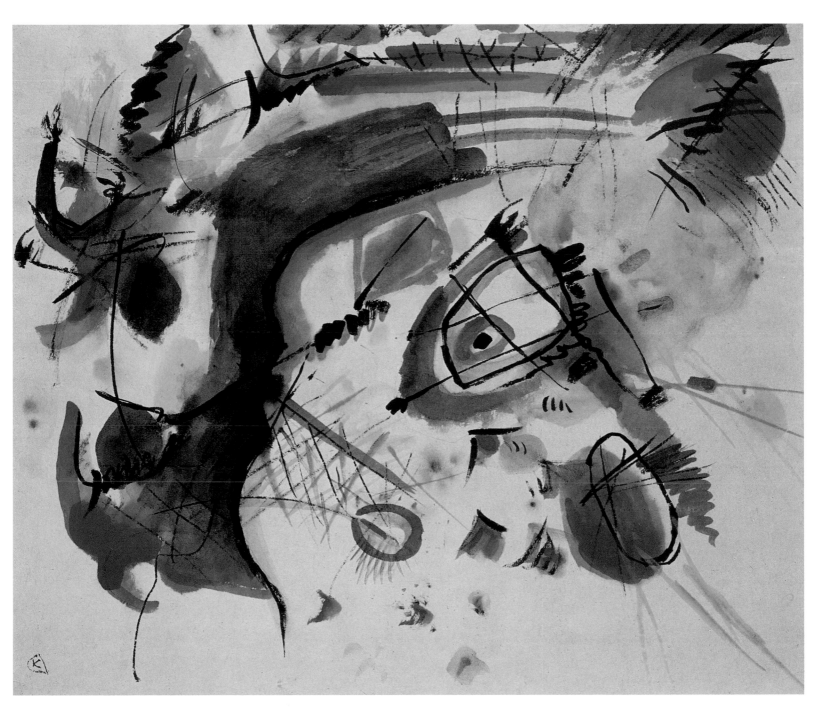

34 Study for "Composition VII", 1913

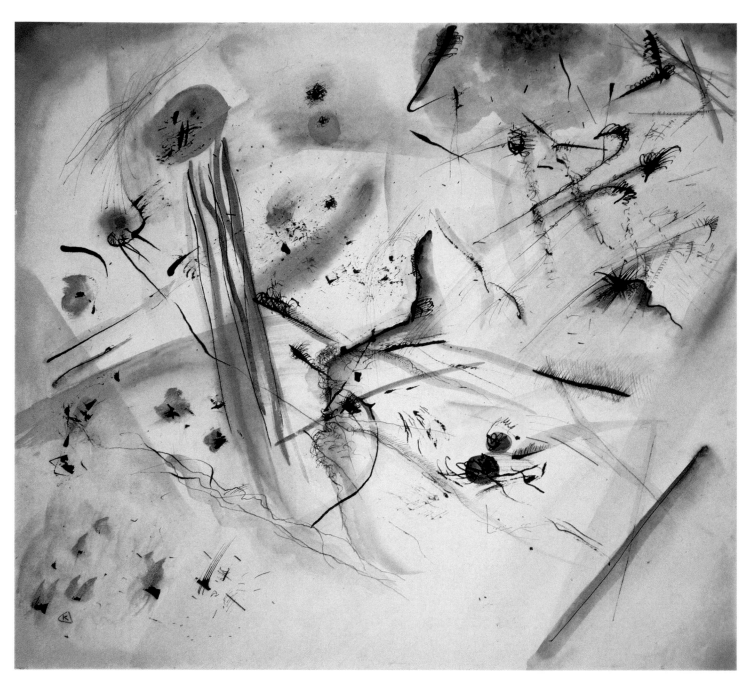

35 Watercolor with Red-Blue Stripes, 1913

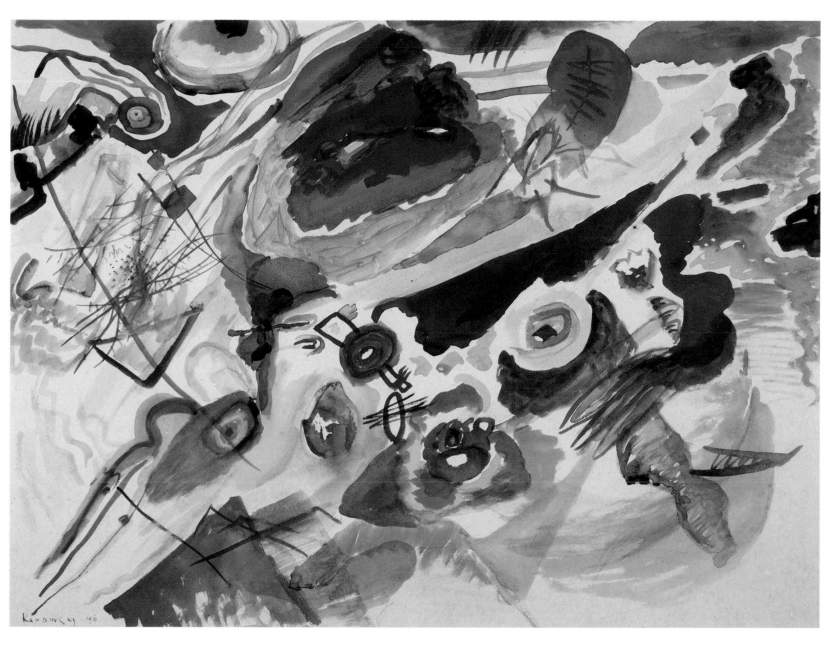

36 Watercolor with Red Spot, 1913

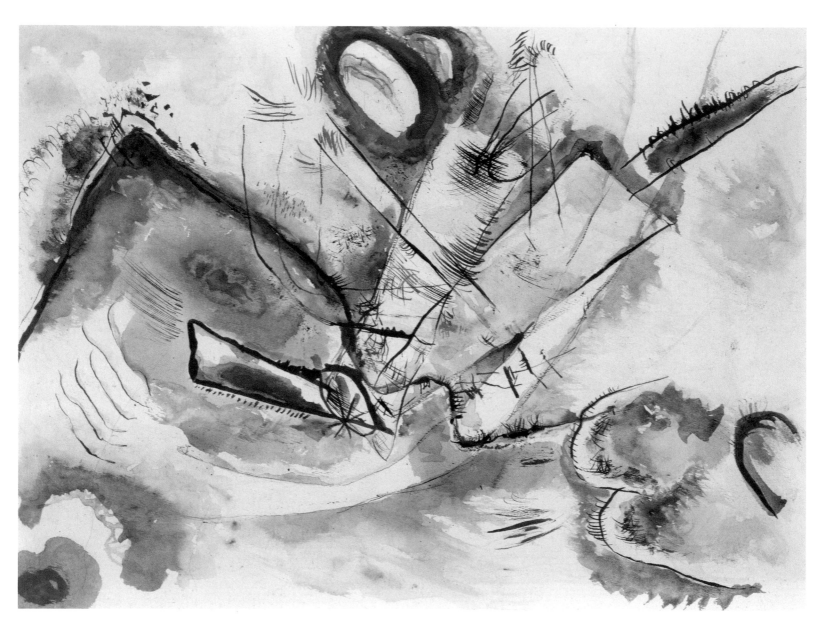

37 Untitled, c. 1914/15

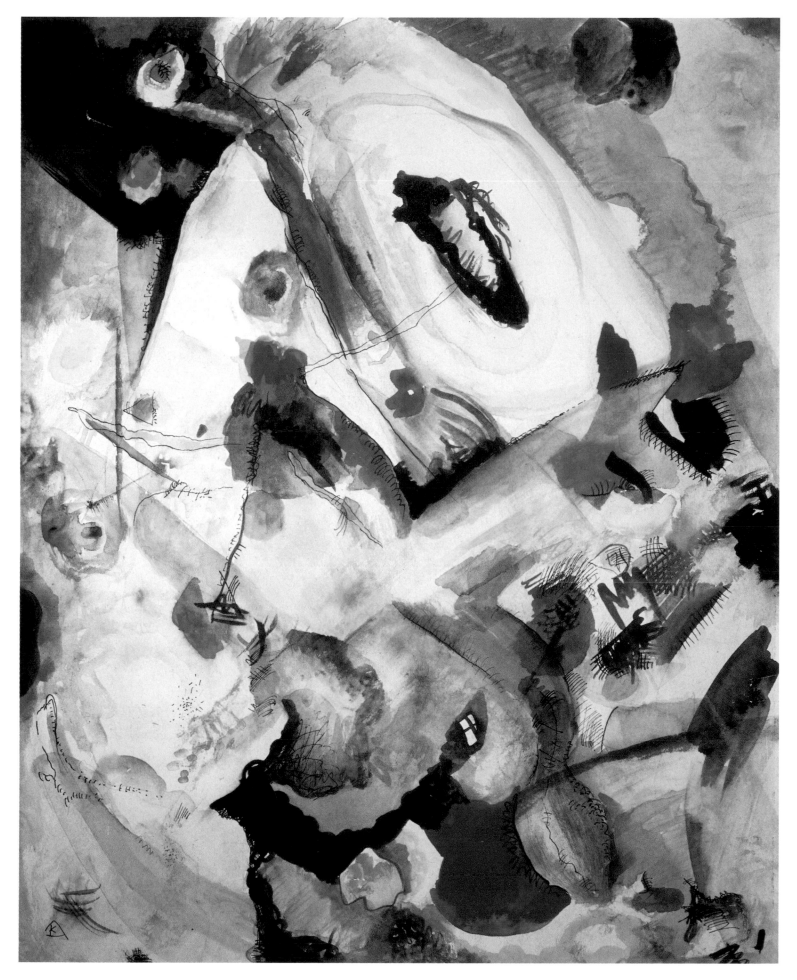

38 Untitled, 1913

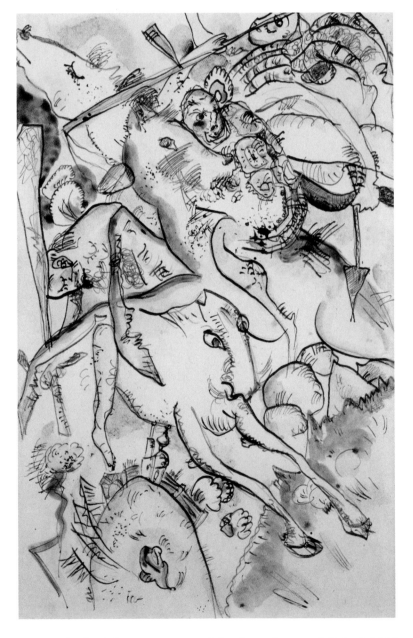

39 Drawing for "Improvisation with Red and Blue Ring", 1913

40 Study for "The Horsemen of the Apocalypse II", July 6, 1914

41 Untitled, 1915

42 Untitled, 1915

43 Untitled, 1915

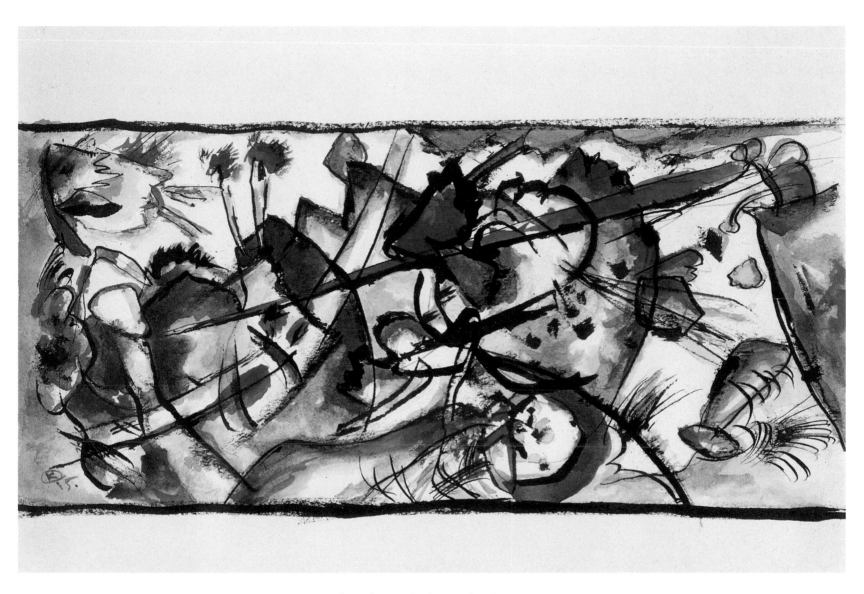

44 Watercolor after "Painting with White Border", 1915

45 Untitled, 1915

46 Untitled, 1915/16

47 **Untitled**, December 1915

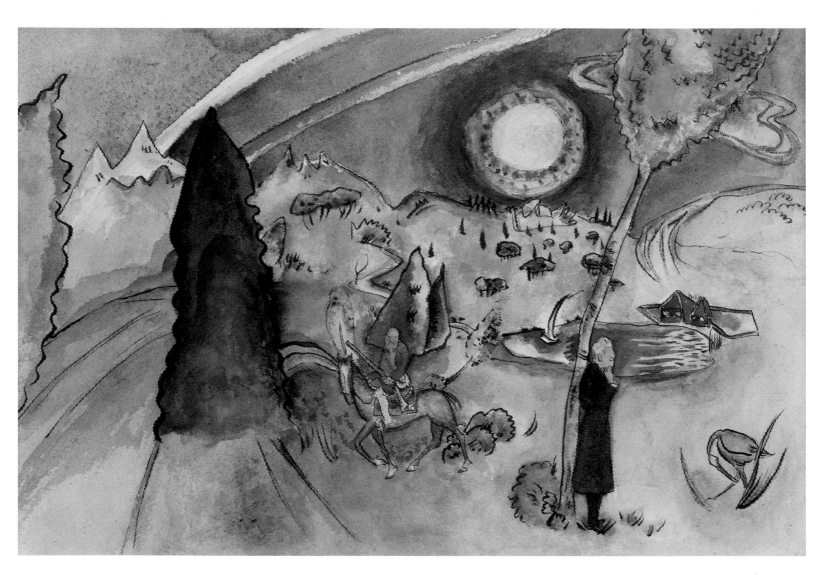

48 **Watercolor for Poul Bjerre**, March 1916

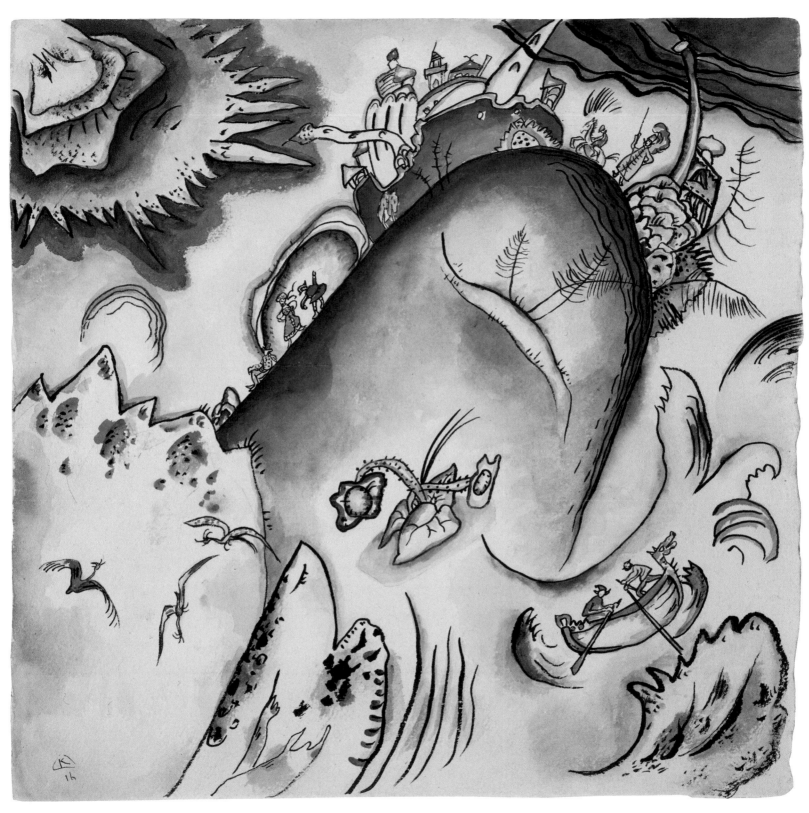

49 **Birds,** January 1916

50 Untitled, March 1916

51 Untitled, 1916

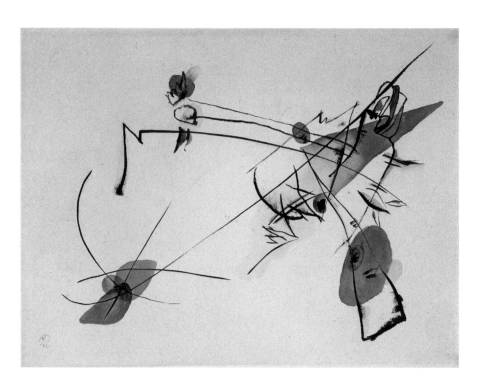

52 Simple, 1916

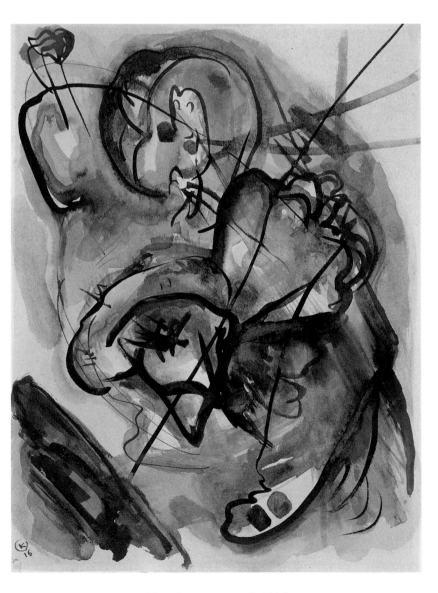

53 Concentrated, 1916

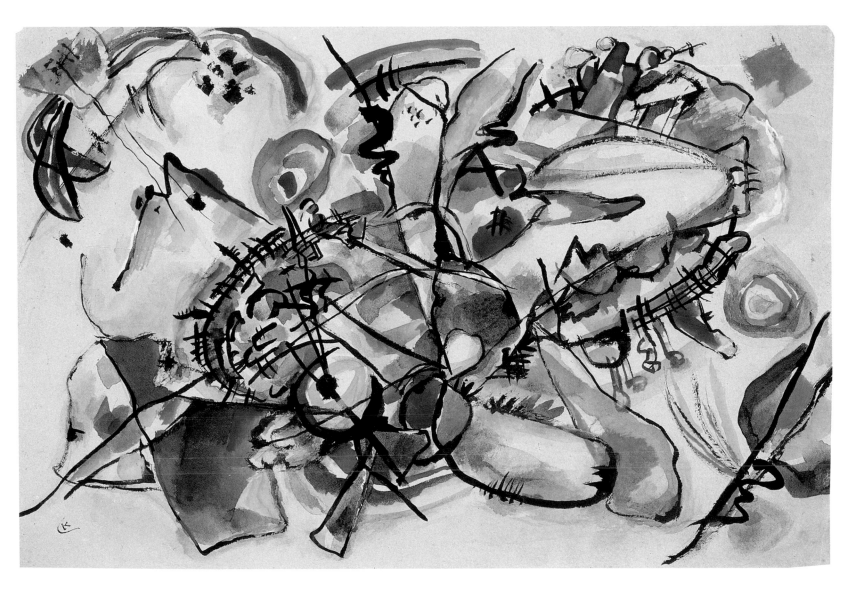

54 Untitled, c. 1916

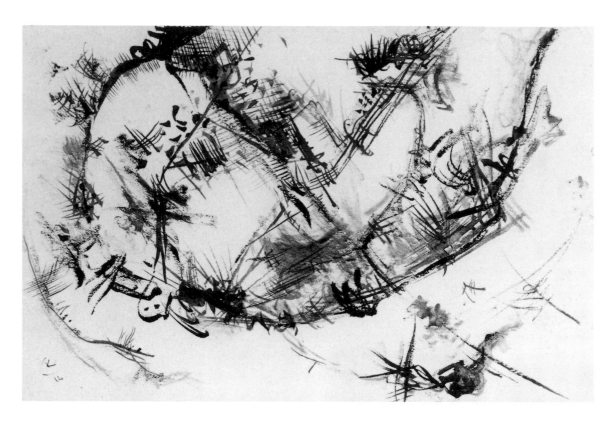

55 Untitled, 1916

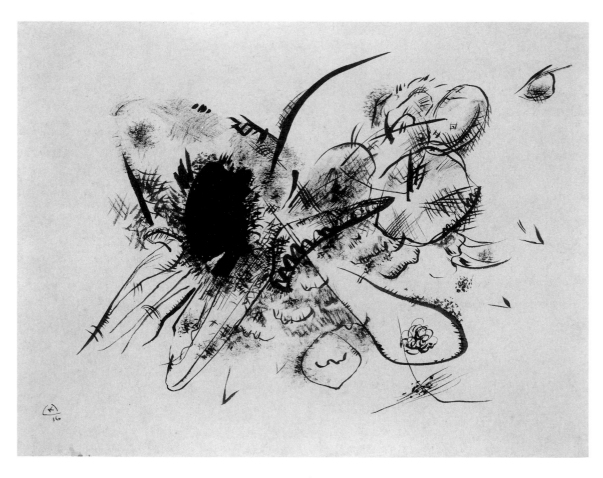

56 Untitled, 1916

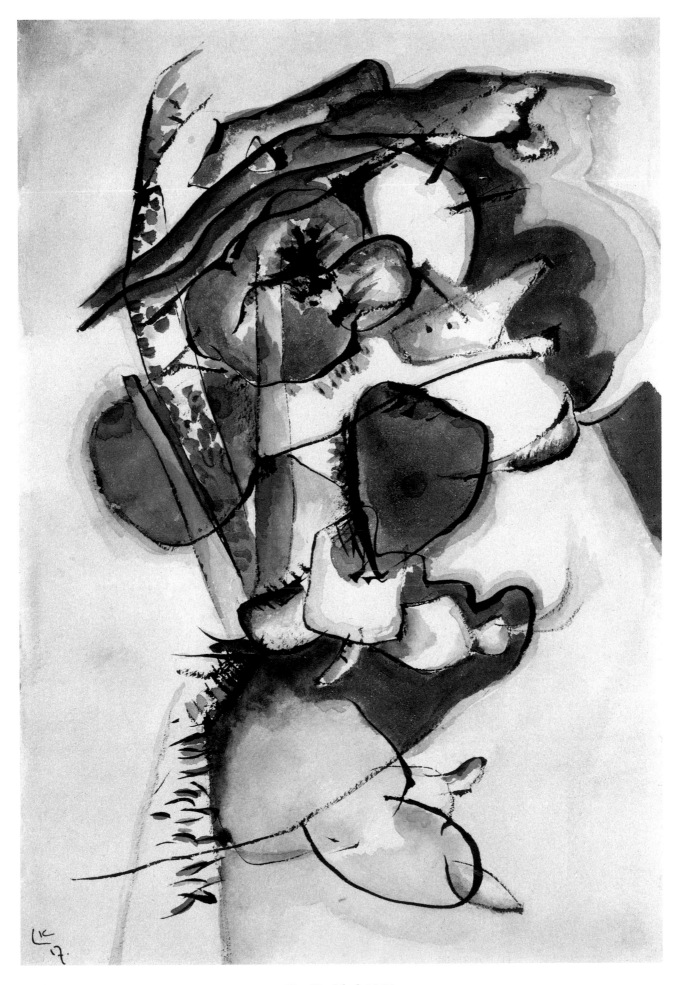

57 Untitled, 1917

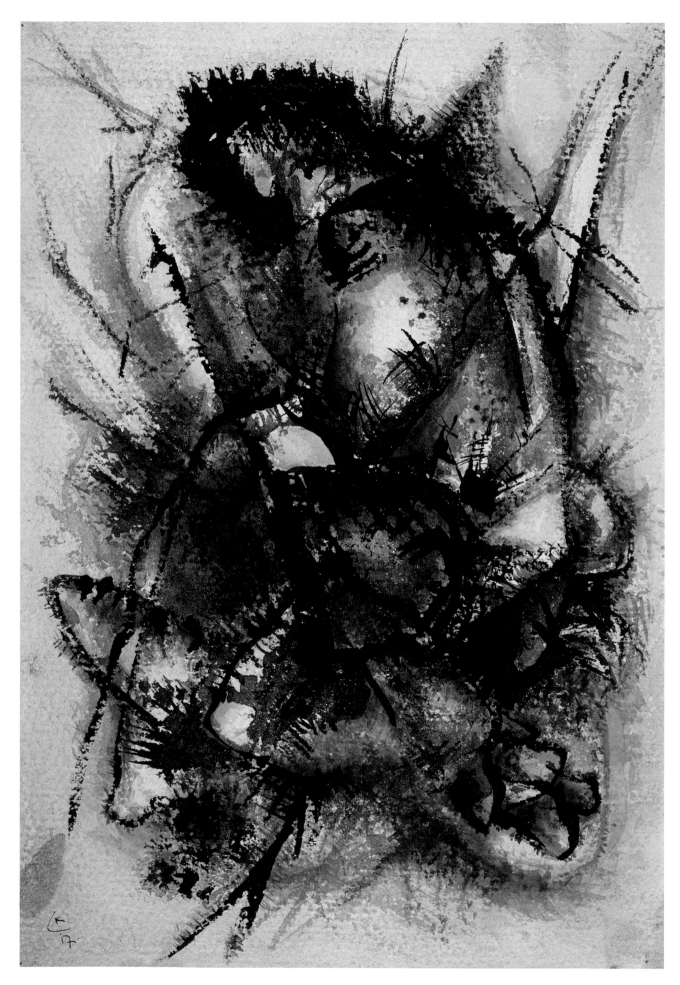

58 Untitled, 1917

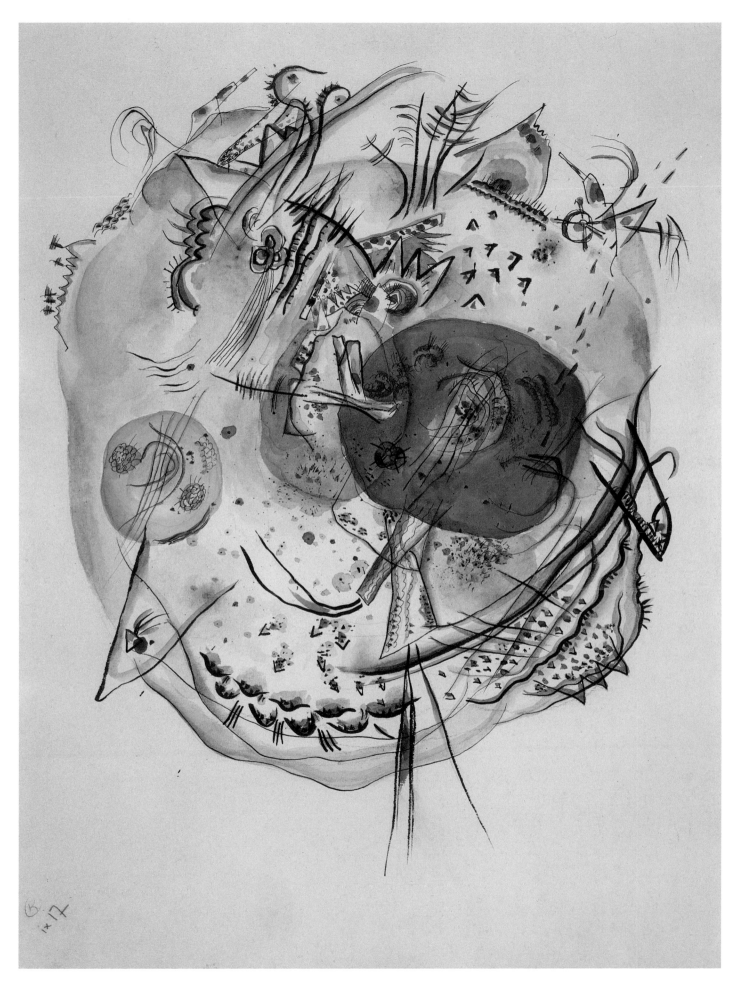

59 Untitled, September 1917

60 **Madonna and Child**, c. 1917

61 **Untitled**, 1918

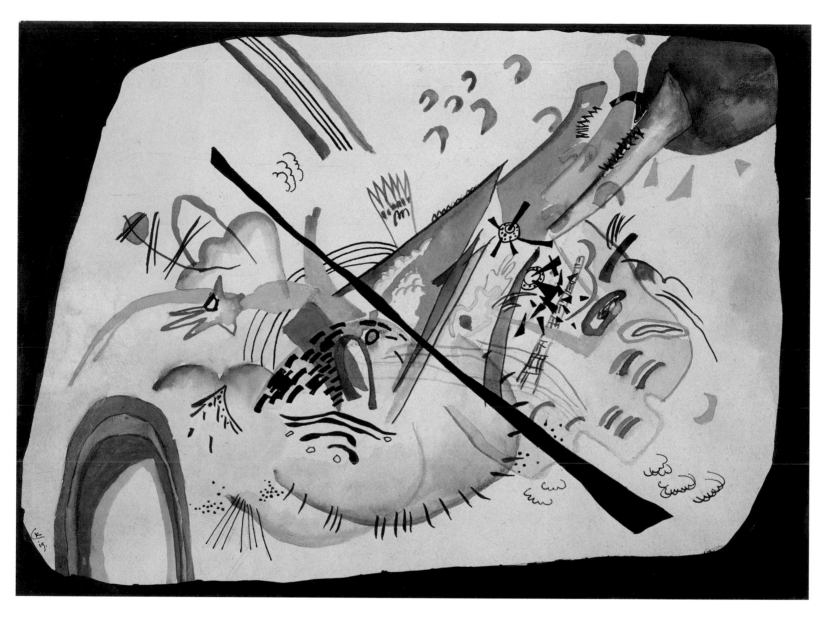

62　**Study for "White Oval"**, January 1919

63 **Untitled**, August 2, 1919

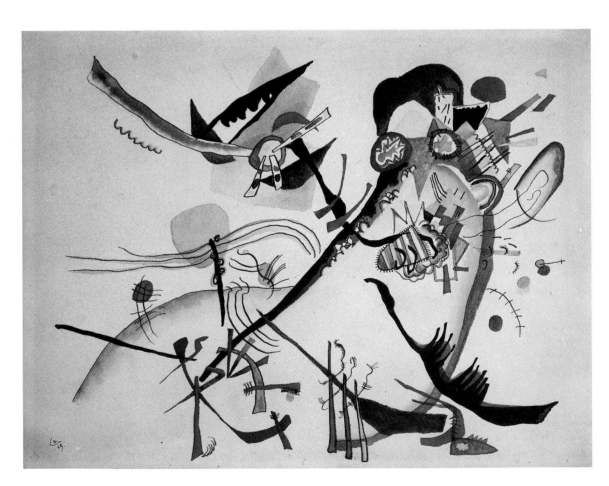

64 **Study for "Blue Segment"**, 1919

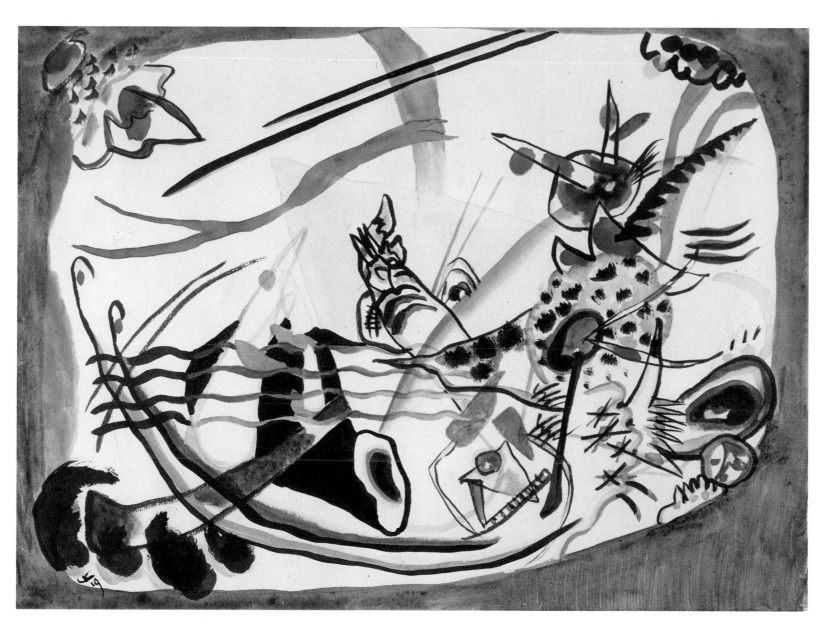

65 Study for "Green Border", 1919

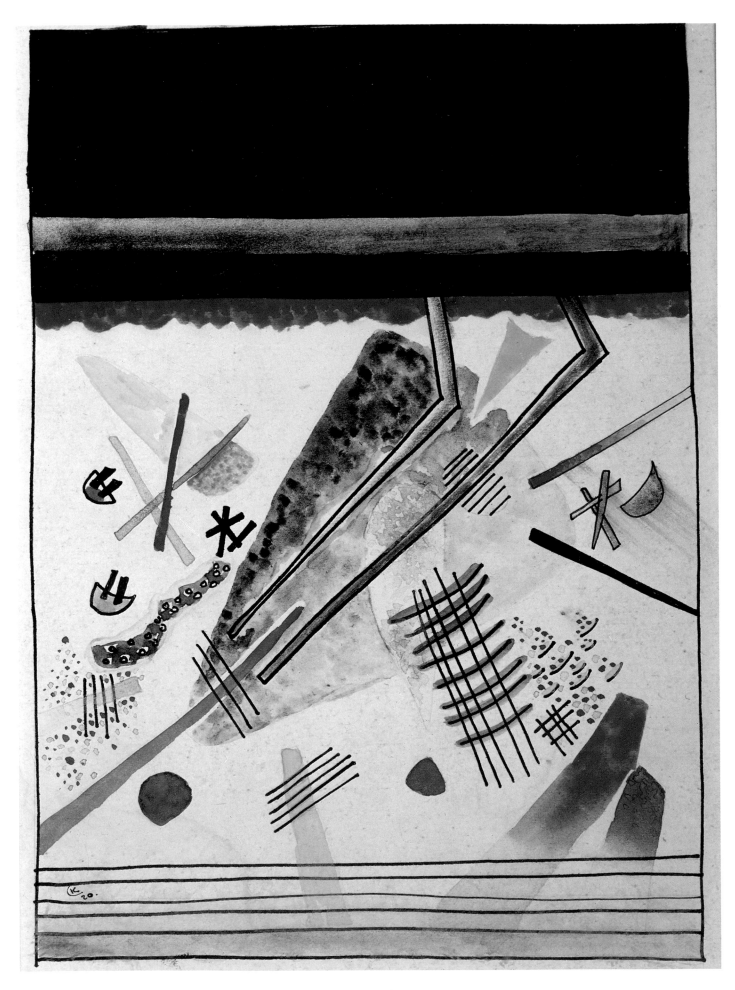

66 Untitled, 1920

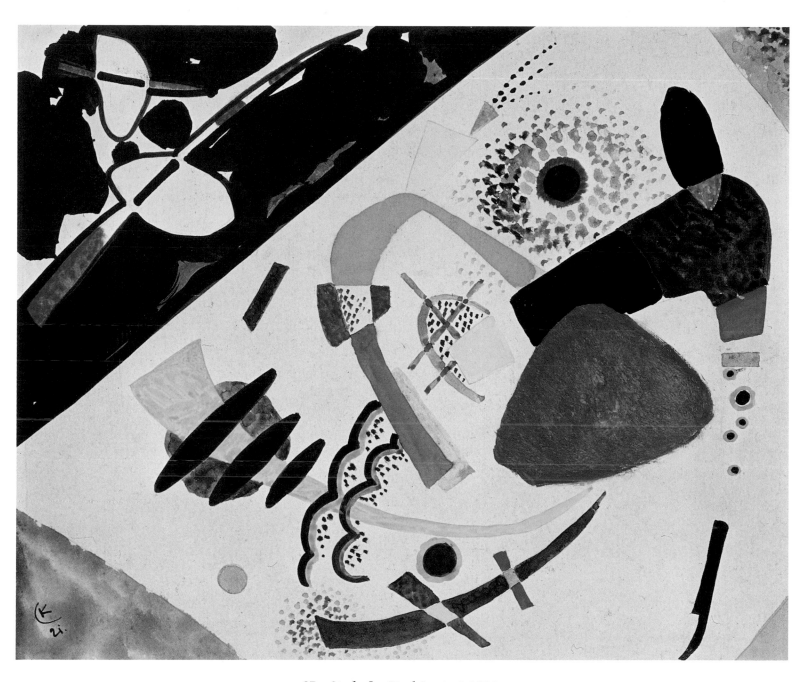

67 Study for "Red Spot II", 1921

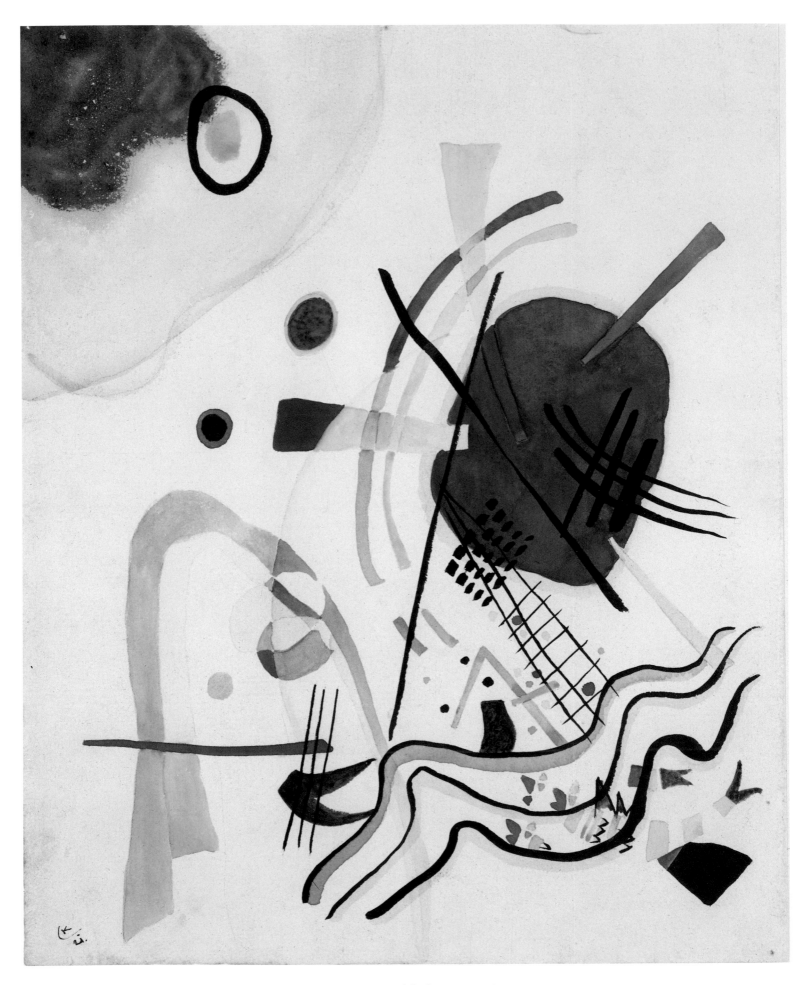

68 Untitled, 1921

69 Study for "Small Worlds I", 1921

70 Study for "Small Worlds IV", 1922

71 Study for "Small Worlds VII", 1922

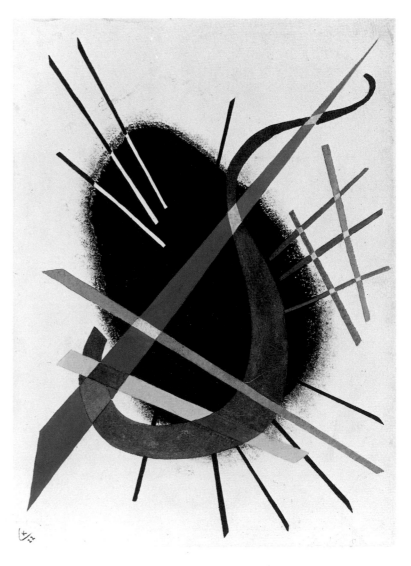

72 Untitled, 1922

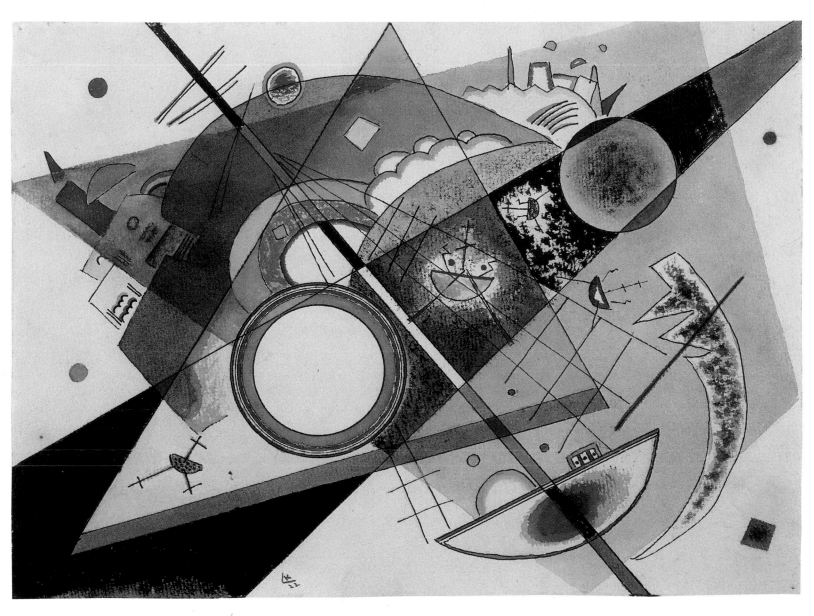

73 Untitled, 1922

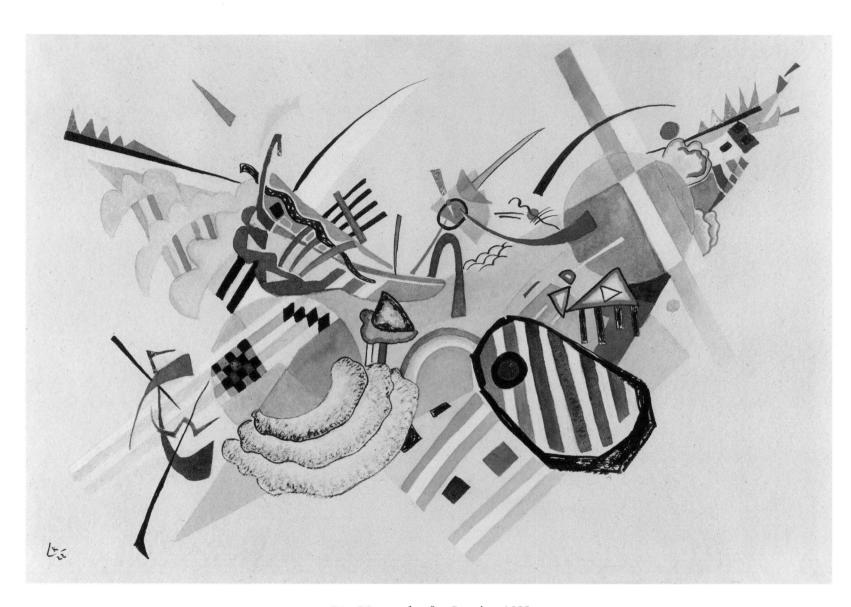

74 Watercolor for Gropius, 1922

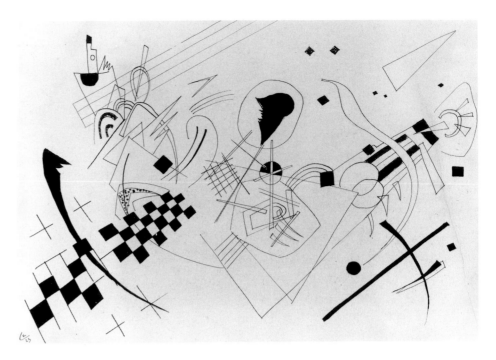

75 Untitled, 1923

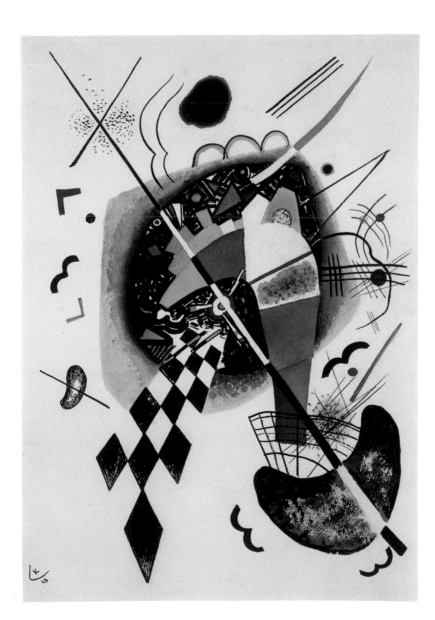

76 Untitled, 1923

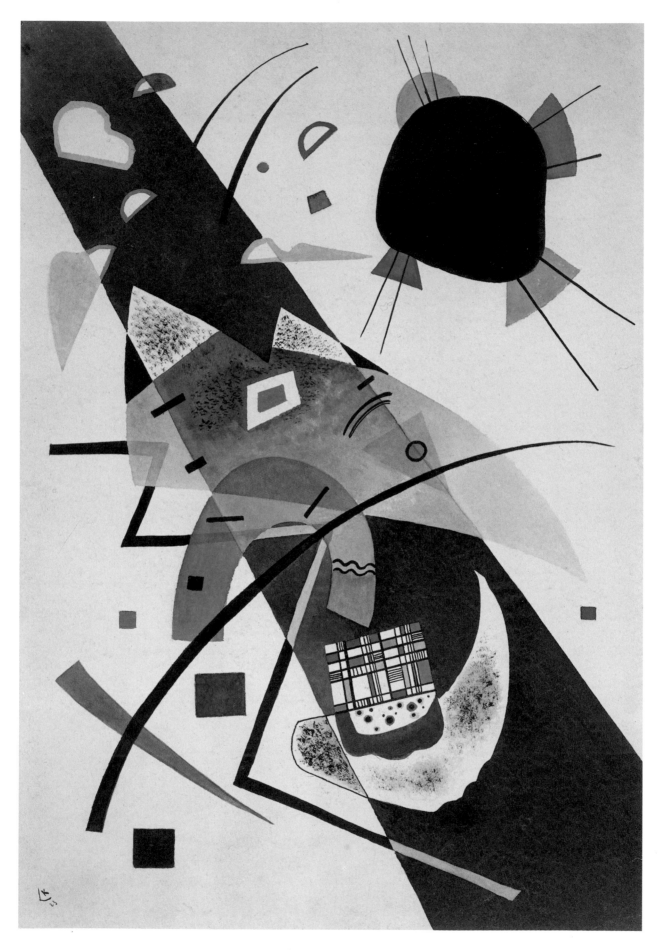

77 **Two Black Spots**, February 1923

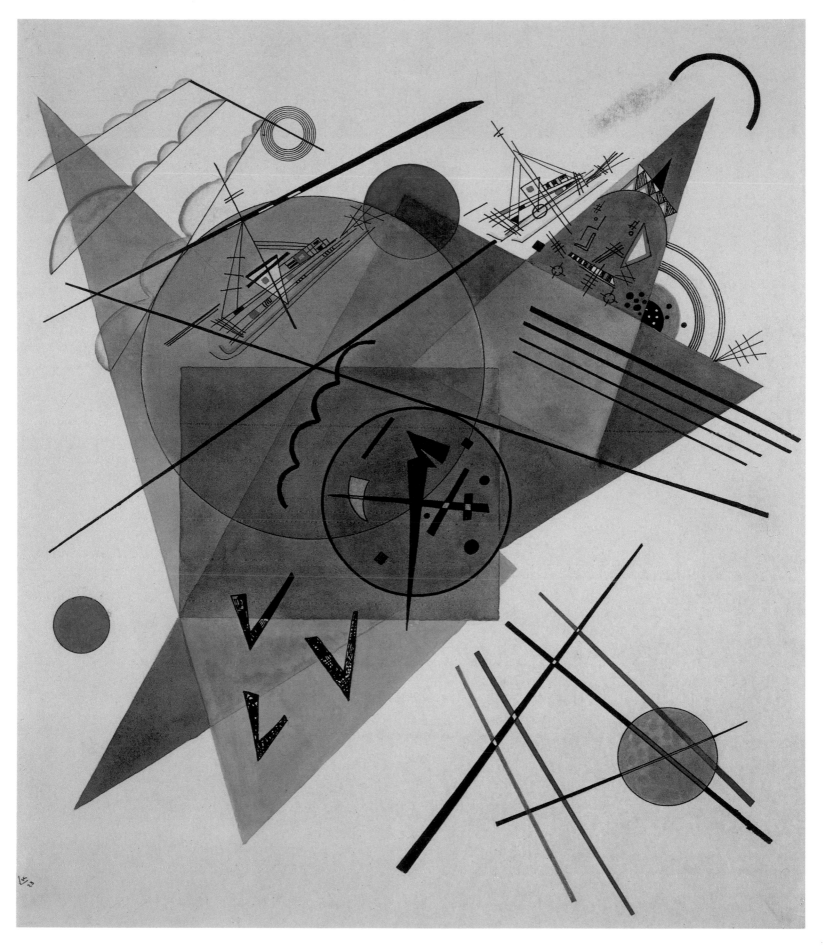

78 **Dream Motion,** March 1923

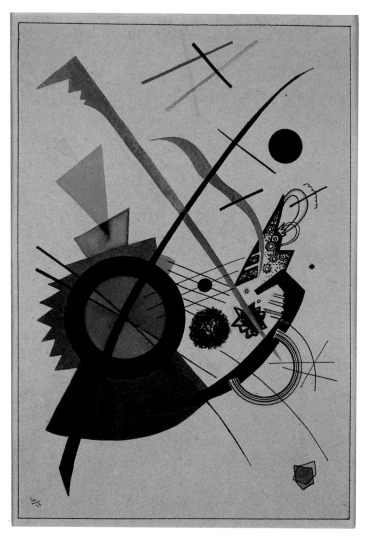

79 **Blue in Violet**, March 1923

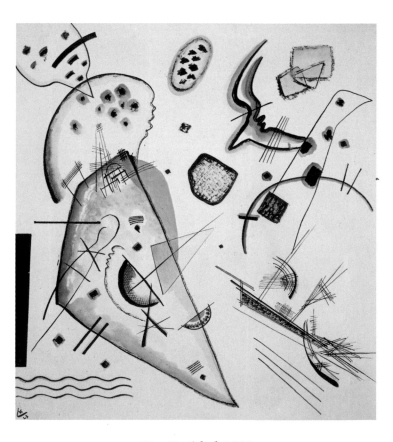

80 Untitled, 1923

81 Arrowform to the Left, May 1923

82 Untitled, 1923

83 Untitled, 1923

84　**Study for "Composition VIII"**, July 1923

85　**Untitled**, 1923

86 **Study for "In the Black Square"**, July 1923

87 **Black Triangle**, November 1923

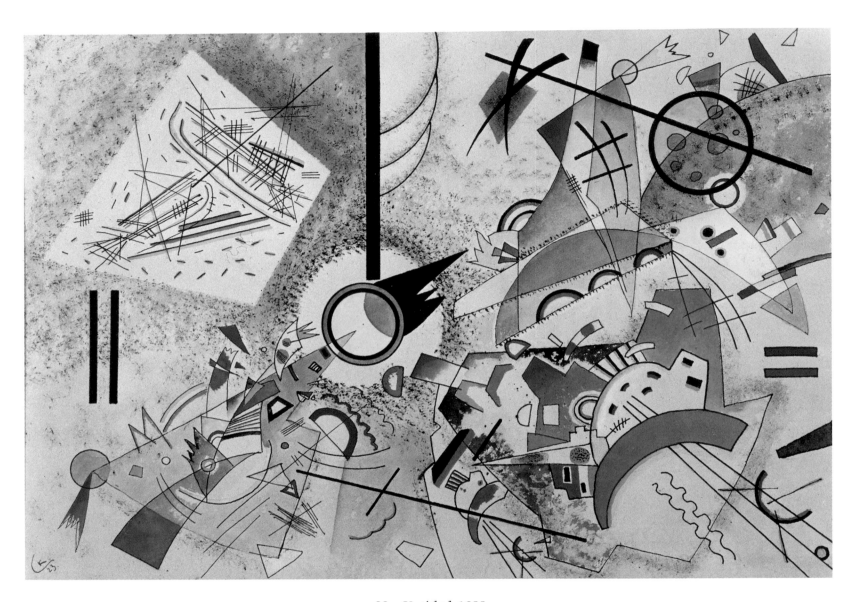

88 Untitled, 1923

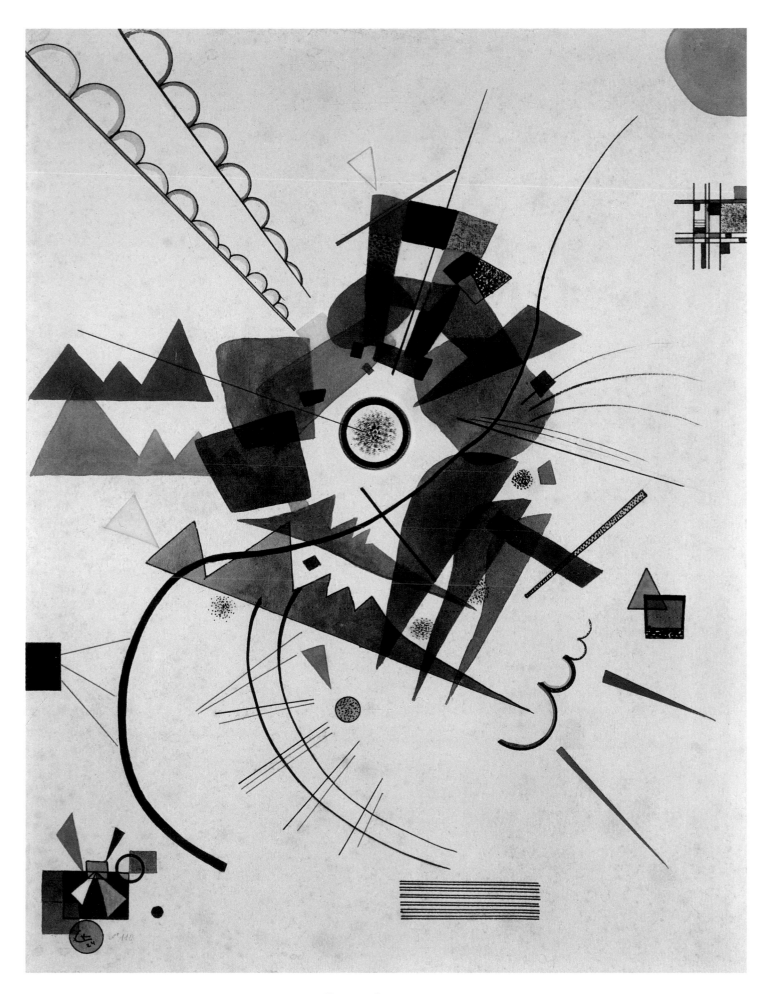

89 **All Around**, January 1, 1924

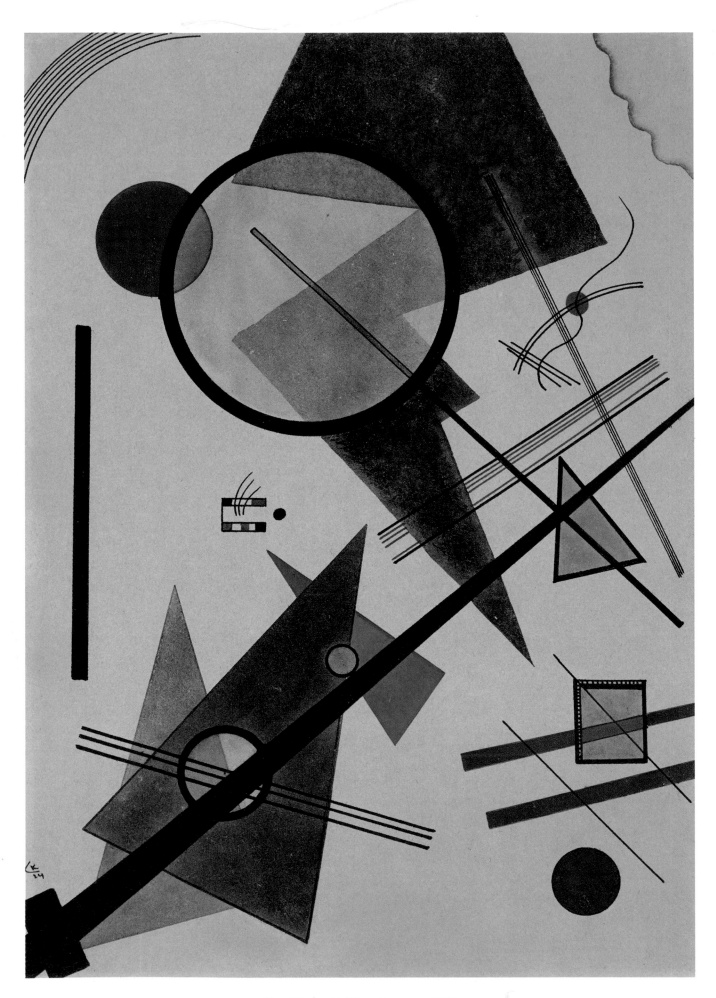

90 **Heavy Falling**, January 1924

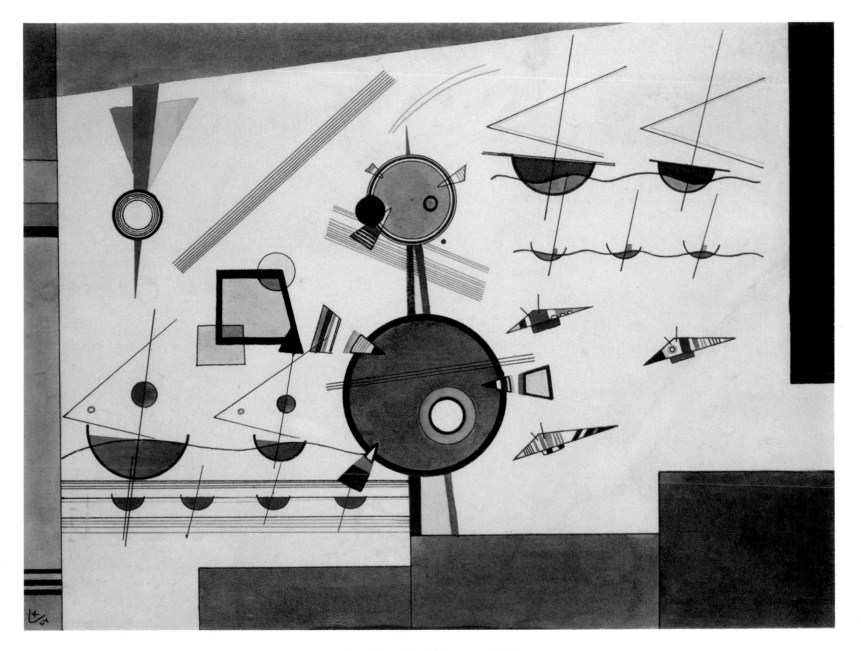

91 **Floating**, February 1924

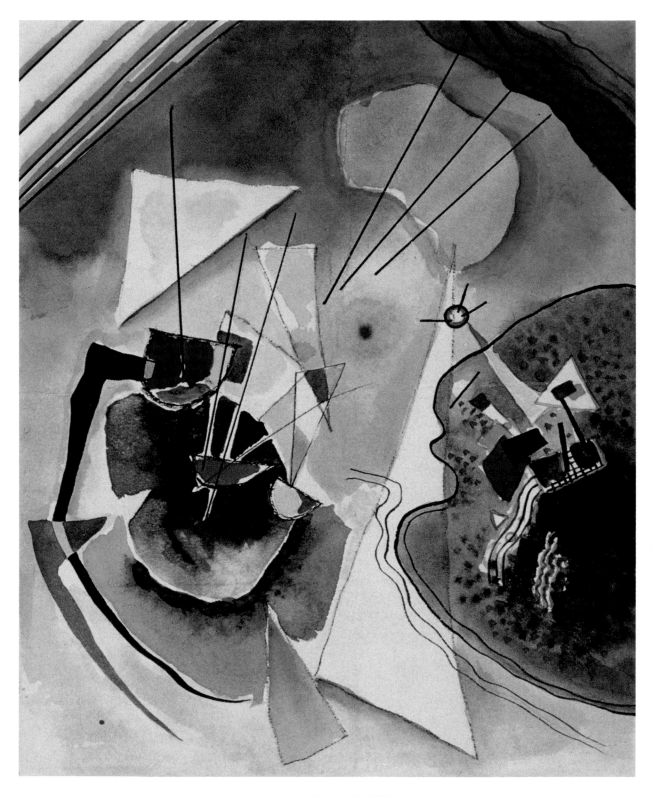

92 **Study**, April 1924

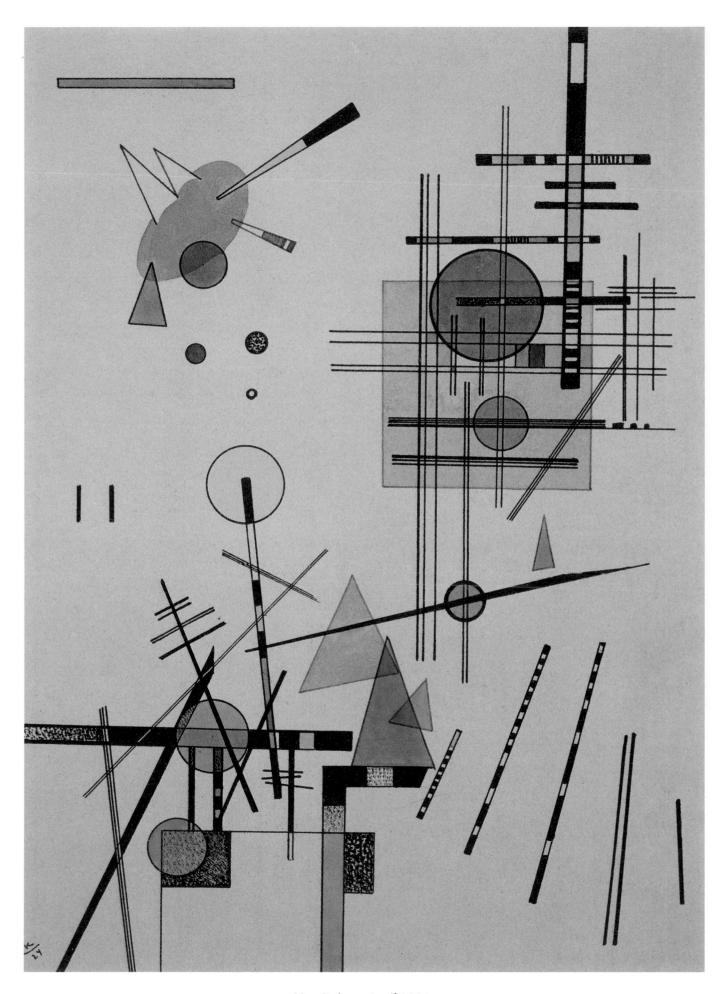

93 **Strings**, April 1924

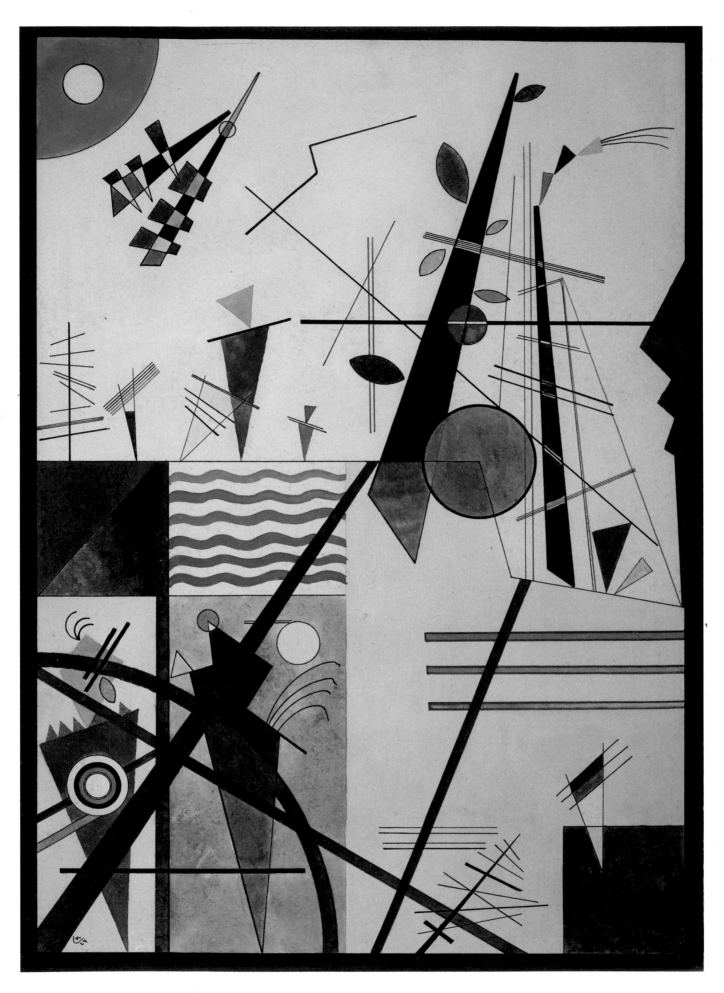

94 Bright Lucidity, May 1924

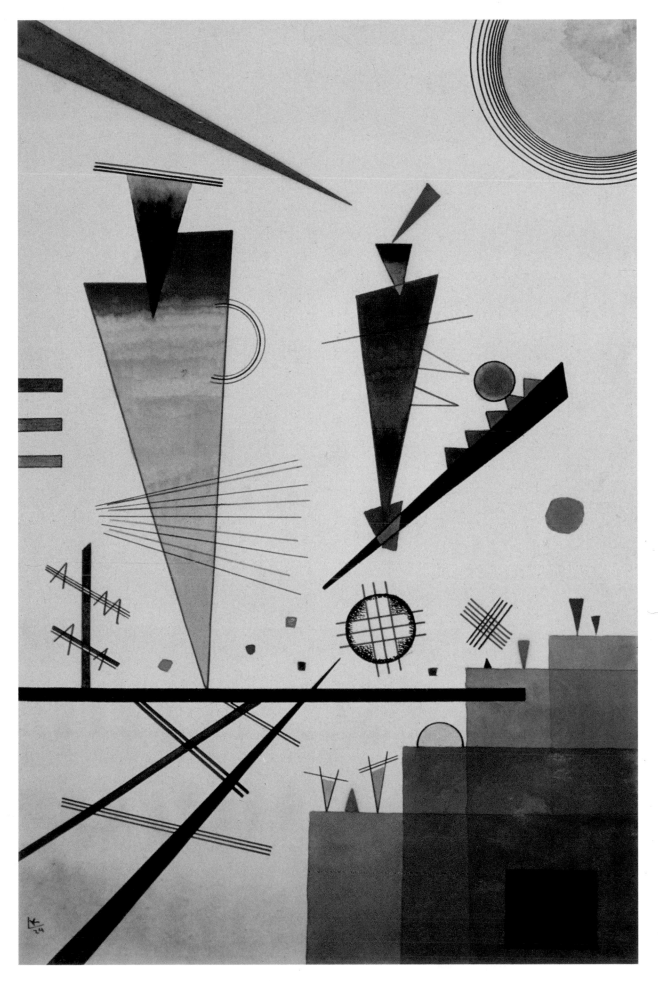

95 **Joyful Structure**, July 1924

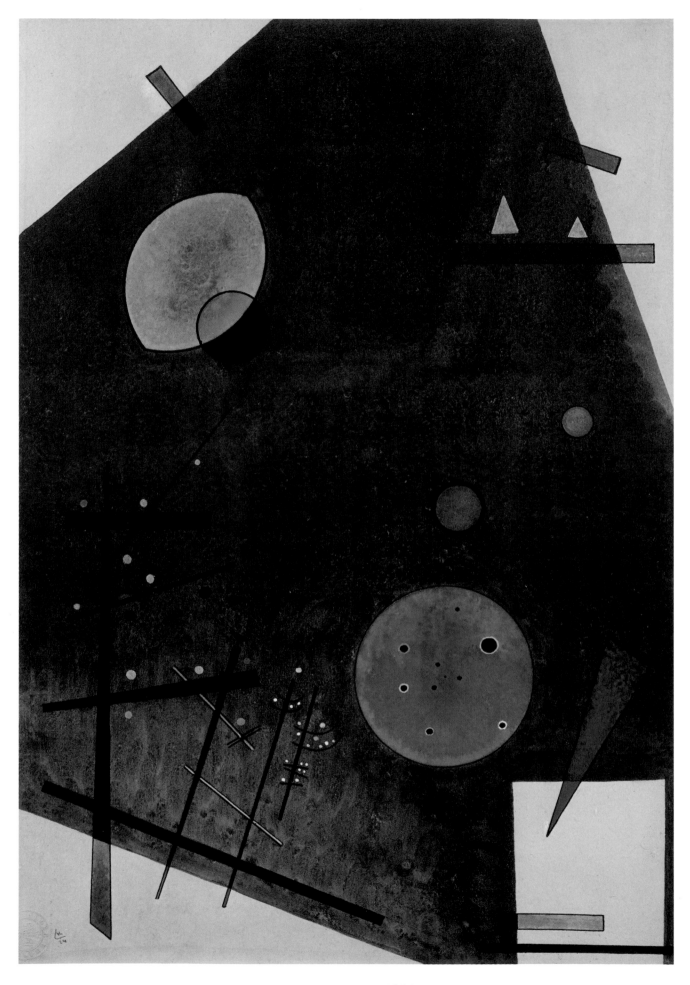

96 **Brown**, June 1924

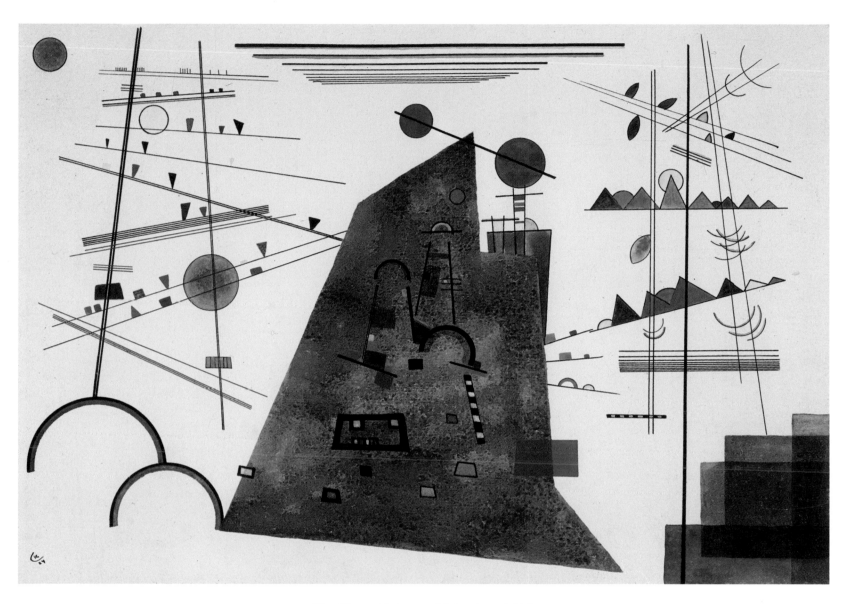

97 **Heavy Between Light**, June 1924

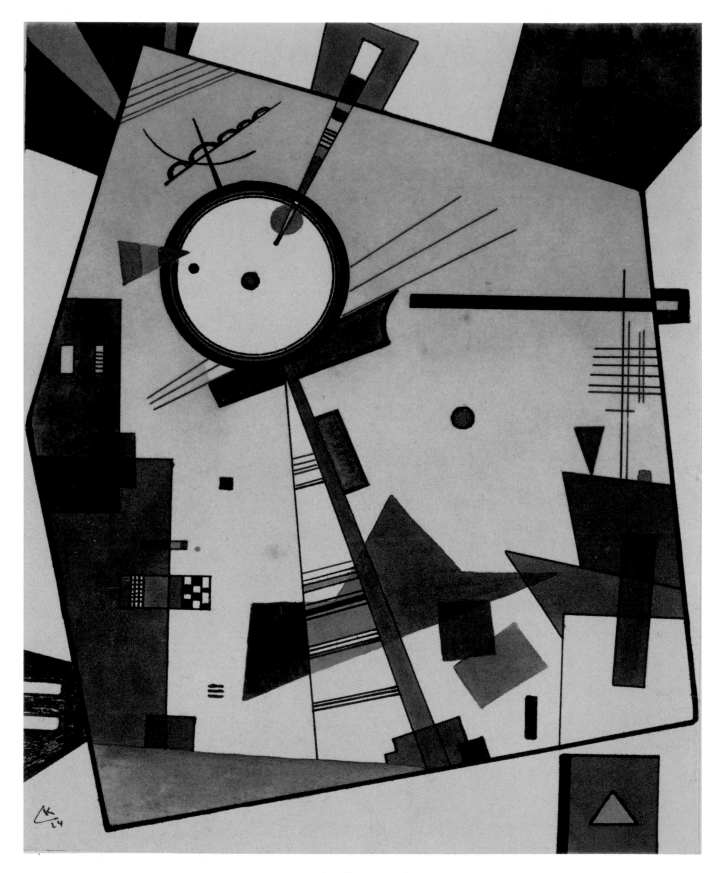

98 **Cool Yellow**, October 1924

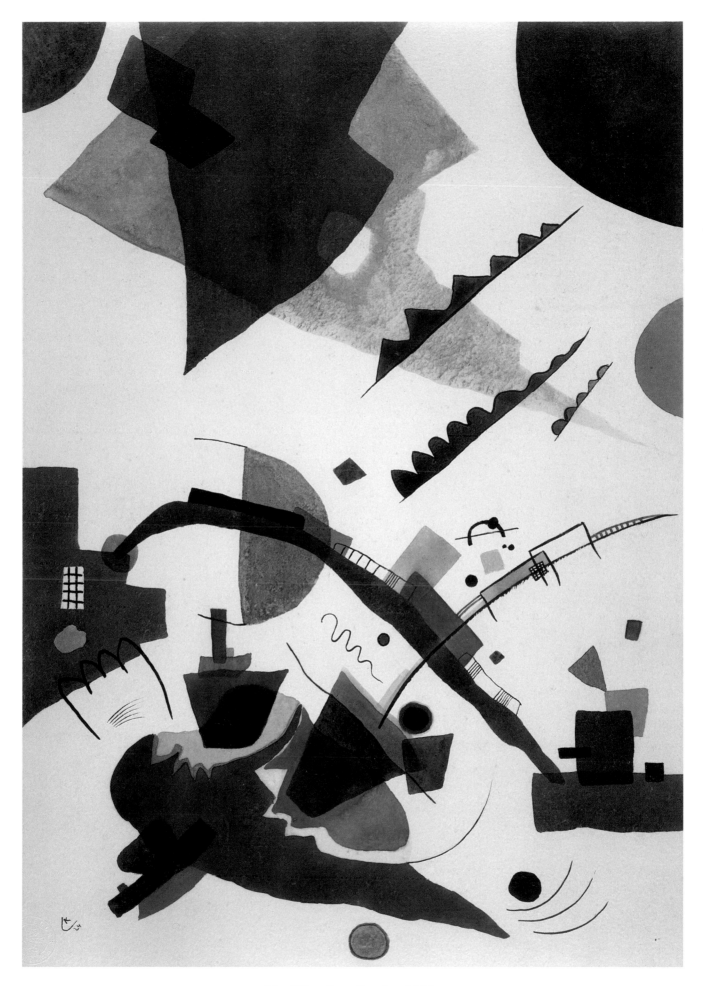

99 **Vibration**, October 1924

100 **Circles in Black**, October 1924

101 **Bent Point**, November 1924

102 **Brown Double Sound**, November/December 1924

103 **Central Line**, November 1924

104 Untitled, 1924

105 **Inner Simmering**, November 1925

106 **Checkered**, December 1925

107 **Upward**, December 1925

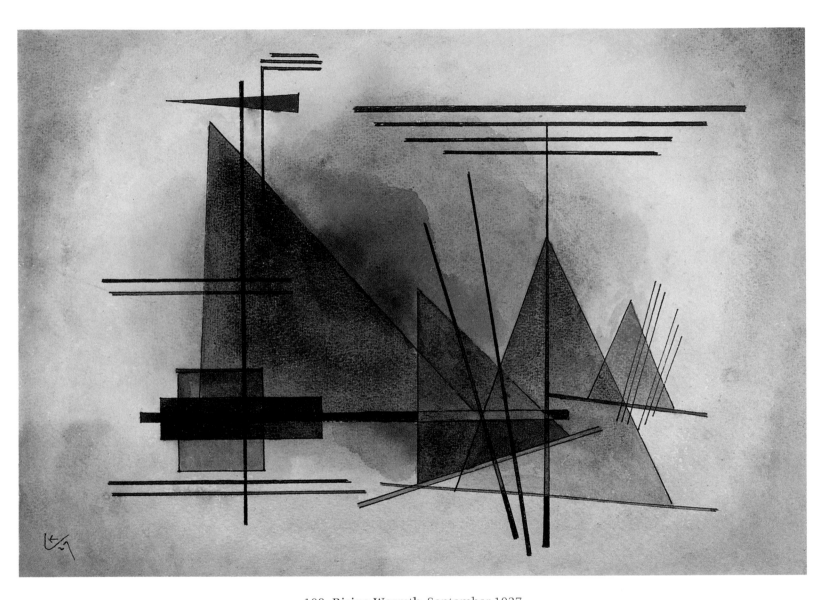

108 **Rising Warmth**, September 1927

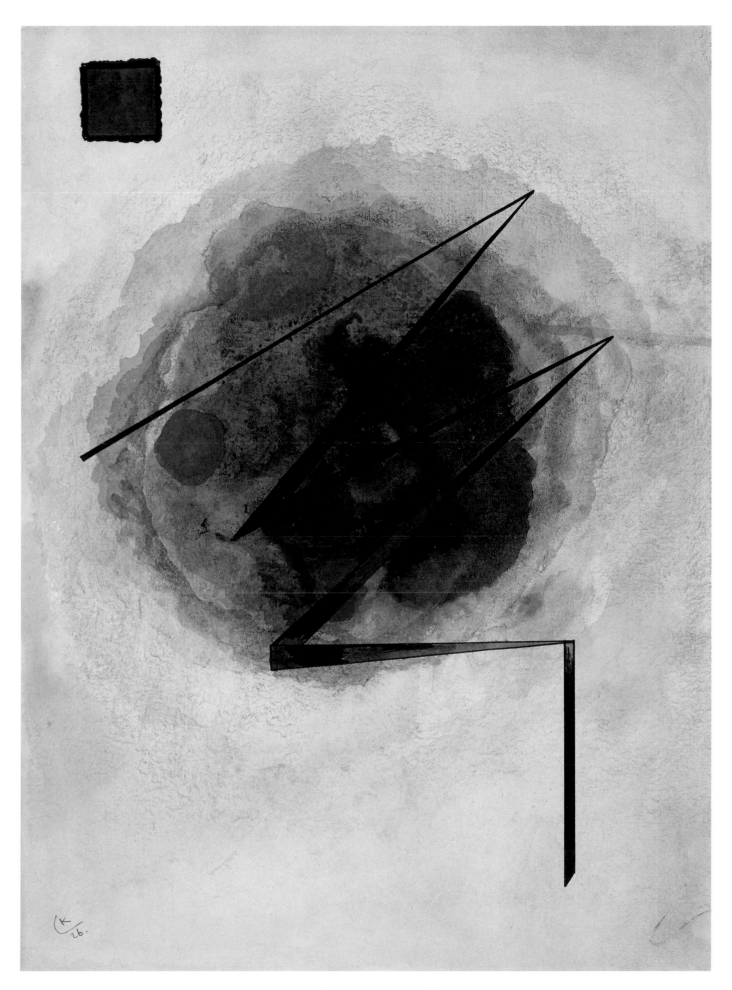

109 **Zigzag**, January 1926

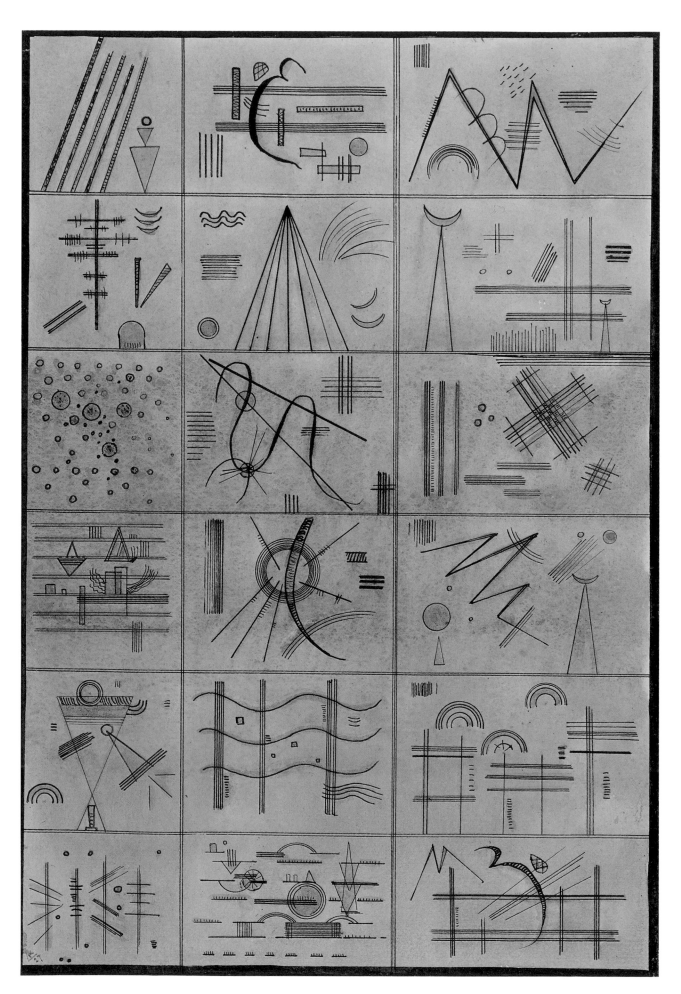

110 **Small Pictures**, October 1927

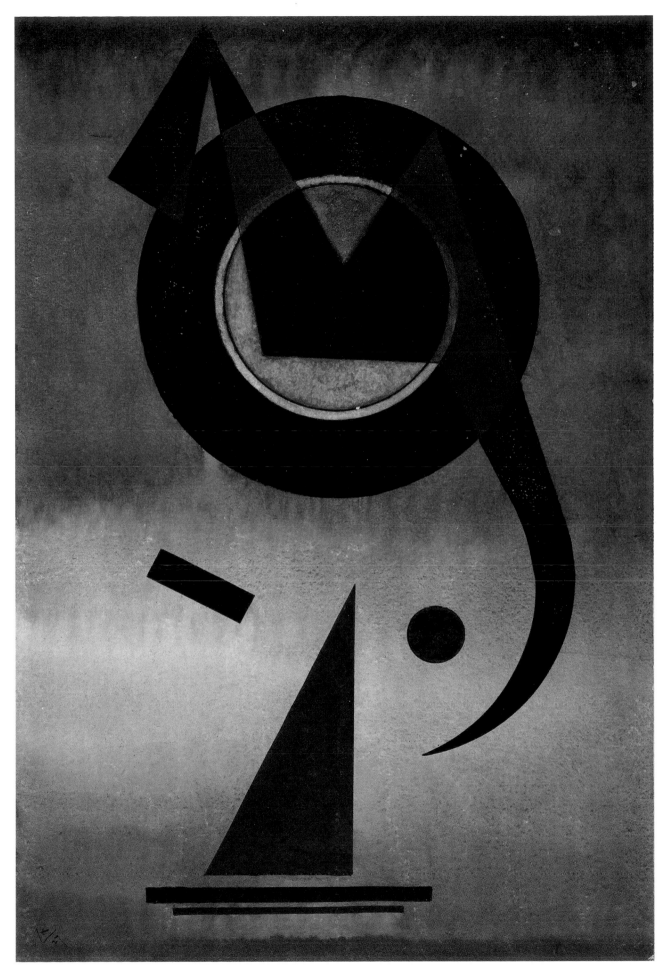

111 **Adhering**, October 1927

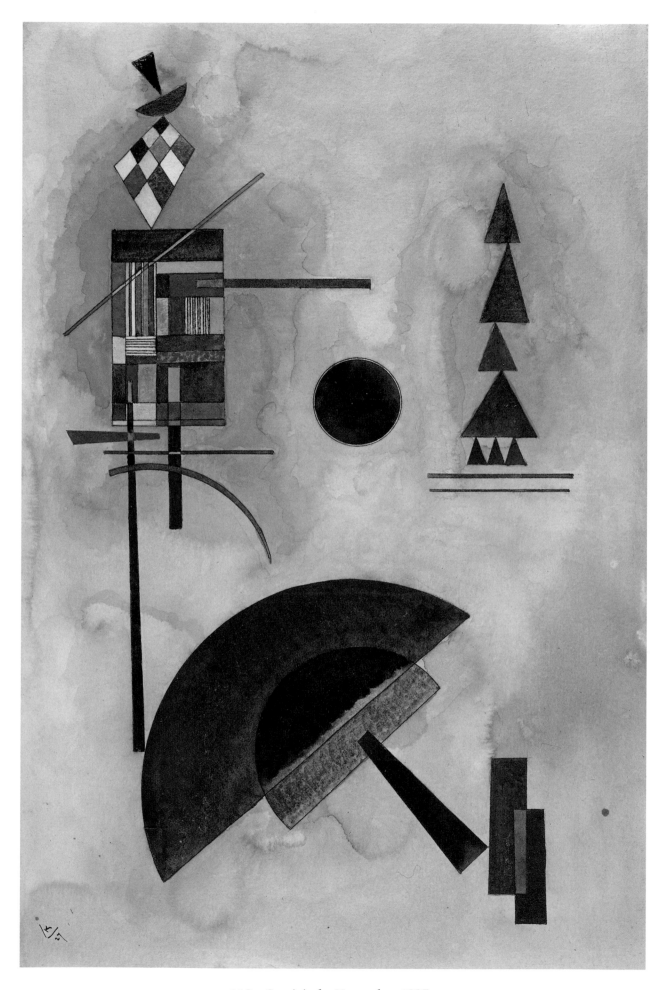

112　**Semicircle**, November 1927

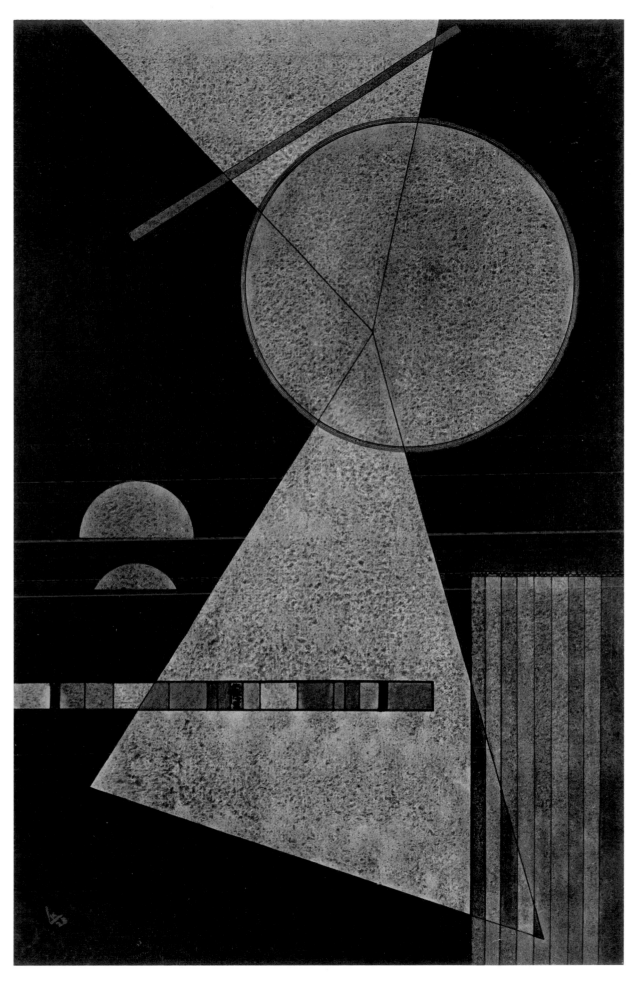

113 **Meeting Point**, May 1928

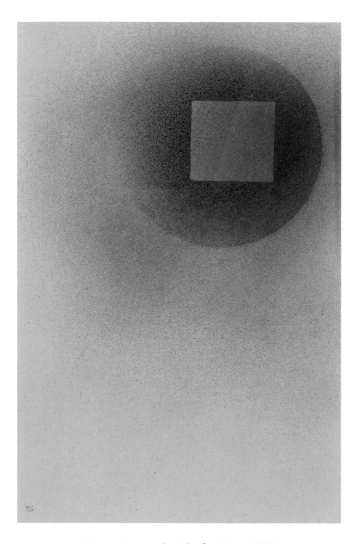

114 **Square in Circle**, May 1928

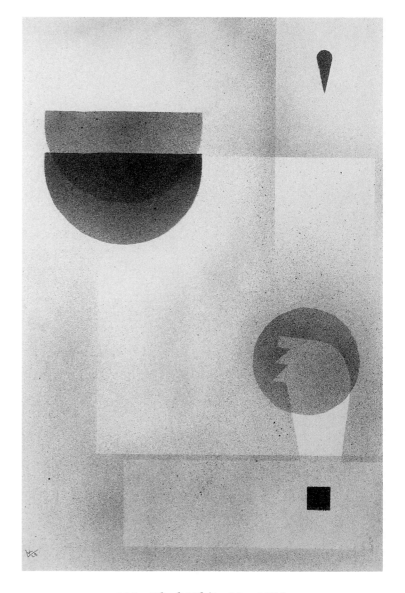

115 **Black-White**, May 1928

116 **Start**, May 1928

117 **Red Square**, May 1928

118 Into the Dark, May 1928

119 **Zigzag Upward**, June 1928

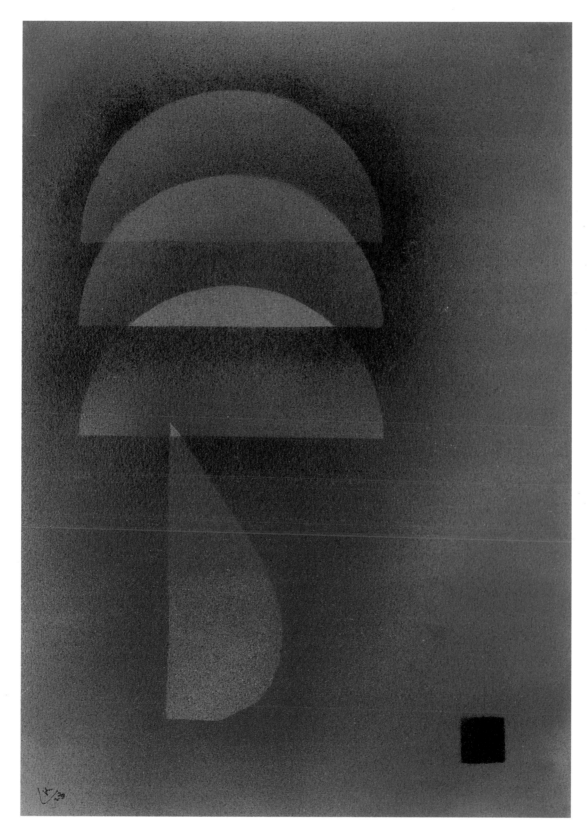

120 **Subdued Glow**, June 1928

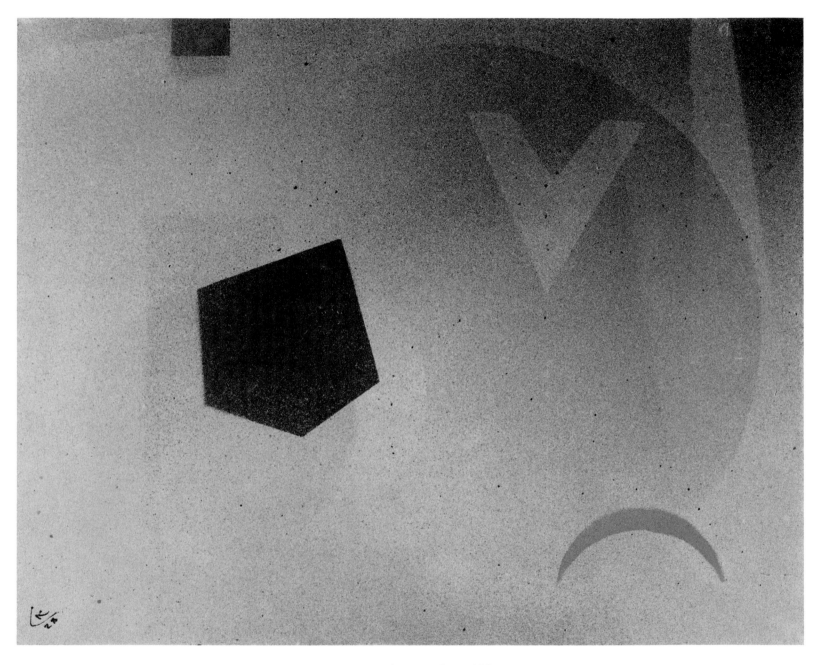

121　**Begins**, October 1928

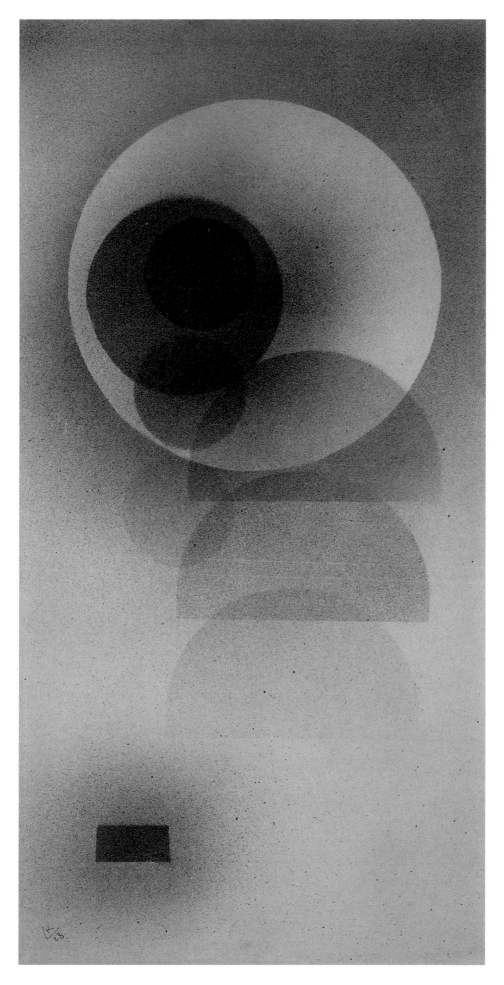

122 **Toward Green**, October 1928

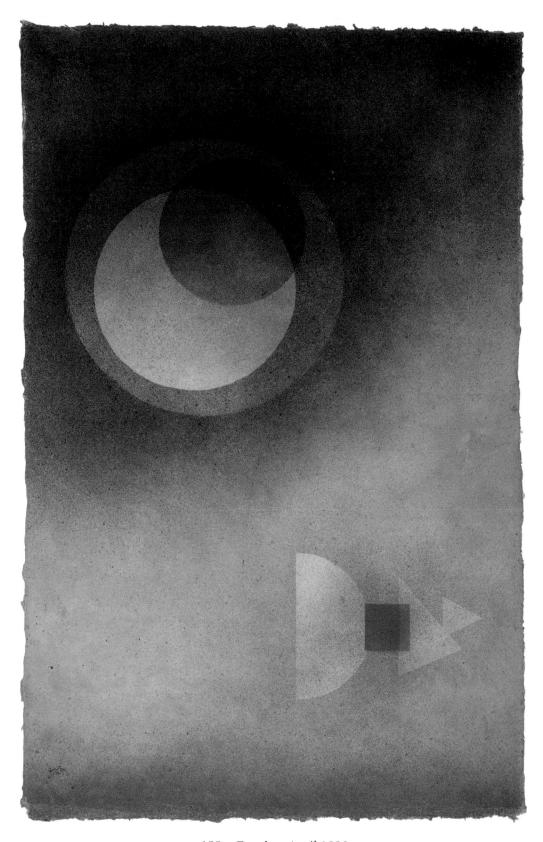

123 **Evasive**, April 1929

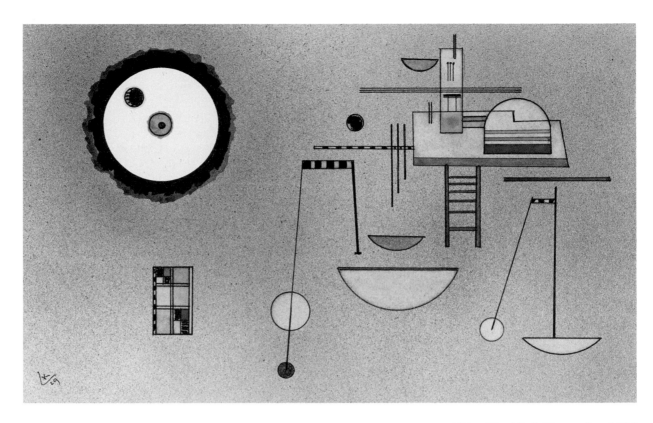

124 Untitled, November 1929

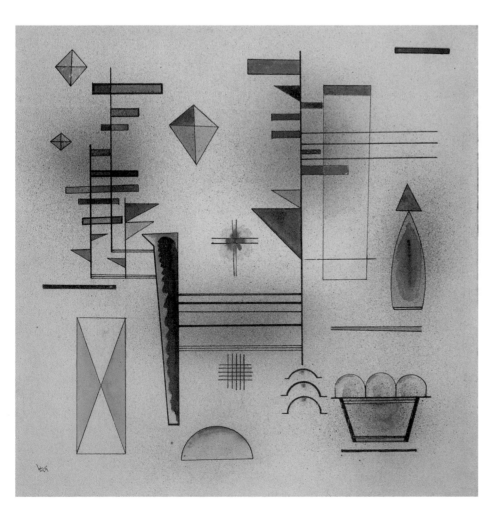

125 **Sonorous**, December 1929

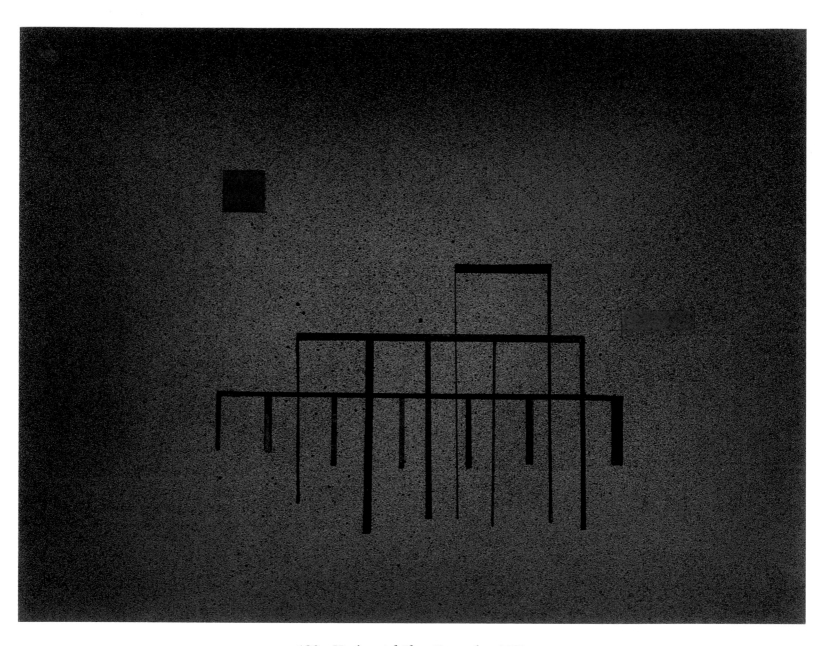

126　**Horizontal Blue,** December 1929

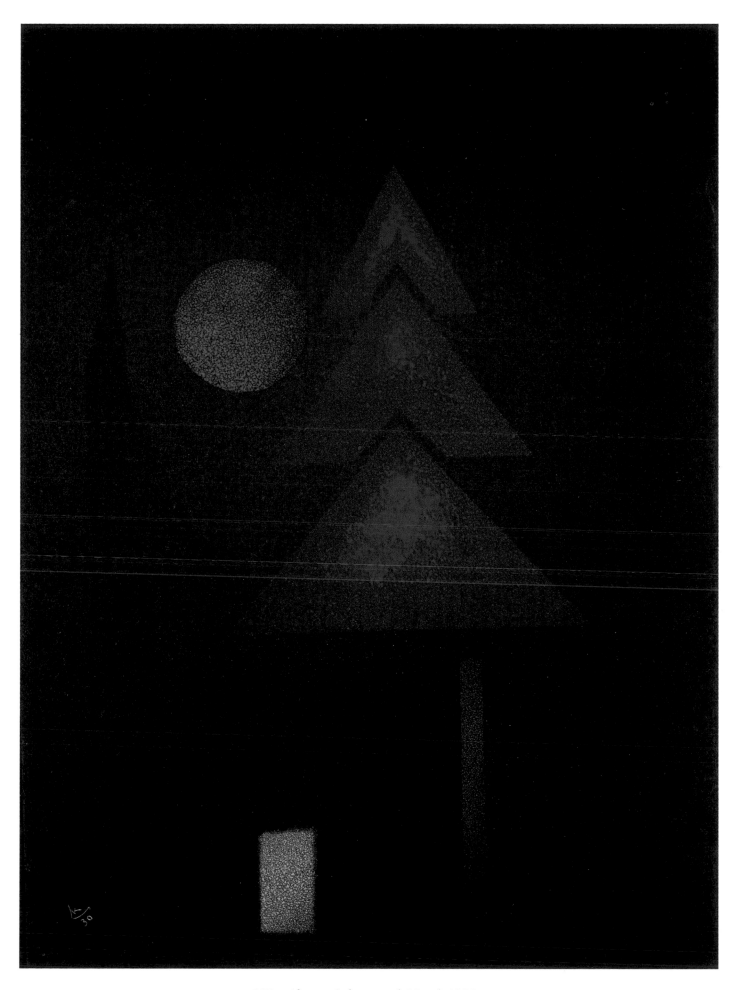

127 **Almost Submerged,** March 1930

128 **Tense**, July 1930

129　**Peaceful**, September 1930

130 **Upright**, September 1930

131 **Restrained**, June 1931

132 **Light Weights,** June 1931

133 **Steadfàst,** July 1931

134 **Hot**, July 1931

136 **Glimmering,** July 1931

135 **Gridded Circles,** July 1931

137 **Red in Square**, August 1931

138 **Pale Knot**, August 1931

139 **Two Spirals**, January 1932

140 **Development**, January 1932

141 **Blurring**, July 1932

142 **Over Here**, November 1932

143 **Two to One**, July 1933

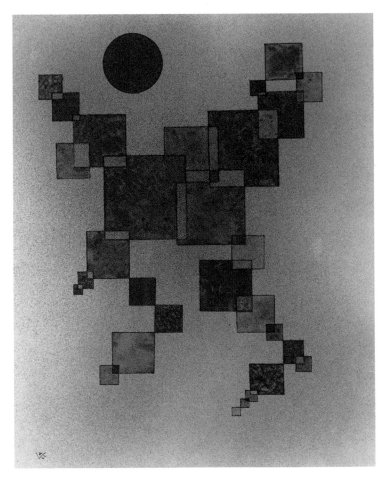

144 **Similibus**, August 1933

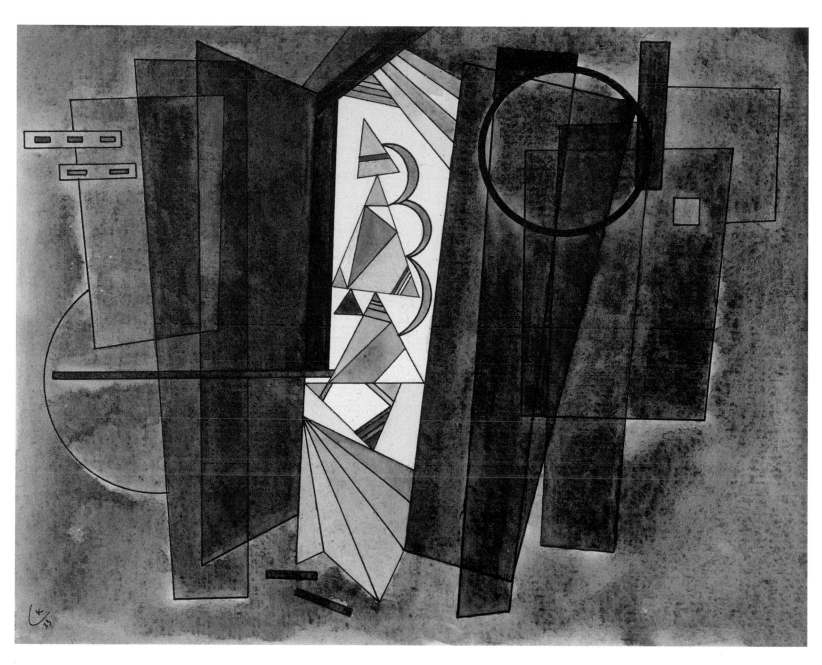

145 Study for "Development in Brown", 1933

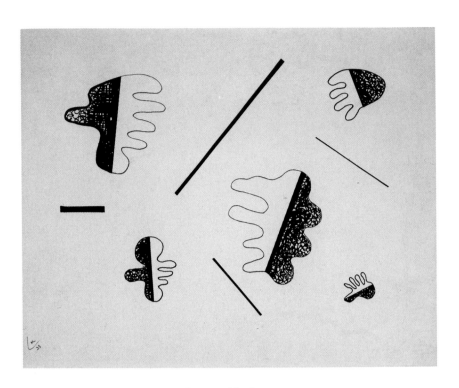

146 Untitled, 1933

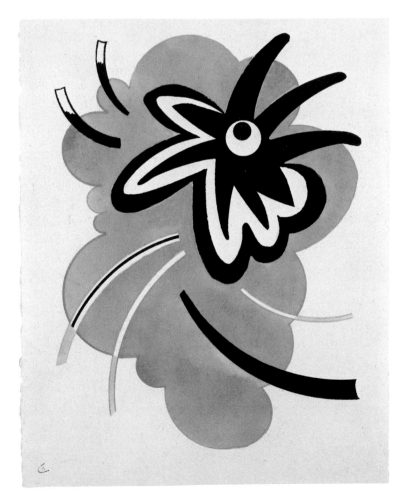

147 Green-Black, May 1934

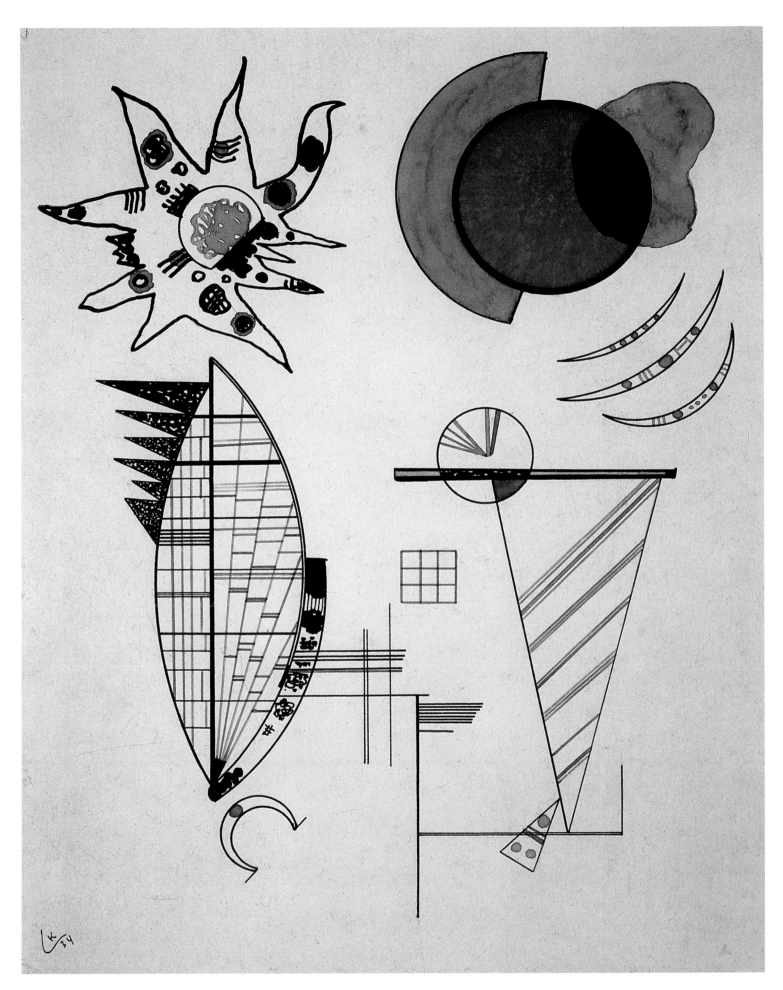

148 **Four**, March 1934

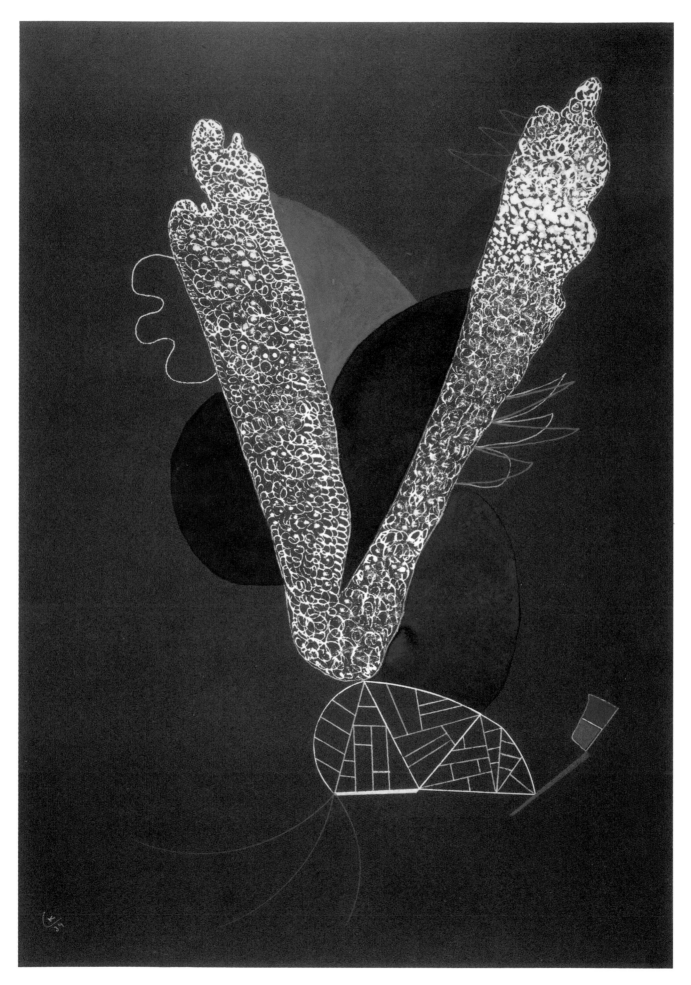

149 **Braided**, July 1934

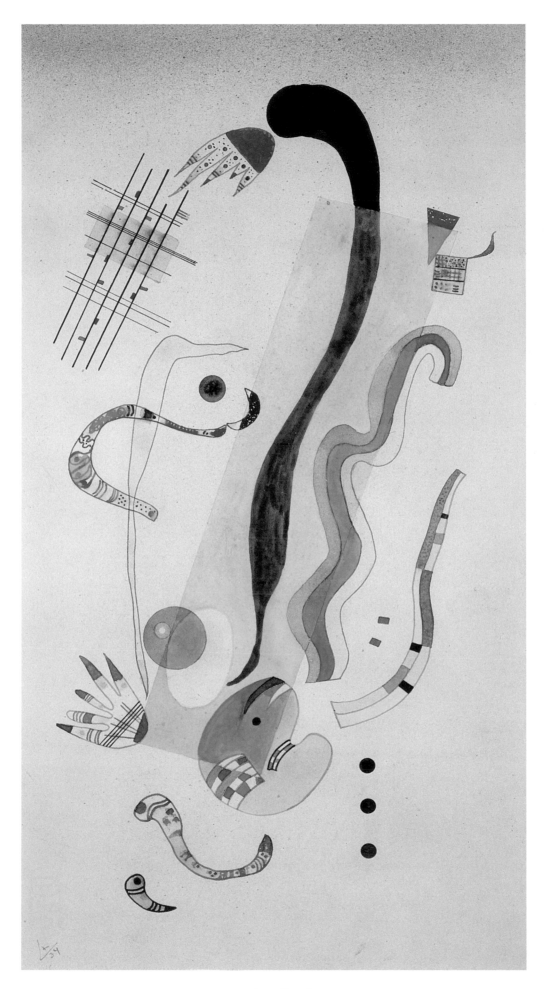

150 **Creeping,** October 1934

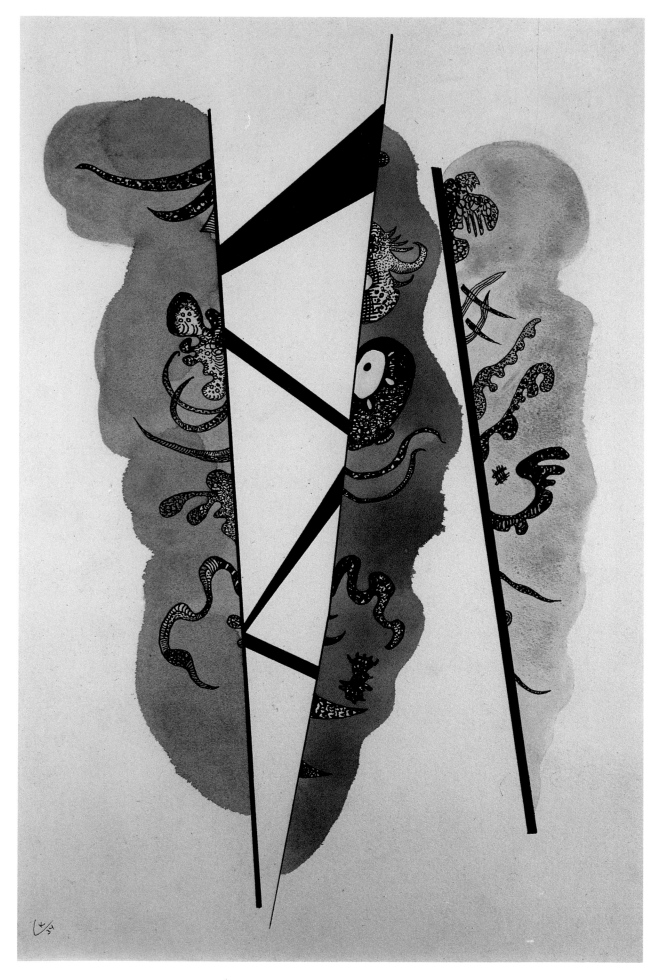

151 **Ends**, December 1934

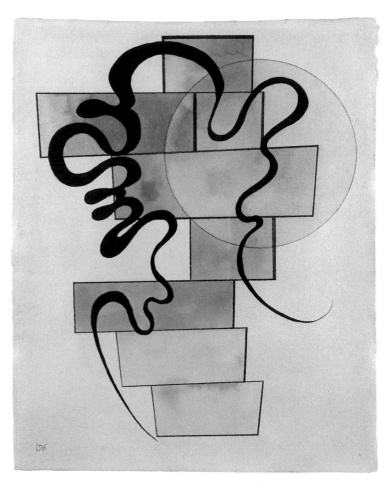

152 **Capricious**, December 1934

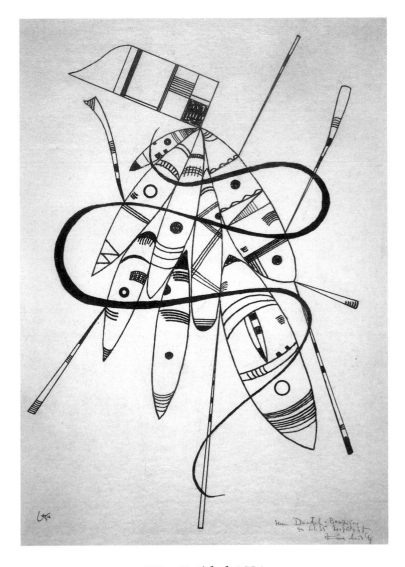

153 Untitled, 1934

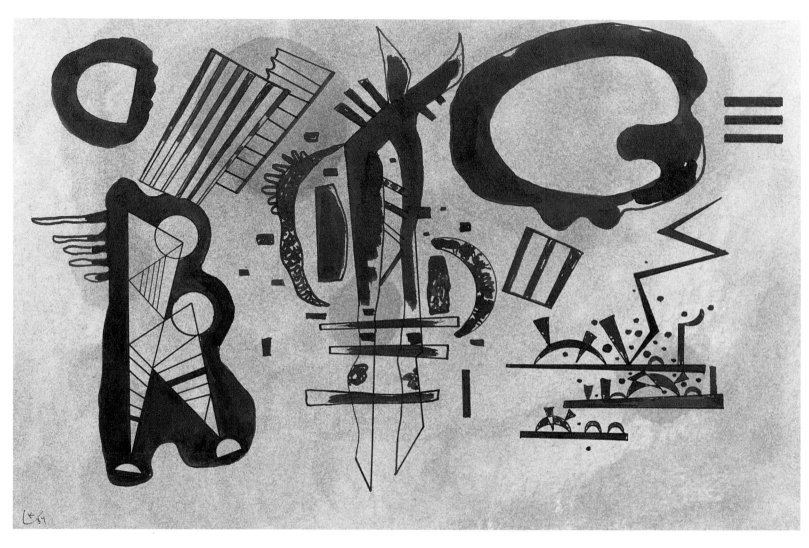

154 **Turning**, December 1934

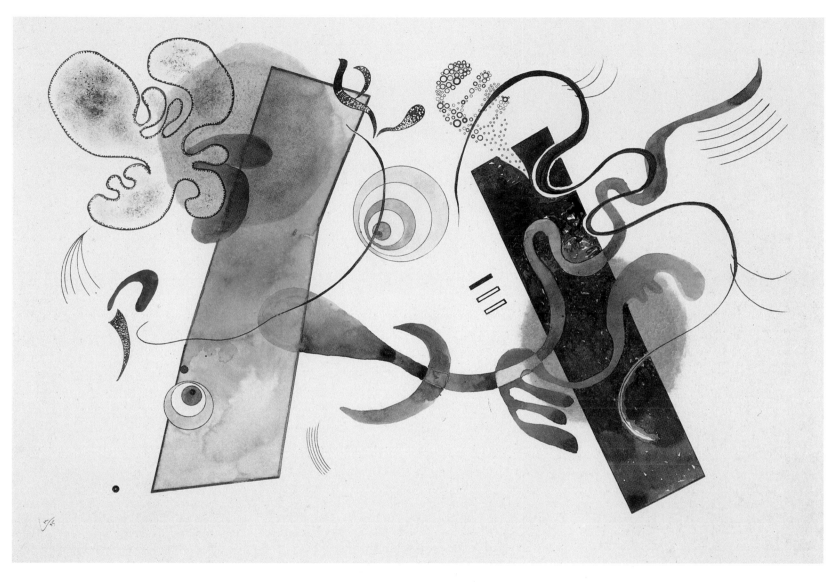

155 **Spots: Green and Pink**, May 1935

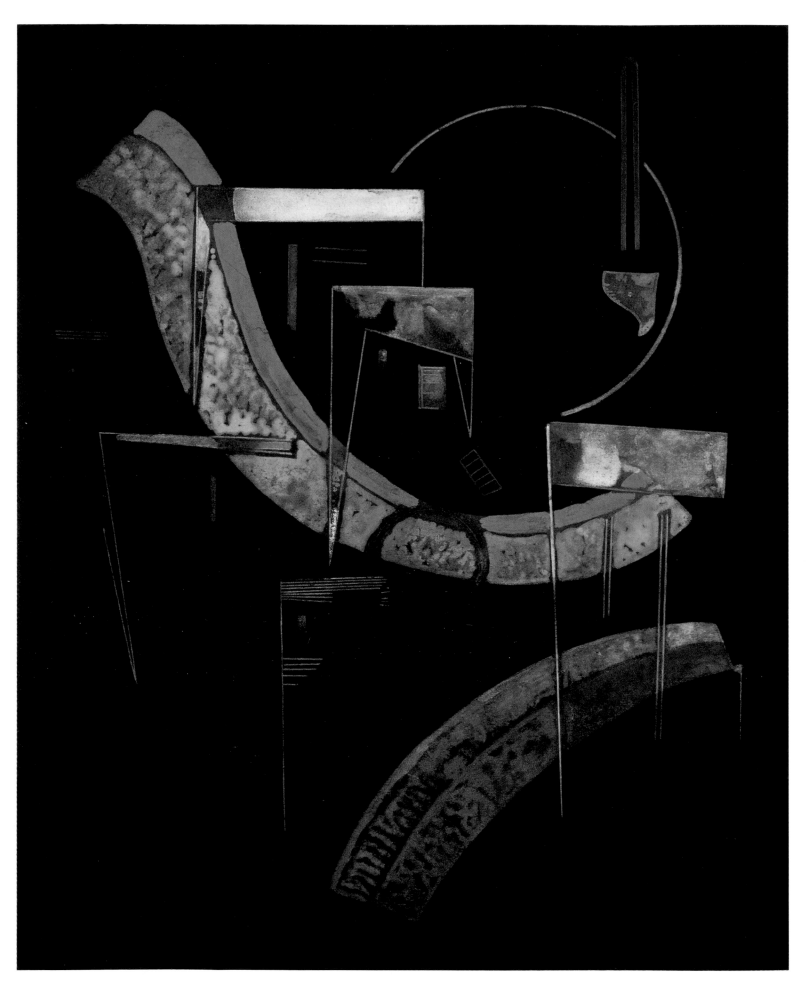

156 **Ascent in White**, May 1935

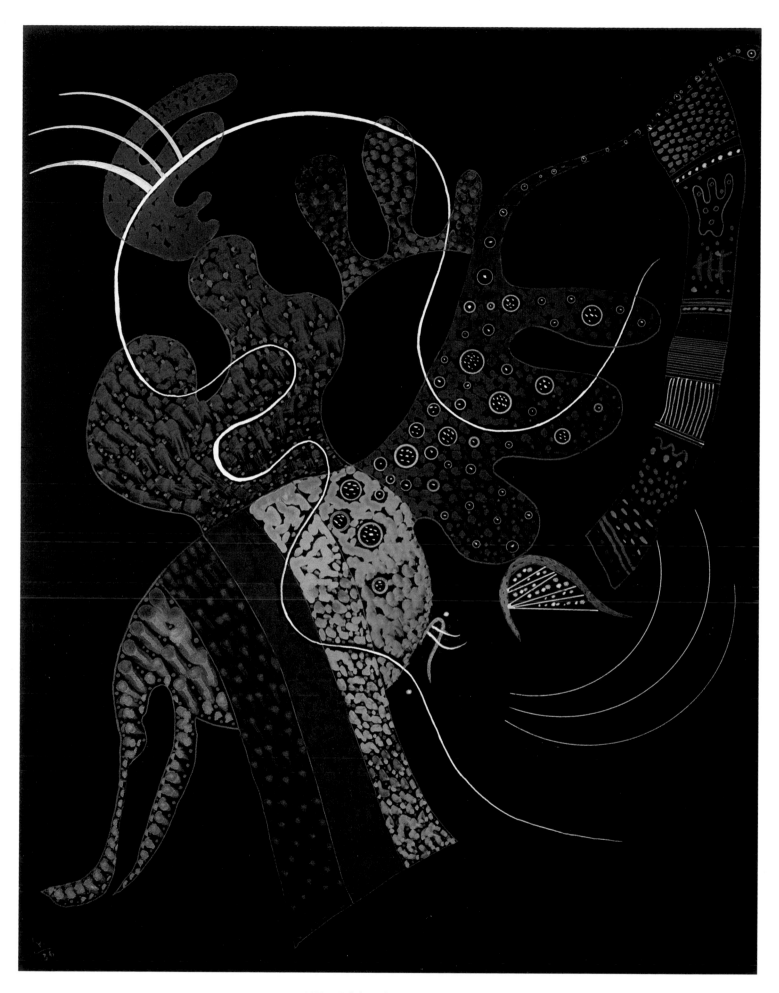

157 **White Line**, June 1936

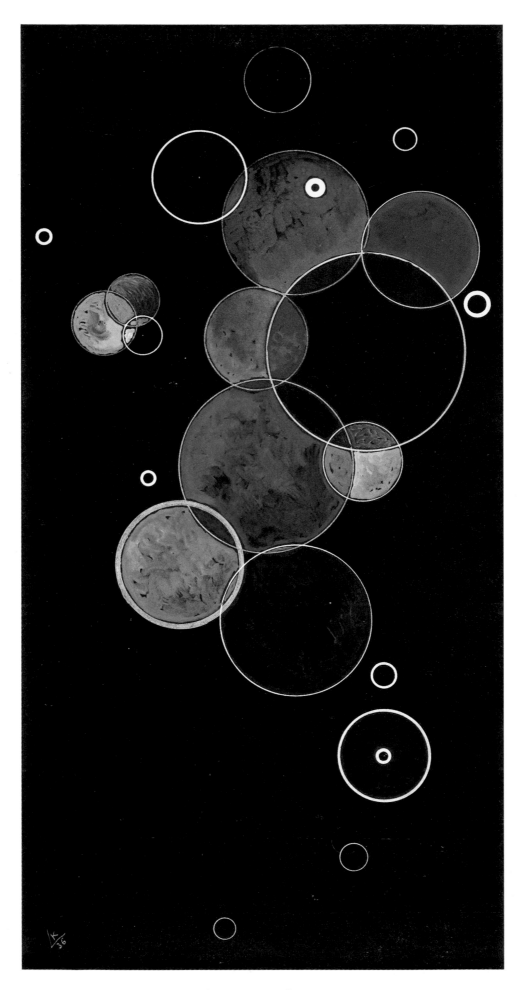

158 **Submissive Circles**, June 1936

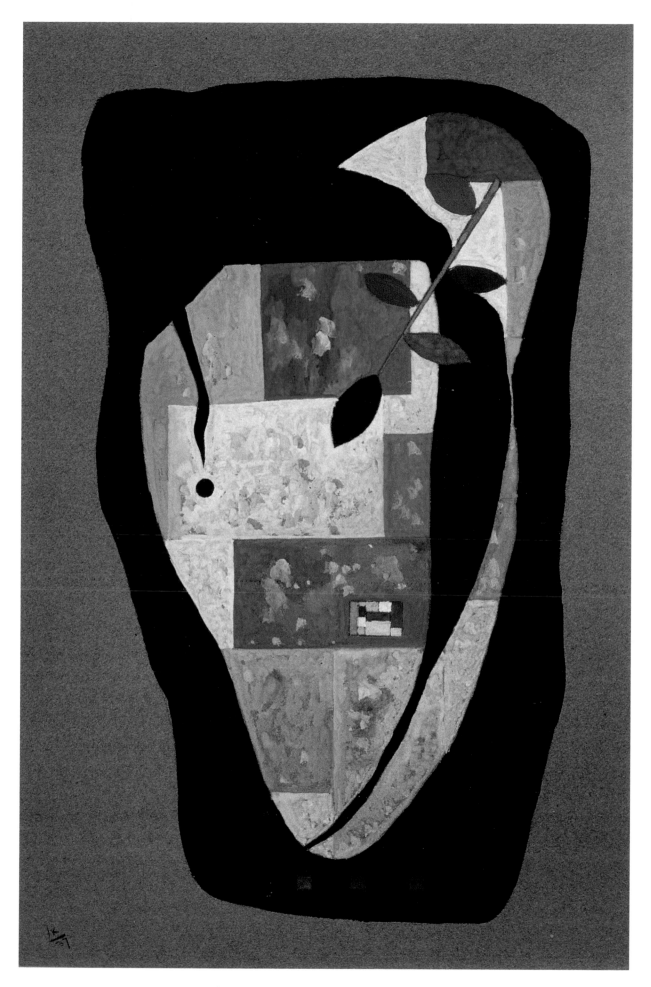

159 Black and Cold, 1937

160 **White on Black**, October 1937

161 **Above**, April 1938

162 **Fifteen**, April 1938

163 **White Zigzag**, May 1938

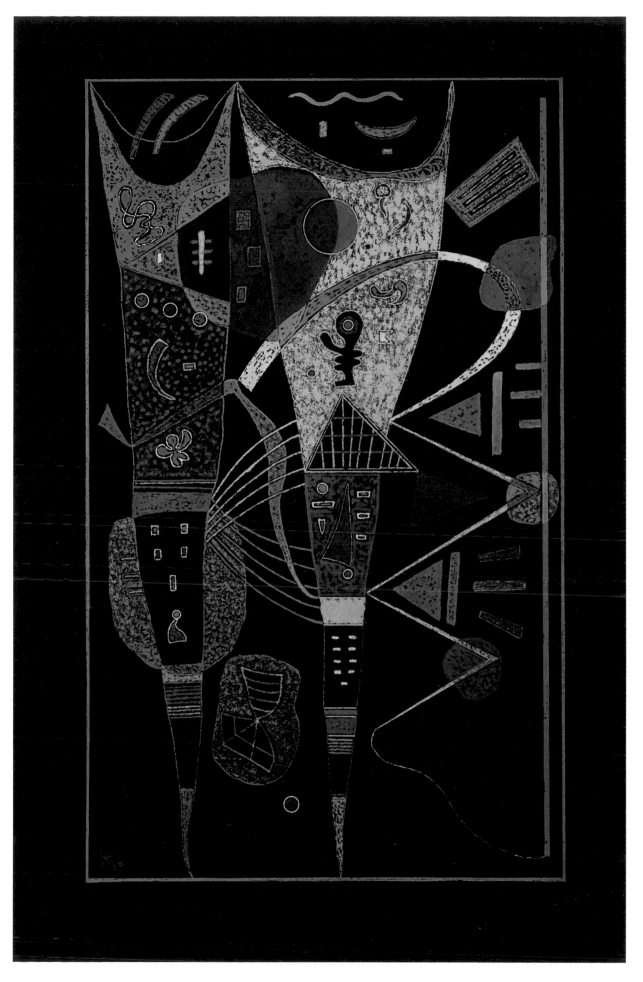

164　**Double Tension,** June 1938

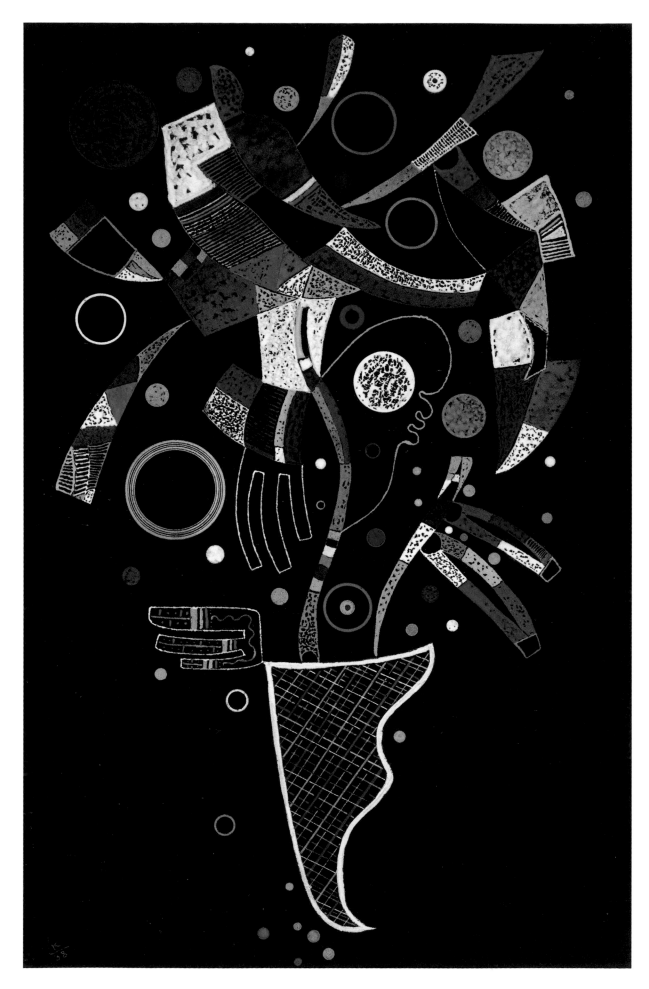

165 **Varied Strokes**, August 1938

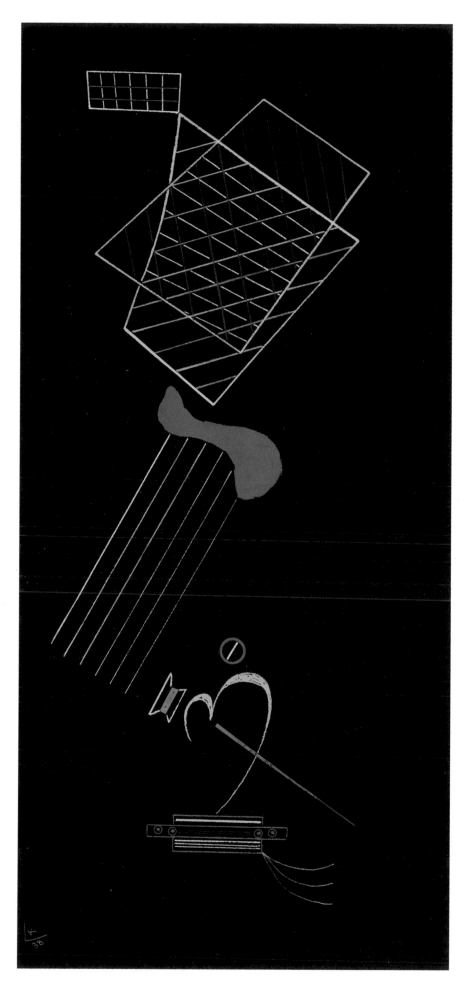

166 **Blue Spot**, December 1938

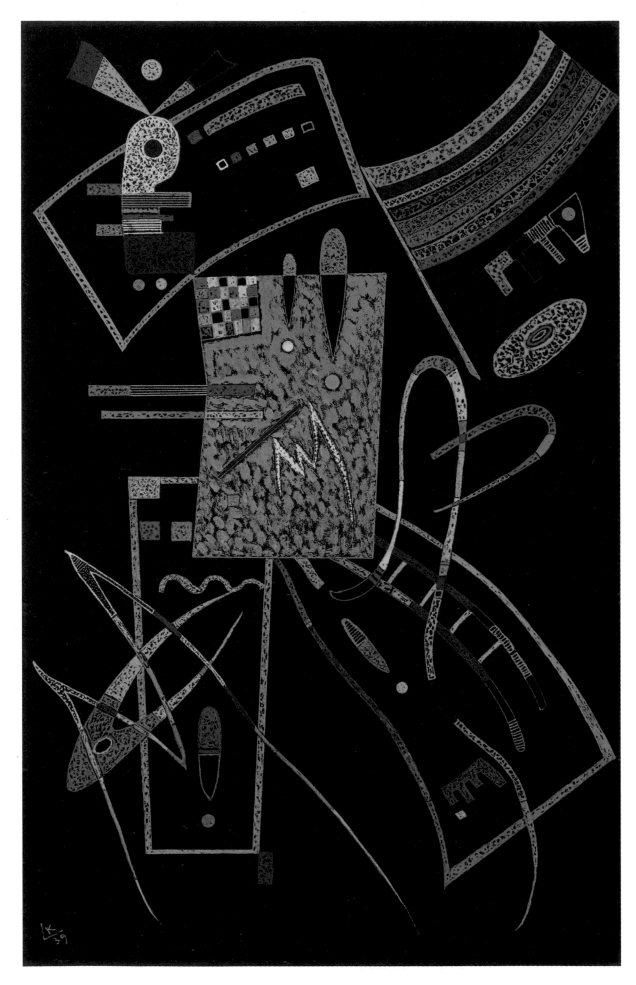

167 Around the Middle, February 1939

168 **White Form**, February 1939

169 **Cubes**, May 1939

170 **Lines**, May 1939

171 Horizontals, 1939

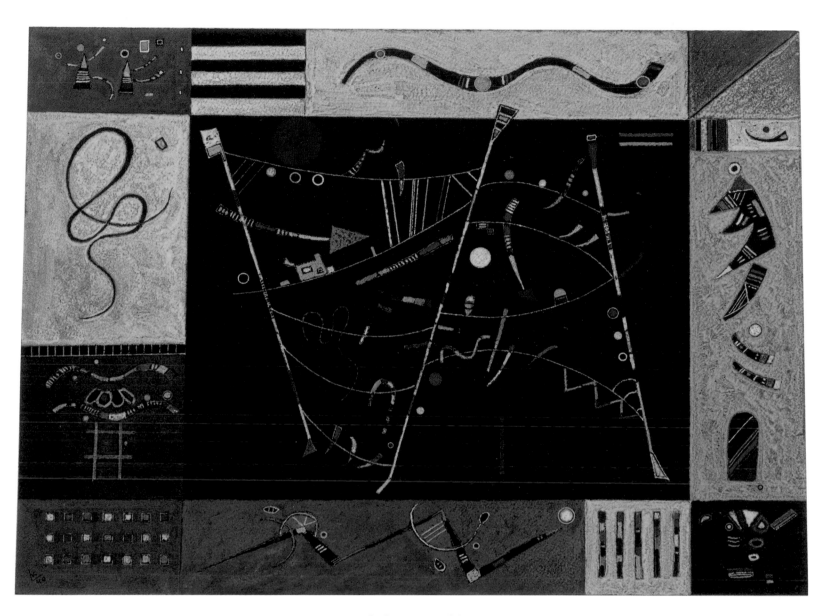

172 Study for "Ensemble", 1940

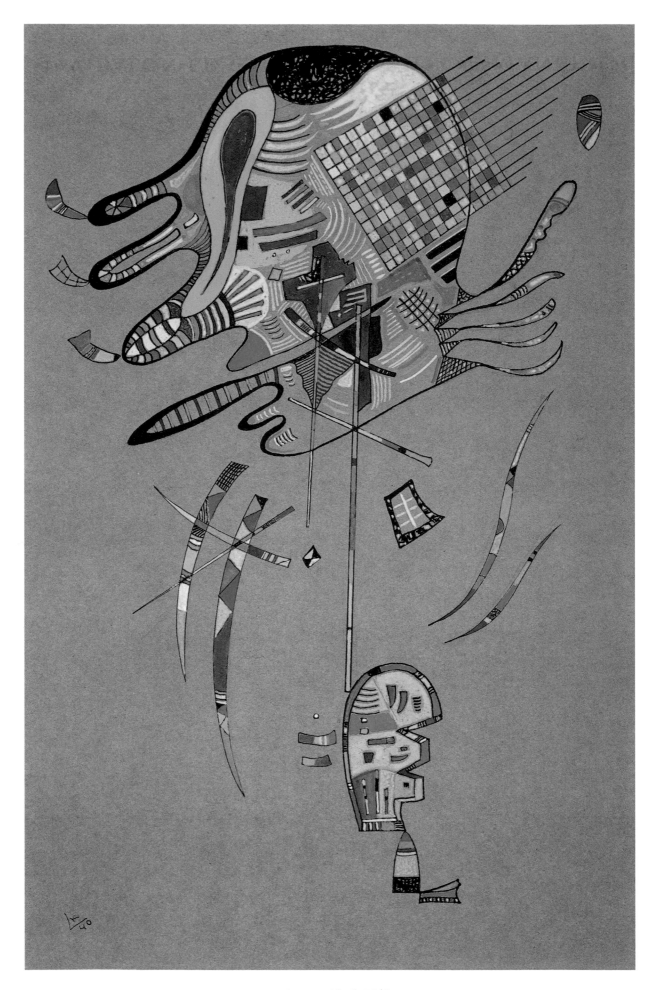

173 Untitled, 1940

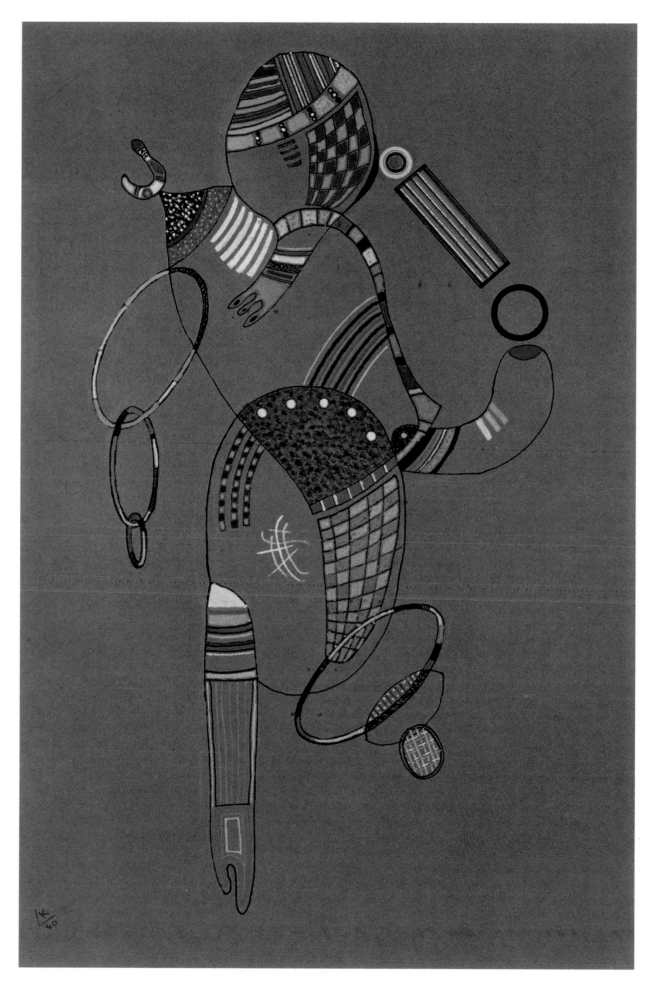

174 Untitled, 1940

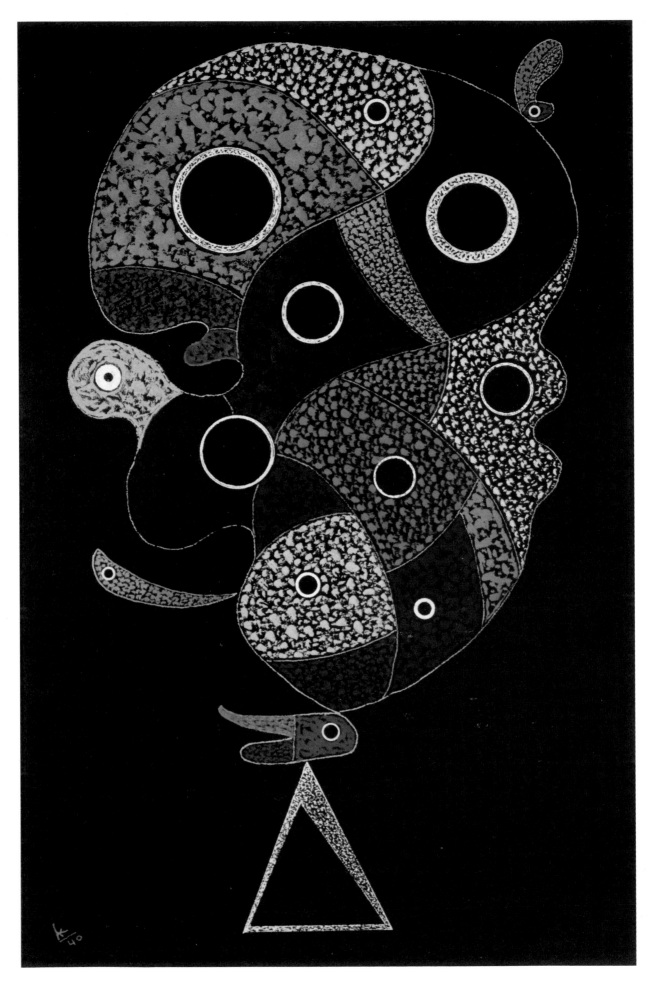

175 Untitled, 1940

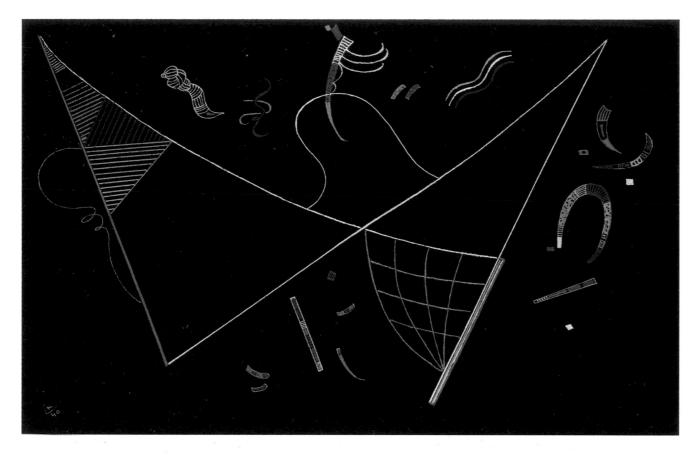

176 Untitled, 1940

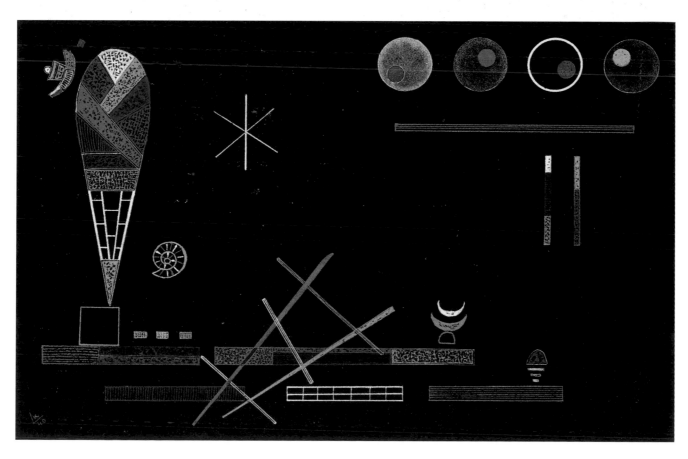

177 Untitled, 1940

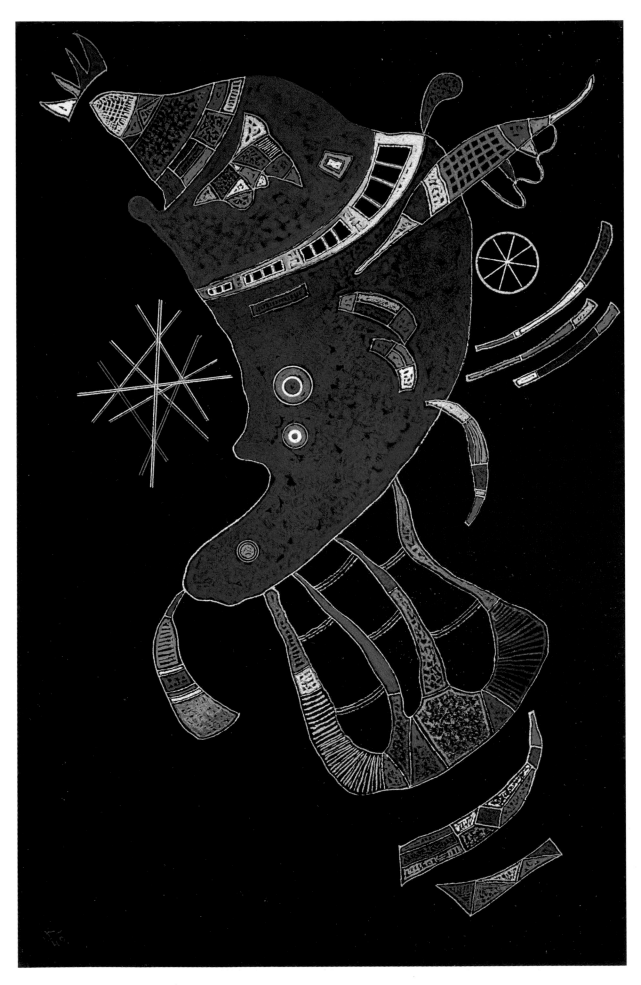

178 Untitled, 1940

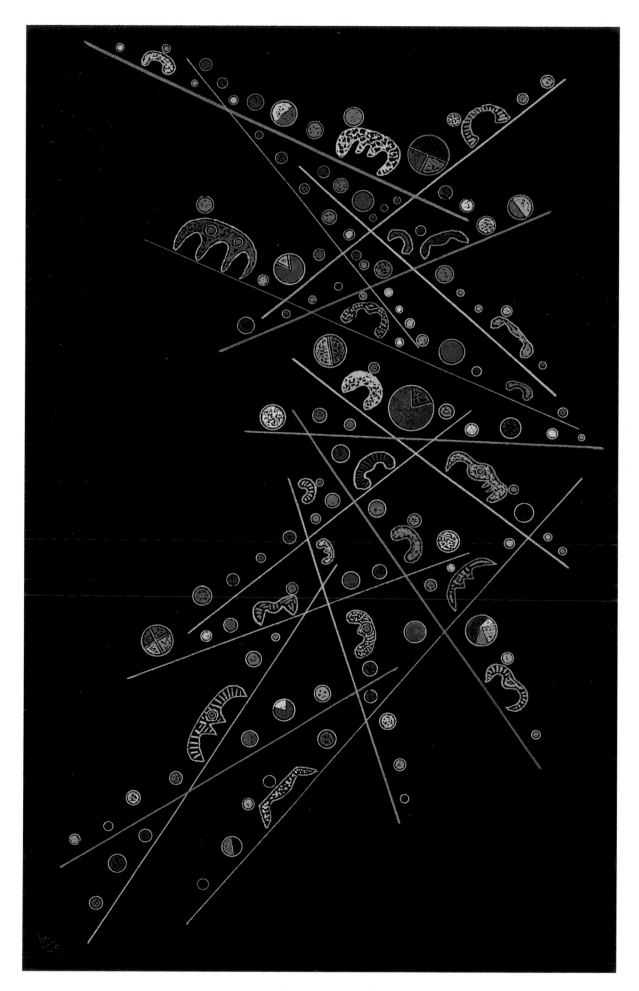

179 Untitled, 1940

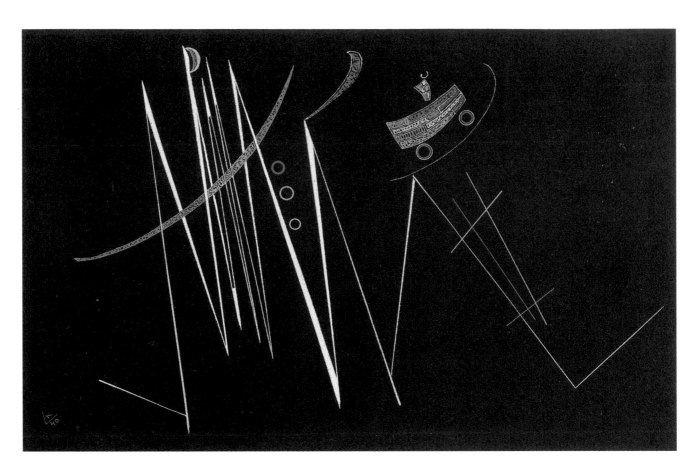

180 Pointed Movement, 1940

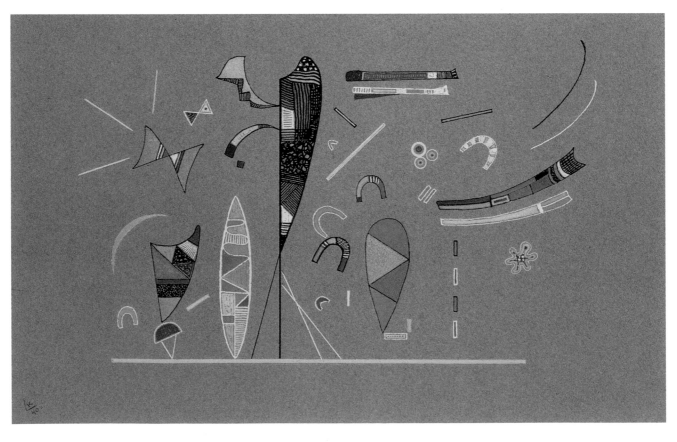

181 Untitled, 1940

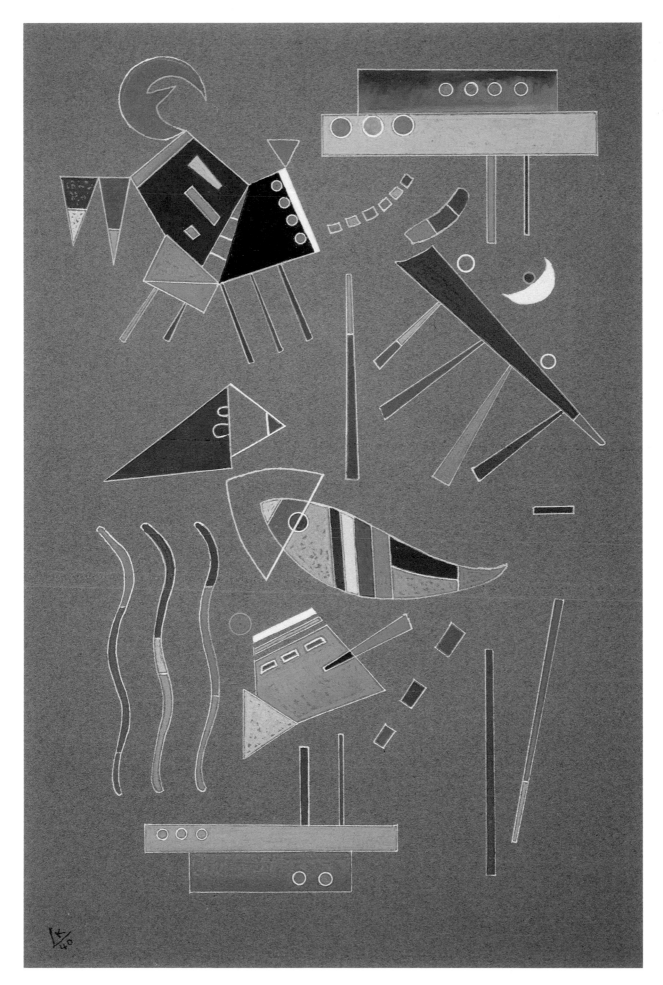

182 Untitled, 1940

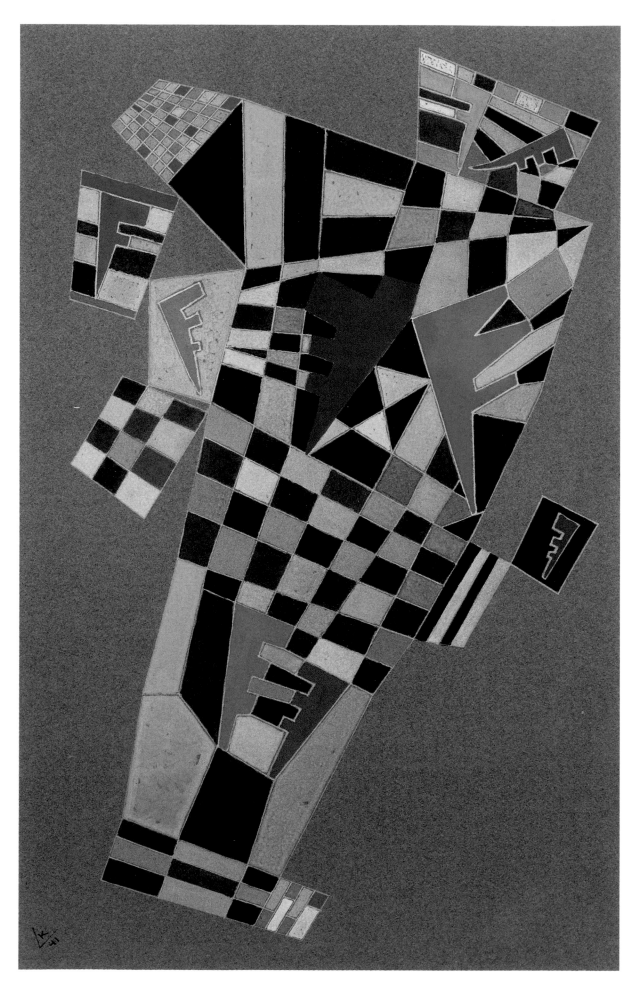

183 Untitled, 1941

184 Untitled, 1941

185 Untitled, 1941

186 Untitled, 1941

187 Untitled, 1941

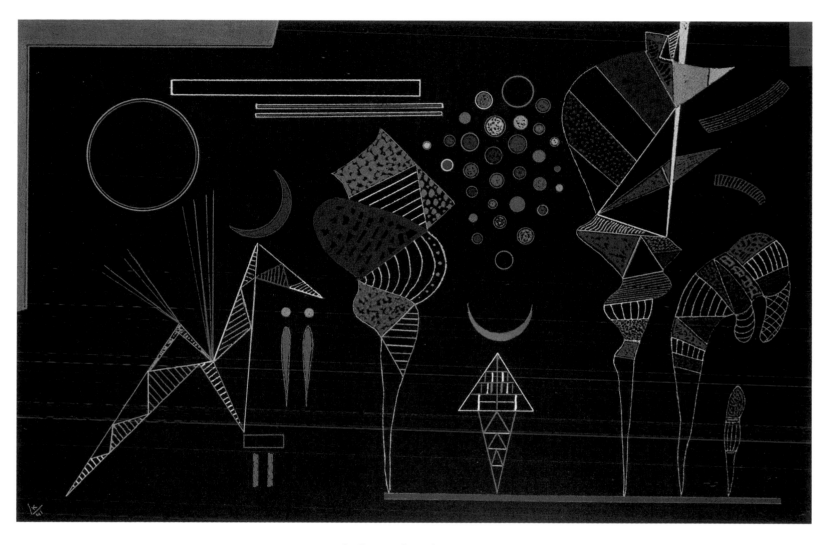

188 Study for "Reduced Contrasts", 1941

189 Untitled, 1941

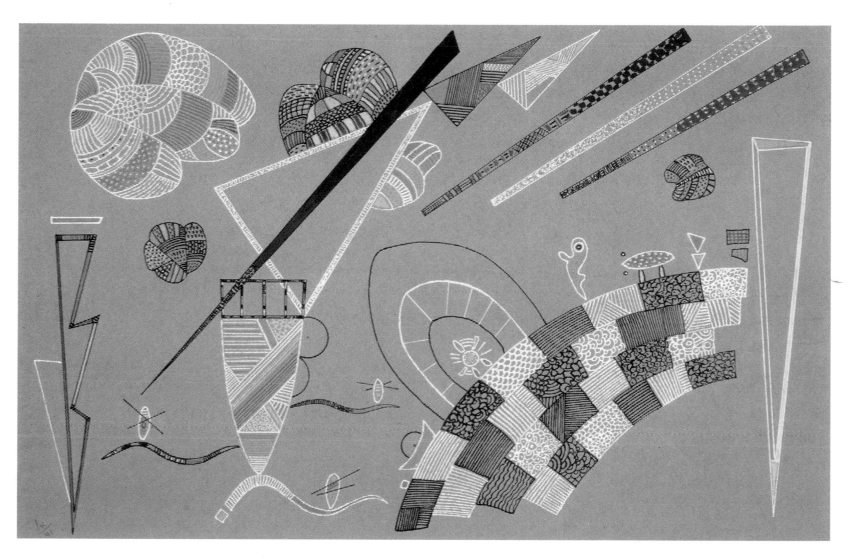

190 Untitled, 1941

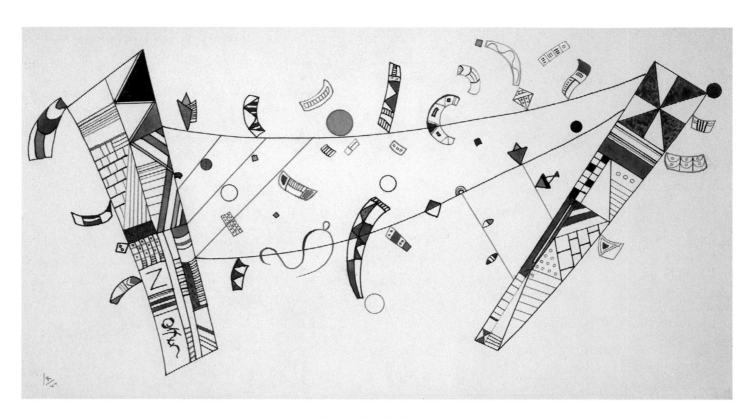

191 Untitled, 1944

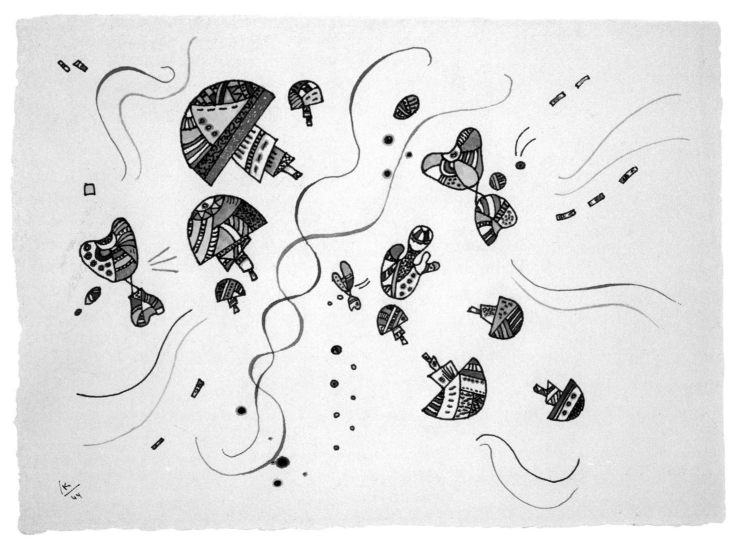

192 Untitled, 1944

Catalogue

by Vivian Endicott Barnett

Dimensions in centimeters
HL = Hauskatalog, Kandinsky's entry
in the Handlist of Watercolors (unless
otherwise specified)

1 Watercolor for Kojève, c. 1910-12
Aquarell für Kojève

Watercolor and india ink on paper, 21.6 x 33
Gift of the artist to his nephew,
Alexandre Kojève
Private collection

Kandinsky's love of fairytales is evident in
his early paintings of medieval subjects
with knights and in the Russian scenes he
depicted before 1908. He recalled that as a
child he had heard not only Russian but also
German fairytales, since his maternal grand-
mother was from the Baltic.

In 1911 the artist painted several glass
paintings with fanciful animals and delight-
ful figures: he made *Imaginary Bird and
Black Panther* for Gabriele Münter and *Lion-
Hunt* for her niece, Annemarie Rose. Prob-
ably around the same time Kandinsky did
this imaginative watercolor for his young
nephew, who later became known as the phi-
losopher Kojève. Born Alexander Kojevni-
koff (1902-68), he was brought up by his
mother in Moscow (his father Vladimir
Kojevnikoff had died in the Orient in 1905).
Kandinsky would have seen his nephew
during visits to Moscow in 1910 and 1912.
Kojève, who left Russia in 1920, studied
philosophy in Heidelberg and Berlin until
1926, when he moved to Paris.

This watercolor, which is exhibited here
for the first time, presents a young boy's fan-
tasy: a Viking ship with guns blazing, a tall
witch, towers within a walled citadel on a
dark mountain, a knight in armor next to a
castle, a mysterious sunset, and a small
scary man dressed in brown.

2 Study for "Composition II", c. 1910
Entwurf zu "Komposition II"

Watercolor and pencil on cardboard,
32.9 x 32.9
Städtische Galerie im Lenbachhaus, Munich

At first glance this watercolor appears to be
very abstract, but gradually a reclining fig-
ure dressed in red emerges in the fore-
ground, a green standing figure with arms
outspread appears at the upper left, and a
seated figure in the lower right foreground
becomes discernible. In the background
there is a tower with yellow-gold dome.
These images also recur in canvases that
Kandinsky painted in 1909/10, *Composition I*
and *Composition II*. This watercolor is
executed on cardboard similar to that used
for *Sound of Trumpets (Large Resurrection),
Nude* (cat. nos. 2, 3), and a study for the
cover of a Russian edition of *Sounds*. In
December 1910 Kandinsky and Vladimir
Izdebsky in Odessa worked on plans to
publish the *Sounds* woodcuts and poems in
Russian, but the book never appeared. This
watercolor can be dated around 1910 be-
cause of the cardboard support and because
of the similarity of the images to those in
Composition I, which was painted in January
1909 (formerly Otto Ralfs, Braunschweig),
and *Composition II*, which was painted
during the winter of 1909/10 (formerly
Botho van Gamp, Berlin). Both these can-
vases were destroyed during the Second
World War; only *Sketch for Composition II*
(formerly collection of Willem Beffie,

Amsterdam, now Solomon R. Guggenheim
Museum, New York) survives. There is also a
very similar pencil drawing with color-notes
for this watercolor in a sketchbook belong-
ing to the Städtische Galerie im Lenbach-
haus, Munich.

3 Sound of Trumpets
(Large Resurrection), 1910/11
*Klang der Posaunen
(Grosse Auferstehung)*

Watercolor, india ink, and pencil on card-
board, 32.5 x 32.5
Städtische Galerie im Lenbachhaus, Munich

4 Nude, 1910/11
Akt

Watercolor on cardboard, 33.1 x 33
Städtische Galerie im Lenbachhaus, Munich

5 With Three Riders, 1910/11
Mit drei Reitern

Watercolor and india ink on paper, 25 x 32
Städtische Galerie im Lenbachhaus, Munich

6 Study for Cover of "The Blue Rider"
Almanac, 1911
*Entwurf für den Umschlag des
Almanachs "Der blaue Reiter"*

Watercolor, gouache, and india ink on paper,
29 x 21
Private collection

Kandinsky and Franz Marc were co-editors
of *The Blue Rider Almanac*, which was pub-
lished in May 1912 by Reinhard Piper in
Munich. On the cover of the regular edition
there is a color woodcut by Kandinsky de-
picting a horse with rider, who resembles
St. George. Kandinsky made at least eleven
watercolor studies while working on the
cover design in late summer 1911. The final
watercolor study is dated September 19,
1911, and includes lettering. However, as
Kandinsky reported to Marc after a meeting
with the publishers: "Piper and Hammel-
mann are both very much against the word
'Almanac' and they are right. So I am going
to delete this word from the woodblock."
[Klaus Lankheit (ed.), *Wassily Kandinsky –
Franz Marc: Briefwechsel*, Munich 1983,
p. 60]

Kandinsky and Marc had begun to work
on the publication early in the summer of
1911. On June 19 Kandinsky wrote to Marc:
"Well now, I have a new plan. Piper must
handle publishing and both of us ... be the
editors. A sort of almanac (annual) with
reproductions and articles** contributed by
artists only." And he added: ** and *news*!! i.e.,
reports on exhibitions – reviews also written
by *artists*." [ibid., p. 40] Although the editors
hoped to prepare other almanacs, none was
published in subsequent years. The costs for
The Blue Rider Almanac were underwritten
by the collector Bernhard Koehler, who was
related to the artist August Macke.

7 Annunciation, c. 1911
Verkündigung

Watercolor, gouache, and india ink on paper,
22.5 x 16
Private collection

8 Announcement of the Blue Rider,
1911/12
Die Verkündigung des blauen Reiters

Watercolor on paper, 31.3 x 27
Acquired from Der Sturm by Felix or Georg
Muche, Berlin, c. 1920
Private collection

9 Boat, 1911/12
Boot

Watercolor, opaque white, india ink, and
pencil on paper, 33.4 x 32.1
Private collection

10 Study for "Improvisation 26
(Rowing)", 1911/12
*Entwurf zu "Improvisation 26
(Rudern)"*

HL: 1910, Les avirons
Watercolor and india ink on paper, 25 x 32.1
Musée National d'Art Moderne,
Centre Georges Pompidou, Paris:
Nina Kandinsky Bequest

11 Untitled, 1911/12

Watercolor and india ink on paper,
20.7 x 46.4
Private collection, New York

12 Untitled, 1911/12

Watercolor, ink, and pencil on paper,
31.5 x 48
Gift of the artist to Franz Marc before
4 February 1913. Later belonged to
Dr. Heinrich Stinnes, Cologne until 1938
Karl Ernst Osthaus Museum, Hagen

In a postcard to Kandinsky dated February
4, 1913, Marc thanks him for the gift of a
copy of *Sounds* and this watercolor. It is not
known exactly when Kandinsky gave the
work to his friend, or how long it remained
with Marc's widow. The watercolor resem-
bles others from 1911/12, with the troika
motif at the upper left, the wave-forms at the
lower left, and the rounded boats in the
middle. Although the work has faded over
the years, the deep blue-violet at the upper
right contrasts with the yellow oval and cir-
cular shapes.

In 1912/13 Kandinsky exchanged paint-
ings with Marc, Alexej Jawlensky, and Paul
Klee. He also gave a painting to Heinrich
Campendonk in 1911/12, and Münter gave
one of Kandinsky's watercolors to Elisabeth
and August Macke in July 1911.

13 Watercolor No. 3 (Garden of Love),
1911/12
Aquarell No. 3 (Liebesgarten)

Watercolor, india ink, and pencil on paper,
40.2 x 45.2
Städtische Galerie im Lenbachhaus, Munich

14 Watercolor No. 8 "Last Judgement",
1911/12
Aquarell No. 8 "Jüngster Tag"

Watercolor, india ink, and pencil on paper,
28.7 x 42.8
Städtische Galerie im Lenbachhaus, Munich

Kandinsky made hand-painted frames for
both *Watercolor No. 3* (cat. no. 13) and *Water-*

color No. 8 (cat. no. 14). Although the artist's frames for watercolors are rare, most of his glass paintings are preserved in their original frames. He painted the black frame for *Watercolor No. 8* with blue, gold, pink, and green colors, which complement the hues in the watercolor. The painted decoration resembles Bavarian folk art, which interested Münter and Kandinsky around 1908. That year, in late summer, they stayed for the first time in Murnau, a village 75 kilometers from Munich. Franz Marc and August Macke also made glass paintings in the manner of local folk art.

Watercolor No. 3 (Garden of Love) is a study for the oil painting *Improvisation 27 (Garden of Love II)* of 1912 and *Watercolor No. 8 "Last Judgement"* is related to the glass painting *Last Judgement,* also of 1912. The watercolors were numbered 3 and 8 in a list of works shown at the second "Blue Rider" exhibition which took place at Hans Goltz's gallery in Munich from mid-February to April 1912.

15 Paradise, 1911/12
 Paradies

Watercolor, india ink, and pencil on paper mounted on cardboard, 24 x 16 (30.1 x 20.5)
Städtische Galerie im Lenbachhaus, Munich

16 Mountain, 1911/12
 Berg

Watercolor, ink, and pencil on paper,
16 x 22.5
Formerly Dr. Ludwig Grote, Munich
Private collection

This watercolor presents in abstracted form the central motifs of Kandinsky's art around 1911/12. The mountain from which the work derives its name appears as a triangular shape in the center, red near the summit but also with green and blue areas. In the foreground there are two boats with rowers: the five figures are red in the boat on the left and blue in the one on the right. At the upper right three domed buildings stand on a hill, and at the left a dark spot obscures the sun. The artist has abstracted the images to such a degree that they are not immediately recognizable, and he has dissociated color and line from the objects they describe. The boats rise up with the waves, so that the rowers are seen against the mountain. In several watercolors depicting boats and waves, the theme of the Deluge emerges as one of the most significant in Kandinsky's art.

17 Untitled, c. 1912

Watercolor on paper, 23.6 x 34.3
Formerly Otto Ralfs, Braunschweig
Ulmer Museum, Ulm: on extended loan from State of Baden-Württemberg

18 Study for Blue Spot, 1912/13
 Etwurf zu Blauer Fleck

Watercolor, opaque white, and india ink on paper, 36.5 x 26.4
Private collection, New York

19 Untitled, 1912/13

Watercolor on paper, 35.7 x 39.7
Acquired from the artist
Private collection, Berne

Around 1912 Kandinsky's art was moving in the direction of total abstraction. Although there are clear landscape associations in this watercolor, it is hard to define specific objects. Suggestions of sun, sky, grass, foliage, an arch, and boldly colored oval and circular forms also occur in another untitled watercolor from the same time (cat. no. 17).

The arch in the middle and the vertical lines at the edge resemble those in the preparatory studies for *Improvisation 33* and *Improvisation 34* from 1913. Kandinsky made five watercolors (cat. no. 20) and a drawing that are closely related to the paintings, and which reflect certain compositional and iconographic elements already present in this watercolor.

20 Study for "Improvisation 34
 (Orient II)", 1913
 *Entwurf zu "Improvisation 34
 (Orient II)"*

Watercolor, india ink, and pencil on paper, 23.9 x 31.6
Probably acquired from Der Sturm by Hilla Rebay, 1916/17
The Hilla von Rebay Foundation

21 Drawing for "Painting with
 White Form", 1913
 *Zeichnung für "Bild mit weisser
 Form"*

India ink on paper, 26.6 x 37.4
R. L. Selle

22 Study for "Painting with
 White Form", 1913
 Entwurf zu "Bild mit weisser Form"

Watercolor and india ink on paper,
27.6 x 38.1
Probably acquired from the artist by Katherine S. Dreier, 1922
The Museum of Modern Art, New York:
Katherine S. Dreier Bequest

23 Study for "Painting with White
 Border", 1913
 Entwurf zu "Bild mit weissem Rand"

Watercolor, gouache, and india ink on paper, 39 x 35
Acquired by H. van Assenfeldt, Gouda, 1913
Art Gallery of New South Wales, Sydney

24 Study for "Painting with White
 Border", 1913
 Entwurf zu "Bild mit weissem Rand"

India ink on paper mounted on grey paper, 27.5 x 37.8
Städtische Galerie im Lenbachhaus, Munich

25 Study for "Painting with White
 Border", 1913
 Entwurf zu "Bild mit weissem Rand"

Watercolor, india ink, and black crayon on paper, 30.3 x 24.1
Städtische Galerie im Lenbachhaus, Munich

In an essay dated May 1913, Kandinsky describes the evolution of *Painting with White Border,* which he completed the same month. "For this picture I made numerous designs, sketches and drawings. I made the first design immediately after my return from Moscow in December 1912. It was the outcome of those recent, as always powerful impressions I had experienced in Moscow – or more correctly, of Moscow itself. This first design was very concise and restricted. But already in the second design, I succeeded in 'dissolving' the colors and forms of the actions taking place in the lower right-hand corner. In the upper left remained the troika motif, which I had long since harbored within me and which I had already employed in various drawings."[Translation from Lindsay and Vergo, vol. I, p. 389]

The three lines of the troika motif are prominent in the two watercolors, which can be placed early in the sequence of at least fifteen preparatory studies. The second watercolor (cat. no. 25) comes from a sketchbook and is inscribed by the artist at the upper right: "The same in watercolor (larger) in the possession of van Assendelft." The first watercolor (cat. no. 23) was acquired by the Dutch collector H. van Assendelft in 1913 and the second was done in a sketchbook in which Kandinsky made numerous studies the same year. Both watercolors resemble Kandinsky's oil *Sketch I for "Painting with White Border" (Moscow)* (formerly collection of Katherine S. Dreier, now The Phillips Collection, Washington, D.C.) rather than the final version of *Painting with White Border* (Solomon R. Guggenheim Museum, New York).

26 Study for "Small Pleasures", 1913
 Entwurf zu "Kleine Freuden"

India ink and pencil on paper, 24 x 24.7
Städtische Galerie im Lenbachhaus, Munich

27 Study for "Small Pleasures", 1913
 Entwurf zu "Kleine Freuden"

HL: Aq. pour "Petites Joies"
Watercolor and india ink on paper, mounted on cardboard, 23.8 x 24 (37.9 x 45.4)
Musée National d'Art Moderne,
Centre Georges Pompidou, Paris:
Nina Kandinsky Bequest

Kandinsky's oil painting *Small Pleasures* (formerly collection of Willem Beffie, Amsterdam, now Solomon R. Guggenheim Museum, New York) dates from June 1913. In an essay from the same time the artist explains that the canvas was based on an earlier glass painting *With Sun* and says of *Small Pleasures:* "I first made a drawing (I emphasized there the softness by means of fine and very fine lines) in order to eliminate the asymmetry in the large composition and to make this composition cool and its parts well balanced for the painting." (see cat. no. 26) Although he does not indicate what the pleasures are, he tells us: "My aim was in fact – to let myself go and to deluge the canvas with lots of small pleasures."

The bright colors and lively, almost playful lines make the watercolor appear even more joyous and carefree than the painting. The colorful towers of citadels stand atop

two mountains under a sunny sky; there is a rowboat at the lower right and a horse on the left. Although it is possible that the watercolor may have been painted after rather than before the canvas, the artist refers to it as "Aq. for 'Small Pleasures'" in his Handlist of watercolors.

28 Study for "Painting with White
 Lines", 1913
 Entwurf zu "Bild mit weissen Linien"

Watercolor, opaque white, and pencil on paper, 39.6 x 36
Gift of the artist, 1914
Germanisches Nationalmuseum, Nuremberg

29 Watercolor No. 13, 1913
 Aquarell No. 13

Watercolor on paper mounted on cardboard, 32.1 x 41

Probably acquired from the artist by Katherine S. Dreier, 1922
The Museum of Modern Art, New York: Katherine S. Dreier Bequest

30 Watercolor No. 14, 1913
 Aquarell No. 14

Watercolor and india ink on paper mounted on cardboard, 24.1 x 31.7
Probably acquired from the artist by Katherine S. Dreier, 1922
The Museum of Modern Art, New York: Katherine S. Dreier Bequest

In 1913 Kandinsky assigned nonspecific, generic titles with numbers to several works, including *Watercolor No. 13* and *Watercolor No. 14* (cat. nos. 29, 30), that can be related to the evolution of his monumental canvas *Composition VII* (Tretyakov Gallery, Moscow). The artist made approximately thirty works on paper (cat. nos. 30-34, 36) and six canvases while formulating the final picture, which he painted from November 25 to 28, 1913. *Watercolor No. 14* also closely resembles the glass painting *Last Judgement* of 1912. The themes of the Last Judgement, All Saint's Day, and the Deluge culminate in *Composition VII*.
 Watercolor No. 13 was one of the watercolors Kandinsky sent to the Germanisches Museum in Nuremberg in December 1913 so that the director could select two works to be donated by the artist; *Study for "Painting with White Border"* (cat. no. 28) was chosen instead. Katherine S. Dreier probably acquired this watercolor in 1922 from Kandinsky personally.

31 Study for "Composition VII", 1913
 Entwurf zu "Komposition VII"

India ink on paper mounted on gray paper, 21 x 33
Städtische Galerie im Lenbachhaus, Munich

32 Study for "Composition VII", 1913
 Entwurf zu "Komposition VII"

India ink on paper mounted on gray paper, 21 x 33.2
Städtische Galerie im Lenbachhaus, Munich

33 Study for "Composition VII", 1913
 Entwurf zu "Komposition VII"

Watercolor, india ink, and pencil on paper mounted on gray paper, 18.4 x 27.1
Städtische Galerie im Lenbachhaus, Munich

34 Study for "Composition VII", 1913
 Entwurf zu "Komposition VII"

Watercolor and india ink on paper, 39.2 x 46
Private collection

35 Watercolor with Red-Blue Stripes,
 1913
 Aquarell mit rotblauen Streifen

Watercolor and india ink on paper, 35.5 x 40.5
Acquired from Der Sturm by Nell Walden, Berlin, c. 1919
Private collection

36 Watercolor with Red Spot, 1913
 Aquarell mit rotem Fleck

HL: 1911. Aq. (avec tache rouge)
Watercolor on paper, 48.3 x 63.3
Deutsche Bank AG

Titled *Watercolor with Red Spot* by the artist, this large watercolor is also related to his masterpiece, *Composition VII.* As in the preceding watercolors (cat. nos. 33, 34), Kandinsky articulates abstract images which are synthesized in the final painting. The complexity of the composition can only be conveyed by the picture itself, which measures two by three meters. In some thirty works on paper, certain motifs are accentuated and explored. *Watercolor with Red Spot* emphasizes the overall compositional structure, featuring geometric forms and several bold red spots besides the large spot at the top center.

37 Untitled, c. 1914/15

Watercolor, india ink, and pencil on paper, 25 x 33.3
Private collection

38 Untitled, 1913

Watercolor, india ink, and pencil on paper, 44.8 x 35.5
Given by Gabriele Münter to Miz Wolfegg and Hans Hofmann, Munich and New York
Stephen Hahn Collection, New York

For many years this watercolor belonged to the artist Hans Hofmann (1880-1966), who lived in Bavaria until he moved to the United States in 1932, where he became a famous teacher and a central figure in American abstract art. In 1915 Hofmann opened the Hans Hofmann School of Visual Art in Munich. His girlfriend, Miz Wolfegg, was a friend of Gabriele Münter. She arranged for Hofmann to take care of works Kandinsky and Münter had to leave behind when they hastily departed for Switzerland on August 3, 1914. Probably after the war, Münter gave this watercolor as well as three Kandinsky paintings to her and Hans Hofmann in appreciation of their assistance. The watercolor is related to an earlier glass painting, *Glass Painting with Pince-nez* of 1912, which Kandinsky kept in his posses-

sion. More abstract than the glass painting, this watercolor has never been exhibited before.

39 Drawing for "Improvisation
 with Red and Blue Ring", 1913
 *Zeichnung für "Improvisation
 mit rot-blauem Ring"*

India ink on paper, 33 x 20.9
Private collection

40 Study for "The Horsemen of the
 Apocalypse II", July 6, 1914
 *Entwurf für "Apokalyptische
 Reiter II"*

Watercolor and india ink on paper, 22.2 x 14.3
Private collection

41 Untitled, 1915

Watercolor and india ink on paper, 33 x 22
Gift of the artist to his nephew
Alexandre Kojève
Private collection

42 Untitled, 1915

Watercolor and india ink on paper, 33 x 22
Gift of the artist to his nephew
Alexandre Kojève
Private collection

During 1915 Kandinsky executed only works on paper. Many, but by no means all, of his watercolors display an extreme degree of abstraction. The artist often used india ink alone (cat. no. 45) or combined with watercolor (cat. nos. 41, 42) to create total abstractions. The nervous, scratchy pen-lines recall his etchings from 1913/14, as well as *Light Picture* from December 1913. Many of the watercolors from 1915/16 were done on sketchpads or can be related to drawings in his Russian sketchbooks.

43 Untitled, 1915

Watercolor and india ink on paper, 22.7 x 33.8
Acquired from the artist, 1924
Graphische Sammlung Albertina, Vienna

44 Watercolor after "Painting with
 White Border", 1915
 *Aquarell nach "Bild mit weissem
 Rand"*

Watercolor and india ink on paper, 15.7 x 23.6
Private collection

In 1915/16 Kandinsky returned to his 1913 canvas *Painting with White Border* and painted four watercolors after the composition. This major painting, which was done in May 1913, was purchased by Franz Kluxen later the same year. In 1915 Kandinsky was in Russia and worked only with watercolor and india ink. This watercolor, which is shown here for the first time, retains the horizontal format and the diagonal lance or spear in the middle, but it omits the troika motif so essential to the painting. However, in another 1915 watercolor done after *Painting with White Border* (cat. no. 43), the forms of the troika and of the dragon are visible, and the curved line of the border is accentuated.

45 Untitled, 1915

India ink on paper, 33.4 x 22.8
Musée National d'Art Moderne,
Centre Georges Pompidou, Paris:
Nina Kandinsky Bequest

46 Untitled, 1915/16

Watercolor and india ink on paper,
22.5 x 33.5
Private collection

This is the only watercolor that Kandinsky signed and dated twice in such a way as to indicate a shift in the directionality of the work, which was originally vertical in format. The artist apparently changed his mind or reworked the composition in 1916, when he designated the horizontal orientation with the "K" monogram and the year at the lower left. During the war years the artist lived primarily in Moscow, and he created many works on paper where the oval compositions seem to rotate and have no strong sense of gravity (cat. nos. 51, 55).

47 Untitled, December 1915

HL (bagatelles): 2
Watercolor, india ink, and pencil on paper,
45 x 61
Acquired from Gummesons Konsthandel by
Johnny Roosval, Stockholm, 1916
Thyssen-Bornemisza Collection, Lugano

48 Watercolor for Poul Bjerre,
March 1916
Aquarell für Poul Bjerre

Watercolor and india ink on paper, 23 x 34.3
Gift of the artist to Dr. Poul Bjerre,
Stockholm, 1916
Private collection, Sweden

In the week before he left Stockholm on March 16, 1916, Kandinsky painted this unusual watercolor for the Swedish psychiatrist Dr. Poul Bjerre (1876-1964).According to Bjerre, the Swedish artist Ernst Norlind (1877-1952) is shown riding a horse in the middle and the doctor himself is portrayed at the right, staring intently at a stork, "which should be interpreted psychoanalytically as man picking at himself." The lake and farmhouse resemble Bjerre's country house outside of Stockholm; however, the dark brownish-blue treelike shape looming large in the foreground and the unearthly green tonality of the landscape and sky suggest symbolic undertones.

49 Birds, January 1916
Vögel

HL (bagatelles): 5 Vögel
Watercolor, india ink, and pencil on paper,
34.2 x 34.2
Acquired from Gummesons Konsthandel
by Arch. Stenhammer, Stockholm, 1916
Private collection

In the Handlist of "bagatelles" that Kandinsky compiled during his visit to Stockholm at the beginning of 1916, he listed fourteen watercolors. Although most of the bagatelles are fanciful, fairytale scenes, other are totally abstract. Like the preceding untitled work (cat. no. 47), Birds was first exhibited at Gummesons Konsthandel in Stockholm in February 1916. Kandinsky has executed both watercolors with meticulous attention to detail and with a spirit of fantasy. In several respects Birds recalls Small Pleasures (cat. no. 27), although it differs radically in style and in the presence of the birds at the lower left, which give the work its title.

50 Untitled, March 1916

HL: 1916, 9a
Watercolor on paper, 28.5 x 22
Private collection, New York

51 Untitled, 1916

Watercolor and india ink on paper, 23.8 x 16
Acquired from the artist by Rudolf Ibach,
Barmen
Etta and Otto Stangl Collection

52 Simple, 1916
Einfach

HL: 1916, 6, Einfach Simple
Watercolor and india ink on paper mounted
on cardboard, 24.4 x 30.5
Musée National d'Art Moderne, Centre
Georges Pompidou, Paris:
Nina Kandinsky Bequest

53 Concentrated, 1916
Konzentriertes

HL: 1916, 7, Konzentriertes
Watercolor on paper mounted on cardboard,
34 x 25.4
Acquired from Galerie Neue Kunst Fides,
Dresden, by Städtisches Museum für Kunst
und Kunstgewerbe, Halle, 1927
Staatliche Galerie Moritzburg Halle

54 Untitled, c. 1916

Watercolor, gouache, india ink, and pencil
on paper, 22.9 x 34
Orix Corporation

55 Untitled, 1916

India ink on paper, 23 x 16
Adrien Maeght, Paris

56 Untitled, 1916

India ink on paper, 18.5 x 24.5
Private collection

57 Untitled, 1917

Watercolor, opaque white, and india ink
on paper, 20.7 x 14
Acquired from the artist by Rudolf Ibach,
Barmen
Etta and Otto Stangl Collection

58 Untitled, 1917

Watercolor and india ink on paper, 30.8 x 21
Mr. and Mrs. Henry M. Reed Collection, USA

59 Untitled, September 1917

Watercolor, india ink, and pencil on paper,
34 x 25.5
Private collection

In September and October 1917 Kandinsky painted several dark, agitated canvases, such as Overcast, Twilight, Southern, and Gray Oval, that undoubtedly reflect the growing political tensions in Russia. During the summer Vasily stayed with his wife Nina at Achtyrka, where the relatives of his first wife had a dacha. There he made realistic landscape drawings, paintings of the church and other buildings, and a picture of Nina and her sister (Musée National d'Art Moderne, Paris). That autumn he inscribed more precise dates than usual on his works on paper. However, even the drawings dated October 23 and 24 seem unrelated to the impending revolution.

60 Madonna and Child, c. 1917
Madonna und Kind

Watercolor, gouache, and india ink on paper,
21.4 x 19.1 (image); 26.5 x 22.1 (sheet)
Private collection

Between 1915 and 1918 Kandinsky made a considerable number of fanciful, figurative works on paper, canvas, and glass. The same image as seen in this watercolor is presented in reverse in a glass painting (State Art Museum of Azerbaijan, Baku) dating from about 1917. The subject-matter of a Madonna and Child set against an exotic landscape is unexpected, but not unprecedented, in Kandinsky's work. The high mountains in the background also occur in the 1915 watercolor in the Handlist of "bagatelles" (cat. no. 47), and the palm-trees appear in other watercolors that Kandinsky painted in Russia.

In other glass paintings and watercolors from 1918 (cat. no. 61), elegantly dressed gentlemen in top hats and ladies in crinolines recall Kandinsky's earlier work done in Munich around 1904-06, as well as the bagatelles painted in Stockholm.

61 Untitled, 1918

Watercolor on cardboard, 26 x 44 (image);
35 x 52.5 (sheet)
Private collection

62 Study for "White Oval", January 1919
Entwurf zu "Weisses Oval"

Watercolor, india ink, and pencil on paper,
25.5 x 34.5
Private collection

In January 1919 Kandinsky painted White Oval (Tretyakov Gallery, Moscow), which is also known as Black Border. Although he had devised innovative borders for two or three prewar paintings, the distinctive oval compositions with borders on all sides were done between 1916 and 1921. By covering all four corners and framing the oval center with a curving border, he created Painting on Light Ground and Painting with Orange Border at the beginning of 1916 in Sweden, and developed the composition the following year in Gray Oval. Kandinsky also titled canvases Red Border, Red Oval, Green Border, and White Oval in 1921. This preparatory watercolor and those for Green Border (cat. no. 65) are remarkably close to the final paintings.

63 Untitled, August 2, 1919

Watercolor and india ink on paper,
18.9 x 30.5
Peter Blum Collection, New York

64 Study for "Blue Segment", 1919
Entwurf zu "Blaues Segment"

Watercolor and india ink on paper,
24.3 x 31.5
Private collection

65 Study for "Green Border", 1919
Entwurf zu "Grüner Rand"

HL: 1919, 11, Le bord vert
Watercolor and india ink on paper,
25.6 x 33.4
Private collection, New York

66 Untitled, 1920

Watercolor and india ink on paper, 24 x 19
Private collection, Switzerland

67 Study for "Red Spot II", 1921
Entwurf zu "Roter Fleck II"

HL: 1921, Entwurf zu "Roter Fleck" No. 234
Watercolor on paper, 19.1 x 22.9
Acquired by Dr. Hans Lühdorf, Dusseldorf,
August 1941
Kunstmuseum Dusseldorf im Ehrenhof

In 1913 Kandinsky had made a watercolor
study for *Red Spot* and *Watercolor with Red
Spot* (cat. no. 36) and several paintings with
blue and green spots. The canvas *Red Spot II*
(Städtische Galerie im Lenbachhaus,
Munich) is based upon, and is almost identi-
cal with, the present watercolor. Likewise,
the artist executed watercolor studies before
painting *Blue Segment* (cat. no. 64), *Green
Border* (cat. no. 65), *Circles on Black,* and
Black Spot in 1919-21. Although Kandinsky
did not paint any canvases in 1918, he made
detailed watercolors for *White Oval* (cat. no.
62) and *In Gray* of 1919.

68 Untitled, 1921

Watercolor, india ink, and pencil on paper,
30.4 x 24.4
Acquired through the Kandinsky-
Gesellschaft by Dr. Richard Doetsch-
Benziger, Basle
Öffentliche Kunstsammlung,
Kupferstichkabinett, Basle:
Gift of Dr. Richard Doetsch-Benziger

69 Study for "Small Worlds I", 1921
Entwurf zu "Kleine Welten I"

Watercolor, india ink, and pencil on paper,
23 x 31
Private collection

70 Study for "Small Worlds IV", 1922
Entwurf zu "Kleine Welten IV"

Watercolor and ink on paper, 27.3 x 23.5
Fridart Foundation

71 Study for "Small Worlds VII", 1922
Entwurf zu "Kleine Welten VII"

Gouache on black paper, 27 x 23.5 (image),
32.5 x 25 (sheet)
Private collection

At the Bauhaus in the autumn of 1922 Kan-
dinsky prepared a portfolio of twelve
prints, *Small Worlds,* which was published
by Propyläen in Berlin. There exist studies
for three color lithographs (cat. nos. 69-71)
as well as several pencil drawings; the *Study

for "Small Worlds I"* is dated 1921. In 1923
Kandinsky made watercolors for his prints
Blue and *Blue in Violet* (cat. no. 79).

72 Untitled, 1922

Watercolor, gouache, and india ink on paper,
34 x 24
Fridart Foundation

73 Untitled, 1922

HL: 1922, 44
Watercolor, india ink, and pencil on paper,
26.9 x 36.6
Gift of the artist to Emilio Cargher,
January 2, 1923; subsequently belonged to
Peggy Guggenheim, London
The Hilla von Rebay Foundation

74 Watercolor for Gropius, 1922
Aquarell für Gropius

Watercolor and india ink on paper,
32.5 x 47.8
Gift of the artist to Walter Gropius, Weimar
Private collection, Monte Carlo

75 Untitled, 1923

India ink on paper, 21.5 x 30.5
Private collection

76 Untitled, 1923

HL: 1923, 48
Watercolor and india ink on paper,
36 x 25.3
Gift of the artist to Gottfried Galston
Kawamura Memorial Museum of Art, Sakura

77 Two Black Spots, February, 1923
Zwei schwarze Flecke

HL: ii 1923, 57, 2 schwarze Flecke
Watercolor and india ink on paper,
47.5 x 32.7
Gift of the artist to Sophie Küppers,
Hanover, February 1924
P. H. Bendix Collection, Bergisch-Gladbach

At first glance Kandinsky's title *Two Black
Spots* might seem puzzling, since the large
black irregular shape at the upper right so
dominates the composition. Only after look-
ing carefully does one see the small black
square at the lower left that balances the
composition. Kandinsky has painted a dark
green-gray band diagonally across the sheet,
which boldly divides it, and against which
colorful details are contrasted.
 In February 1924 Kandinsky gave this
watercolor to Sophie Küppers, the widow of
Paul Küppers, who had been director of the
Kestner-Gesellschaft in Hanover. At that
time she was a close friend of El Lissitzky,
whom she later married, and she assisted
with the exhibition of Russian art that took
place at the Neue Galerie in Vienna.

78 Dream Motion, March 1923
Träumerische Regung

HL: iii 1923, 61, Träumerische Regung
Watercolor, india ink, and pencil on paper,
46.6 x 40
Acquired through the Kandinsky-Gesell-
schaft by Dr. Heinrich Stinnes, Cologne,
1926
Solomon R. Guggenheim Museum, New
York: Gift of Solomon R. Guggenheim, 1938

79 Blue in Violet, March 1923
Blau in Violet

HL: iii 1923, 63, Blau in Violett – Litho
Watercolor, gouache, and india ink on tan
paper, 31.7 x 21.5
Gift of the artist to Hugo Erfurth, Dresden
Wellesley College Museum, Wellesley,
Massachusetts: The Dorothy Braude Edin-
burg (Class of 1942) Collection

80 Untitled, April 1923

HL: iv 1923, 66
Watercolor and india ink on paper, 46 x 42
Private collection, Switzerland

81 Arrowform to the Left, May 1923
Pfeilform nach links

HL: v 1923 73, Pfeilform nach links
Watercolor and india ink on paper,
42.5 x 47.5
Private collection

Arrowform to the Left anticipates Kandin-
sky's oil painting *The Arrow Shape* from
May/June 1923. In the canvas, however, the
arrowform and colored stripes go toward the
right. The emphasis on circles and other geo-
metric forms, which was already discernible
in Kandinsky's art during the preceding
years, becomes dominant in 1923. Kandin-
sky's drawing of circles (cat. no. 83) dates
from this year, as does the watercolor *Dream
Motion* (cat. no. 78), where circles, triangles,
angles, and rectangle overlap. However,
objects are not totally absent from the
artist's work, as is indicated by the sugges-
tions of boats in both this work and *Dream
Motion.*

82 Untitled, 1923

Watercolor and india ink on paper, 33 x 37
Galerie Thomas

83 Untitled, 1923

India ink and crayon, 32.1 x 23.2
Musée National d'Art Moderne,
Centre Georges Pompidou, Paris:
Nina Kandinsky Bequest

84 Study for "Composition VIII",
July 1923
Entwurf zu "Komposition VIII"

HL: vii 1923, 81
Watercolor and india ink on paper, 47 x 42.5
Private collection

85 Untitled, 1923

India ink and pencil on paper, 37.6 x 36.7
Musée National d'Art Moderne, Centre
Georges Pompidou, Paris: Nina Kandinsky
Bequest

86 Study for "In the Black Square",
July 1923
Entwurf zu "Im schwarzen Viereck"

HL: vii 1923, 84
Watercolor and india ink on paper, 36.8 x 36
Private collection

According to Kandinsky's Handlist, he paint-
ed both of these watercolors (cat. nos. 84,
86) in July 1923. Although they are not
given titles in the Handlist, they are closely
related to major oil paintings on which the

artist was working in June and July, *Composition VIII* and *In the Black Square.* In preparing the large canvas *Composition VIII* (Solomon R. Guggenheim Museum, New York), Kandinsky made several related sketches, including the study for the right side of the painting (cat. no. 84). The watercolor for *In the Black Square* corresponds more closely to the painting and may have even been done after the canvas.

87 Black Triangle, November 1923
Schwarzes Dreieck

HL: xi 1923, 104, Schwarzes Dreieck
Watercolor and india ink on paper,
30.8 x 40.5
Private collection, Stuttgart

88 Untitled, 1923

HL: 1923, 109c
Watercolor and india ink on paper,
33 x 47.5
Private collection

89 All Around, January 1, 1924
Ringsum

HL: 1 i 1924, 110, Ringsum
Watercolor, gouache, and ink on paper,
35 x 25
Gift of the artist to his lawyer,
Joseph Wolfsohn, Berlin, June 1924
Galerie Thomas

90 Heavy Falling, January 1924
Schweres Fallen

HL: i 1924, 111, Schweres Fallen
Watercolor and india ink on paper,
34.4 x 24.4
Formerly Museum in Dessau
Private collection

91 Floating, February 1924
Schweben

HL: ii 1924, 118, Schweben
Watercolor and india ink on paper, 30 x 40
Gift to the artist's niece Lidia Méla,
June 1930
Private collection, New York

92 Study, April 1924
Entwurf

HL: iv 1924, 133, Entwurf
Watercolor, india ink, and pencil on paper,
22 x 18
Private collection

93 Strings, April 1924
Streicher

HL: iv 1924, 136, Streicher
Watercolor and india ink on paper, 35 x 24.5
Acquired through the Kandinsky-
Gesellschaft by Dr. Hermann Bode,
Hanover, December 1925
Renate Pünjer Collection

94 Bright Lucidity, May 1924
Helle Klarheit

HL: v 1924, 139, Helle Klarheit, Lucidité
Watercolor, gouache, and india ink on paper,
50.7 x 36.5
The Hilla von Rebay Foundation

By 1924 Kandinsky's titles for the watercolors become more complex, conceptual, and poetic. The titles *Bright Lucidity* and *Joyful Structure* (cat. no. 95) are more evocative and individual than those assigned to earlier works. Kandinsky gave specific titles in German to his watercolors and paintings until he moved to Paris and when he resumed work there early in 1934 he used French titles. In the Handlist of watercolors the artist sometimes added a French title: "Lucidité" was inserted after "Helle Klarheit".

In both German and French titles Kandinsky often combines contrasting or contradictory elements. The title *Heavy between Light* (cat. no. 97) resembles those of a 1929 oil painting, *Light in Heavy* and a 1930 painting, *Heavy and Light.* In the titles for both canvases and watercolors he played with words: for example, *Hard, but Soft, Hard in Soft, Hard-Soft, Small Hard-Soft, Soft Hard, Softened Hard,* and *Soft Hardness.* And occasionally he repeats a title.

95 Joyful Structure, July 1924
Fröhlicher Aufbau

HL: vii 1924, 148 Fröhlicher Aufbau
Watercolor and india ink on paper, 35 x 23
Private collection

96 Brown, June 1924
Braun

HL: vi 1924, 147, Braun
Watercolor and gouache on paper, 48 x 32
Formerly Heinrich Kirchhoff, Wiesbaden
Private collection

97 Heavy between Light, June 1924
Schweres zwischen Leichtem

HL: vi 1924, 145, Schweres zwischen
Leichtem, Lourd entre léger
Watercolor, gouache, and india ink on paper,
34 x 48.5
Formerly Galka E. Scheyer, Los Angeles
Private collection

98 Cool Yellow, October 1924
Kühles Gelb

HL: x 1924, 156 Kühles Gelb
Watercolor, and india ink on paper, 22 x 18
Gift of the artist to Paul Klee,
December 18, 1924
Private collection, Australia

When Kandinsky and Klee were both teaching at the Bauhaus, they gave each other works of art. They exchanged works on paper in November 1923, and the following year Kandinsky gave the watercolor *Cool Yellow* to Klee for his birthday on December 18, 1924. In 1927 Kandinsky's present to Klee was *Circles in Black* of 1924 (cat. no. 100); he had recently received Klee's watercolor *Letter-Picture,* where the inscription reads "To Mr. Kandinsky in *Dessau*", with "Moscow", "Munich", and "Weimar" crossed out above (Musée National d'Art Moderne, Paris). Kandinsky also gave watercolors to Klee on his birthdays from 1928 to 1932. *Toward Green* (cat. no. 122) is one of two watercolors presented to Klee on the occasion of his fiftieth birthday in 1929. Two years later Kandinsky chose *Peaceful* (cat. no. 129) for his friend's birthday.

99 Vibration, October 1924
Vibration

HL: x 1924, 160, Vibration
Watercolor and india ink on paper,
48.5 x 33.6
Acquired by Walter Arensberg,
November 1931
Philadelphia Museum of Art:
Louise and Walter Arensberg Collection

100 Circles in Black, October 1924
Kreise im Schwarz

HL: x 1924, 163, Kreise im Schwarz
Watercolor, gouache, and india ink on paper,
34.5 x 22.5
Gift of the artist to Paul Klee,
December 18, 1927
E. Cefis, Zurich

101 Bent Point, November 1924
Gebogene Spitze

HL: xi 1924, 174, Gebogene Spitze
Watercolor and india ink on paper,
34.2 x 22.5
Gift of the artist to Dr. Will Grohmann,
Dresden, December 1924
Private collection

Kandinsky gave this watercolor to the art historian Dr. Will Grohmann (1887-1968) in December 1924. That year Grohmann had published articles on the artist in *Jahrbuch der Jungen Kunst* and *Der Cicerone*; he later wrote a monograph which appeared in Paris in 1930, and published the definitive *Wassily Kandinsky: Leben und Werk* in 1958. The correspondence between the two men, which belongs to the Staatsgalerie in Stuttgart, dates from 1923 to 1943: the letters give a sense of their friendship and mutual respect. Like Kandinsky, Grohmann was born on December 4, but was twenty-one years younger than the artist. In 1926, the year of his own sixtieth birthday exhibitions, Kandinsky gave Grohmann the oil painting known as *Homage to Will Grohmann* (Staatsgalerie, Stuttgart). *Tense* (cat. no. 128) was a present to Grohmann's wife in 1931, and *Braided* (cat. no. 149) was dedicated to "the respected and dear friend Dr. Will Grohmann" in Paris in October 1937.

102 Brown Double Sound,
 November/December 1924
Brauner Doppelklang

HL: xi–xii 1924, 176, Brauner Doppelklang
Watercolor, india ink, and pencil on paper,
48.5 x 33.3
The Hilla von Rebay Foundation

Kandinsky used the term "Doppelklang" in 1911 in *On the Spiritual in Art* and again fifteen years later in *Point and Line to Plane.* In the former he writes "As regards the two notes (a spiritual chord) sounded by the two constituent elements of the form, the organic may either reinforce the abstract (by means of consonance or dissonance) or disturb it." And in the latter he refers to "two voices resounding in one form, i.e., the creation of a two-part melody by means of one form". He also explains here that the "dual nature of the sound becomes audible: 1) absolute sound of the point and 2) sound of its given position upon the surface".

In the manuscript for *Point and Line to Plane*, which was completed in November 1925, Kandinsky also speaks of "Zweiklang" to refer to a dual sound when two tones are sounded together, and to "Dreiklang" for triple sound. Although Kandinsky does not write about the color brown, it appears in several titles, for example, *Brown* (cat. no. 96) and *Development in Brown* (cat. no. 145).

103 Central Line, November 1924
Strich Zentraler

HL: xi 1924, 175, Strich zentraler
Watercolor and ink on paper, 34.6 x 22.9
Gift of the artist to Alexej Jawlensky, February 1924
Ingrid Hutton, New York

104 Untitled, 1924

India ink on paper, 24.5 x 34.3
Max Bill, Zumikon

105 Inner Simmering, November 1925
Inneres Kochen

HL: xi 1925, 194, Inneres Kochen (rot)
Watercolor, india ink, and pencil on paper, 48.4 x 32.1
The Hilla von Rebay Foundation

Kandinsky's title, *Inner Simmering*, derives from his writings. In his essay on "Painting with White Border" which was written in May 1913, the artist refers to the lower left where "there is a battle in black and white, which is divorced from the dramatic clarity of the upper left-hand corner by Naples yellow. The way in which black smudges rotate within the white I call 'inner simmering within a diffuse form.'"

The term reappears in *Point and Line to Plane* where Kandinsky states that "red is distinguished from yellow and blue by its tendency to lie firmly upon the surface; from black and white by its intensive, inner simmering and its tension within itself." As the artist noted in his Handlist, the color of *Inner Simmering* is red. It dates from November 1925, when Kandinsky completed the manuscript for *Point and Line to Plane*.

106 Checkered, December 1925
Kariertes

HL: xii 1925, 203 Carriertes
Watercolor and india ink on paper, 48.5 x 32.5
Acquired from the artist by Robert Olsen, Copenhagen, September 1937
Maxime Seligmann, Paris

In his Handlist of watercolors Kandinsky records the title of this work as "Carriertes" and the date as December 1925. Although he does not mention the painting there, the artist returns to the distinctive checkerboard motif in January 1927 in a remarkably similar oil painting entitled *Square*. The canvas retains the bold design of three superimposed checkerboards, although it omits the dark triangle at the upper right of this watercolor and changes the specific color-patterns of the earlier work. Each checkerboard is presented at a different angle to create conflicting planes in space.

In 1920 Kandinsky had adopted the black and white checkerboard pattern, which is familiar from Russian icon painting. After he returned to Germany he developed its compositional possibilities in *Study for "Small Worlds IV"* (cat. no. 70) and an untitled watercolor and drawing from 1923 (cat. nos. 75, 76). At the Bauhaus, Kandinsky expanded the coloristic possibilities; he no longer limited the checkerboard to a detail but made it the entire picture.

107 Upward, December 1925
Hinauf

HL: xii 1925, 207, Hinauf
Watercolor and india ink on paper, 48.4 x 31.8
Private collection, New York

108 Rising Warmth, September 1927
Aufsteigende Wärme

HL: ix, 1927, 212, Aufsteigende Wärme
Watercolor, india ink, and pencil on paper, 25.3 x 36
The Hilla von Rebay Foundation

109 Zigzag, January 1926
Zickzack

HL: i 1926, 209, Zickzack
Watercolor, gouache, and india ink on paper, 44.4 x 32
Acquired through the Kandinsky-Gesellschaft by Otto Ralfs, Braunschweig, 1926; subsequently acquired by Dr. Richard Doetsch-Benziger, Basle, 1932
Private collection

110 Small Pictures, October 1927
Kleine Bildchen

HL: x 1927, 227, Kleine Bildchen
Watercolor and india ink on paper, 48.1 x 32.1
Acquired through the Kandinsky-Gesellschaft by Rudolf Ibach, Barmen, 1927/28
W. Wittrock Kunsthandel, Dusseldorf

The composition of *Small Pictures* is particularly innovative in Kandinsky's art, and the concept of smaller paintings within a painting occurs in several later works. Within a narrow black border, the artist has divided the sheet into six vertical rows of three horizontal spaces. Within each of the eighteen compartments he has drawn a small work of art in ink over the pale watercolor background. None of these eighteen small pictures within the picture appears to be identical with other works by Kandinsky. However, the motif in the second row center resembles that in the watercolor *Vertical Structure* of 1927, the many small circles and the curving lines recall diagrammatic drawings for *Point and Line to Plane* and the zigzag motif occurs in drawings and watercolors such as *Zigzag* from 1926 (cat. no. 109). The compartmentalized composition recurs in works from the Paris period: for example, the 1937 oil painting *Thirty* and the 1938 gouache *Fifteen* (cat. no. 162).

Stylistically, *Small Pictures* contrasts dramatically with both *Adhering* (cat. no. 111) which was also painted in October 1927, and *Semicircle* (cat. no. 112) which is the next watercolor in the Handlist.

111 Adhering, October 1927
Haftend

HL: x 1927, 222, Haftend
Watercolor, gouache, and india ink on paper, 48.3 x 32.3
Formerly Ludwig Gutbier, Dresden and Munich
Private collection

112 Semicircle, November 1927
Halbkreis

HL: xi 1927, 228, Halbkreis
Watercolor and ink on paper, 55.9 x 33
Acquired through the Kandinsky-Gesellschaft by Otto Ralfs, Braunschweig, 1927/28
Los Angeles County Museum of Art, David E. Bright Bequest

113 Meeting Point, May 1928
Treffpunkt

HL: v 1928, 252, Treffpunkt
Watercolor and gouache on paper, 48.5 x 31
Private collection, New York

114 Square in Circle, May 1928
Quadrat im Kreis

HL: v 1928, 255, Quadrat im Kreis
Watercolor on paper, 47 x 31
Acquired through the Kandinsky-Gesellschaft by Heinrich Kirchhoff, Wiesbaden, 1928
Private collection

115 Black-White, May 1928
Schwarz-Weiss

HL: v 1928, 261, Schwarz-Weiss
Watercolor on paper, 47 x 30.5
Private collection, Switzerland

116 Start, May 1928
Beginn

HL: v 1928, 259, Beginn Start
Watercolor on paper, 32.2 x 48.3
Formerly Galka E. Scheyer, Los Angeles
Long Beach Museum of Art
The Milton Wichner Collection

117 Red Square, May 1928
Rotes Quadrat

HL: v 1928, 270, Rotes Quadrat
Watercolor on paper, 32.2 x 48.3
Formerly Galka E. Scheyer, Los Angeles
Long Beach Museum of Art
The Milton Wichner Collection

118 Into the Dark, May 1928
Ins Dunkel

HL: v 1928, 266, Ins Dunkel
Watercolor on paper, 48 x 31.8
Acquired from the Nierendorf Gallery, New York, by Hilla Rebay, November 1944
The Hilla von Rebay Foundation

Of the twenty-one works Kandinsky lists in his Handlist of watercolors for May 1928, six are included in this exhibition (cat. nos. 113-18). Many of these watercolors were executed with a spraying technique rather than with the brush. In *Square in Circle* (cat. no. 114) and *Red Square* (cat. no. 117) the red squares were made with stencil-shapes,

which covered the surrounding paper and left the square exposed when the diluted watercolor was sprayed on. *Black-White* and *Start* (cat. nos. 115, 116) share similar shapes: however, the delicate gradations of color in *Start* have been translated into subtle shades of grey in the monochromatic *Black-White.*

119 Zigzag Upward, June 1928
Zickzack in die Höhe

HL: vi 1928, 279, Zickzack in die Höhe
Watercolor and gouache on paper, 24 x 58
Acquired through the Kandinsky-Gesellschaft by Rudolf Ibach, Barmen 1928
Etta und Otto Stangl Collection

120 Subdued Glow, June 1928
Gedämpfte Glut

HL: vi 1928, 284, Gedämpfte Glut
Watercolor and gouache on paper, 36.5 x 25.1
Acquired from Galerie Zak by André Breton, Paris, January 1929
Ulmer Museum, Ulm

Of all the Surrealists, Kandinsky had the most contact with André Breton (1896-1966). Breton bought this work and another 1928 watercolor, *Small White,* at the Galerie Zak, where Kandinsky had his first one-man show in Paris in January 1929. In the autumn of 1933 Breton was influential in having Kandinsky included in the Salon des Surindépendants. He also contributed a short text (translated by Samuel Beckett) to the catalogue for Peggy Guggenheim's Kandinsky exhibition, which took place at her London gallery early in 1938. Later that year the artist gave Breton a work from 1936 on black paper, entitled *Flying.*

121 Begins, October 1928
Fängt an

HL: x 1928, 307, Fängt an
Watercolor on paper, 31.3 x 36.2
(21.3 x 26.5)
Private collection, Berlin

122 Toward Green, October 1928
Zu grün

HL: x 1928, 319, Zu grün
Watercolor on paper, 49.8 x 24.7
Gift of the artist to Paul Klee on his 50th birthday, December 18, 1929
Private collection, Switzerland

123 Evasive, April 1929
Ausweichend

HL: iv 1929, 341, Ausweichend Evasif
Watercolor on paper, 56.4 x 35.5
Acquired from Nierendorf Gallery, New York, by Hilla Rebay, February 1945
The Hilla von Rebay Foundation

124 Untitled, November 1929

HL: xi 1929, 360
Watercolor and india ink on paper, 17.4 x 27.7
Gift of the artist to Oskar Schlemmer, Dessau, November 9, 1929
Private collection

125 Sonorous, December 1929
Klangvoll

HL: xii 1929, 368, Klangvoll
Watercolor and india ink on paper, 43 x 42
Gift of the artist to Hermann Rupf, Berne, 1935
Kunstmuseum Berne:
Hermann und Margrit Rupf Stiftung

Kandinsky often refers to music and to sound in his writings and in the titles for his works. Around 1909 he wrote the prose poems for *Sounds* and worked on the stage compositions *Yellow Sound* and *Green Sound.* The concept of spiritual resonance was central to his artistic theories, and the term "inner resonance" [innerer Klang] often recurs. During the Bauhaus period the artist titled paintings *Contrasting Sounds, Three Sounds, Several Sounds,* and watercolors *Bright Sound, Chord,* and *Brown Double Sound* (cat. no. 102).
 Kandinsky gave *Sonorous* to the Swiss businessman and collector Hermann Rupf in 1935, the same year that Rupf selected a recent painting, *Light Tension.* Rupf, whom Kandinsky had met through Klee at the end of 1933, was Kandinsky's bank contact in Berne.

126 Horizontal Blue, December 1929
Waagerecht Blau

HL: xii 1929, 369, *Wagerecht-Blau*
Watercolor, gouache, and blue ink on paper, 24.2 x 31.7
Acquired from Nierendorf Gallery, New York by Hilla Rebay, 1945-47
The Hilla von Rebay Foundation

127 Almost Submerged, March 1930
Fast versunken

HL: iii 1930, 383, Fast versunken
Gouache on dark gray-brown paper, 36 x 26
Private collection

128 Tense, July 1930
Gespannt

HL: vii 1930, 386, Gespannt
Watercolor and india ink on paper, 49.2 x 36.8
Gift of the artist to Frau Dr. Grohmann, March 1931
Graphische Sammlung Staatsgalerie Stuttgart

129 Peaceful, September 1930
Friedlich

HL: ix 1930, 394, Friedlich
Watercolor and india ink on paper, 47.5 x 33
Gift of the artist to Paul Klee, December 18, 1931
Private collection, courtesy of Galerie Thomas

130 Upright, September 1930
Aufrecht

HL: ix 1930, 389, Aufrecht
Watercolor on paper, 46.5 x 27
Acquired through the Kandinsky-Gesellschaft by Werner Vowinckel, Cologne, December 1930
Private collection, Cologne

131 Restrained, June 1931
Verhalten

HL: vi 1931, 405, Verhalten
Watercolor, gouache and india ink on paper, 51 x 36
Acquired through the Kandinsky-Gesellschaft by Dr. Richard Doetsch-Benziger, Basle, December 1931
Private collection

132 Light Weights, June 1931
Leichte Lasten

HL: vi 1931, 418, Leichte Lasten
Watercolor and india ink on paper, 31.5 x 48.5
Acquired from the artist by Fritz Bienert, Dresden, February 1933
Private collection, London

133 Steadfast, July 1931
Standhaft

HL: vii 1931, 420, Standhaft
Watercolor and india ink on paper, 46.5 x 47
Gift of the artist to Alberto Magnelli, Paris
Private collection

134 Hot, July 1931
Heiss

HL: vii 1931, 429, Heiss Chaud
Watercolor, gouache, india ink and pencil on paper, 28.3 x 48.6
Acquired from Nierendorf Gallery, New York, by Hilla von Rebay, January 1946
The Hilla von Rebay Foundation

During the summer of 1931 Kandinsky made many watercolors, which display diverse stylistic tendencies. The intense reds, purples, and blues of *Hot* contrast with the more subdued colors of *Steadfast* (cat. no. 133), *Gridded Circles* (cat. no. 135), and *Pale Knot* (cat. no. 138). The application of the black ink wash to the background of *Hot* and several other watercolors from this time anticipates the artist's selection of black paper for works in 1935 (cat. no. 156). The expressive title may not be coincidental, since the work was done in July. The Kandinskys went on a Mediterranean cruise for their vacation in August and the first half of September. It is not known whether any of the six watercolors dated August in the Handlist was painted during this trip to Egypt, Jerusalem, Baalbek, and Constantinople.

135 Gridded Circles, July 1931
Gitterkreise

HL: vii 1931, 431, Gitterkreise
Watercolor and gouache on paper, 50 x 30
Private collection

136 Glimmering, July 1931
Flimmern

HL: vii 1931, 435, Flimmern
Watercolor and colored ink on paper, 34.2 x 34.8
The Hilla von Rebay Foundation

137 Red in Square, August 1931
Rot im Quadrat

HL: viii 1931, 446, Rot im Quadrat
Watercolor and india ink on paper, 34 x 33.9
Acquired through exchange by
Willi Baumeister, March 1932
Private collection

In February 1932 Willi Baumeister (1889-1955) wrote to Kandinsky in Dessau expressing admiration for his recent work. Kandinsky replied in a letter dated February 17: "I am glad that you like my new work. I shall be delighted to exchange [pictures] as you suggest." He received a work on paper from Baumeister, which is dated 1932 (Musée National d'Art Moderne, Paris), and in exchange sent the younger artist this watercolor, which is inscribed "To my respected and dear colleague Willi Baumeister heartily Kandinsky, March 1932".

138 Pale Knot, August 1931
Blasser Knäuel

HL: viii 1931, 447, Blasser Knäuel
Watercolor on paper, 48 x 28
Max Bill, Zumikon

139 Two Spirals, January 1932
Zwei Spiralen

HL: i 1932, 453, 2 Spirale
Watercolor on paper, 40.8 x 25
Formerly Will Grohmann, Dresden
Private collection, Berlin

140 Development, January 1932
Entwicklung

HL: i 1932, 454, Entwicklung
Oil, tempera, watercolor, and india ink on paper, 39.2 x 25.2
Gift of the artist to Hilla Rebay,
July 27, 1935
The Hilla von Rebay Foundation

141 Blurring, July 1932
Verschwimmend

HL: vii 1932, 477, Verschwimmend
Watercolor on paper, 40 x 58
Acquired through the Kandinsky-Gesellschaft by Ida Bienert,
Dresden, November 1932
Leonard Hutton Galleries, New York

142 Over Here, November 1932
Herüber

HL: xi 1932, 496, Herüber
Gouache on paper, 32 x 52
Galerie Tokoro, Tokyo

143 Two to One, July 1933
Zwei zu Eins

HL: vii 1933, 516, Zwei zu Eins Deux vers un
Watercolor on paper, 48.5 x 31.7
Private collection, Japan

The juxtaposition of simple geometric shapes, two circles and one rectangle, against a background of pale blue sprayed watercolor suggests Klee's watercolor *Naval Observatory* from 1926 (Fogg Art Museum, Harvard University, Cambridge, Mass.), where two black circles become eyes and a red flag stands for the mouth. Likewise, Kandinsky's watercolor *Upright* of 1930 (cat. no. 130) recalls Klee's *Monsieur Pearlypig* of 1925 (Kunstsammlung Nordrhein-Westfalen, Dusseldorf). In stylistic as well as technical aspects Kandinsky was influenced by Klee, especially during the late twenties and early thirties, when they both taught at the Bauhaus and shared a "master's house" in Dessau.

144 Similibus, August 1933

HL: viii 1933, 522, Similibus
Watercolor on paper, 38.7 x 31
Gianna Sistu

145 Study for "Development in Brown", 1933
Entwurf zu "Entwicklung in Braun"

Watercolor and india ink on paper,
22.9 x 29.8
Private collection

Kandinsky titled the last canvas he painted in Germany in August 1933 *Development in Brown* (Musée National d'Art Moderne, Paris), and he made a watercolor study for it, which he did not include in the Handlist. The color brown may refer to the rise to power of the National Socialist party earlier that year, which forced the closing of the Bauhaus on July 20, 1933.

146 Untitled, 1933

India ink on paper, 42 x 50
Private collection

147 Green-Black, May 1934
Vert-noir

HL: v 1934, 526, Vert-noir
Watercolor and india ink on paper,
31.5 x 24.5
Private collection, Basle

In the Handlist of watercolors under the year 1934, Kandinsky records a group of eight watercolors dated from April to July, to which he gives simple titles in French. All have the same dimensions and share bold, simplified shapes with flat areas of color; it is possible that they were intended as studies for prints that were not realized. Later, in December, Kandinsky added to the Handlist three watercolors (cat. no. 148) that he had painted in March, in which the images suggest biological forms.

148 Four, March 1934
Quatre

HL: iii 1934, 522a Quatre
Watercolor and india ink on paper, 54 x 29
Fondazione Antonio Mazzotta, Milan

149 Braided, July 1934
Tressé

HL: vii 1934, 532, Tressé
Gouache and watercolor on brown paper,
46.7 x 32.6
Gift of the artist to Will Grohmann, Dresden,
October 1937
Graphische Sammlung Staatsgalerie
Stuttgart

150 Creeping, October 1934
Rampant

HL: x 1934, 536, Rampant
Watercolor and india ink on paper, 53 x 30
Ueda Culture Projects, Tokyo

In 1934, after Kandinsky settled in Paris, new images entered his paintings and works on paper: amoebas, embryonic creatures, marine invertebrates, and other specific biological forms. In his canvases *Dominant Violet* of June and *Division-Unity* of October as well as in this watercolor *Creeping*, the imagery derives from deep-sea life. Medusas, jellyfish, seaweed, sea-worms, snakes, deep-sea fish, and underwater flora are identifiable in this 1934 watercolor and in *Spots: Green and Pink* (cat. no. 155) of 1935. Moreover, Kandinsky saved scientific illustrations from magazines and owned copies of Ernst Heinrich Haeckel's *Kunstformen der Natur* (Artforms of Nature) (1904) and Karl Blossfeldt's *Urformen der Kunst* (Protoforms of Art) (1929).

151 Ends, December 1934
Bouts

HL: xii 1934, 539, Bouts
Watercolor and india ink on paper, 70 x 51.5
Adrien Maeght, Paris

152 Capricious, December 1934
La capricieuse

HL: xii 1934, 542, La capricieuse
Watercolor and ink on paper, 61.2 x 49
Acquired from the artist by Prof. Müller,
Basle, April 28, 1936
Private collection, Basle

The distinctive whiplash line prominent in this watercolor also appears in a 1934 drawing (cat. no. 154) and in *White Line* (cat. no. 157). It can be traced back to the Bauhaus period. In *Point and Line to Plane*, which appeared in 1926, Kandinsky writes about the expressive qualities of various lines, including a similar emphatic black line: "Curve-independently undulating: Variations of the latter: 1. Tip deflected to the left by the forceful impact of the negative thrust 2. Tip emphasized by thickening the line-stress."

153 Untitled, 1934

Ink and pencil on paper, 33.7 x 23
Gift of the artist to
Dr. Richard Doetsch-Benziger, Basle,
January 1, 1935
Graphische Sammlung Staatsgalerie
Stuttgart

154 Turning, December 1934
Virage

HL: xii 1934, 547, Virage
Oil, watercolor, and india ink on paper,
23.2 x 35
Acquired from the artist by Dr. Hans
Lühdorf, Dusseldorf, December 2, 1941
Private collection

155 Spots: Green and Pink, May 1935
Taches: verte et rose

HL: v 1935, 551, Taches: verte et rose
Watercolor and india ink on paper mounted
on cardboard, 38.5 x 57
Formerly Galka E. Scheyer, Los Angeles
Private collection

156 Ascent in White, May 1935
Montée de blanc

HL: v 1934, 556, Montée de blanc
Gouache on black paper, 48 x 39
Acquired by Mme Yvonne Zervos,
September 1935
Rossetti Collection

157 White Line, June 1936
La ligne blanche

HL: vi 1936, 571, La ligne blanche
Gouache on black paper, 49.9 x 38.7
Acquired from the artist by Musée Jeu de
Paume, Paris, June, 1937
Musée National d'Art Moderne,
Centre Georges Pompidou, Paris

In 1937 Kandinsky's gouache *White Line* was
acquired by the Musée Jeu de Paume in
Paris for two thousand francs. The artist
wrote to André Dézarrois, Director of the
Musée Jeu de Paume, who was organizing
the exhibition "Origins and Developments of
Independent International Art" that: "I
should greatly appreciate it if you could
include my little gouache 'White Line' in the
exhibition at the Musée du Jeu de Paume
that you are planning to mount at the same
time. I think this would make a favorable
impression on my foreign collectors."
Although it was apparently not shown at
the Jeu de Paume during the summer of
1937, this gouache on black paper had been
included in the exhibition at the Galerie
Jeanne Bucher in Paris in December 1936,
which Dézarrois admired.

158 Submissive Circles, June 1936
Cercles soumis

HL: vi 1936, 572, Cercles soumis
Gouache on black paper, 50 x 25.5
Acquired from Galleria del Milione, Milan
by Prof. Rognoni, January 19, 1941
Galerie Thomas

159 Black and Cold, 1937
Noir et froid

HL: 1937, 575, Noir et froid
Gouache on gray paper, 51.2 x 33
Private collection

160 White on Black, October 1937
Blanc sur noir

HL: x 1937, 581, Blanc sur noir
Gouache on black paper, 49.6 x 46.2
Acquired by Fernand Graindorge,
Liège, December 2, 1944
Private collection

161 Above, April 1938
Au dessus

HL: iv 1938, 586, Au dessus
Gouache on black paper, 34 x 49.6
Private collection

Most but not all of Kandinsky's watercolors
from the summer of 1936 through 1939 are
painted with opaque pigments on black
paper. Often the colored lines are so thin
that they appear to be drawings on a dark
ground (cat. nos. 169, 170). In other works,
such as *Double Tension, Varied Strokes,* and
Around the Middle (cat. nos. 164, 165, 167),
the texture and the more painterly qualities
of the gouache are accentuated. Kandinsky
favored certain colors – purples, pinks,
bright blues and greens, reds – that stand out
on black paper.

162 Fifteen, April 1938
Quinze

HL: iv 1938, 589, Quinze
Gouache on black paper, 34.5 x 50
Kunstmuseum Berne

163 White Zigzag, May 1938
Le zigzag blanc

HL: v 1938, 598, Le zigzag blanc
Gouache on black paper, 49.5 x 33.6
Mr. and Mrs. Thomas M. Messer Collection

164 Double Tension, June 1938
La tension double

HL: vi 1938, 600, La tension double
Gouache on black paper, 50.9 x 33.3
Acquired from the artist, October 28, 1938
Private collection, Berne

165 Varied Strokes, August 1938
Coups divers

HL: viii 1938, 602, Coups divers
Gouache on black paper, 64.5 x 44
Private collection

166 Blue Spot, December 1938
La tache bleue

HL: xii 1938, 609, La tache bleue
Gouache on black paper, 49.5 x 22.8
Private collection

167 Around the Middle, February 1939
Autour du milieu

HL: ii 1939, 619, Autour du milieu
Gouache on black paper, 49 x 31
Private collection, Switzerland

168 White Form, February 1939
La forme blanche

HL: ii 1939, 620, La forme blanche
Gouache on black paper, 31.6 x 48.5
Private collection, New York

169 Cubes, May 1939
Cubes

HL: v 1939, 627, Cubes
Gouache on black paper, 48.5 x 36.5
Private collection, Japan

170 Lines, May 1939
Lignes

HL: v 1939, 628 Lignes
Gouache on black paper, 26 x 49
Katsuya Ikeuchi Collection, Japan

171 Horizontals, 1939
Horizontales

IIL: 1939, 633, Horizontales
Watercolor and gouache on paper, 44 x 32
Private collection

172 Study for "Ensemble", 1940
Étude pour "L'Ensemble"

HL: 1940, 634, projet du No. 671
Gouache on black paper, 29.5 x 39.5
Private collection, New York

During Kandinsky's last years in Paris, he
continued to make preparatory watercolors
for some of his oil paintings. The canvas
L'Ensemble, which was painted in
January/February 1940, follows this study
closely, although the colors have been slight-
ly changed. In September of the same year
the artist created *Moderation* after a water-
color. *Study for "Reduced Contrasts"* (cat. no.
188) dates from 1941, and was developed
into an oil painting. However, from 1940 to
1944 he usually made detailed drawings
rather than watercolors for his paintings.

173 Untitled, 1940

HL: 1940, 636
Gouache and india ink on tan paper, 49 x 32
Acquired from the artist by Pierre Bruguière
Private collection

174 Untitled, 1940

HL: 1940, 638
Gouache on gray paper, 47 x 30.8
Adrien Maeght, Paris

175 Untitled, 1940

HL: 1940, 644
Gouache on black paper, 49 x 32
Acquired from the artist by Pierre Bruguière
Private collection, Paris

176 Untitled, 1940

HL: 1940, 654
Gouache on black paper, 32 x 49.4
Private collection

177 Untitled, 1940

HL: 1940, 662
Gouache on black paper mounted on
cardboard, 32 x 49.4 (44 x 61)
Private collection

178 Untitled, 1940

HL: 1940, 663
Gouache on black paper, 49 x 31.5
Acquired by Mme. Lecoutoure, Paris
Private collection, Tokyo

Because Kandinsky recorded his water-
colors and gouaches in a basically chrono-
logical sequence in the Handlist, it is possi-
ble to compare works executed around the
same time (cat. nos. 177, 178). Although
most of the works from 1940 are untitled,
the artist specified the color of the support
and assigned each a number. Handlist num-
bers 662 through 668 are painted in gouache
on black paper of approximately the same
dimensions. Within a restricted format
and technique, Kandinsky articulates inter-
related motifs.

179 Untitled, 1940

HL:1940, 665
Gouache on black paper, 49 x 30.5
Private collection

180 Pointed Movement, 1940
 Mouvement aigu

HL: 1940, 667
Gouache on black paper, 32 x 49.4
Acquired by Mme. Lecoutoure, Paris,
April 3, 1944
Mr. and Mrs. E. I. Firestone, USA

Although most of Kandinsky's works on
paper from 1940 through 1944 are untitled,
he assigns this work a specific title in the
Handlist, *Pointed Movement*. He also notes
that the work went to Mme. Lecoutoure in
April 1944. Noëlle Lecouture and Maurice
Panier directed the Galerie L'Esquisse in
Paris, where works by César Domela, Alber-
to Magnelli, Nicolas de Staël, and Kandinsky
were shown clandestinely in the spring of
1944 during the Occupation. The last one-
man show during Kandinsky's lifetime was
on view at the Galerie L'Esquisse when he
died on December 13, 1944.

181 Untitled, 1941

HL: 1940, 679
Gouache on gray paper, 33 x 51
Private collection, Milan

182 Untitled, 1940

HL: 1940, 669
Gouache on tan paper, 50 x 32.5
Private collection

183 Untitled, 1941

HL: 1941, 697
Gouache and india ink on gray paper,
49.5 x 31.5
Fondation Dina Vierny Collection, Paris

184 Untitled, 1941

HL: 1941, 699
Watercolor, gouache and india ink on gray
paper, 47.5 x 31
Private collection

185 Untitled, 1941

HL: 1941, 703
Gouache on tan-gray paper mounted
on cardboard, 39.8 x 49 (49 x 58.5)
Private collection

186 Untitled, 1941

HL: 1941, 713
Watercolor and india ink on gray paper,
31 x 48
Private collection

187 Untitled, 1941

HL: 1941, 705
Gouache on dark gray cardboard, 21.2 x 54.5
Acquired by Mme. San Lazzaro, May 8, 1943
Private collection

188 Study for "Reduced Contrasts", 1941
 Étude pour "Contrastes réduits"

HL: 1941, 721
Gouache on black cardboard, 31.8 x 49.5
Private collection, New York

189 Untitled, 1941

India ink on paper, 18.6 x 27.9
Private collection

During his last years Kandinsky executed
many drawings, on which he also relied for
motifs for his paintings. In 1941 he filled a
sketchbook from Sennelier which originally
contained thirty-nine drawings. Although
the sheets have been dispersed, one is pre-
sented here. In the preface to a facsimile
published by Karl Flinker in 1972, Gaëton
Picon writes: "Some drawings from 1941 are
followed within a year or two by pictures
that are color versions of the same. These
pictures add nothing but color: they leave
the structures quite untouched The
reduction, the abstraction of the drawing, far
from being revealed as deficiency, serves in
fact as a challenge and inspiration for an
acuteness, an extreme subtlety."

190 Untitled, 1941

HL: 1941, 723
Watercolor, gouache and india ink on gray
paper, 31 x 48
Private collection, Japan

191 Untitled, 1944

HL: 729
Watercolor and india ink on paper,
25.9 x 49.1
Musée National d'Art Moderne,
Centre Georges Pompidou, Paris:
Nina Kandinsky Bequest

192 Untitled, 1944

HL: 730
Watercolor, india ink, and pencil on paper,
25.5 x 34.6
Musée National d'Art Moderne,
Centre Georges Pompidou, Paris:
Nina Kandinsky Bequest

After two years in which the artist does not
indicate that he had painted any water-
colors, he entered two works dated 1944 in
the Handlist. On the reverse of Handlist
numbers 729 and 730, respectively, Nina
Kandinsky has written in French "Penulti-
mate watercolor" and "Last watercolor". The
latter (cat. no. 192) is based on a drawing
from the 1941 sketchbook, and the former
(cat. no. 191) is similar to a gouache from
1940 (HL 643). Although Kandinsky may
have continued to work after painting the
last watercolor, he did not enter any more
works in his Handlist. According to Nina
Kandinsky's memoirs, her husband was not
well in 1944 and was unable to work after
July. There is no explanation as to why Kan-
dinsky did not paint any watercolors in 1942
and 1943, since he made many small-scale
oils during this time.

Photographic Acknowledgments

Photographs were kindly provided by the
institutions and collectors named in the
captions, except in the following cases:

Photo Christian Baur, Basle
cat. no. 115

Courtesy of the Art Institute of Chicago
p. 44, fig. 2

Guglielmo Chiolini & c. S. R. L., Pavia
cat. no. 84

Photographie Jean Dubout, Paris
p. 39, fig. 8; cat. nos. 71, 189

Carmelo Guadagno, Solomon R. Guggen-
heim Museum, New York
p. 49, fig. 7

Solomon R. Guggenheim Museum,
New York
p. 11, fig. 1; p. 24, fig. 18, 19; p. 34, fig. 2;
p. 40, fig. 9; p. 45, fig. 3; p. 51; fig. 9

David Heald, New York
cat. nos. 95

J. Hyde, Paris
cat. nos. 113, 133, 174

Walter Klein, Dusseldorf
p. 39, fig. 7; cat. no. 8

Fotocolor Ed. Mazzotto, Milan
cat. nos. 148, 181

Photo Philippe Migeat,
Centre G. Pompidou, Paris
cat. no. 146

André Morain, Paris
p. 41, fig. 10

Clichée Musée National d'Art Moderne,
Paris
p. 38, fig. 6; p. 48, fig. 6; cat. nos. 45, 83, 85

Otto E. Nelson
cat. no. 141

Orcutt Photo
cat. no. 63

Alain Perruchaud, Geneva
cat. no. 106

Photo H. Preisig, Sion
cat. no. 137

Prudence Cuming Associates Ltd., London
cat. no. 75

Friedrich Rosensteil, Werbefotografie,
Cologne
cat. nos. 40, 121

Photoarchiv C. Raman Schlemmer,
Oggebbio
cat. no. 124

Piotr Trawinski Photographe, Paris
cat. no. 107

Jens Willebrand Foto-Design, Cologne
cat. no. 110

Biography

Compiled by
Vivian Endicott Barnett

1866
Vasily Vasilevich Kandinsky [Vasilij Vasil'-evic Kandinskij] is born on December 4 in Moscow to Vasily Silvestrovich Kandinsky and Lidiya Ivanovna Ticheeva.

1869
Travels to Italy with his parents.

1871
Moves with mother to Odessa. Parents are divorced.

1876-85
Attends secondary school in Odessa, where he learns to play the piano and cello. Annual visits to Moscow, where father lives.

1886
Begins study of economics and law at University of Moscow.

1889
Travels to Vologda region and subsequently publishes essay on "Sentences Imposed by the Peasant Courts in Moscow Province."

1892
Marries his cousin Anya Shemyakina.

1893
Writes dissertation *On the Legality of Workers' Wages* and is appointed teaching assistant in economics and statistics at University of Moscow.

1895
Becomes artistic director of the Kushverev printing company in Moscow.

1896
Declines teaching position at the University of Dorpat (now Tartu) and decides to study painting. Moves to Munich, where he lives at Friedrichstrasse 1. Enrolls in the private art school of Anton Azhbè.

1897
Meets Alexej Jawlensky, Marianne Werefkin, Dmitry Kardovsky, Igor Grabar and other Russian artists at Azhbè's school.

1898
Fails entrance examination at Art Academy in Munich and works independently.

1900
Studies with Franz von Stuck at Art Academy where Paul Klee is student. Begins to exhibit work with Moscow Artists' Association.

1901
Paints first gouaches and temperas on cardboard (*farbige Zeichnungen*) and small oil studies on canvasboard. Co-founder of Phal-anx artists' association in May, participates in their first exhibition in fall. At end of year begins to teach drawing and painting when Phalanx art school opens. First trip to Rothenburg ob der Tauber.

1902
Meets Gabriele Münter, a student in his painting class. Takes class to Kochel. Writes reviews of art exhibitions for periodical *Mir iskusstva* in St. Petersburg. Exhibits his work with Berlin Secession.

1903
Takes painting class to Kallmünz. Phalanx school closes and group dissolves following year. Goes to Venice, Vienna and Odessa. Publishes *Poems without Words* in Moscow.

1904
Travels to the Netherlands with Münter in May and June. Separates from wife in September. Travels to Odessa in October and visits Paris in late November. Begins to exhibit at *Salon d'Automne* and Les Tendances Nouvelles in Paris. In December travels to Tunis with Münter.

1905
First one-man show takes place at Galerie Krause in Munich and other galleries in Germany. Kandinsky stays in Tunisia until April and then travels in Italy with Münter. Lives with her in Dresden during summer before returning to Munich. Travels to Odessa in October, to the Rheinland in November, and to Italy in December.

1906
Lives with Münter in Rapallo until end of April and travels via Switzerland to Paris in May. At end of June moves to 4 petite rue des Binelles in Sèvres where he lives for one year with Münter. Numerous exhibitions of his work in France and in Germany.

1907
Paints many Russian scenes while in Paris. Shows work at Salon des Indépendants in Paris and at Musée du Peuple in Angers. In June returns to Munich and takes rest cure at Bad Reichenhall. Moves to Berlin in September, where he lives with Münter until following April.

1908
First summer in Murnau with Jawlensky, Werefkin, and Münter. Then moves to apartment at Ainmillerstrasse 36 in Munich. Meets Thomas von Hartmann and begins work on collaborative projects with him.

Vasily, age 6

1909
Co-founds New Artists' Association Munich (Neue Künstlervereinigung München, NKVM) and is elected its president. Begins to write abstract stage compositions *The Yellow Sound* (Der gelbe Klang), *Green Sound* (Grüner Klang) and *Black and White* (Schwarz und Weiss). His series of woodcuts, *Xylographies*, published in Paris. Münter buys house in Murnau where they spend following summers. Paints first glass paintings and first Improvisations. In December participates in first NKVM exhibition at Moderne Galerie Thannhauser in Munich and Salon of Vladimir Izdebsky in Odessa.

1910
Paints first Composition. Meets Franz Marc at time of second NKVM exhibition at Thannhauser's gallery in September. Travels to Russia in autumn and returns to Munich at end of year. Many works shown at Salon Izdebsky in Odessa in December. Participates in "Knave of Diamonds" exhibition in Moscow. Completes manuscript for *On the Spiritual in Art* (Über das Geistige in der Kunst).

1911
Paints the Impressions. During summer works with Marc on plans for Blue Rider (Der Blaue Reiter) almanac. Friendships with Arnold Schönberg and Klee. Divorce from first wife finalized. In December Kandinsky, Münter, Marc, and Alfred Kubin leave NKVM. First exhibition "Der Blaue Reiter" opens at Moderne Galerie Thannhauser and *On the Spiritual in Art* is published by Piper in Munich at end of year.

1912
Second exhibition "Der Blaue Reiter" takes place in February at Galerie Hans Goltz in Munich; *Der Blaue Reiter Almanach* published by Piper in May. Herwarth Walden's gallery Der Sturm presents important one-man show in October which travels to other European cities. Kandinsky goes to Russia in fall and returns to Munich at end of year. *Sounds* (Klänge), prose poems and woodcuts, published by Piper in November.

1913
Exhibits paintings at International Exhibition of Modern Art (known as the "Armory Show") in New York, Chicago and Boston; participates in Walden's First German Fall Salon in Berlin in September. Der Sturm also publishes the album, *Kandinsky 1901-1913*, which includes his essay "Reminiscences" as well as texts on *Painting with White Border* and *Composition IV*. Shows with Moderne Kunst Kring (Modern Art Circle) in Amsterdam.

1914
One-man show held at Moderne Galerie Thannhauser in Munich in January. In August World War I begins. Kandinsky and Münter go to Switzerland where they stay in Mariahalde near Goldach on Lake Constance. Writes *Violet Curtain* (Violetter Vorhang) and begins work on *Point and Line to Plane* (Punkt und Linie zu Fläche). Returns to Russia through Balkans in November, lives in Moscow from Christmas onward.

1915
Participates in the Moscow exhibition "The Year 1915". In June moves to apartment at 8 Dolgy Lane in Moscow. Remains in Russia until end of year and makes only watercolors and drawings. Travels to Stockholm to meet Münter for Christmas.

1916
Stays in Sweden until mid-March and paints watercolors, which he refers to as "bagatelles". Exhibits work at Gummesons Konsthandel, which also publishes his essay "On the Artist" (Om Konstnären). Returns to Moscow. In September meets Nina Andreevskaya.

1917
Marries Nina Andreevskaya on February 11, and goes to Finland for wedding trip. Spends summer at country house of Abrikosoff family near Achtyrka. Son Vsevolod Vasilevich Kandinsky born in September.

1918
Becomes active in Department of Visual Arts (IZO) within Narkompros (People's Commissariat of Enlightenment), which was established previous fall. In July named director of theater and film sections. Appointed head of Svomas (Free State Art Schools) in October. *Text of the Artist: Steps* [Tekst Khudozhnika. Stupeni] published by IZO in Moscow in fall. In December Kandinsky becomes member of commission on the organization of the Museums of Painting Culture.

1919
Named first director of Museums of Painting Culture, works on organizing a system of twenty-two provincial museums, and heads acquisitions committee. Appointed honorary professor at University of Moscow.

1920
Presents pedagogical program in June for Inkhuk (Institute of Artistic Culture), which was established in Moscow previous month. Teaches at Vkhutemas (Higher State Artistic-Technical Workshops) which replaced Svomas in September. At end of year leaves Inkhuk after his program is rejected.

1921
Co-founder of Russian Academy of Artistic Sciences with Kogan; and becomes its vice-president in autumn. In December leaves Soviet Russia and goes to Berlin.

1922
Walter Gropius offers him professorship at Bauhaus in Weimar, where he moves in June and joins Klee and Lyonel Feininger. Vacations at Timmendorfer Strand near Lübeck. Teaches preliminary course and is "form-master" of wall painting workshop. *Small Worlds* (Kleine Welten) published by Propyläen, Berlin.

1923
First one-man exhibition in New York organized by Société Anonyme, of which he becomes honorary vice-president. Vacations at Müritz and Binz on Baltic Sea.

With his painting
Small Pleasures, 1913

1924
Blue Four (Blaue Vier) exhibition group, which includes Feininger, Jawlensky, Kandinsky, and Klee, founded by Galka E. Scheyer, who becomes the artists' representative in United States. Kandinsky vacations in Wenningstedt on island of Sylt in North Sea.

1925
Moves to Dessau in June after Bauhaus is closed in Weimar and relocates in Dessau. Lives at Moltkestrasse 7. Otto Ralfs founds Kandinsky Society.

1926
Punkt und Linie zu Fläche, which was completed in November of previous year, is published by Albert Langen in Munich. Kandinsky's sixtieth birthday exhibition opens in Braunschweig in May. Jubilee exhibition shown in to Dresden, Berlin, Dessau, and other European cities. Moves to Burgkhünauer Allee 6 in Dessau, where he shares masters' double house with Klee.

1927
Teaches free painting class at Bauhaus. Friendship with Christian Zervos begins. Vacations in Switzerland and Austria, where he visits Schönberg.

1928
Kandinskys become German citizens. Designs scenery and costumes for and directs Mussorgsky's *Pictures at an Exhibition* (Bilder einer Ausstellung) which opens in April in Dessau. Vacations on French Riviera.

1929
First one-man exhibition in Paris of watercolors and gouaches takes place at Galerie Zak in January. Travels in Belgium and later vacations with Klee at Hendaye-Plage.

1930
Begins involvement with Cercle et Carré. Meets Jean Hélion and Gualtieri di San Lazzaro. Travels in Italy in the summer. Moves to Stresemann Allee 6 in Dessau in December.

1931
Designs ceramic tiles for music room at German Building Exhibition in Berlin. Travels to Egypt, Turkey, Greece, and Italy in summer. First contribution to periodical *Cahiers d'Art.*

1932
National Socialist Party closes Bauhaus in Dessau; Bauhaus reopens as private institution in Berlin in October. In December moves to Bahnstrasse 19, Berlin-Südende.

1933
Bauhaus closes permanently in July. Kandinsky vacations in Les Sablettes (Var). Travels to Paris in fall and relocates there in December. Lives at 135 boulevard de la Seine in Neuilly-sur-Seine, a suburb of Paris, for rest of his life.

1934
Meets Joan Miró, Piet Mondrian, and Alberto Magnelli; renews friendship with Arp. Exhibits with Abstraction-Création and Cahiers d'Art in Paris and vacations in Normandy.

1935
Declines invitation to serve as artist in residence at Black Mountain College in North Carolina. Exhibits at Galerie Cahiers d'Art in Paris in summer. Vacations on French Riviera. Exhibits work in New York with J.B. Neumann, who becomes his representative in eastern United States.

1936
Exhibits at J.B. Neumann's New Art Circle in New York and Stendahl Gallery in Los Angeles. Vacations in Italy. First exhibition at Galerie Jeanne Bucher in Paris in December.

1937
Karl Nierendorf interviews Kandinsky and presents one-man show of his work in New York. Works are confiscated from German museums by National Socialists and included in "Degenerate Art" (Entartete Kunst) exhibition in Munich and Berlin. Vacations in Brittany.

1938
Work shown in London at Guggenheim-Jeune Gallery and New Burlington Gallery. Four poems and woodcuts published in *transition* and essay on "Concrete Art" (L'Art Concret) appears in first issue of *XXe Siècle.* Vacations at Cap Ferrat on French Riviera.

1939
French National Museums purchase *Composition IX.* Becomes French citizen. Vacations at Croix-Valmer on Mediterranean.

1940
Following German invasion, spends summer at Cauterets in the Pyrenees.

1941
Centre Américain de Secours offers Kandinskys passage from Marseille to New York, but they decide to stay in France. Vacations in Marlotte.

Paris, 1935 (photo: Hannes Beckmann)
Below: With Paul Klee in Dessau, 1930

1942
Writes preface for portfolio *10 Origins,* edited by Max Bill. Paints last large canvas, *Delicate Tensions* and then works only on board. One-man show held at Galerie Jeanne Bucher in Paris.

1943
Vacations at Rochefort-en-Yvelines.

1944
Exhibits at Galerie Jeanne Bucher and Galerie l'Esquisse in Paris. Becomes ill in March but continues to work until July. Dies on December 13 in Neuilly from a sclerosis of the cerebellum.

Selected Bibliography

Catalogues Raisonnés

Barnett, Vivian Endicott. *Kandinsky Watercolours: Catalogue Raisonné,* vol. 1 *1900-1921,* vol. 2 *1922-1944.* London 1992, 1993.

Roethel, Hans K. *Kandinsky: Das graphische Werk.* Cologne, 1970.

Roethel, Hans K. and Benjamin, Jean K. *Kandinsky: Catalogue Raisonné of the Oil Paintings,* vol. 1 *1900-1915,* vol. 2 *1916-1944.* London and New York, 1982, 1984.

Books and Articles

Barnett, Vivian Endicott. "Kandinsky Watercolors." In *Kandinsky Watercolors: A Selection from The Solomon R. Guggenheim Museum and The Hilla von Rebay Foundation.* New York, 1981, pp. 8-18.

–. *Kandinsky at the Guggenheim.* New York, 1983.

–. *Kandinsky and Sweden.* Malmö and Stockholm, 1989.

Bill, Max, ed. *Wassily Kandinsky.* Paris, 1951.

Bowlt, John E. and Long, Rose-Carol Washton, eds. *The Life of Vasilii Kandinsky in Russian Art. A Study of "On the Spiritual in Art."* Newtonville MA, 1980.

Brisch, Klaus. *Wassily Kandinsky (1866-1944): Untersuchungen zur Entstehung der gegenstandslosen Malerei an seinem Werk von 1900-1921.* PhD dissertation, University of Bonn, 1955.

Cassou, Jean. *Wassily Kandinsky: Interférences. Aquarelles et dessins.* Paris, 1960.

Conil Lacoste, Michel. *Kandinsky.* Paris, 1979.

Derouet, Christian. "Vassily Kandinsky: Notes et documents sur les dernières années du peintre." In *Cahiers du Musée National d'Art Moderne 9* (1982), pp. 84-107.

– and Boissel, Jessica. *Kandinsky: Œuvres de Vassily Kandinsky (1866-1944).* Collections du Musée National d'Art Moderne. Paris, 1984.

Droste, Magdalena. "'... oh, du liebe Kunstpolitik': Kandinsky-Ausstellungen und seine Verkäufe während der zwanziger Jahre in Deutschland." *Kandinsky: Russische Zeit und Bauhausjahre 1915-33.* Berlin, 1984, pp. 66-71.

Düchting, Hajo. *Wassily Kandinsky 1866-1944: Revolution der Malerei.* Cologne, 1990.

Eichner, Johannes. *Kandinsky und Gabriele Münter: Von Ursprüngen moderner Kunst.* Munich, 1957.

Feininger, Julia and Lyonel. "Wassily Kandinsky." *Magazine of Art 38* (May 1945), pp. 174-175.

Gollek, Rosel. *Der Blaue Reiter im Lenbachhaus München: Katalog der Sammlung in der Städtischen Galerie.* Munich, 1982 and 1985, pp. 317-342.

Grohmann, Will. "Wassily Kandinsky." *Der Cicerone 16* (September 1924), pp. 887-898.

–. *Wassily Kandinsky.* Paris, 1930.

–. "Wassily Kandinsky." *Sélection 14* (July 1933).

–. *Wassily Kandinsky: Life and Work.* New York, 1958.

Hahl-Koch, Jelena, ed. *Arnold Schönberg–Wassily Kandinsky: Briefe, Bilder und Dokumente einer außergewöhnlichen Begegnung.* Salzburg, 1980.

Hanfstaengl, Erika. *Wassily Kandinsky: Zeichnungen und Aquarelle. Katalog der Sammlung in der Städtischen Galerie im Lenbachhaus München.* Munich, 1974 (reprint 1981).

Haxthausen, Charles W. "'Der Künstler ohne Gemeinschaft': Kandinsky und die deutsche Kunstkritik." In *Kandinsky: Russische Zeit und Bauhausjahre 1915-1933.* Berlin, 1984, pp. 72-89.

Kandinsky, Nina. *Kandinsky und ich.* Munich, 1976.

Kleine, Gisela. *Gabriele Münter und Wassily Kandinsky: Biographie eines Paares.* Frankfurt, 1990.

Lärkner, Bengt, et al. *New Perspectives on Kandinsky.* Malmö, 1990.

Langer, Johannes. "Gegensätze und Widersprüche – das ist unsere Harmonie.'" In *Kandinsky und München: Begegnungen und Wandlungen 1896-1914.* Munich, 1982, pp. 106-133.

Lankheit, Klaus, ed. *Wassily Kandinsky-Franz Marc: Briefwechsel.* Munich, 1983.

Le Targat, François. *Kandinsky.* Paris, 1986.

Lindsay, Kenneth C. *An Examination of the Fundamental Theories of Wassily Kandinsky.* PhD dissertation, University of Wisconsin, 1951.

– and Vergo, Peter, eds. *Kandinsky: Complete Writings on Art,* 2 vols. Boston, 1982.

Long, Rose-Carol Washton. *Kandinsky: The Development of an Abstract Style.* Oxford, 1980.

Marc, Franz. "Kandinsky." *Der Sturm 4* no. 186/7 (November 1913), p. 130.

Overy, Paul. *Kandinsky: The Language of the Eye.* New York, 1969.

Poling, Clark V. *Kandinsky-Unterricht am Bauhaus.* Weingarten, 1982.

Read, Herbert. *Kandinsky (1866-1944).* London, 1959.

Riedl, Peter Anselm. *Wassily Kandinsky: In Selbstzeugnissen und Bilddokumenten.* Reinbek, 1983.

Ringbom, Sixten. *The Sounding Cosmos: A Study in the Spiritualism of Kandinsky and the Genesis of Abstract Painting.* Abo, 1970.

Roethel, Hans K. and Benjamin, Jean K. *Kandinsky.* New York, 1979.

Rudenstine, Angelica Zander. *The Guggenheim Museum Collection: Paintings 1880-1945,* vol. 1, New York, 1976, pp. 204-391.

Thürlemann, Felix. *Kandinsky über Kandinsky: Der Künstler als Interpret eigener Werke.* Berne, 1986.

Umanskij, Konstantin. "Russland. IV: Kandinskijs Rolle im russischen Kunstleben." *Der Ararat 2* (May/June 1920, special issue), pp. 28-30.

XXe Siècle 27 (December 1966, special issue).

Volboudt, Pierre. *Die Zeichnungen Wassily Kandinskys.* Cologne, 1974.

–. *Kandinsky.* Geneva, 1985.

Weiss, Peg. *Kandinsky in Munich: The Formative Jugendstil Years.* Princeton, 1979.

Whitford, Frank. *Kandinsky.* London, 1967.

Zehder, Hugo. *Wassily Kandinsky.* Dresden, 1920.

Zervos, Christian. "Notes sur Kandinsky." *Cahiers d'Art 9* (1934), pp. 149-157.

Zweite, Armin. "Kandinsky zwischen Tradition and Innovation." In *Kandinsky und München: Begegnungen und Wandlungen 1896-1914.* Munich, 1982, pp. 134-177.

–, ed. *Der Blaue Reiter im Lenbachhaus München.* Munich, 1991.

Catalogues of one-man exhibitions (in chronological order)

Kandinsky: Kollektiv-Ausstellung 1902-1912. Der Sturm, Berlin, 1912. Text by Kandinsky.

Jubiläums-Ausstellung zum 60. Geburtstage. Galerie Arnold, Dresden, 1926; traveled to Berlin (Galerie Neumann & Nierendorf), et al. Texts by Paul Klee, Will Grohmann, et al.

Exposition d'aquarelles de Wassily Kandinsky. Galerie Zak, Paris, 1929. Text by E. Tériade.

Kandinsky. Galerie de France, Paris, 1932. Text by Christian Zervos et al.

Wassily Kandinsky. Guggenheim Jeune, London, 1938. Texts by André Breton, Michael E. Sadler, et al.

In Memory of Wassily Kandinsky. Museum of Non-Objective Painting, New York, 1945; traveled to Chicago (Arts Club of Chicago). Text by Kandinsky.

Kandinsky. Moderne Galerie Otto Stangl, Munich, 1948. Text by Ludwig Grote.

Kandinsky. Wallraf-Richartz-Museum, Cologne, 1958. Organized by Otto H. Förster and Will Grohmann.

Vasily Kandinsky, 1866-1944: A Retrospective Exhibition. The Solomon R. Guggenheim Museum, New York, 1963; traveled to Paris (Musée National d'Art Moderne), The Hague (Gemeente Museum), et al. Organized by Thomas M. Messer.

Kandinsky. Moderna Museet, Stockholm, 1965. Organized by Pontus Hultén.

Kandinsky: Das druckgraphische Werk. Zum 100. Geburtstag. Städtische Galerie im Lenbachhaus, Munich, 1966. Organized by Hans Konrad Roethel.

Kandinsky Watercolors. The Museum of Modern Art, New York, 1969; traveled to Fort Worth (Fort Worth Art Center), Toronto (Art Gallery of Ontario), et al.

Kandinsky: Aquarelle und Gouachen. Kunstmuseum, Berne, 1971. Text by Sandor Kuthy.

Kandinsky: Aquarelle und Zeichnungen. Galerie Beyeler, Basle, 1972. Text by Nina Kandinsky.

Kandinsky: Aquarelles et dessins. Galerie Berggruen, Paris, 1972. Reprinted excerpts from artist's texts.

Kandinsky: Peintures, dessins, gravures, éditions. Galerie Karl Flinker, Paris, 1972. Text by Jacques Lassaigne.

Wassily Kandinsky 1866-1944. Haus der Kunst, Munich, 1976. Organized by Thomas M. Messer.

Kandinsky: Trente peintures des musées soviétiques. Musée National d'Art Moderne, Paris, 1979. Text by Christian Derouet.

Kandinsky in Munich, 1896-1914. The Solomon R. Guggenheim Museum, New York, 1982; traveled to Munich (Städtische Galerie im Lenbachhaus). Text by Peg Weiss.

Kandinsky: Russian and Bauhaus Years 1915-1933. The Solomon R. Guggenheim Museum, New York, 1983; traveled to Zurich (Kunsthaus), Berlin (Bauhaus-Archiv), et al. Text by Clark V. Poling.

Kandinsky: Musée National d'Art Moderne, Paris, 1984. Organized by Christian Derouet.

Kandinsky in Paris 1934-1944. The Solomon R. Guggenheim Museum, New York, 1985. Texts by Christian Derouet and Vivian Endicott Barnett.

Wassily Kandinsky: Die erste sowjetische Retrospektive. Schirn Kunsthalle, Frankfurt, 1989. Organized by Natasha Avtonomova.